ROMAN BODIES

This volume has been published with the help of subventions from

The Roman Society
The Samuel H. Kress Foundation
The University of Reading

ROMAN BODIES

ANTIQUITY TO THE EIGHTEENTH CENTURY

Edited by

ANDREW HOPKINS AND MARIA WYKE

The British School at Rome, London
2005

© The British School at Rome, *at* The British Academy
10 Carlton House Terrace, London, SW1Y 5AH

www.bsr.ac.uk

Registered charity no. 314176

ISBN 0 904152 44 8

Typeset and printed by ALDEN GROUP, OXFORD, GREAT BRITAIN

CONTENTS

LIST OF FIGURES

ACKNOWLEDGEMENTS

THE EDITORS wish to thank all the staff of the British School at Rome, its Director Andrew Wallace-Hadrill and the Publications Manager Gill Clark, for their assistance with this project. The anonymous readers made many helpful suggestions; Mary Beard and Helen King helped with funding applications; Sible de Blauuw, then of the Dutch Institute, and Ingrid Rowland, then of the American Academy at Rome, epitomized collegiality and friendship in Rome. For institutional support thanks go to the Department of Comparative History and Methodology at the University of l'Aquila and the Department of Classics of the University of Reading.

THE BODY OF ROME: INTRODUCTION

Maria Wyke and Andrew Hopkins

A painting entitled *Carità Romana (Cimone e Pero)* hangs in the galleries of the Palazzo Doria Pamphilj in the heart of Rome (Fig. 1.1). Composed by the Roman artist Giovanni Antonio Galli (called lo Spadarino) towards the middle of the seventeenth century, it incarnates the virtue of Roman charity in a striking image of a young daughter. Inside her father's prison cell, Pero exposes her breast to suckle Cimon and thus save him from the starvation to which he has been condemned. The history of this transgressive image well illustrates the themes and overall narrative development of *Roman Bodies*.

Galli's depiction of the remarkably virtuous conduct of a daughter toward her male parent owes its details to two legends of such filial piety described by the Roman author Valerius Maximus in a first-century collection of anecdotes dedicated to the Emperor Tiberius (*Facta et dicta memorabilia* 5.4). His Roman version tells of an anonymous daughter's nourishment of her imprisoned mother, while his lengthier Greek version tells of Pero's nourishment of her father. Yet, in subsequent usage, the two accounts were amalgamated to make a daughter's physical act of devotion to her father the exemplary embodiment of Roman charity (*caritas romana*). As a startling moral lesson in filial piety, the legend was even connected in other ancient sources to the original consecration of a temple to Pietas, variously located either where the daughter had lived or where her parent had been incarcerated — as if the daughter's corporeal gesture constituted the very action of the official cult of Pietas at Rome.[1]

As was so typical of Roman writings that gained new relevance within the context of Christianity, this example was taken up and incorporated into the *Gospel of Saint Matthew* (25.34–6), which catalogued the six acts of mercy by which mankind could attain salvation: feeding the hungry, giving drink to the thirsty, taking in the stranger, clothing the naked, tending the sick and visiting the prisoner. Thus, in Christian theology, taking care of the physical bodies of others can lead to the redemption of one's own soul. By the Middle Ages, a seventh act of burying the dead had been added. It was this expanded theme that Caravaggio was commissioned to paint at the end of 1606 as a *Madonna della Misericordia* or *The Seven Acts of Mercy* (Fig. 1.2).[2] Within a web of allusions to classical texts, the gospels, the lives of the saints (the young nobleman carries overtones of Saint Martin, a Roman soldier who shared his military cloak with a shivering beggar), and the appalling conditions that were besetting the poor in his contemporary Italy, Caravaggio here appropriates specific details of the pagan narrative of *caritas romana* to illustrate Christian virtue. The presence of the Madonna and Child, who look down tenderly on the various scenes of mercy compressed beneath them, indicates that the soul's salvation is made possible through charitable acts. The prominent case of Pero and Cimon suggests metaphorically that earthly life and the mortal body are a prison, the daughter's physical lactation will lead to her father's spiritual nourishment and ultimate rebirth. Caravaggio's famous painting was commissioned to adorn the high altar of a Neapolitan church, the Pio Monte della Misericordia. Its installation there celebrated a new institution founded by Italian aristocrats in order to practise systematically all seven acts of mercy. The seventeenth century was to witness many such moves, driven by Counter-Reformation Catholic doctrine, away from individual acts of charity to the formation of charitable institutions. And, while the seven acts of mercy came to figure in the rules of the newly-founded institution of the hospital, images of *caritas romana* came to decorate hospital windows and adorn their walls.[3] It is these shifts in the history of Rome, from capital of Empire, to head of Church, to theatre of science and medicine, that this collection explores through an analysis of Rome's changing culture of the corporeal.

Bodies have long since taken up a central place in theoretical analyses of both society and the self, and have become important sites upon which the past might be read.[4] From the 1970s,

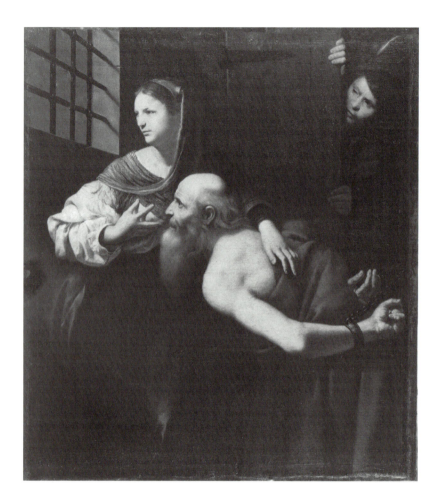

FIG. 1.1. Giovanni Antonio Galli called lo Spadarino (1585–1651), *Carità Romana (Cimone e Pero)*, 1630s, oil on canvas, 153 × 118 cm, Palazzo Doria Pamphilj, Rome. *Photo: Istituto Centrale per il Catalogo e la Documentazione, Rome, neg. Serie E no. 41770. Reproduced courtesy of the Istituto Centrale per il Catalogo e la Documentazione, Ministero per i Beni e le Attività Culturali.*

the reiterated acts and gestures of the body. Bodies, therefore, now constitute social and political cartographies.[7] They map out categories of difference such as gender, sexuality, religion, ethnicity and social status, and stand in (rather than outside) history.

The corporeal turn in historical scholarship needs no further rehearsal here.[8] Rather, this introduction serves to indicate the particular contribution our collection makes to both the history of the body and the history of Rome. The processes whereby social identity and sexual difference are constituted through the material of the body feature as central and persistent motifs of *Roman Bodies*. Against the youthful male beauty of Greek cultural identity, the normative condition of Romanness is established as the aged male body, its fragility and decrepitude paradoxically operating as an index of the Roman virtues of toughness, endurance and maturity. The centrality of the Roman subject is heavily circumscribed by bodily aspect. The Roman (whether pagan or Christian) is his male genitalia, his uncircumcised organs the somatic marker of his social integration set against the exclusion of the Jew. In opposition to the bodily integrity of the true Roman, decapitation and dismemberment put on public display non-Romans and

Michel Foucault systematically exposed the body as an historical fabrication. He described the ordering of the body politic (including the State's establishment of the institutions of the madhouse, the hospital and the prison) as taking place in and over the body physical.[5] During the course of the 1980s, the body took up a place at the heart of social theory. Bryan Turner, for example, developed a neat typology of the body such that reproduction, regulation, restraint and representation constitute the four problems of the body that societies have to solve.[6] Once the body was no longer understood as a fully natural, pre-social object, the place of embodiment in social life required urgent interrogation. More recently, in the 1990s, Judith Butler elaborated on the ways bodies are materialized performatively as sexed and gendered. The cultural production of a gendered identity takes place through render them the enemy-other (whether treacherous emperors, political rivals, barbarians or criminals). Adding to the now extensive feminist scholarship on the ancient cultural association of the body with the feminine and the mind with the masculine, *Roman Bodies* also demonstrates that it is not just femininity that is highly embodied, its sexuality in need of control. The genitalia are so intimately associated with the Roman male that the bodies of babies born with only minimal foreskin must be moulded into masculinity proper, while the circumcised penis is the bodily signifier of the troublesome lustfulness and sexual excess of which the Roman male was thought capable.

In histories of the body, metaphors and metonymies are regularly scrutinized as indicators of how bodies are embedded into particular cultures. The body is revealed discursively as mirror or microcosm of society. In the

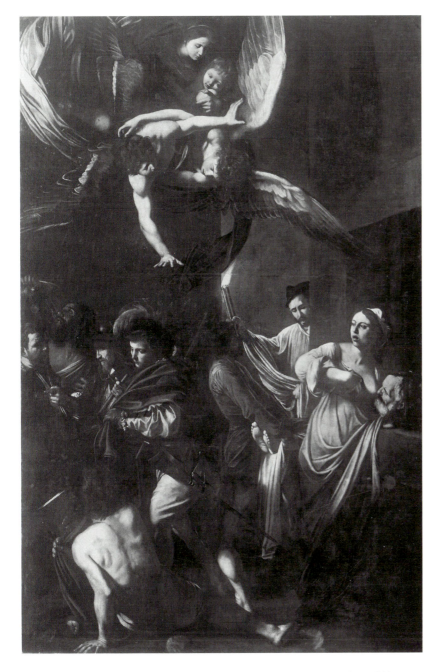

FIG. 1.2. Michelangelo Merisi da Caravaggio (1571–1610), *The Seven Acts of Mercy*, 1607, oil on canvas, 390 × 260 cm, Pio Monte della Misericordia, Naples. *Photo: Fototeca Berenson, Villa I Tatti (The Harvard University Center for Italian Renaissance Studies), Florence.*

pagan blindness is indicative of spiritual ignorance. Similarly, discourses of the body physical can reveal an anatomy of the body politic and religious. Fragmentation of the Roman body displays or enacts the disintegration of the state (the decapitation of an emperor renders that state headless), while bodily integrity is a necessary condition for sanctity (martyrs are frequently virginal, the flesh of popes is incorruptible). Such analyses illustrate both the ideological importance of the body in Roman philosophy, religion and politics, and the corporeality of Roman culture.

A recent trend in body scholarship argues that such discursive approaches to the body usefully destabilize any notion that bodies are simply natural or biological, but are none the less in danger — firstly, of rendering the body incorporeal (a system of significations deprived of flesh) and, secondly, of precluding any academic engagement with the day-to-day experience of the lived body.[9] This collection, however, is not indifferent to the materiality of the body. Rather than leaving the body as only an undifferentiated surface of social and political inscription, these essays incorporate as parts in an anatomy of the Roman body the head, face, hair, eyes, legs, penis (especially the foreskin), heart and intestines, and describe various stages in the biography of the Roman body from birth to death (including, most notably, disability, illness, ageing, death, and the afterlife allotted by dissection, burial, desecration and veneration). Nor do the various methodologies deployed in *Roman Bodies* preclude examination of the body as a material site where individual experience is actively felt and interpreted. The collection opens, for example, with Seneca's first-person epistolary narratives on how to deal with the ageing body's frailties and physical discomforts. The individual here is found to be involved in the construction and control of his own body, through a daily regime of sleep, rest, exercise, care, consumption and abstinence. Towards the volume's close, and in contrast with the

essays that form *Roman Bodies*, the dichotomies health/sickness and fragmentation/wholeness in particular regularly reappear as terms by means of which corporeal matter intersects with philosophical, religious and political matter. Bodily frailty is construed as analogous to (or, in contradistinction, as a mismatch with) frailties of the mind; the healing of physical disability is an outward marker of the soul's cure;

intervening accounts of the exemplary deaths of Seneca, Saint Agnes and a variety of popes, attention is momentarily focused on a specific individual, Rodolfo di Bernabeo — a Roman citizen without historical dimension who was hanged one January morning in the late sixteenth century and then dissected. In fact, these analyses of Roman bodies sketch a specificity of corporeal experience and generate narratives of feeling that are especially remarkable. The bodies of Christian martyrs (and their representation), pierced, beaten and burned with stakes, rakes, shears and sickles, are found capable of moving their observers to tears of both sorrow and joy, and of spurring them on willingly to endure their own excruciating pain and death. In our somatic mapping of the Roman past, neither materiality nor sentience is lost from view.

Furthermore, several essays in *Roman Bodies* directly concern themselves with the intimacy of the relationship between the body as sign and the body as sentient flesh. Here bodies are not just immaterial surfaces or discursive constructions but substantive flesh into which a particular cultural formation and its symbolic topography has been heavily imprinted.[10] The social taxonomies of ancient Rome are inscribed into the bodily matter of the penis. The appearance of a Roman citizen's genitals is the index of his ethnicity, morality and sexuality. Hence the anatomical convertibility of organ and person: a man looks and behaves like his organ, while his organ becomes himself in miniature. Similarly, if in a somewhat different historical context and in relation to another body part, heart and man are subject to assimilation in Counter-Reformation Rome. Within the extraordinarily holy (such as saints and popes) beats a perfect heart that is incorruptible even in death. In a period especially concerned with the corporeality of religious experience, spiritual purity and religious ecstasy are written into the body and thus provide scientific proof of a connection between the human and the divine. Finally (and providing an intriguing parallel for modern theoretical concerns over any potential separation of discursive and materialist analyses of the body), our final essay observes that in late eighteenth-century Rome the body of Christ becomes a battleground for a heated religious debate over the relationship between the symbolism and the materiality of bodies. The cult of the Sacred Heart of Jesus fully embraced the unity of the carnal heart of the man and the figural heart of the Son of God.

An important feature of this collection's study of the bodies of the past is its simultaneous attention to place.

But investigation of the space–time of bodies has received serious attention only in the last decade.[11] In *Space, Time and Perversion: Essays on the Politics of Bodies*, published in 1995, Elizabeth Grosz — an important theorist of how to reconceive the body as a socio-cultural artefact — explores the relationship between body and place, in particular the contemporary relationship between body and city. For Grosz, the city is a highly significant context and frame for the body:

> The city is one of the crucial factors in the social production of (sexed) corporeality: the built environment provides the context and coordinates for contemporary forms of body. The city provides the order and organization that automatically links otherwise unrelated bodies: it is the condition and milieu in which corporeality is socially, sexually, and discursively produced.[12]

Accordingly, Grosz calls for an examination of how different cities, and different socio-cultural environments, actively produce the bodies of their inhabitants. She argues further that city and body are constitutive and mutually defining, their two-way linkage to be understood as a complex 'interface': the city shapes the body and the body shapes the city.

Study of the interface between body and city has also already gained an historical dimension in the work of Richard Sennett. In *Flesh and Stone: the Body and the City in Western Civilization*, published in 1994, he constructs a history of the city through people's bodily experience, from Periclean Athens to modern New York. He opens his account of how beliefs about bodies shape urban design with the twelfth-century philosopher John of Salisbury, who presented bodily form and urban form as literally analogous: the city's palace or cathedral is its head, the market its stomach, and houses its hands and feet. Later, on ancient Rome, he turns to the architect Vitruvius, who drew attention to the bilateral symmetries of bone, muscle, ears and eyes that structure the human body:

> By studying these symmetries, Vitruvius then showed how the body's structure could be translated into the architecture of a temple. Other Romans used similar geometrical imagery to plan cities, following the rules of bilateral symmetry and privileging linear visual perception. From the geometer's ruler thus came Rule; the lines of bodies, temples, and cities seemed to reveal the principles of a well-ordered society.[13]

Several essays in *Roman Bodies* work to support Sennett's argument that culturally specific ideas about bodies have shaped cities and that flesh moulds stone. The cult of relics recrafted the intramural topography of medieval Rome when the fragments of holy bodies were brought into the city for veneration in newly-built churches (whose architectural vocabulary was itself shaped by their precise function as relic shrines). The peopling of Rome with the corporeal remains of the saints was designed to provide tangible proof of the city's sanctity and thereby render it the earthly embodiment of the heavenly city.

Several more recent works on the space–time of bodies also have drawn attention to the permeability of bodies and their environments (here considered in terms of continents rather than cities), and to the ways in which place has been thought to leave its imprint on flesh. *A Centre of Wonders: the Body in Early America*, edited by Janet Lindman and Michele Tarter and published in 2001, is concerned with 'the Columbian enterprise' or the Old World's uncomfortably corporeal confrontation with the New; while *Imperial Bodies: the Physical Experience of the Raj, c. 1800–1947* by E.M. Collingham, published in 2001, addresses the troubling somatics of British imperial rule in India.[14] Both volumes explore the emergence under colonialism of an intense anxiety about the potential instability of European bodies, that in such strange environments they might undergo subtle constitutional transformation, physical deterioration, develop idiosyncrasies of appearance and demeanour, or even perish altogether. Such research demonstrates clearly that the body is central to the colonial experience, that the colonies wrote themselves into European flesh. But while they deal with bodies on the margins of Empire, this work concerns bodies at the centre of Empire. What then, we should ask, does Rome do to bodies and for body scholarship?

Rome is a place but also an idea. It is the head of Empire, the heart of the Church, a home to science and medicine. Lamenting the sack of Rome in 410, the Christian exegete Jerome remarked 'the head of the Roman Empire was cut off and, to speak more truthfully, with that single city the whole globe was destroyed'.[15] Similarly, in his twelfth-century text *Mirabilia urbis Romae*, Canon Benedict described the Capitoline Hill as the 'head of the world' ('caput mundi'), where consuls and senators had met to govern over all. As the city of Empire, Rome is perceived to extend throughout the world to its far-flung frontiers and, simultaneously, all the world converges within its walls. If Rome may thus function as the world's metonymy, correspondingly our somatic mapping of Rome may help supply a partial anatomy of the world.[16]

Focused in place, *Roman Bodies* explores dramatic changes in Western conceptions of the body, encompassing the cultural shifts (and even bodily encounters) that occurred across Empire, religion and science from antiquity until the eighteenth century. The end point for our somatic history is the late eighteenth century because it is the period when 'the modern body' is understood to have emerged. The discoveries of early modern science propelled a radical revision of ancient and medieval conceptions of human physiology, and led to the development of wholly new knowledges about corporeality. Made invisible as a social creation, the body was rendered purely physical by modern science. According to Foucault's now canonic, three-fold analysis in *Madness and Civilization, The Birth of the Clinic* and *Discipline and Punish*, the body became the docile object of increasingly intrusive rituals of clinical examination and unparalleled state regimentation. By the end of the eighteenth century the modern body was born.[17] *Roman Bodies* thus effectively contributes to a prehistory of that modern body.

Our collection constitutes a wide-ranging, interdisciplinary project that draws together the work of scholars from many different academic fields. Their various essays situate Roman bodies historically through an array of critical approaches and unifying themes. The types of primary evidence subjected to scrutiny are highly diverse: language and literature (including the philosophical, historical, theological, legal and medical; graffiti and inscriptions; and the genres of epic, satire and the novel), architecture (such as triumphal monuments, churches and catacombs) and architectural decoration (from frescoes and mosaics, to textiles and work in marble or precious metals), the visual arts (whether painting, sculpture, manuscript illumination, engravings or prints), and artefacts (as various as surgical implements, coins, glass ware, lamps, bells and pendants). Despite such diversity of primary material, a number of overarching themes emerge along the body/place axis of our volume to generate an intratextual dialogue about 'the body of Rome' across both periods and anatomies. We have referred earlier to the corporeal constitution of Roman gender, sexuality, and social and political identity, and to the recurring metaphors of health/sickness and wholeness/fragmentation. Other themes or motifs that cut across the essays, binding them together, include

the cultural importance of special or spectacular bodies (of emperor, saint, pope or Christ); the body in death (whether by suicide, decapitation or martyrdom) and after (abused, venerated, dissected); corporeal aesthetics (both external and internal); dualism; and the intersection of religion and science. Its division into the three sections of 'Empire', 'Church', and 'Religion and science' gives to *Roman Bodies* a loose structure and identifies conveniently its chronological progression from antiquity to the late eighteenth century. But, while Roman bodies here accumulate layers of history and transformation, their analysis supplies not an evolutionary tale, but a collection of fragments — a collection that together helps map out the prehistory of the modern body.

In the process of tracing this prehistory, Catharine Edwards opens our first section dedicated to care, modification and abuse of the body in the Roman Empire. Her essay focuses on the creased, worn and sagging body of Seneca, which might be considered, perhaps surprisingly, as normative for ancient Rome. Whereas Seneca placed importance on spiritual rather than bodily health, the philosopher's letters record various personal responses to his ageing body, as he muses about its tyranny and how it distracts from the soul. Ordered by Nero, Seneca's suicide likewise took on an exemplary quality and was narrated in detail by Tacitus, an external observer whose description is here analysed in parallel with, and as an addendum to, Seneca's own perceptions of his infirm body.

Seneca cut into his own and his wife's arms so that they would both bleed to death, transgressing the primary cultural and aesthetic concept of the intact Roman body. Mutilation was specifically prohibited by legislation in the late Roman Empire, with respect to two of the most prominent, if generally invisible, forms that could be inflicted on male bodies: circumcision and castration. Circumcision, as religious practice or mutilation, was probably the most controversial surgical procedure in the ancient world, symbolizing the extraordinary social and cultural differences perceived to exist between Roman and Jew. In the next essay, the first of three chapters on the subject, Ralph Jackson analyses Celsus's writings on circumcision and de-circumcision. The practical medical issues of the operation are examined in detail, including the specific instruments employed, all of which can be identified in the archaeological record. Undertaken specifically for appearance's sake, the painful process of de-circumcision is a particularly significant and revealing cultural practice that is literally incised on the body.

That the Romans considered circumcision morally repugnant has long been an uncontested part of academic literature, but that view is challenged by the essay that follows Jackson's. Pierre Cordier's acute philological analysis of the ancient sources demonstrates that, within the context of Roman social and behavioural norms, it was the high semiotic value attached to bodily appearances and their representation that necessitated a negative (though purely aesthetic) judgement on the procedure of castration. It was only in Hadrian's reign that the infamous law prescribing castration as a punishment for circumcision was enacted, and only then was circumcision finally associated with castration and the severity of mutilation (rather than mere cosmetic transformation). Extending this reassessment into the Christian era, Gillian Clark focuses on the writers of late antiquity such as Philo of Alexandria, who defended circumcision in his *Special Laws* (claiming that it countered excessive lust) while none the less conceding that it was an unnatural and mutilating procedure. Antoninus Pius's rescript of Hadrian's decree and Augustine's commentary on Paul's letter to the Galatians both reveal the heated disagreement on the matter that continued well into the fourth century, when Christian writers employed metaphors such as circumcision of the heart to substitute for the physical act both symbolically and practically.

Although highly symbolic, circumcision was a relatively minor physical intervention compared with the military practice of headhunting that Nic Fields next explores. Carefully distinguished from decapitation, by virtue of the ritual preservation and display of the battlefield trophy, headhunting (as represented on Trajan's Column) is identified convincingly as a practice pursued by Celtic soldiers who were auxiliaries in the Roman army. Hitherto peripheral to Roman military practice, under Trajan headhunting appears to have received the emperor's tacit sanction, since it now achieves official representation. Headhunting was quite distinct both from the regular abuse by Romans of the bodies of enemies in warfare, and their occasional abuse of the bodies of Rome's citizens and its rulers. Decapitation was often only the beginning of post-mortem abuse that could include kicking or hurling the head through the city or displaying it publicly on a spear. This latter abuse was even enacted in a symbolic and representational register, as set out in the essay by Eric Varner that concludes the volume's first section on the corporeality of the Roman Empire. Posthumous decapitation and

the abuse of severed heads through display and mockery effectively placed these bodies (and their owners' reputations) outside Roman social norms. To effect figuratively the same results, sculptural representations of imperial bodies that functioned as surrogates were also abused. Numerous examples survive where heads have been deliberately and demonstrably 'decapitated' from the bodies of imperial statues, such as in the ubiquitous case of Nero's effigy. This type of *damnatio memoriae* sometimes was performed in parallel to actual corpse abuse, indicating the close alignment of bodies with their representation, as well as the importance of somatic performance, in ancient Roman society.

In the Roman world, corpses and effigies that had been mutilated in a political gesture were visibly displayed, whereas bodies mutilated by their very 'nature' were deliberately kept out of sight. Only with the shift to Christianity was this distinction undermined, as Livio Pestilli convincingly argues in the essay that opens the collection's second section dedicated to disablement, transformation and veneration within the Roman Church. In the pagan world, lameness signified dishonour or divine displeasure, whereas in early Christian and medieval art the lame became useful advocates for Christianity because they were frequently situated in narratives with miraculous outcomes, and thus could symbolize the power of Christ to heal body and soul. However, sensually disabled pagan persecutors are the principal protagonists in the narrative passions examined by Kristina Sessa in the essay that follows that of Pestilli. The attitudes of early Christian writers to the relationship between sensory and religious knowledge is amplified though an analysis of Augustine's works and Apuleius's Latin novel *The Golden Ass*. This unexpected juxtaposition provides the basis for an epistemological analysis that brings to the fore the important role played in Christian theology by the senses, considered both as metaphors for the incorporeal apprehension of the divine but also as material channels of sin that can impede spiritual salvation.

Relics of the virgin Agnes, whose martyrdom was integrally related to the history and topography of Rome, were located at two specific shrines: within the city walls at the church in Piazza Navona, and without at the catacombs and basilica on the via Nomentana. In the central essay of our section on the Roman Church, Lucy Grig focuses on Agnes's intense corporeality and incorruptible virginity, both of which featured so prominently in her martyrdom. She also examines the connections made between gender, sexuality and sanctity that are so central to understanding representations of the saint and other such early narratives of martyrdom. Agnes's relics still survive at her original shrines, but the ninth century witnessed the transformation of both the cult of relics and the topography of Rome, when over 2,000 saintly remains were brought from the periphery into two renovated urban churches, in order to establish a highly organized cult scheme within Rome's walls. Linked to the importation of these corporeal remains, architectural and decorative changes instigated at Santa Prassede and Santa Cecilia in Trastevere — here examined by Caroline Goodson — enabled authentic relics (rather than 'contact' substitutes) to be venerated within Rome. However, this translation and transformation of the cult of relics also initiated an increasing demand for remains to venerate, such that the bodies of many saints were subjected to dismemberment and theft. Goodson's analysis thus provides tangible evidence of the growing corporeal focus of religious worship in the medieval period.

After death, the body of the pope became a holy relic, and in the essay that concludes our section on the Roman Church's concern with corporeal veneration, Minou Schraven examines the change in status of the pope's body in its extraordinary passage between life, death and burial. In preparation for its lying-in-state, and to ensure preservation for the lengthy period that preceded burial, the papal corpse was dissected in autopsy and eviscerated. The mortality of the papal body at death was affirmed through the removal and conservation of the papal *praecordia* or intestines. That such dissection and autopsy constituted a necessary part of papal funeral rites contrasts markedly with the current development of medical dissection, and highlights a significant conflict over somatics in sixteenth-century Rome between religion and science. In the essay that opens the volume's third section, dedicated to Roman religion and science, Andrea Carlino presents a micro-history of one particular dissection, undertaken as a public lecture in anatomy at the University of Rome. This public, theatrical dissection of an ignominious Roman citizen exemplifies the developing interest in anatomy of early modern medical science but, as Carlino vividly details, the corpse's bones and flesh were subsequently returned to the religious Archconfraternity of San Giovanni. While science was permitted temporary access to the bodies of criminals for the purpose of dissection, the Church still laid claim to ownership of the body parts, requiring that the dissected remains be reassembled,

returned and ritually buried in order to save the souls of their occupants.

Rather than scientific enquiry, it was the Counter-Reformation return to the values of the early Christian Church that inspired Antonio Gallonio's scholarly and devotional typology of the instruments of martyrdom discussed by Opher Mansour. Published in 1591, these curiously abstract and aestheticized representations of martyrdom refuse dissection's penetration to the visceral realities of the body. Instead they put on display intact, classically idealized bodies that even appear thoroughly to negate the excruciating experience of bodily torture in a deliberate response to the enormous shift in the religious aesthetics and decorum of late sixteenth-century Rome. Here martyrs' fragmented and pierced bodies are banished, and attention is focused on the instruments rather than the objects of torture, better to persuade Catholics in Rome of the blissful merits of martyrdom as a symbolic rather than a literal aspiration, and to remind them of their city's corporeal claims to sanctity. Indeed, horrific images of tortured bodies were now normally proscribed, but in late sixteenth-century Rome, in the decoration of the churches of Santo Stefano Rotondo and the English College, fresco cycles graphically depicting tortured bodies were exceptionally permitted because they had a most urgent missionary purpose. Richard Williams sets out the important symbolic parallel established in the decorations of the English College between the depiction of persecuted Christians living under Roman rule and the suffering of English Catholics now living under a Protestant queen. English heroes and martyrs in the cycle are clearly modelled on the early Christian martyrs. Atrocities are depicted in gruesome detail, with specific attention to bodily mutilation, in order to stir the sympathies of the college's novices, spur them on to their dangerous mission in England, prepare them for the real suffering they might have to endure in its performance, and exalt that suffering as a glorious continuation of the early Church's history.

Catrien Santing returns us to the theme of conflict and collaboration between religion and science in Counter-Reformation Rome in her examination of the startling role dissection played in the post-mortem examination of potential saints. The three great Counter-Reformation saints, Ignatius of Loyola, Carlo Borromeo and Filippo Neri, were all examined by physicians at death, and Neri's organs, including his heart, were removed during autopsy. Science here was placed at the service of religion: holy bodies were anatomized and medical criteria were established for

sanctity. This seemingly unlikely union between anatomy and the Church, materiality and symbolism or, perhaps, the 'holiness of hearts', also provides the theme for the essay that concludes our collection. Jon Seydl examines the enormous impact of Pompeo Batoni's painting of *The Sacred Heart of Jesus*, in which Christ holds out his fully anatomized heart (complete with valves, ventricles, musculature and dripping blood) that none the less radiates yellow–white rays, and is surmounted by a cross, a tongue of flame and a crown of thorns. As Seydl argues, both painting and cult fully realize the potential unity of religion and science. Inscribed into Christ's sacred heart is the recognition that the body is always simultaneously symbolic and material.

Despite its title, *Roman Bodies* takes as its project the exploration of many diverse Roman bodies. Moving through the Rome of Empire, Church, religion and science, it considers the multiple and sometimes contradictory ways in which bodies have shaped the city and the city has shaped the bodies of its inhabitants. But, throughout, the collection recognizes the centrality of the body to the history of Rome and Rome to the history of the body.

NOTES

1. On the classical representation of *caritas romana* and its later reception, see R. Raffaelli, R.M. Danese and S. Lanciotti (eds), *Pietas e allattamento filiale: la vicenda, l'exemplum, l'iconografia* (Urbino, 1997); A. Tapié, 'L'allégorie, la charité', in *L'allégorie dans la peinture: la représentation de la charité au XVII^e siècle* (exhibition catalogue (Musée des Beaux Arts de Caen), Caen, 1986), 18–57.

2. On Caravaggio, see in particular the discussion by H. Langdon, *Caravaggio: a Life* (London, 1998), 327–33, and compare with the numerous versions of *Cimon and Pero* by Rubens: E. McGrath, *Rubens: Subjects from History* II (*Corpus Rubenianum Ludwig Burchard* 13) (London, 1997), 97–114.

3. Tapié, 'L'allégorie' (above, n. 1), 45–8.

4. For convenient introductions to scholarship on the body see, for example, A. Synott, *The Body Social: Symbolism, Self and Society* (London, 1993); C. Walker Bynum, 'What's all this fuss about the body?', *Critical Inquiry* 22.1 (1995), 1–33; C. Walker Bynum, *The Resurrection of the Body in Western Christianity, 200–1336* (*Lectures on the History of Religions* 15) (New York, 1995); J. Price and M. Shildrick (eds), *Feminist Theory and the Body: a Reader* (Edinburgh, 1999); P. Hancock, B. Hughes, E. Jagger, K. Paterson, R. Russell, E. Tulle-Winton and M. Tyler, *The Body, Culture and Society: an Introduction* (Buckingham, 2000); L.M. Meskell, 'Writing the body in archaeology', in A.E. Rautman (ed.), *Reading the Body: Representations and Remains in the Archaeological Record* (Philadelphia, 2000), 13–21.

5. M. Foucault, *Madness and Civilization: a History of Insanity in the Age of Reason* (London, 1971); M. Foucault, *The Birth of the Clinic: an Archaeology of Medical Perception* (New York, 1973); M. Foucault, *Discipline and Punish: the Birth of the Prison* (London, 1977). For the importance of his analysis of the body, see the introductory works listed above, in n. 4.

6. B. Turner, *Body and Society* (Oxford, 1984).

7. We here borrow our geographical metaphors from J.M. Lindman and M.L. Tarter (eds), *A Centre of Wonders: the Body in Early America* (Ithaca, 2001), 1–9.

8. For examples of recent collections, see, on antiquity: M. Wyke (ed.), *Gender and the Body in the Ancient Mediterranean* (Oxford, 1998); M. Wyke, *Parchments of Gender: Deciphering the Bodies of Antiquity* (Oxford, 1998); D. Montserrat (ed.), *Changing Bodies, Changing Meanings: Studies on the Human Body in Antiquity* (London, 1998); J.I. Porter (ed.), *Constructions of the Classical Body* (Ann Arbor, 1999). For the medieval and early modern periods, see: D. Grantley and M. Taunton (eds), *The Body in Late Medieval and Early Modern Culture* (Aldershot, 2000); Lindman and Tarter (eds), *A Centre of Wonders* (above, n. 7).

9. As, for example: J.M. Ussher (ed.), *Body Talk: the Material and Discursive Regulation of Sexuality, Madness and Reproduction* (London, 1997), 1–9; Price and Shildrick (eds), *Feminist Theory* (above, n. 4), 6–10; Lindman and Tarter (eds), *A Centre of Wonders* (above, n. 7), 1–3; Meskell, 'Writing the body' (above, n. 4); Montserrat (ed.), *Changing Bodies* (above, n. 8), 4–6.

10. Compare R. Longhurst, *Bodies: Exploring Fluid Boundaries* (London, 2001), 10, drawing on V. Kirby, *Telling Flesh: the Substance of the Corporeal* (New York, 1997).

11. See, for example, the account of bodies in geographical scholarship in Longhurst, *Bodies* (above, n. 10), 9–32.

12. E. Grosz, *Space, Time and Perversion: Essays on the Politics of Bodies* (New York, 1995), 104.

13. R. Sennett, *Flesh and Stone: the Body and the City in Western Civilization* (London, 1994), 90.

14. Lindman and Tarter (eds), *A Centre of Wonders* (above, n. 7); E.M. Collingham, *Imperial Bodies: the Physical Experience of the Raj, c. 1800–1947* (Cambridge, 2001).

15. 'Romani imperii truncatum caput! et ut uerius dicam, in una urbe totus orbis interiit', *Commentary to Ezekiel*, pr.

16. For Rome as the world's metonymy, and further discussion of the texts cited, see C. Edwards, *Writing Rome: Textual Approaches to the City* (Cambridge, 1996), 87–90.

17. For details of the works by Foucault, see n. 5. On Foucault and the emergence of the modern body, see most usefully B. Duden, *Geschichte unter der Haut. Ein Eisenacher Arzt und seine Patienten um 1730* (Stuttgart, 1987) (= B. Duden, *The Woman Beneath the Skin: a Doctor's Patients in Eighteenth-century Germany* (trans. T. Dunlap) (Cambridge (MA), 1991)), 1–49.

EMPIRE: CARE, MODIFICATION AND ABUSE

ARCHETYPALLY ROMAN? REPRESENTING SENECA'S AGEING BODY

Catharine Edwards

How might we imagine the quintessentially Roman body? The archetypal Greek body is perhaps an idealized vision of virile youth, such as Polycleitus's Doryphorus, 'poised on the brink of manhood' in Andrew Stewart's words.[1] The archetypal Roman body, though also male (of course), by contrast is lived in, battered, worn — old. Let us consider the so-called veristic portraiture characteristic of the late Republic and certain periods of the Principate. These Roman portraits represent their subjects with crow's-feet, lined foreheads, creased cheeks and sagging jowls (**Fig. 2.1**).[2] The Roman preference for such representations is often linked specifically with the custom among aristocratic families of keeping masks of ancestors (*imagines*) on display in the atrium of the family house.[3] The senate was named for the age of its members: (*senes*) old men. And one had to be at least 42 to be eligible for election to the consulship, Rome's highest magistracy — an indication of Roman respect for maturity. In many ways, then, our ideal Roman is an older man, whose heavy responsibilities have etched their traces on his sagging face and body.[4]

This chapter will focus on representations of the body of one old Roman man, the philosopher Seneca, tutor to the Emperor Nero. This body, I shall argue, although it is presented as weakened and decrepit, nevertheless is idealized both in Seneca's own writings and elsewhere. In some important respects the representation of Seneca's body can be related to ideas of what a specifically Roman body should be like. Yet in other ways Seneca's body is presented, particularly in his *Letters*, as essentially that of a philosopher rather than that of a Roman. Seneca committed suicide (on Nero's orders) in 65 CE. His death is one of a number described in Tacitus's *Annals*; Tacitus's account of Seneca's suicide, I shall argue, can also be read as idealizing Seneca's ageing body. Here, too, philosophical models are important.[5] But it is perhaps in this context that contrasts between Greek and Roman ideals are most significant. With the death of Seneca we are a long way indeed from the beautiful death of the Homeric hero, so deftly characterized by Jean-Pierre Vernant.[6] In Homer's *Iliad*, it is the death of a valiant young man in battle that constitutes the ideal end. As Vernant emphasizes, a significant part of the value of such a death lies in the youthful perfection of the warrior's corpse, a perfection to be immortalized in the poet's song. Aged King Priam is made to contrast the honourable nature of the young warrior's death with the shameful and ugly end of an old man killed in battle (*Iliad* 22.74–6). This emphasis on the physical beauty of the warrior killed in his prime can to some extent also be traced in fifth-century Greek literature. It is perhaps above all in his dying moments that Seneca's body appears as archetypally Roman.

We shall return to Tacitus's account of Seneca's death and its implications for interpreting Seneca's body at the end of this chapter. The earlier part of my argument will focus on Seneca's own *Letters*, which, as I have noted, present a powerful image of their author's feeble body. One hundred and twenty-four letters survive, written in the last years of Seneca's life and ostensibly addressed to his friend Lucilius. The letters pursue a number of interrelated philosophical themes, returning repeatedly to the philosopher's increasing bodily infirmity and to the variety of strategies he claims to be adopting to make the best of his remaining strength. Old age as a topic was discussed occasionally in earlier philosophical literature. Plato makes his characters, for instance Cephalus in the *Republic*, comment on some positive features of growing old.[7] Cicero wrote a *De senectute*, 'On old age', in which Cato is made to consider the disadvantages and advantages of old age. Cicero's work, while sharing a number of concerns with Seneca's *Letters*, has little to say about the details of the physical process of ageing, as well as being much less personal in tone. Indeed, Seneca's apparent preoccupation with his own ageing body can at times be seen as significantly at odds with some of

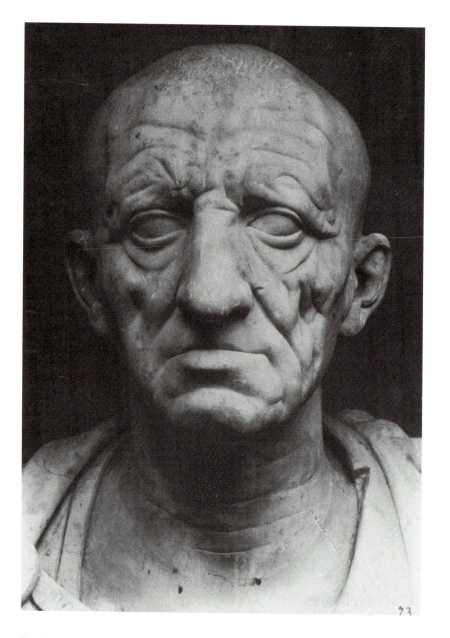

Fig. 2.1. *Portrait of a Man*, from near Otricoli, *c.* 50 BCE, Museo Torlonia, Rome.
Photo: Deutsches Archäologisches Institut, Rome neg. no. 1933.58. Reproduced courtesy of the Deutsches Archäologisches Institut, Rome.

expensive repairs undertaken at the villa. The steward replies that such problems are inevitable with an old house. Yet Seneca himself had overseen the construction. He complains, too, at the decrepit state of some plane trees. They are not neglected, replies the steward, simply old; yet Seneca himself had planted them. Finally Seneca reports his comments on an elderly slave, seated near the door: 'who is that old wreck? By the door is the right place for him, since he'll be on his way soon. Where did you get hold of him? What was the pleasure for you in picking up a man someone else was due to bury?'.[9] Seneca's harsh words, spoken, as becomes clear, in the slave's hearing, have disconcerted some modern readers. The elderly slave addresses his master, 'don't you recognize me?'.[10] He turns out to have been known as a child to Seneca — indeed, he was once Seneca's 'pet slave' (*deliciolum*). Seneca himself, then, must be older than the man he so readily dismisses as on his last legs. The object of Seneca's contemptuous outburst is thus surely as much himself as the slave. The implication of this elision is pressed home in a later letter. Letter 26 begins:

> I was just lately telling you that I was within sight of old age. I am now afraid that I have left old age behind me. For some other word would apply to my years, or at any rate to my body; since old age means a time of life that is weary rather than crushed.[11]

the philosophical concerns articulated in his *Letters*. The would-be philosopher, he frequently suggests, should be detaching himself from such frailties of the flesh. The relationship between these two preoccupations, with body and with mind, will be central to the following discussion.

A letter near the start of Seneca's collection begins characteristically with an anecdote apparently taken from his own life: 'wherever I turn, I see proofs of my own old age', writes Seneca.[8] On a recent visit to his suburban estate, he complains to the steward about the

None the less, despite his state of physical collapse, Seneca does manage to write another hundred or so letters. Other letters, too, detail numerous ailments associated with ageing, to which the philosopher is, it seems, increasingly subject. Letter 54, for instance, begins: 'my ill health had allowed me a long stretch of leave, when suddenly it resumed the attack. 'What kind of ill health?' you say. And you surely have a right to ask; for it is true that no kind is unknown to me'.[12] He goes on to describe his asthma attacks (a topic he also

touches on elsewhere, *Letters* 65.1, 104). Letter 67 begins with a complaint at how Seneca suffers from the cold now that he is older: 'I can scarcely thaw out in the middle of summer'.[13]

The physical discomforts of ageing seem to dominate other letters, too. Letter 78 includes a lengthy and detailed description of pains in the joints (*Letters* 78.8–10). An even more detailed description of painful symptoms follows at chapter 19. These are not, however, acknowledged as Seneca's own. Indeed, the letter goes on to advise that one should not dwell on one's sufferings: 'a man is as wretched as he has convinced himself that he is'.[14] In general, the later letters in the collection are considerably more theoretical (and less apparently personal) than the earlier ones. One might see the shift away from an explicit preoccupation with Seneca's own ills as a measure of his own philosophical progress, on the road toward becoming the Stoic wise man (*sapiens*), who is completely indifferent to material concerns.[15] Nevertheless, the body (even if not explicitly Seneca's own body) remains an abiding preoccupation.

There are a number of ways in which Seneca's preoccupation with his ageing flesh relates to his philosophical agenda. Bodily health is frequently used as an analogy for spiritual health in Seneca's *Letters* (for instance at 120.5). However, he also explores the potential for mismatch between a person's physical and mental aspects, in a way that seems to emphasize the ultimate insignificance of the body. The Stoics traditionally regarded bodily health as among the 'indifferents', the things that in the end do not affect one's capacity to lead a virtuous life. In letter 92, Seneca suggests that in fact a strong, healthy body is more common among worthless men: 'Those attributes are worthless with which the most worthless men are often blessed in fuller measure, such as a sturdy leg, strong shoulders, good teeth, healthy and solid muscles'.[16]

This is in line with the comments he makes earlier, in letter 66, which takes as its starting-point the poor health of an elderly friend, Claranus. And we might note that in the first sentence, Seneca refers to this man as his school friend (*condiscipulus*), thus making clear that they are much the same age. Claranus is described as having 'an ugly and insignificant body'.[17] But the nature of his soul brings glory to the body; 'so', says Seneca, 'I have come to regard him as just as handsome and upstanding in body as in mind'.[18] Through his knowledge of Claranus's character, Seneca's perception of his body is transformed. We are a long way here from the Greek ideal of the noble mind in a beautiful body (*kalos k'agathos*).

Elsewhere, Seneca stresses still more explicitly the relative unimportance of the body:

> Without philosophy, the mind is ailing, and the body, too, though it may have great strength, is strong only as that of a madman or a lunatic is strong. The health of the mind then is the health you should primarily cultivate; the other kind of health comes second, and will involve little effort if you wish to be well physically. Indeed it is foolish, my dear Lucilius, and very unsuitable for an educated man, to work hard developing his muscles, broadening his shoulders and strengthening his lungs. For although heavy feeding builds you up and your sinews grow solid, you can never be a match, either in strength or in weight for a first class bull. Besides, when you overload the body with food, the soul is crushed and becomes less active. Limit the flesh as much as possible and give free play to the spirit.[19]

For Seneca, development of the body is not only a distraction from the development of the mind but actively undermines it, 'the soul is crushed'. Seneca goes on to criticize in further detail the lives of those who devote themselves to bodily exercise. He particularly disapproves of having to submit oneself to taking orders from personal trainers, whom he labels 'slaves of the vilest stamp'.[20] Characteristically, however, Seneca's lengthy and insistent denunciation of body-building at the same time betrays a certain fascination with the grotesque spectacles of the gymnasium.[21]

Despite his expressions of disdain for those who devote themselves to developing their bodies, Seneca does not advocate neglecting the body altogether. Rather, the body is something that needs to be brought under control. He recommends a regime of:

> short and simple exercises that tire the body rapidly, and so save time. These exercises are running, brandishing weights, and jumping — high-jumping or broad-jumping, or the kind that I may call 'the Priest's dance' [a reference to the Salii or leaping priests of Mars] or, in slighting terms 'the clothes-cleaner's jump' ... But whatever you do, come back soon from body to mind. The mind must be exercised both day and night, for it is nourished by moderate labour; and this form of exercise need not be hampered by cold or hot weather, or even by old age.[22]

While the needs of the body are to be catered for as simply and swiftly as possible, the mind deserves ceaseless attention.

Developing this idea further, letter 83 sets out Seneca's daily regime, apparently in response to a request in one of Lucilius's letters.[23] A brief space is given over to bodily exercise: 'on this ground, I can thank old age, my exercise requires very little effort; as soon as I move, I am tired'.[24] He goes on to comment further on the decline of his physical powers: 'my life is not declining; it is falling outright'.[25] Seneca then takes a cold bath (though much less cold than was his custom in his younger days); 'after the bath, some stale bread and breakfast without a table; no need to wash the hands after such a meal. Then comes a very short nap'.[26] The requirements of the body have been satisfied, and with the minimum of fuss. Seneca then moves on to the more complex requirements of the mind. He is now ready for contemplation (*cogitatio*), from which nothing can distract him. He describes in detail the philosophical arguments in which he became absorbed after the previous day's breakfast, namely a consideration of arguments against drunkenness. Seneca starts off by finding fault with the syllogistic approach adopted by the earlier Stoic Zeno but goes on to voice his own criticisms of excessive drinking. Drunkenness incites and exposes every vice (*Letters* 83.19). Drunkenness also brings horrible physical effects (*Letters* 83.21). Seneca cites the examples of Alexander and Antony, great men ruined by their propensity to drink to excess. Though the main concern of the letter is ostensibly to contrast different styles of argument, the syllogistic versus the expository (*Letters* 83.27), Seneca's vivid account of the excesses of those who drink stands in strong contrast to the sober picture of his own carefully controlled life with which the letter began. Control of the body and control of the mind are inseparable, however much the former is meant to be in service to the latter.

From this point of view, old age has considerable advantages for the philosopher. In letter 83, as we have just seen, Seneca thanks old age for curtailing his physical requirements and thus allowing him to concentrate on the life of the mind. This is a theme pursued in other letters. Letter 67 notes how, feeling the cold, Seneca spends much of his time bundled up in bed, and consequently reads more: 'I thank old age for keeping me fastened to my bed'.[27] Even illness, often associated with ageing, can bring advantages. It enforces a meagre diet, making luxury impossible: 'you will dine like a sick man, rather, sometimes like a sound man'.[28] Letter 26, which begins, as we saw, with an apparently despairing comment on the author's decrepitude, goes on to emphasize that although Seneca's body is weak, his mind (*animus*) is unchanged. Indeed, his mind is benefited by the increasing invulnerability of his body to the attractions of vice, 'only my vices and the outward aids to these vices have reached senility'.[29] In letter 12, too, which begins with Seneca confronting the signs of his own advancing years, he goes on to rehearse the arguments often advanced in favour of old age. It is a time of life with its own particular pleasures, 'or else the very fact of our not wanting pleasures has taken the place of the pleasures themselves. How comforting it is to have exhausted one's appetites and left them behind!'.[30] Old age, then, brings a partial withdrawal from the demands of the body.[31]

Not only this but the body whose requirements are limited is to a certain degree protected from fortune's vicissitudes — a major preoccupation of Stoic philosophy. Letter 14, for instance, articulates a concern to be found in many of Seneca's letters, 'we must not be slaves to the body. He will have many masters who makes the body his master, who is over fearful on its behalf, who judges everything according to the body'.[32] An ascetic regime, by which the body is schooled to be satisfied with little, provides insurance against a time when little may be all there is. In letter 123, Seneca writes with some pride of how he can be satisfied with a meal of bad bread when that is all that is available (*Letters* 123.3). The tyranny of the body is, for an old man, easier to keep at bay.

Yet at the same time, these different exercises can serve as strategies to make the most of the philosopher's declining physical strength. Seneca comments in letter 58.29–32 that:

> To some extent our petty bodies can be made to linger longer upon earth by our own providence, if only we acquire the ability to control and check those pleasures whereby the greater portion of mankind perishes ... Frugal living can bring us to old age; and to my mind old age is not to be refused any more than it is to be craved. There is pleasure in being in one's own company as long as possible, when a man has made himself worth enjoying.[33]

These comments are, however, a prelude to a consideration of whether sometimes it may be appropriate to consider suicide when one is bowed down by the sufferings of old age:

I shall not abandon old age, if old age preserves me intact as regards the better part of myself; but if old age begins to shatter my mind, and to pull its various faculties to pieces, if it leaves me not life, but only breath of life, I shall rush out of a house that is crumbling and tottering. I shall not avoid illness by seeking death; but if I find out that the pain must always be endured, I shall depart, not because of the pain but because it will be a hindrance to me as regards all my reasons for living.[34]

It is the functions of the mind rather than those of the body that are of primary concern to Seneca; yet he also acknowledges that the sufferings of the body may make the activities of the mind impossible.[35]

Letter 83 gives an account of Seneca's daily routine in old age, as we have seen. This is contextualized further in letter 108, which presents his regime of ascetic habits as a lifelong practice and one that has been integral to his philosophical formation. Seneca describes how, in his youth, he studied with the philosopher Attalus:

Whenever he criticized our pleasure-seeking lives, and praised personal purity, moderation in diet, and a mind free from unnecessary, not to mention unlawful, pleasures, the desire came upon me to limit my food and drink. And that is why some of these habits have stayed with me, Lucilius … Later, when I returned to the duties of a citizen, I did indeed keep a few of these good resolutions. That is why I have given up oysters and mushrooms for ever: since they are not really food but are relishes to bully the stomach into further eating, as is the fancy of gourmands and those who stuff themselves beyond their power of digestion: down with it quickly and up with it quickly! … That is why my stomach is unacquainted with wine. That is why throughout my life I have shunned the bath, and have believed that to emaciate the body and sweat it into thinness is at once unprofitable and effeminate. Other resolutions have been broken but after all in such a way that, in cases where I have ceased to practice abstinence, I have observed a limit that is indeed next door to abstinence.[36]

Even in old age, he notes later, Seneca uses the kind of hard, unyielding, pillow recommended by Attalus (*Letters* 108.23). His treatment of his body is both a reflection and a reinforcement of his commitment to philosophy.

So far, Seneca's attitude to his own body and his discussions of how the body should be treated might seem to owe considerably more to Greek philosophical ideas than to Roman traditions. Yet Seneca also can be found highlighting the Romanness of a regime that avoids indulgence of the flesh. In letter 86, for instance, he describes the country estate of the great Roman general Scipio Africanus, a leading figure of the late third and early second centuries BCE. Seneca focuses particularly on Scipio's modest bath-house:

In this little corner the 'terror of Carthage' … used to bathe his body, tired out from working in the fields. For he used to keep himself occupied and worked the soil with his own hands, as was the custom of the men of old. He stood beneath this dingy roof; this commonplace floor bore his weight.[37]

The letter goes on to contrast Scipio's bath with the luxury enjoyed by Seneca's contemporaries, who bathe in steaming water, in vast pools constructed of exotic marble (Seneca himself, the passage from letter 108 asserts, strove to avoid steaming baths). Such persons would disdain Scipio for his crude bathing arrangements — and all the more so if they knew he did not bathe every day:

For people say, who report to us the old ways of Rome, that the men of those times washed only their arms and legs daily — since those limbs were dirtied in their labours — and bathed all over only once a week. Here someone will remark, 'Indeed, they must have been very dirty fellows. And how do you think they smelled?'. But they smelled of warfare, of hard work, of manliness. Now that refined bath complexes have been devised, people are dirtier than they used to be.[38]

The muscular, dirty and sweating flesh of a real Roman hero can, after all, arouse a philosopher's admiration. The practices of the men of old (*prisci*) are not philosophically inspired, yet they may offer an example to the would-be philosopher. It is surely no coincidence that in the subsequent letter (87) Seneca describes his own attempt, with his friend Maximus, to subsist on the bare minimum, as they embark on a few days' journey. A telling model for their simple travel arrangements is that offered by the Elder Cato. In going on to assert that Cato's benefits to Rome equalled those of Scipio (*Letters* 87.9), Seneca makes an explicit link back to the topic of letter 86. Here, too, then, the practices of the philosopher and those of the virtuous Roman are both presented as fostering bodies immune to the softening effects of luxury.

I am very grateful to Frederick Brenk for drawing these studies to my attention. As he emphasizes (pers. comm.), doubts still remain as to the identification.

45. This is discussed most recently by Beard and Henderson, *Classical Art* (above, n. 2), 1–3; E. Borea (ed.), *L'idea del bello: viaggio per Roma nel Seicento con Giovan Pietro Bellori* II (exhibition catalogue (Palazzo delle Esposizioni, Rome), Rome, 2000), 194–5.

46. Alte Pinakothek, Munich. Rubens was much influenced by the scholar Justus Lipsius, who saw Seneca's writings as full of lessons for modern Christians (Seneca's suicide could be excused as equivalent to judicial execution). See E. McGrath, *Rubens: Subjects from History* II (*Corpus Rubenianum Ludwig Burchard* 13) (London, 1997), 282–94.

47. On this see McGrath, *Rubens* (above, n. 46), esp. p. 286.

48. McGrath, *Rubens* (above, n. 46), 287.

49. Rubens also introduces significant changes, which are discussed by McGrath, *Rubens* (above, n. 46), 284.

50. One might compare the paradoxically central role played by the body of Socrates in Plato's *Phaedo*, a dialogue in which many arguments are devoted to emphasizing the insignificance of the body as opposed to the soul. On this see Loraux, *Experiences* (above, n. 7), 160–6.

Circumcision, De-circumcision and Self-image: Celsus's 'Operations on the Penis'

Ralph Jackson

Circumcision, which removes the prepuce, critically alters bodily appearance and hence an individual's self-image. Bodily appearance was of such importance in the ancient world that de-circumcision was developed as a procedure to reverse the original operation and was sought out by those who wished to claim or reclaim full Roman identity. Both these operations were described by Celsus in his treatise and are examined in detail here in the first of three chapters that examine respectively the practicalities of the procedures, a philological analysis of the ancient sources and a reassessment of the meaning of circumcision in the Christian era.[1] Although a relatively small part of the physical body, the prepuce and its removal had an enormous impact on identity in the Roman world.

The late first century CE Roman satirist Marcus Valerius Martialis leaves his readers in little doubt that bodily appearance mattered in first-century CE Rome. If he is to be believed, men and women alike went to considerable lengths to conceal the ageing process, vain attempts where Martial was concerned. Wigs, cosmetics, false teeth were all revealed (and reviled) under the poet's withering gaze. But there were also more ambitious attempts to repair disfigurements or mutilations, as in the case of Eros, who is included in a list of surgical specialists: 'the degrading brands on slaves Eros obliterates'.[2] The reality of such cosmetic surgery is confirmed by the near-contemporary writings of medical authors such as A. Cornelius Celsus, whose remedial treatments included operations for raising slack eyelids, for healing diseased pierced ears, for excising and patching mutilations to ears, lips and nose, and for restoring the foreskin of those who wanted to become uncircumcised (*De medicina* 7.8.3, 7.9, 7.25). The latter operation prompts the questions why should anyone wish to reverse circumcision and how could it be done?

Male circumcision, like a few other specific surgical interventions (as, for example, cranial trepanation), can be demonstrated to have had a very long history.[3] The earliest surviving evidence comes from Egypt, where circumcision of males was practised throughout the Old Kingdom and New Empire, and is likely to have extended back to pre-dynastic times. In antiquity, too, Egypt was given primacy for the custom by early Greek writers such as Herodotus (2.36–7, 104), Diodorus (*Bibliotheca historica* 1.28.2–3) and Strabo (*Geographica* 17.2.5).

The Egyptian burial practice of mummification has preserved the physical evidence of circumcision, from which it has been observed that the operation was most commonly performed in late puberty and that, while common, it was not universal, even to those classes who were mummified.[4] Its frequency suggests a non-medical, probably religious, motive. Circumcision was also depicted in contemporary Egyptian art, most notably in the celebrated Sixth Dynasty low-relief sculpture on the doorway to the tomb of Ankh-ma-hor at Saqqara. In what is currently interpreted as an initiation ceremony for a funerary priest, two scenes show the ritual shaving of the pubic hair and the circumcision itself.[5] In both cases blades of flint appear to be depicted.

Stone knives for circumcision are documented also in the Old Testament (*Joshua* 5.23, with further descriptions at *Genesis* 17.9–14 and *Exodus* 4.25). While the term 'stone knife' may sound rather daunting and hardly consistent with delicate surgery on a sensitive part of the anatomy, blades of flint, chert or obsidian in reality make excellent surgical knives, capable of being fashioned into fine and extremely sharp cutting instruments. Furthermore, in contrast to instruments in other materials, they have a most important benefit: if, before each use, a fresh flake were detached from a flint core then the blade would be, potentially, aseptic. Since infection was very hard to control, such a property was of considerable significance.

According to the Bible, the Jewish practice of circumcision, traditionally performed on the eighth day, originated in God's covenant with Abraham: 'circumcise yourselves, every male among you. You must circumcise the flesh of your foreskin, and it will be a sign of the covenant between us' (*Genesis* 17.9–14). Together with the Sabbath, circumcision became the external sign *par excellence* of the Jews, even though other groups in the ancient world sometimes followed the custom and Jewish masters, in accordance with biblical texts, circumcised their male household, including Gentile slaves.[6]

The operation, though painful, was straightforward, requiring a minimum of surgical equipment — in fact nothing other than a blade, as the use of finger and thumb in opposition being in many ways preferable to the use of a forceps. Circumcision, however, was contrary to Greek and Roman aesthetics, for it went against the ancient Greek ideal of bodily beauty and perfection.[7] The erect penis, exposing the glans, was considered ugly, and in Greek and Roman art it was rarely depicted other than on satyrs, barbarians and comic burlesque characters as well as apotropaic phalli (**Fig. 3.1**).[8] Even then, the foreskin was often shown unretracted (**Fig. 3.2**).[9] Since the lack or loss of a prepuce was considered a bodily flaw, and exposure of the glans was equated with sexual activity, a missing foreskin was, potentially, a source of embarrassment and derision. It was socially unacceptable in the Roman world and was concealed with difficulty in a society in which communal nude bathing was the norm, as in the dramatic 'unmasking' of Menophilus in Martial:

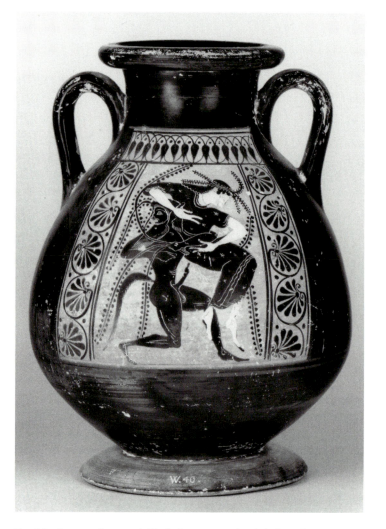

FIG. 3.2. **Satyr and maenad, black-figure vase, the Acheloos Painter, late sixth century BCE, British Museum, GR1865.11–18.40.** *Photo: British Museum, PS 320529. © The Trustees of the British Museum. Reproduced courtesy of the British Museum.*

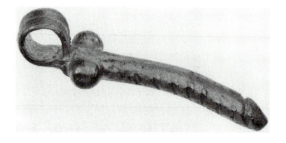

FIG. 3.1. **Gold phallic pendant, probably 1st–2nd centuries CE, from Braintree, Essex, Braintree District Museum, Braintree, Essex. Length 28 mm.** *Photo: British Museum, PS 349612. © The Trustees of the British Museum. Reproduced courtesy of the British Museum.*

So large a sheath covers Menophilus's penis that it would be enough by itself for all our comic actors. I had supposed (we often bathe together) that he was anxious to spare his voice, Flaccus. But while he was in a game in the middle of the sports ground with everybody watching, the sheath slipped off the poor soul; he was circumcised![10]

As Gillian Clark observes in her eloquent analysis of Philo of Alexandria's defence of circumcision in his *Special Laws*, even Philo, himself a circumcised Jew (albeit entirely Greek-educated), conceded that circumcision was unnatural and a mutilation.[11]

In the early Roman Empire, then, to those with a Roman cultural identity, circumcision was regarded both as a disfigurement and as a sign of Jewishness. It is hardly surprising, therefore, given their unease with the

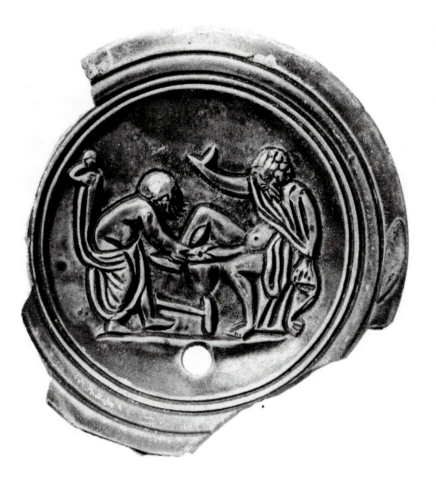

FIG. 3.3. **Roman terracotta lamp with a burlesque scene showing what may be a satirical view of circumcision, c. 40–75 CE, British Museum, GR1814.7–4.34.** *Photo: British Museum, B-258. © The Trustees of the British Museum. Reproduced courtesy of the British Museum.*

practice, that circumcision was not represented in the art of the period (indeed, apart from a small number of generic medical scenes, no specific operation is thus depicted).[12] However, a vignette on the discus of a Roman terracotta lamp (**Fig. 3.3**) shows what may be a satirical view of circumcision as depicted in a stage comedy:

> a bearded man, seated ... with his clothing drawn to one side, exposing his lower body, looks with well-founded apprehension as his penis, resting on an anvil, is gripped by a pair of forceps. The forceps are wielded by a bald-headed, bearded man, who ... is draped about the lower limbs ... The burlesque character of the scene is emphasized by a large hammer awaiting use below the block.[13]

Although the precise meaning and context of the scene are lost to us, there are a number of possible witty conflations, not least the ambivalence in the appearance of the operator, who may be both the great healer Hippocrates and the smith-god, Hephaestus/ Vulcan, while the forceps (or shears) could be identified just as well as blacksmith's tongs, and the operation easily confused with castration.[14] In view of the date of manufacture of the lamp, *c.* 40–75 CE, it is

possible, too, that this particular scene would have resonated with the recent vicious conflict (*stasis*) that had taken place between the Jewish and Greek communities in Alexandria in 38 CE.[15]

As ever, the Roman satirists, most notably Martial, took things one step further and correlated circumcision (and hence Jews) with lustfulness and sexual potency: 'a slave, girt round the groin with a black covering of dressed leather, waits on you while you are being caressed all over by warm water. But my slave, Laecania, to say nothing of myself, has a Jewish load beneath bare skin'.[16] The prevalence of this view is indicated by Philo's carefully constructed rejection of it (*De specialibus legibus* 1.8).[17] Indeed, Martial more than once uses the word *verpa*, a basic Latin obscenity denoting an erect penis with retracted foreskin, to indicate 'circumcised': 'what tortures me is this, that you, circumcised poet, although born in the very midst of Jerusalem, bugger my boy'.[18] Martial may have felt threatened by his perception of an excessive Jewish lustfulness, but Tacitus is openly hostile to the Jews for their otherness and exclusiveness, of which circumcision was the very essence — values that he regarded as un-Roman and unacceptable:

The Jews are extremely loyal toward one another, and always ready to show compassion, but toward every other people they feel only hate and enmity. They sit apart at meals, and they sleep apart, and although as a race, they are prone to lust, they abstain from intercourse with foreign women; yet among themselves nothing is unlawful. They adopted circumcision to distinguish themselves from other peoples by this difference. Those who are converted to their ways follow the same practice, and the earliest lesson they receive is to despise the gods, to disown their country, and to regard their parents, children, and brothers as of little account … the Jews conceive of one god only, and that with the mind alone: they regard as impious those who make from perishable materials representations of gods in man's image … Therefore they set up no statues in their cities, still less in their temples; this flattery is not paid their kings, nor this honour given to the Caesars.[19]

Circumcision, then, which both characterized and stigmatized Jews, had powerful negative connotations well before it was subject to restrictive legislation following the Jewish Revolt of 132–5 CE.[20] For those who had undergone circumcision as slaves in Jewish households, or for those Jews who sought to enhance their social standing in Greek or Roman society, there was good reason to attempt to remove their disfigurement. Restoration of the foreskin (*epispasmos*), or uncircumcision, is referred to by Josephus (*Antiquitates* 12.241), in *Corinthians* 1.7.18 and much earlier (c. 167 BCE) in *Maccabees* 1.1.14–15. It is only in the early first century CE, however, in the *De medicina* of A. Cornelius Celsus that a clear description is given of the surgical procedures involved.

Virtually nothing is known of the life of Celsus, other than that he wrote at about the time of Tiberius, the emperor who expelled 4,000 Jews from Rome in 19 CE. The *De medicina* comprises eight books, the only surviving part of a much larger encyclopaedic work (Quintilian 12.11.24).[21] It drew on both Greek and Latin medical sources and, although Celsus provides extremely clear and detailed accounts of surgery on the penis, there is no reason to believe either that those surgical procedures were new or that they were ever performed by Celsus himself.[22] As with all the other aspects of medicine Celsus discusses, the accounts are arranged logically and articulated clearly, and the few instruments he specifies can be illustrated in the archaeological record.[23]

The arrangement of the *De medicina* is such that the relevant text is in two sections: those conditions of the penis susceptible, at least in the first instance, to treatment by drugs (included in book 6.18) and those conditions requiring surgery (found in book 7.25). In his introduction (6.18) Celsus notes that the Greek sexual vocabulary is 'more tolerable'. He points out that the terms 'are now accepted for use, since they are met with in almost every medical book and discourse', but on the other hand in Latin, 'not even the common use has commended our coarser words for those who would speak with modesty'.[24] Despite these observations, Celsus only rarely uses Greek loan words in his reproductive vocabulary, favouring instead Latin metaphors, and euphemisms and *calques* on Greek words.[25] These enabled him to 'observe both propriety and the precepts of the art [of medicine]' but, most importantly to 'include everything which I have heard of as salutary', and 'above all things to be generally understood'. That is, to communicate clearly and concisely with the widest possible readership and not just the refined and Greek-speaking élite already catered for by other medical authors. Thus, for Celsus the penis is a stalk (*coles*), the foreskin simply skin (*cutis*), rather than a prepuce (*praeputium*), and the tip of the penis an acorn (*glans*).

Although Celsus uses a similarly specific detailed terminology for the female genitalia, admitting colloquialisms and euphemisms but avoiding obscenities, it differs from his male terminology in that the vocabulary comprises almost exclusively Latin words.[26] As von Staden has observed, 'Celsus … shuns Greek words for female parts but succeeds in transposing a Greek female body into the Latin language by making novel use of older Latin words': however, 'this abandonment of a significant part of his normal lexical arsenal, along with his reticence toward the female body ('a reluctant yet richly detailed detour'), results in a considerably less articulated version of the female than of the male'.[27]

In the preliminary comments to the surgical section Celsus reviews the reasons for surgery of the penis and assesses the various prognoses for the different categories of patient:

If the glans is bare and the man wishes for the look of the thing to have it covered, that can be done; but more easily in a boy than in a man; in one in whom the defect is natural, than in one who after the custom of certain races has been circumcised; and in one who has the glans small and the adjacent skin rather ample, while the penis itself is shorter, rather than in one in whom the conditions are contrary.[28]

While assuring his readership that the operation is feasible, Celsus nevertheless makes some qualifications, all relating to the ratio of skin to penis size. The operation is easier to accomplish in boys than in men because the proportion of skin to penis is greater in the young. For the same reason the operation is more straightforward for those men who have a relatively small glans and a short penis with comparatively ample skin. Finally, Celsus contrasts the congenital condition of a deficient prepuce with the lack of prepuce due to circumcision. The former is easier to correct simply because some skin is better than none. As Rubin has observed, Celsus's use of the words 'for the look of the thing' or 'for the sake of appearance' (*decoris causa*) allows us to classify as plastic surgery his operations to restore the foreskin, and they are two of the earliest examples of this class of surgery.[29]

As was his normal practice, Celsus begins with the lesser operation, the restoration of a congenitally deficient foreskin (which is shown in schematic form in **Fig. 3.4**):

> Now the treatment for those in whom the defect is natural is as follows. The prepuce around the glans is seized, stretched out until it actually covers the glans, and there tied. Next the skin covering the penis just in front of the pubes is cut through in a circle until the penis is bared, but great care is taken not to cut into the urethra, nor into the blood vessels there. This done the prepuce slides forward towards the tie, and a sort of small ring is laid bare in front of the pubes, to which lint is applied in order that flesh may grow and fill it up.[30]

The incision might be made with any sharp blade, but a Roman medical practitioner would most likely have used a scalpel of normal form, with a bronze handle and an iron (or steel) blade, the latter probably a small example of the common convex blade with bellied cutting edge (**Fig. 3.5**).[31] There is no doubt that pain would be involved: true anaesthetics did not exist, and the most effective known analgesics, draughts made from henbane, white mandrake or opium poppy, would not always have been available. But pain is relative, and its threshold also varies from one individual to another. In any case, the surgery was hardly more invasive than that for circumcision. On the positive side, the operation was quite straightforward. It is on a part of the body that is very easy of access, a considerable advantage in pre-modern surgery both for the operation itself and for the subsequent dressing and bandaging. It was also greatly aided by the mobility of the penile skin, which is only loosely connected to the underlying structure. This mobility enabled the sliding forward of the skin necessary to the success of the operation. It also helped the operator to avoid the accidental laceration or severing of blood vessels, urethra and other structure when making the incision: these were potential dangers to which Celsus draws particular attention.

More problematic would have been the securing of the penile skin until scar tissue had formed, as free-grafting of skin onto the newly-exposed subcutaneous tissue (as has been the practice in recent times) was not done in antiquity.[32] With the skin extended forward to the required position, the end was tied beyond the tip of the glans, leaving just sufficient opening for the passing of urine. Because the inner face of the newly-formed foreskin comprised existing preputial dermis problems of adhesion to the glans generally would not have arisen. The tie was to remain in position until healing was complete. However, as Rubin has described, the tissue shrinkage (retraction) caused by the healing process of an annular scar at the base of the penis, would have exerted a strong pull on the adjacent skin.[33] In the absence of suturing — Celsus mentions none — it must be concluded that careful dressing and bandaging were the means employed to avoid over-retraction, which otherwise might partially nullify the operation by pulling back part of the newly-formed foreskin. Certainly, as described elsewhere by Celsus (*De medicina* 5.26.24), and by other ancient medical authors, sophisticated bandaging techniques were employed, and there was a sound knowledge, too, of wound dressings and of medications that promoted the growth of flesh (*De medicina* 5.19.5–6; 7.7.9b; 7.14.4; 7.19.9).

Celsus's description of the second operation, that for de-circumcision (shown in schematic form in **Fig. 3.6**), is similarly lucid and succinct:

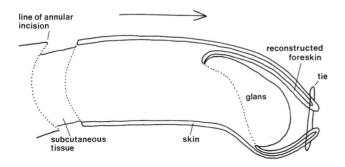

FIG. 3.4. **Diagram showing Celsus's operation to restore a congenitally deficient foreskin.** *Drawing: author, after J. Rubin, 'Celsus's de-circumcision operation',* Urology 16.1 (1980), fig. 1.

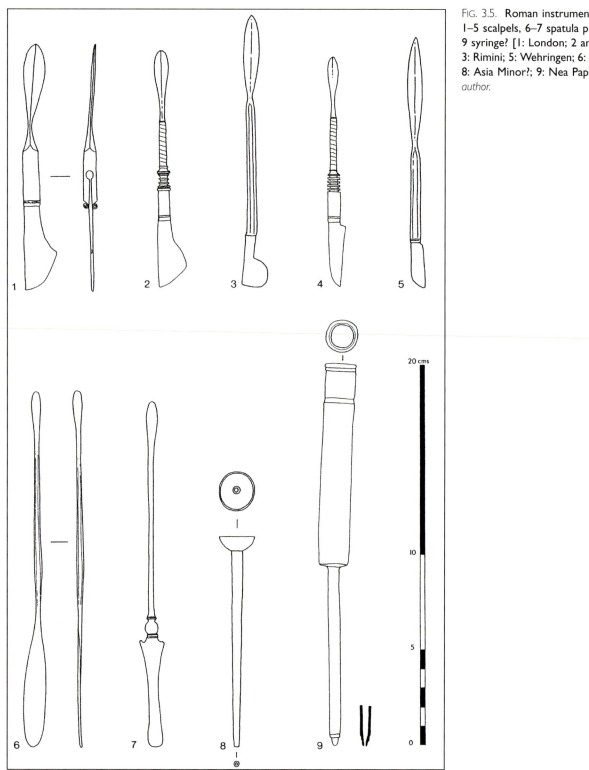

FIG. 3.5. Roman instruments of surgery: 1–5 scalpels, 6–7 spatula probes, 8 clyster, 9 syringe? [1: London; 2 and 4: Cologne; 3: Rimini; 5: Wehringen; 6: Italy; 7: Pompeii; 8: Asia Minor?; 9: Nea Paphos]. *Drawing: author.*

In one who has been circumcised the prepuce is to be raised from the underlying penis around the circumference of the glans by means of a scalpel. This is not so very painful, for once the margin has been freed, it can be stripped up by hand as far back as the pubes, nor in so doing is there any bleeding. The prepuce thus freed is again stretched forwards beyond the glans; next cold water affusions are freely used, and a plaster is applied around to repress severe inflammation. And for the following days the patient is to fast until nearly overcome by hunger lest satiety excite that part.[34]

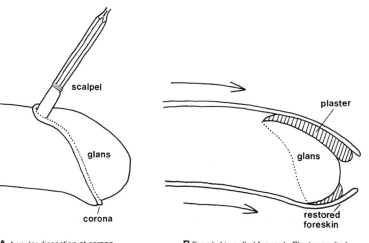

FIG. 3.6. **Diagram showing Celsus's de-circumcision operation.** *Drawing: author, after J. Rubin, 'Celsus's de-circumcision operation', Urology 16.1 (1980), fig. 2.*

A Annular dissection at corona. Skin loosened back to base of penis.

B Freed skin pulled forward. Plaster applied.

The freeing of the penile skin at the corona (the junction with the glans) was performed by annular dissection with a scalpel. Although the scalpel may have been of the same form as that used in the previous operation, some Roman surgical practitioners had at their disposal a wide range of scalpels with handles of different size and shape, and even more variation in their iron (or steel) blades. For de-circumcision a small, slender, elongated blade, with a lightly convex cutting edge, would have been most appropriate, and the blunt dissector that was the normal scalpel handle terminal may well have been used following the sharp dissection to help free the margin from the corona back towards the base of the penis (**Fig. 3.5**). Once the freeing of the tube of penile skin had been accomplished it was eased forward over the glans in order to form the reconstructed foreskin. Celsus's assertion that the dissection was 'not so very painful' was probably not shared by the patient. More critical, however, is his comment that, apart from the dissection, there was no further cause of bleeding, for haemorrhage was one of the major hazards that beset early surgery.

Unlike the operation for a deficient prepuce, the newly-formed foreskin in de-circumcision had a raw inner face which required the growth of a new layer of skin. In fact, rapid regeneration of the epithelium is a positive feature of surgery in this region, and the primary post-operative treatment was to ease pain and repress inflammation, for which Celsus recommends cold-water affusions and a plaster. Several of the plasters that Celsus describes (*De medicina* 5.19.1–6) would have been appropriate, both to repress inflammation and to promote the growth of a new epithelial surface. Once again, a difficulty would have been to maintain the new position of the penile skin while healing took place.

An added complication was the need to prevent the underside of the new foreskin from adhering to the glans. Celsus's technique was firstly to have the patient fast for the days following the operation, 'lest satiety excite that part'. Then, once inflammation had ceased, the penis was to be bandaged from the pubes to the corona, and a non-adherent plaster was applied between the glans and the foreskin. In this way the tube of penile skin was immobilized as far as possible in order to provide optimum conditions for agglutination, while the prepuce and glans remained uncovered to permit urination and to prevent adhesion. This arrangement also enabled the practitioner to monitor progress and to change the plaster as necessary. Celsus's text is incomplete at this point, but the instrument specified for the application of the plaster (*averso* [.]) was probably the small bulbous olivary terminal of a double-ended probe, very likely a spatula probe (*spathomele*) (**Fig. 3.5**), with the spatulate end of which the plaster could have been prepared.[35] The spatula probe, while not diagnostically surgical, is a recurrent find in sets of Roman medical and surgical instruments, and was made in a variety of shapes and sizes reflecting its wide and multi-purpose usage.[36]

Assuming that the surgery was performed according to Celsus's instructions, both operations had a good chance of success as long as the wounds did not become infected. The operation to reconstruct a deficient prepuce benefited from the mobility of the skin of the penis and its loose connection to the underlying structure: with care the Celsian operator could restrict his surgery to the skin, and the blood supply and the physiology of erection would have been unimpaired. For de-circumcision the regenerative property of the skin in the region of the glans permitted

a good prognosis. The greatest single danger, always a disincentive to surgery, was infection. Medical practitioners in the ancient world had no knowledge of its causes and therefore no understanding of the need to sterilize instruments. Its occurrence is attested time and time again by Celsus as one of the complications described in the paragraphs following operative techniques. In the case of operations on the penis, complications such as inflammation and ulceration are incorporated (*De medicina* 6.18). For inflammation and swelling of the penis, and tightness of the foreskin, hot-water fomentations were recommended, if necessary to be injected between the glans and the foreskin using an ear syringe (*clyster oricularius*). It is not certain whether this instrument was a true syringe or a very fine tube of bronze or bone (*clyster*).[37] A possible example has been found in a set of instruments from Nea Paphos, Cyprus (**Fig. 3.5**).[38] Ulcerations of the glans and foreskin, often consequent on prolonged swelling and inflammation, were also to be irrigated if they were dry. Subsequently they were to be treated with 'either buckthorn in wine or olive lees in the same, or butter with rose oil' (6.18.2C). Buckthorn (*lycium*) was a highly-esteemed and costly medication from Lycia that Greek and Roman medical writers recommended frequently for its astringent properties. Celsus advocates its use in treating discharges and ulceration of the ears, eyes and nostrils, as well as the genitals. In addition to tannin, which gives it its stringent property, buckthorn contains berberine, which has an antibiotic action: as was undoubtedly often the case, both medical and lay practitioners in antiquity had a sound empirical understanding of beneficial healing substances.

In conclusion, it may be seen from Celsus's account that some Roman medical practitioners would have had the ability to reverse the perceived disfigurement of circumcision effectively, and comparatively safely — even if somewhat painfully —, by plastic reconstruction of the prepuce. This was not major surgery, but no surgical intervention in antiquity was without risk. That men were prepared to undergo discomfort and pain, in fact to hazard their life, for an operation motivated not by health but by decorum, indicates just how strong social pressures were, how far bodily appearance mattered, and to what extent body image might be manipulated.

NOTES

I am most grateful to my colleagues Catherine Johns and Don Bailey for discussions and advice.

1. J.D. Hill, "The end of one kind of body and the beginning of another kind of body'? Toilet instruments and 'Romanization'", in A. Gwilt and C. Haselgrove (eds), *Reconstructing Iron Age Societies: New Approaches to the British Iron Age* (Oxford, 1997), 96–107, esp. p. 101: 'people's bodies, how they thought about them and did things with and to them, may … have constituted a changing but readily available, symbolic source through which people thought about, and acted in their worlds'.

2. 'Tristia saxorum stigmata delet Eros', Martial, *Epigrammata* 10.56.

3. It is sometimes asserted that cranial trepanation was commonly practised in antiquity and the more remote past. This is unlikely to have been the case. In fact, the evidence shows only that the operation was undertaken across a wide geographical and chronological span. See, for example, C. Roberts and K. Manchester, *The Archaeology of Disease* (Stroud/New York, 1995), 91–4. The illusion that it was common has arisen solely because it is one of the very few surgical interventions that leaves a distinctive 'fingerprint' in skeletal remains. Most surgery, like circumcision, was located in the soft tissues that, except in cases of mummification, almost never survive.

4. G.E. Smith and W.R. Dawson, *Egyptian Mummies* (London, 1924), 131; J. Nunn, *Ancient Egyptian Medicine* (London, 1996), 171.

5. See Nunn, *Ancient Egyptian Medicine* (above, n. 4), 169–71, and A.M. Roth, *Egyptian Phyles in the Old Kingdom* (Chicago, 1991), for recent authoritative discussions of the scene.

6. *Luke* 2.21; M. Goodman, 'Jewish proselytizing in the first century', and J. Lieu, 'History and theology in Christian views of Judaism', in J. Lieu, J. North and T. Rajak (eds), *The Jews Among Pagans and Christians in the Roman Empire* (London/New York, 1992), 53–78, esp. pp. 66 and 69, and 79–96, esp. p. 93; P. Schäfer, *Judeophobia: Attitudes towards the Jews in the Ancient World* (trans. D.R. Shackleton Bailey) (Cambridge (MA)/London, 1997), 99; Petronius, *Satyricon* 102.13 ('please circumcise us too so that we look like Jews'); Horace, *Sermones* 1.9.68–70; Persius, *Saturae* 5.184; Martial, *Epigrammata* 7.30; R. Lane Fox, *Pagans and Christians* (London, 1998), 296.

7. For the classical ideal of bodily integrity, with the naked male as its paradigm, see J. Boardman (ed.), *The Oxford History of Classical Art* (Oxford, 1993), esp. pp. 87–9. On attitudes to bodily imperfection, see R. Garland, *The Eye of the Beholder: Deformity and Disability in the Graeco-Roman World* (Ithaca/New York, 1995).

8. C. Johns, *Sex or Symbol? Erotic Images of Greece and Rome* (London, 1982).

9. K.J. Dover, *Greek Homosexuality* (London/Cambridge (MA), 1978), 127; Johns, *Sex or Symbol?* (above, n. 8), for example, figs 13, 28, 64, 69 and colour plates 6, 20.

10. 'Menophili penem tam grandis fibula vestit, / ut sit comoedis omnibus una satis. / hunc ego credideram nam saepe lauamur in unum / sollicitum uoci parcere, Flacce, suae: / dum ludit media populo spectante palaestra, / delapsa est misero fibula: uerpus erat', *Epigrammata* 7.82. Schäfer, *Judeophobia* (above, n. 6), 101. For communal nude bathing as a norm, see F. Yegül, *Baths and Bathing in Classical Antiquity* (New York/ Cambridge (MA)/London, 1992), 40–3.

11. See Clark, Chapter Five in this volume.

12. A. Krug, *Heilkunst und Heilkult: Medizin in der Antike* (Munich, 1985); R. Jackson, *Doctors and Diseases in the Roman Empire* (London, 1988); J.D. Hillert, *Antike Ärztedarstellungen* (*Marburger Schriften zur Medizingeschichte* 25) (Frankfurt am Main/Bern/New York/Paris, 1990).

13. D.M. Bailey, *Roman Lamps Made in Italy* (*A Catalogue of the Lamps in the British Museum* 2) (London, 1980), 163–4, Q875, pl. 12, figs 66, 112. The lamp, reg. number GR1814.7–4.34, is unprovenanced.

14. The conflation, confusion or at least association of castration and circumcision was not purely popular: Antoninus Pius's edict (rescript) restricting circumcision was essentially an extension of the ban on castration, and in legal texts the penalties were often the same for both. Modestinus, *Digesta* 48.8.11; O.F. Robinson, *The Criminal Law of Ancient Rome* (London, 1995), 51–3.

15. Josephus, *Antiquitates* 18.257; Philo of Alexandria, *In flaccum* and *Legatio ad Gaium*; Schäfer, *Judeophobia* (above, n. 6), 136–60. Tension between the two groups and the native Egyptians was long-standing, but in 38 CE, as a consequence of inept political manoeuvring by the Roman prefect A. Avillius Flaccus, hostility turned to violent persecution in which many Jews were massacred. Subsequently, in 40 CE, a delegation of Alexandrian Greeks was sent to Rome.

16. 'Inguina succinctus higra tibi servus aluta / stat, quotiens calidis tota foveris aquis. / sed meus, ut de me taceam, Laecania, servus / Iudaeum nulla sub cute pondus habet', Martial, *Epigrammata* 7.35. For the alternative and compelling reading 'under no skin' (*nulla sub cute*), which makes even more explicit the perceived connection between circumcision and sexual potency, see Schäfer, *Judeophobia* (above, n. 6), 100. Also *Epigrammata* 7.55, 7.82, 11.94. Tacitus, too, characterizes the Jews as 'prone to lust': *Historiae* 5.5.2.

17. See Clark, Chapter 5 in this volume.

18. 'Illud me cruciat, Solymis quod natus in ipsis pedicas puerum, verpe poeta, meum', *Epigrammata* 11.94 and also 7.82. J.N. Adams, *The Latin Sexual Vocabulary* (London, 1982), 12–14.

19. 'Et quia apud ipsos fides obstinate, misericordia in promptu, sed aversus omnis alios hostile odium. separati epulis, discreti cubilibus, proiectissima ad libidinem gens, alienarum concubitu abstinent; inter se nihil inlicitum. circumcidere genitalia instituerunt ut diversitate noscantur. transgressi in morem eorum idem ursupant, nec quicquam prius imbuuntur quam contemnere deos, exuere patriam, parentes liberos fraters vilia habere ... Iudaei mente sola unumque numen intellegunt: profanes qui deum imagines mortalibus materiis in species hominum effigant ... igitur nulla simulacra urbibus suis, nedum temples sistunt; non regibus haec adulatio, non Caesaribus honor', *Historiae* 5.5 (trans. C.H. Moore). Schäfer, *Judeophobia* (above, n. 6), 98.

20. Whether or not Hadrian attempted to ban circumcision, an issue that remains unresolved, the earliest recorded legislation against the practice is the edict (rescript) of Antoninus Pius (Modestinus, *Digesta* 48.8.11). This stated that Jews were permitted to circumcise only their sons, and that transgressors would suffer the same punishment as castrators.

21. P. Mudry, 'Le *De medicina* de Celse: rapport bibliographique', in W. Haase (ed.), *Aufstieg und Niedergang der Römischen Welt* (*Geschichte und Kultur Roms im Spiegel der Neueren Forschung* II, 37:1) (Berlin/New York, 1993), 787–818.

22. Opinion is still divided, but it is unlikely that Celsus was a regular medical practitioner. Indeed, Pliny the Elder aligns Celsus with *auctores* rather than describing him as a *medicus*: 'Celsus apud nos ... ' (*Historia Naturalis* 21.176). Mudry, 'Le *De medicina* de Celse' (above, n. 21).

23. R. Jackson, 'The surgical instruments, appliances and equipment in Celsus' *De medicina*', in G. Sabbah and P. Mudry (eds), *La médecine de Celse: aspects historiques, scientifiques et littéraires* (*Mémoires* 13) (Saint-Étienne, 1994), 167–209.

24. 'Quarum apud Graecos vocabula et tolerabilius se habent et accepta iam usu sunt, cum in omni fere medicorum volumine atque sermone iactentur: apud nos foediora verba ne consuetudine quidem aliqua verecundius loquentium commendata sunt, ut difficilior haec explanatio sit simul et pudorem et ailis praecepta servantibus.'

25. Adams, *The Latin Sexual Vocabulary* (above, n. 18), 228; H. von Staden, '*Apud nos foediora verba*: Celsus's reluctant construction of the female body', in G. Sabbah (ed.), *Le latin médical: la constitution d'un langage scientifique* (*Mémoires* 10) (Saint-Étienne, 1991), 271–96, esp. p. 280.

26. The terms most frequently found in Celsus are genitals (*naturalia*); vagina (*naturale*); womb (*uterus*) but, more often womb or vagina (*vulva*), or both; cervix, mouth of womb, vulvar orifice, entrance of vagina (*os vulvae*); and *orae*, used instead of *labia*. See Adams, *The Latin Sexual Vocabulary* (above, n. 18), 80–117; von Staden, '*Apud nos foediora verba*' (above, n. 25), 281–9; L. Dean-Jones, 'Medicine: the 'proof' of anatomy', in E. Fantham, H. Peet Foley, N. Boymel Kampen, S.B. Pomeroy and H.A. Shapiro, *Women in the Classical World: Image and Text* (Oxford, 1994), 183–205; H. King, *Hippocrates' Woman: Reading the Female Body in Ancient Greece* (London/New York, 1998).

27. von Staden, '*Apud nos foediora verba*' (above, n. 25), 280, 292.

28. 'Ab his ad ea transeundum est, quae in cole ipso fiunt. in quo si glans nuda est, vultque aliquis eam decoris causa tegere, fieri potest; sed expeditius in puero quam in viro; in eo, cui id naturale est, quam in eo, cui quarundam gentium more circumcises est; in eo, cui glans parva, iuxtaque eam cutis spatiosior, brevior vero ipse coles est, quam in quo contraria his sunt', *De medicina* 7.25.1a (trans. W.G. Spencer).

29. J. Rubin, 'Celsus's de-circumcision operation', *Urology* 16.1 (1980), 121–4.

30. 'Curatio autem eorum, quibus id naturale est, eiusmodi est. cutis circa glandem prehenditur et extenditur, donec illam ipsam condat, ibique deligatur. deinde iuxta pubem in orbem tergus inciditur, donec coles nudetur, magnaque cura cavetur, ne vel urinae iter vel venae, quae ibi sunt, incidantur. eo facto, cutis as vinculum inclinatur, nudaturque circa pubem velut circulus; eoque linamenta dantur, ut caro increscat et id impleat … satisque velamenti supra latitudo plagae praestat. sed donec cicatrix sit, vinctum esse debet, in medio tantum relicto exiguo urinae itinere', *De medicina* 7.25.1b (trans. W.G. Spencer).

31. For example R. Jackson, 'Roman doctors and their instruments: recent research into ancient practice', *Journal of Roman Archaeology* 3 (1990), 5–27, esp. figs 1, 6–8; Jackson, 'The surgical instruments' (above, n. 23), 169–71, esp. figs 1,1–2.

32. J. Penn, 'Penile reform', *British Journal of Plastic Surgery* 16 (1963), 287.

33. Rubin, 'Celsus's de-circumcision operation' (above, n. 29), 122.

34. 'At in eo, qui circumcises est, sub circulo glandis scalpello deducenda cutis ab interiore colest. non ita dolet, quia summo soluto deduci deorsum usque ad pubem manu potest; neque ideo sanguis profluet. resoluta autem cutis rursus extenditur ultra glandem; tum multa frigida aqua fovetur, emplastrumque circa datur, quod valentem inflammationem reprimat. proximisque diebus ei prope a fame victus sit, ne forte eam partem satietas excitet', *De medicina* 7.25.1C (trans. W.G. Spencer).

35. The missing word was probably *specillo*. 'The other end of the probe' or 'the reverse end of a probe' (*aversum specillum*) is specified by Celsus in several other places in the *De medicina*. Their context suggests that the *specillum* intended was a spatula probe. See Jackson, 'The surgical instruments' (above, n. 23), 182.

36. R. Jackson, 'A set of Roman medical instruments from Italy', *Britannia* 17 (1986), 119–67, esp. pp. 156–8.

37. Jackson, 'The surgical instruments' (above, n. 23), 184–7; L. Bliquez and J.P. Oleson, 'The origins, early history and applications of the *pyoulkos* (syringe)', in G. Argoud (ed.), *Science et vie intellectuelle à Alexandrie* (Saint-Étienne, 1995), 83–119.

38. D. Michaelides, 'A Roman surgeon's tomb from Nea Paphos', *Report of the Department of Antiquities, Cyprus* (1984), 315–32.

A ROMAN PERSPECTIVE ON CIRCUMCISION

Pierre Cordier

So much better does it profit a man to train his member than his mind![1]

Petronius, *Satyricon* 92.11

The idea that circumcision horrified Greeks and Romans generally has been accepted as proven.[2] As far as Rome is concerned, the traditional arguments are based on imperial legislation, which applied the penalty of castration to those who circumcised, and on old anti-Jewish polemics well documented by sources of the Hellenistic period.[3] The prohibition on circumcision initiated by Hadrian in the 130s CE is interpreted as testifying to a long-standing repugnance for circumcision considered as a mutilation, a physical disgrace, or as an absurd and foolish superstition. The aim of this chapter is to re-examine the pagan Roman perspective on circumcision and to demonstrate that Roman hostility was not based upon medical, aesthetic or religious conceptions of the human body. Instead, an accurate reading of the sources indicates that circumcision was not regarded as a mutilation before Hadrian, and neither was it considered a behavioural practice inspired by *superstitio*.[4] The negative attitude of the Romans refers to representations that focused on the semiotic value of bodily appearances according to specifically Roman conceptions and to their norms of behaviour and social identity. In this context, the case of the circumcised may, at first sight, seem misplaced or artificial, because it has become commonplace to insist on the prevalence of the clothed body in Rome in contrast to the nudity associated with Greece. But with the construction of numerous baths (*thermae*) during the empire, the opportunity of seeing people in the nude became more frequent and drew Roman eyes towards the intimate and ordinarily invisible parts of other male bodies. In addition to physical parts that were normally viewed, the genitals and other normally hidden physical features were supposed to mirror and reveal the moral, and therefore behavioural, features of a man. His soldiers associated Caesar's baldness with an excessive sexuality; and the size and general appearance of the virile member, once it was publicly exhibited, was also interpreted as the corporeal translation of one's nature — thus male bodies contributed to social taxonomies.

To understand, on the one hand, Roman attitudes towards circumcision and, on the other hand, the motives for the prohibition on circumcision, Roman ways of naming circumcision and the circumcised need to be examined. Graeco-Roman writings discuss two types of circumcision: the therapeutic resection of the foreskin and the ritual operation that demonstrated membership of a cult or ethnic community.[5] Most references concern the latter, although the terms are often polysemous, and the notion of circumcision has never been defined by a homogeneous vocabulary. There are three principal categories or designations in the vocabulary of circumcision, the first being verbal forms of *circumcidere* (and the later derivation *circumcisio*), which evokes an incomplete or uncovered member. The second designation is the pair formed by the adjective *uerpus* and the noun *uerpa*, which establishes the most clear explanation of the Roman attitude towards circumcision and the fact that, in these first two categories, the idea of physical mutilation is not important for the Roman point of view. The third category or designation contains the vocabulary that includes *recutitus* and *uerpus*, which introduces the term into the Latin nomenclature.

The least ambiguous term for the act of circumcising and its result is the verb *circumcidere*, an equivalent of the Greek *peritemnō*, itself a compound derived from *temnō*.[6] The noun *circumcisio* seems to be a late invention of Christian authors, derived from *peritomē*.[7] Both the Greek and Latin terms evoke, without giving technical details, the resection of the foreskin. *Circumcidere* is abundantly used by Latin medical literature, referring to ritual as well as therapeutic resections.[8] In Roman law, the verb, with its objects *filios*, *homines*, needs no definition.[9] The first explanations of the word in ancient literature belong to the late context of religious polemic. Zeno of Verona, who

died *c.* 380 CE, reduces circumcision to a surgical gesture in order to diminish the importance of the Jewish rite:

> He is accustomed to boast and proclaim that it [i.e. circumcision] is the nobleness of his nation, the virtue of a heavenly sacrament, the legitimate mother of eternal life, the eternal companion of the kingdom to come, without which nobody can ever draw God's attention. That is why I think it is necessary, before all, to define what circumcision is, in order to be able to identify its nature with good reasons. Circumcision, brothers, is a round cut made with an iron, which turns into a ring scar.[10]

In its earlier attestations, *circumcidere* speaks for itself, as soon as the context makes clear the organ in question. In Petronius (*Satyricon* 102.14), for example, the verb needs no other object than *nos* because it is explained by *ut Iudaei uideamur*: "Oh! yes', said Giton, 'and please circumcise us too, so that we look like Jews, and bore our ears to imitate Arabians, and chalk our faces till Gaul takes us for her own sons!'".[11]

Tacitus (*Histories* 5.5) alone specifies the object of circumcision, *genitalia*, in the unequivocal context of his ethnographic digression about Jews: 'they adopted circumcision to distinguish themselves from other peoples'.[12] This insistence is not coincidental and will be re-examined.

Besides that descriptive and neutral term, a second category appears in Latin. Instead of stressing the gesture of resection, as *circumcidere* does, it only notes the absence of some part of the penis. Circumcised people are called *uerpi*, because in Roman terms their genitals look like those of Priapus. The circumcised penis is not considered a mutilated and diminished member, but rather as a parading phallus that permanently exhibits the symptoms of its shameless excitement, in contempt of propriety. In that case, the repugnance towards sexual mutilation (never explicit nor insisted upon in Roman sources) appears as an anachronism when it is put forward to explain the criminalization of circumcision, on the model of castration, instigated by Hadrian in the second century CE. The interdiction is not connected to castration by the idea of mutilation — which is really a modern point of view — but by the similar behavioural improprieties with which the circumcised and castrates were credited: their morality (an important facet of their social identity) was, so to speak, inscribed on their sexual organ. Regarding circumcision as a mutilation

was not the cause but the consequence of Hadrian's statute; the theme of mutilating circumcision becomes significant only in the third century CE, especially when Christian authors use it in their polemics against Judaism.

In his *Satires* (1.5.97–100), Horace makes a pun with the proper name Apella: 'then Gnatia, built under the wrath of the water-nymphs, brought us laughter and mirth in its effort to convince us that frankincense melts without fire at the temple's threshold. Apella, the Jew, may believe it, not I'.[13] By no means a typical Jewish name, the pun on Apella's name makes sense only with the juxtaposition of *Iudaeus*.[14] Horace's ancient commentators toiled to explain that Apella is a nickname, composed of a privative prefix and of an element that calls to mind the word *pellis*: Apella means 'skinless' and refers to circumcision.[15] Recently, a less convincing attempt has been made to find in a fragment of Naevius a precedent for Horace's pun.[16]

In the same category (indicating absence), the adjective *curtus* is given by the *Glossaries* as an equivalent of the Greek 'truncated' (*kôlobos*).[17] The term, associated with the verb 'to fart' (*oppedere*) by Horace (*Satires* 1.9.69–72), is a joking insult. Coupled with *Iudaei*, it characterizes Jews by their 'truncated' sexual organs: 'Today is the thirtieth Sabbath. Would you fart against the truncated Jews?'.[18] The joke does not lie in referring to the idea of a specifically genital mutilation, but in a caricatural metonymy that evokes something between an armless and legless man and a walking, incomplete phallus. Porphyrio, Horace's commentator, stresses the audaciousness of the figure when he provides a grammatical restoration of the lacking foreskin: 'he said the truncated Jews, because their virile member is so to speak shortened, having the prepuce cut off'.[19] The same adjective appears in a similar figure by Persius (*Satyricon* 5.179–84 and 190–1).[20] The context and the symmetry with *centum Graecos* invite us to read *curto* as an equivalent to *Iudaeo*. Finally, *curtus* is used only in metonymical figures that use, so to speak, *partes pro toto* to characterize Jews. In the same passage, Persius also has recourse to the adjective *recutitus*, which usage he shares with Martial and Petronius.[21] In Persius the term qualifies a Jewish ritual time (*sabbata*), and in the other authors being Jewish (*recutitorum Iudaeorum* and *recutitus est* respectively). *Recutitus*, a compound form of *cutis*, means 'having the skin drawn back'.[22]

This word introduces into the Latin nomenclature of circumcision a third and last category, which contains

recutitus and *uerpus*. These adjectives do not concern surgical processes (like *circumcidere*), nor the absence of a part of the penis (like *Apella* and *curtus*), but simply denominate a penis exhibiting its glans. Their use, much more than the neutral *circumcidere* or the series of aforementioned metonymical designations, makes the motives for the Roman attitude towards circumcision clear: the member of the circumcised calls for an analogy that implies at once embarrassment and laughter. At least occasionally the word *uerpus* is specifically intended for a circumcised member. Martial and Juvenal use it in an unequivocal context, where it concerns Jewish ritual circumcision, that demands a total resection of the foreskin.[23] It also seems to be used in this sense in Martial (*Epigrammata* 7.82).[24] When the huge *fibula* of Menophilus falls down, it reveals, instead of a chaste foreskin, the member of a *uerpus*.[25] However, a Latin passage by Dioscorides implies that the word could be used also for a partial or complete removal of the prepuce and not only its retraction.[26] The word occurs in the work of Catullus who, significantly, calls someone a *uerpus Priapus* in poem 47:

> Porcius and Socration, Piso's two left hands, you plague and mere famine. Has that obscene Priapus preferred you to my dear Veranius and Fabullus? Are you spending money and holding splendid rich banquets at vast expense in broad daylight, whilst my old friends must walk about the streets to hunt for an invitation?[27]

Verpus is equivalent to the Greek *psôlos*. Its precise meaning is 'having the foreskin drawn back' rather than 'circumcised'.[28] The etymology of the term is obscure, but, related to *uerpa* — comparable to the French slang term 'noeud' —, is a coarse name for the protruding penis.[29] This term is quite unusual in literary language, except for that of Martial, the *Carmina Priapea* and a restored fragment of Pomponius; it is frequent, however, in Pompeian graffiti.[30]

In Pompeii, an inscription is addressed to passers-by and threatens the penetration of both their anus (*pedicatio*) and their mouth (*irrumatio*): 'The one who writes loves, the one who reads is buggered. The one who listens is itching; the one who passes by is a poof; let the bears eat me and let me the reader eat a cock'.[31] Here *uerpa* is actually an aggressive and unruly organ nobody can approach without risk, as we also see in another inscription: 'The one who paid a visit to the cock, what did he have for dinner, in

your opinion?'.[32] Catullus's expression *uerpus Priapus* recalls that *uerpa* is the name of the enlarged penis of Priapus, the garden keeper: this red-daubed member is his weapon and his scarecrow.[33] In the *Carmina Priapea*, Priapus is offered a votive *uerpa* by a prostitute at the close of a sacred wake, or by a sick man saved by a vow.[34] In a fragment of Pomponius, *uerpa* appears to be an excellent conjecture: 'I am going to one side to shit. Has the thorn bush changed into a cock?'.[35]

This passage alludes to a typically priapic revenge: the after-effect of the painful anal penetration (*pedicatio*) promised to imprudent 'shitters' (*cacatores*) by a Pompeian inscription: 'You see the monument of nettles; go away, you shitter: it is not safe to open your arse here'.[36]

Priapus is *uerpus* by nature. The name of his obscene and aggressive member is never used in a neutral way like the word *mentula*, which is prohibited even in refined language.[37] A passage of Celsus devoted to surgical restoration of the foreskin (*epispasm*) makes clear that a visible glans such as that attributed to Priapus may be regarded as an embarrassing anatomical feature: 'And, if the glans is bare, and the man wishes for the look of the thing to have it covered, that can be done'.[38]

The nudity of Priapus's glans, commonly documented by iconography, expresses an uncontrolled sexuality, and that is why a permanently drawn-back foreskin may betray an excess of sexual activity.[39] Martial gives an example of that kind of excess, when he suggests to the dissolute Mevius to raise his old crippled *uerpa* with the rejuvenating treatment of *irrumatio*.[40] Just like the god he imitates by his loose living, Mevius has lost his ability to have an orgasm. But whereas Priapus is condemned to erection for life, Mevius has lost all hardness. This is no mere rhetorical symmetry. In his foolish way, Mevius the impotent embodies priapism, a severe penile condition often described by ancient medical treatises.[41] Simultaneously, the long story of Mevius's *uerpa* discusses priapean traditions and illustrates a wrong use of the penis. In both cases, it is a question of defining a behavioural norm.

The circumcised penis looks like Priapus's and the circumcised man looks like his organ. Circumcision also induces physiological and moral qualities. Martial demonstrates this attitude when he evokes the Jewish member of a slave and ascribes to it the weight of an overdeveloped virility.[42] Circumcision means growth. Martial again compares the moral and physical features

FIG. 4.1. **Phallic caricature**. *From V. Väänänen, Le latin vulgaire des inscriptions pompéiennes (Helsinki, 1937), 128, no. 36.*

of a Roman penis with Jewish largeness: 'You will lick a cock — not mine, which is well-behaved and diminutive — but one that comes from burned-out Jerusalem, one lately doomed to pay taxes'.[43] Romans have normal organs. Moreover the comical mischance of Menophilus contrasts the *fibula*, sign of chastity, and the frenzied sexual activity of a *uerpa* that jumps up like a spring toy at the end of the last verse. In our opinion, the gossip of Tacitus about Jewish sexual dissoluteness relates to that semantic field: 'They sit apart at meals, and they sleep apart, and although as a race they are prone to lust, they abstain from intercourse with other women; yet among themselves nothing is unlawful. They adopted circumcision to distinguish themselves from other peoples'.[44] In a symptomatic way, Tacitus talks about circumcision just after hinting at an alleged absence of incest prohibitions among Jews: immorality is the shadow of circumcision.

Even medical writings about foreskin restoration support this analysis of Roman attitudes to circumcision: *epispasm*, like circumcision, belongs to bodily semiotics. A passage by Oribasius (*Collectiones medicae* 50.1.1) devoted to the restoration of naturally short foreskins reveals, in fact, that a complete covering of the glans is thought to be the 'natural' condition of the penis: 'When the prepuce lacks even a small piece of skin for the penis to regain its natural condition, I often was successful with a mere extension'.[45] In a *Carmen Priapeum*, the dedicant explains that his votive painted *uerpa* is a thank-offering for deliverance (*soterion*): the *uerpus* god has saved his foreskin

from the surgeon's hands.[46] Romans, in fact, appreciate having Priapus's *uerpa* at their disposal on certain private occasions, but they dread keeping it for life.

The image of the male sexual organ, in short, contributed to building social taxonomies among the Romans. Even outside the smutty vocabulary of Pompeian inscriptions or satiric poems, Roman iconography tended to give genitals an autonomous shape. The bells (*tintinnabula*) of Herculaneum and Pompeii represent in a mythological or fantastic way zoomorphic phalluses with tails, wings, legs, claws or hooves, and even with secondary sexual organs.[47] Metal pendants or terracotta figurines depict personified apotropaic phalluses, sometimes comically involved in typical human actions.[48] We should not be surprised to see which Latin vocabulary is employed for the terminology that interests us: for the glans (*caput*), foreskin (*cucutium*), pubic hair (*capillus* or *barba*) or if, here and there, the very penis shows its *nasus*.[49] The penis is a sort of face and, inversely, the face may be turned into a groin: in some Roman or Pompeian caricatures, a human face is adorned with a respectable phallus instead of a nose (**Fig. 4.1**).[50] This anatomical convertibility underlines the parallel between a man's head and his genitals, obvious in many lamps with figures wearing a hooded coat (*cucullatus*): the glans of their member may significantly reproduce, on a small scale, the shape of their hood and their beard may refer to pubic hair.[51] A respectable individual suddenly could be turned into a phallic model; because of his short silhouette and the bald head evoked by his cognomen, Licinius Calvus is sketched as a raging penis by Catullus; the comparison is all the more credible given that a bald head was commonly considered to be the symptom of excessive sexual activity, as with Caesar's triumph.[52] The groin may even mirror the face: Martial caricatures Papylus's nose as meeting its symmetrical reflection when it touches his cock: 'So large is your cock, Papylus, and so long your nose, that you can sniff it whenever you are erect'.[53]

Physiognomy, therefore, can apply to private parts as well as to heads and faces. As can be seen through onomastics and its series of anatomical *cognomina*, a Roman man could owe his public nickname to the physiognomy of his genitals.[54] The late chronological distribution of the sources is due merely to the fact that the question of conformity or deviation of sexual organs from an accepted norm did not make sense until the Romans frequented public baths. In that new context, the penis shows, in a way, the face of the *privatus*, just as

he takes his public face round the forum. If the Roman embarrassment with circumcision is not to be connected with a particular repugnance for bodily mutilations, but is based on the signification assigned to it according to a specifically Roman semiotics, it becomes difficult to explain how the legal punishment for castration could be applied to the case of circumcision. The interdiction of the latter actually appeals to a jurisprudence principle, when it classes foreskin resection as an ablation concerning the genital area akin to castration, which was itself obviously regarded as a degrading mutilation with heavy civil consequences: 'A rescript of Antoninus Pius permits the Jews to circumcise only their children, and anyone who will do it to a [slave] not belonging to the same religion will be punished for the crime of castration'.[55] The common characteristic of circumcision and castration is that both types of genital resection rank the marked bodies among categories of modified sexual behaviour and social deviation. Just as circumcised people seem to escape social control with their expansive organ, castrates are nothing but curios of sexuality and *luxuria*. For that reason, eunuchs were believed by Romans to be capable of amazing and disturbing sexual achievements. They have lost the ability to sire, but they can still copulate. They are by nature ready to use any means to give their partner sexual pleasure, and they are supposed to be haunted by the obsession of their cut-off virility.[56] Just like circumcised Jews or Egyptians, castrates live in the unstable world of their unruly sexuality, and the taxonomic effect of bodily marks reduces them paradoxically to mere genitals.[57] The parallel of circumcised men to castrates originates in the normative values of Roman sexual semiotics.

It is therefore only after having been placed in the setting of the *lex Cornelia de sicariis et ueneficis*, enacted in the reign of Hadrian, that the matter of circumcision appears to be connected with castration and the idea of mutilation.[58] In the first three decades of the third century, Cassius Dio distinguishes between the effective circumcision and the intended castration of Elagabalus: 'Closely related to these irregularities was his conduct in the matter of Elagabalus ... also in his circumcising his privates and abstaining from swine's flesh, on the ground that his devotion would thereby be purer — he intended in fact to cut them utterly off'.[59] If he distinguishes between the two categories of genital resection, Dio significantly considers them as connected to each other. Their association seems to follow from the very formulation of Hadrian's statute. The same association emerges from a passage of the *Historia*

Augusta: 'At this time also the Jews began war, because they were forbidden to mutilate their genitals'.[60] According to this sentence in Hadrian's biography, written in the fourth century CE, the Roman point of view on circumcision seems to evolve into an insistence upon the cut and into the prevalence of the idea of mutilation.[61] In the Christian tradition, circumcision gives rise to polemics inspired by Paulinian argument, as in the aforementioned sentence of Zeno of Verona or in several passages of Origenes: in the opposition between the flesh and the heart, it is reduced to a mere cutaneous scar and a simple ritual mutilation. Those remarks do not resolve the question of the dating of Hadrian's interdiction. They focus on the interdiction's cultural context; there is no need to assume an alleged Roman anti-Semitism, nor to credit the emperor with the vast project of taking in hand the eastern fringe of the Empire. Like the Jewish rules about licit and illicit unions evoked by Tacitus, circumcision infringes upon the Roman definition of social order. And even so, Jewish newborns and Egyptian priests were soon excepted, in so far as those communities had to follow the prescriptions of their *religio*.[62] There was a conflict between the demands of Roman morality and the predominant attitude of non-intervention in the religious affairs of the Mediterranean peoples as long as they did not contravene Roman law. Here, circumcision used not to come under the law before having been ranged in the *lex Cornelia*'s provisions; before that, it was only considered as an embarrassing practice. The prohibition of circumcision is one of many of Hadrian's decisions that aimed to reaffirm *mores*, such as those regarding the opening hours of, or intermingling in, the baths, or the wearing of the toga by *senatores* and *equites*.[63]

In any case, the effects of the new jurisprudence mechanism were to overrun that initial purpose. Even before the legislation of Theodosius (died 395), the interaction between Christian thought and Roman law sanctioned the reduction of the Jewish rite to a bodily mutilation, though circumcision was not called 'the Jewish mark' (*nota iudaica*) until the Theodosian Code and the triumph of the Paulinian hostility to ritual foreskin resection of Gentiles.[64] This pejorative expression, even if it claims to refer to an earlier statute, relates to a polemic between Bible religions, which surpasses, to a large extent, the properly Roman terms of the problem of circumcision.

Inscribing a social taxonomy on the male sexual organ is only a facet of a much larger question: the importance of bodily aspect in social integration or exclusion at Rome. To consider solely the pattern of

exclusion, as well as obvious physical disgraces like the hunchback's, many hidden corporeal features, once public, were part of one's *facies* and supposed to disqualify a person, especially in the case of a citizen.[65] The genital area was no exception: Livy relates that an old soldier had to justify the groin hernia from which he was suffering when an accidental slippage of his *toga*, instead of exhibiting the scars of his courage, unveiled his private parts.[66] Obviously, circumcision implies an intentional modification of the innate shape of the body. But the Romans do not focus on that point: in foreskin resection, they consider the result rather than the process. The possible argument that the inborn shape of the body should be respected is never put forward.[67] It seems indeed to be a misplaced anachronism: firstly, because the very notion of nature it assumes is quite seldom invoked, either expressly or allusively, and should anyway be seriously defined.[68] Secondly, because the necessity of respecting the physical integrity of the human body, as well as the concept of physical integrity itself, seems to be based (at least indirectly) on the presupposition, absolutely unfamiliar to pagan Romans, that man is a corporeal image of God (an argument that is abundantly developed in the Jewish and Christian discussions for and against circumcision); and lastly, because the whole body appears in Rome to be conceived first as a ductile silhouette that is modelled by the social and ecological environment. For that reason, the human body is readable and meaningful in the Roman perspective. The emergence of the circumcision problem in Roman sources proves to arise from the development, from the first century BCE, of places where nudity became a common form of sociability. The pattern of circumcision invites historians and anthropologists of Rome to take chronological and environmental factors into careful account when studying the Roman body.

NOTES

I want to thank Elizabeth Sara Yellen for her help and — already — long-standing friendship. Translations are from Loeb Classical Library editions unless otherwise noted.

1. 'Tanto magis expedit inguina quam ingenia fricare.'
2. See, for example, J.P.V.D. Balsdon, *Romans and Aliens* (London, 1979), 231: 'By the Romans, as by the Greeks and the Arabs, it was held in great contempt; it seemed a gross physical deformity'; L.H. Feldman and M. Reinhold, *Jewish Life and Thought Among Greeks and Romans: Primary Readings* (Edinburgh, 1996), 377. For the Greek and Roman pagan perspective on circumcision, see J.A. Gager, *The Origins of Anti-Semitism: Attitudes toward Judaism in Pagan and Christian Antiquity* (Oxford, 1983), 56; L.H. Feldman, *Jew and Gentile in the Ancient World: Attitudes and Interactions from Alexander to Justinian* (Princeton, 1993), 153–8.
3. See, for example, III *Maccabees* 2.25–30; Josephus, *Jewish Antiquities* 12.237–41, 248–56. For the Roman period, *Against Apion* 2.83–4.
4. Superstitious behaviour was supposed to run counter to the Roman way of life. *Superstitio* was regarded by Cicero (*De specialibus legibus* 1.22–3) as incompatible with the notion of *humanitas*, which influenced the imperial idea of a law-abiding community (*communio iuris*) — that is, fundamental rules the inhabitants of the *imperium* were meant to have in common in spite of their diversity, for which see V. Marotta, *Politica imperiale e culture periferiche nel mondo romano: il problema della circoncisione* (Naples, 1985), 443, nn. 95–6.
5. Originally, in Semitic societies, circumcision was an initiation rite introducing young men to clan life; in Hebrew and Arabic, the word is related to the idea of wedding. See, in general, G. Mayer, 'Circumcision', in G.J. Botterweck, H. Ringgren and H.J. Fabry (eds), *Theological Dictionary of the Old Testament* VIII (trans. D.W. Stott) (Grand Rapids (MI)/ Cambridge, 1997), 158–9. Circumcision was performed in several priesthoods, such as that of Elagabalus (see Cassius Dio 79.11.1).
6. G. Loewe and G. Goetz (eds), *Corpus glossariorum latinorum* [hereafter *CGL*] (Leipzig, 1888–1923), IV, 131, 139, 270, 385 *s.v. peritomen/pentomen*. See *temnô* in P. Chantraine, *Dictionnaire étymologique de la langue grecque: histoire des mots* IV (Paris, 1977), 1103.
7. The noun *peritomê* appears 35 times in the New Testament, meaning variously the act of circumcising (for example *Galatians* 5.11), the fact of being circumcised (for example *Romans* 4.10) or the community of the circumcised (for example *Romans* 3.30); in a polemic use, it characterizes the Christians who observed the Jewish ritual observance (for example *Ephesians* 2.11). See J. Marcus, 'The circumcision and the uncircumcision in Rome', *New Testament Studies* 35 (1989), 67–81; P. Fredriksen, 'Judaism, the circumcision of gentiles, and apocalyptic hope: another look at *Galatians* 1 and 2', *Journal of Theological Studies* 70.2 (1991), 532–64.
8. Celsus, *De medicina* 7.25.1, see notes below.

9. *Digesta* 48.8.11; Modestin 1.6 regularum. See *Codex Theodosianus* [hereafter *CTH*] (Berlin, 1903–4) 16.8.28, 16.9.1–3; J. Juster, *Les Juifs dans l'empire romain: leur condition juridique, économique et sociale* (Paris, 1914), 263, n. 4, and the discussion of A.M. Rabello, 'Il problema della circumcisione in diritto romano fino ad Antonino Pio', *Studi Biscardi* 2 (1982), 201–4.

10. 'Solet enim magnis cum uociferationibus saepe iactare hanc esse gentis suae nobilitatem, hanc caelestis sacramenti uirtutem, hanc aeternae uitae legitimam genitricem, hanc perpetuam futuri regni consortem, sine qua nemo possit omnino ad dei notitiam peruenire. unde primo omnium definiendum puto, quid sit circumcisio, ut tunc demum, qualis sit, iure possit agnosci. circumcisio est, fratres, in damnum rotundi uulneris ferro circulata cicatrix', *Tractatus* 1.3.1–2.

11. 'Quidni?' inquit Giton, 'etiam circumcide nos, ut Iudaei uideamur, et pertunde aures, ut imitemur Arabes, et increta facies, ut suos Gallia ciues putet?'

12. 'Circumcidere genitalia instituerunt ut diuersitate noscantur.'

13. 'Dein Gnatia lymphis / iratis extructa dedit risusque iocosque, / dum flamma sine tura liquescere limine sacro / persuadere cupit. credat Iudaeus Apella / non ego.'

14. See H. Solin, 'Juden und Syrer im Westlichen Teil der römischen Welt: eine ethnischdemographische Studie mit besonderer Berücksichtigung der sprachlichen Zustände', *Aufstieg und Niedergang der Römischen Welt* 2.29.2 (1983), 587–1249, esp. p. 642.

15. Pomponius Porphyrio, *Commentum in Horati sermones* 1.5.100; Pseudo-Acron, *Ad sermones* 1.9.70; see also *Scholia ad Juvenalem* 14.104.

16. Naevius, *Tunicularia*, ap. Festus 290, 21 (cited in E.H. Warmington, *Remains of Old Latin* II (Cambridge (MA)/ London, 1935–40), 107, nn. 97–100); J. Geiger, *Cornelius Nepos and Ancient Political Biography* (*Einzelschriften* 47) (Stuttgart, 1985).

17. *CGL* (above, n. 6), VII.299, *s.v. curtus*.

18. 'Hodie tricensima sabbata. vin tu / curtis Iudaeis oppedere?'

19. 'Curtos Iudaeos dixit, quia uirile membrum uelut decurtatum habeant recisa inde pellicula', Pomponius Porphyrio, *Commentum in Horati sermones* 1.9.69–70; see also Pseudo-Acron, *Ad sermones* 1.9.70.

20. 'You silently twitch your lips, turning pale at the Sabbath of the circumcised ... The hulking Pulfennius straightway bursts into a huge guffaw, and bids a clipped hundred-penny piece for a lot or a hundred Greeks' ('labra moues tacitus recutitaque sabbata palles / ... continuo crassum ridet Pulfenius ingens / et centum Graecos curto centusse licetur'). For this passage, see R.A. Harvey, *A Commentary of Persius* (*Mnemosyne Supplement* 64) (Leiden, 1981), 176–80.

21. Martial, *Epigrammata* 7.30: 'nor do you shun the loins of circumcised Jews' ('nec recutitorum fugis inguina Iudaeorum'). Petronius, *Satyricon* 68.8: 'He is circumcised and he snores' ('recutitus est et stertit').

22. See J.N. Adams, *The Latin Sexual Vocabulary* (London, 1982), 73; J. André, *Le vocabulaire latin de l'anatomie* (Paris, 1991),

176–7; F.K. Forberg, *Manuel d'érotologie classique* (trans. A. Bonneau) (Paris, 1906), 129, n. 74; G. Vorberg, *Glossarium eroticum* (Stuttgart, 1932) *s.v. recutitus*.

23. Martial, *Epigrammata* 11.94: 'What does upset me is that born in Jerusalem itself you sodomize my boy, circumcised poet' ('illud me cruciat, solymis quod natus in ipsis/ pedicas puerum, uerpe poeta, meum'). Juvenal, *Saturnalia* 14.96–108. See S.J.D. Cohen, 'Those who say they are Jews and are not: how do you know a Jew in antiquity when you see one?', in S.J.D. Cohen and E.S. Frerichs (eds), *Diasporas in Antiquity* (*Brown Judaic Studies* 288) (Atlanta, 1993), 14–15; J. Preuss, *Biblisch-Talmudische Medizin: Beiträge zur Geschichte der Heilkunde und der Kultur* (Berlin, 1911) (= J. Preuss, *Biblical and Talmudic Medicine* (trans. F. Rosner) (Northvale (NJ)/London, 1993)), 278.

24. For the citation see, Jackson, Chapter Three in this volume, n. 10.

25. For Roman infibulation, see E. Holländer, *Plastik und Medizin* (Stuttgart, 1912), 345, fig. 248; J. Benedum, 'Fibula: Naht oder Klammer?', *Gesnerus* 27 (1970), 20–56, esp. p. 53, fig. 2.

26. Dioscorides 2.107.12; *Corpus inscriptionum latinarum* [hereafter *CIL*] IV 793 and 1375: two inscriptions mention the word *uerpus* without any contextual detail.

27. 'Porci et Socration, duae sinistrae / Pisonis, scabies famesque mundi, / vos Veraniolo meo et Fabullo / verpus praeposuit Priapus ille? / vos convivia lauta sumptuose / de die facitis? mei sodales / quaerunt in trivio vocationes.'

28. See Chantraine, *Dictionnaire étymologique* (above, n. 6), 1290, *s.v. pseô*, who translates *psolos* by *praeputio retracto* on the basis of the argument of composed forms like *apopsôleô* (*praeputium retrahere alicui*). See also K.J. Dover, *Greek Homosexuality* (London/Cambridge (MA), 1978), 129–30; *drîmus* offers another equivalent of *uerpus*, see *Anthologia palatina* XI, 197 (Lucillius); Vorberg, *Glossarium eroticum* (above, n. 22), *s.v. Verpus*: 1 *psôlos, drîlos qui uerpam nudata glande ex libidinis usu praefert* 2 Der Beschnittene, der Jude. A. Ernout and A. Meillet, *Dictionnaire étymologique de la langue latine* (Paris, 1959), *s.v. uerpa* proposes the periphrasis *membrum uirile* and, for *verpus*, 'circoncis', apparently in conformity with *CGL* (above, n. 6), II, 206, 49 *uerpus ... ho leipodermos* 'Verpus = skinless'. But P.G.W. Glare, *Oxford Latin Dictionary* (Oxford, 1976), *s.v. verpus*, gives 'having the foreskin drawn back', and, *s.v. verpa* 'the penis (as protruded from the foreskin)'. André, *Le vocabulaire latin* (above, n. 22), 170, rightly translates *uerpa* by 'pénis dégagé du prépuce', but adopts for the cognomen *uerpatus* a curious translation: 'bien membré'.

29. *Verpa* could be related to *rhapis* (stick)/*rhapizô* (to beat with a stick), see André, *Le vocabulaire latin* (above, n. 22), 170; Adams, *The Latin Sexual Vocabulary* (above, n. 22), 13, n. 1.

30. V. Väänänen, *Le latin vulgaire des inscriptions pompéiennes* (Helsinki, 1937), 187; Adams, *The Latin Sexual Vocabulary* (above, n. 22), 12–14 and index. Several derivative forms of *verpa,* according to a common onomastic practice, are used to form *cognomina*: (Windisch,) *L'Année Épigraphique* 6 (1926);

I. Kajanto, *The Latin Cognomina* (*Commentationes huma-norum litterarum* 36.2.1–4) (Helsinki, 1965), 100, 226; G.B. de Rossi, *Inscriptiones christianae urbis Romae* VII (Rome, 1857–88), 2069; H. Solin and O. Salomies, *Repertorium nominum gentilium et cognominum latinorum* (*Alpha–Omega A* 80) (Hildesheim, 1988), 420; H. Herter, 'Genitalien', *Reallexikon für Altertum und Christentum* 10 (1978), 5–58, esp. p. 5.

31. 'Amat qui scribit pidicatur qui ligit qui opscultat prurit paticus ist qui praitirit ursi mi comidant it igo virpa (m) qui ligo', *CIL* (above, n. 26) IV 2360; the text of *CIL* (above, n. 26) IV 2415 remains uncertain; see Adams, *The Latin Sexual Vocabulary* (above, n. 22), 12–14 and index *s.v. pedicatio* and *irrumatio*.

32. 'Qui uerpam uissit quid cenassii illum putes', *CIL* (above, n. 26) IV 1884. For the aggression of *uerpa*, see F.A. Todd, 'Some *cucurbitaceae* in Latin literature', *Classical Quarterly* 37 (1943), 101–11, esp. p. 110. See *CIL* (above, n. 26) IV 1655, 4082.

33. Columella, *De agricultura* 10.33; *Carmina Priapea* 6, 9, 20, 55. Circumcision, like Priapus, is laughed at. See Philo, *De specialibus legibus* 1.2, 'Now the practice which is thus ridiculed, namely the circumcision of the genital organs ...' (*Gelâtai de hê tôn gennêtikôn peritomê*). See Herter, 'Genitalien' (above, n. 30), 9–10; M. Olender, 'Priape, le dernier des dieux', in Y. Bonnefoy (ed.), *Dictionnaires des mythologies* (Paris, 1981), 311–14; M. Olender, 'Priape à tort et de travers', *Nouvelle Revue de Psychanalyse* 63 (1991), 59–82.

34. *Priapea*, 34 and 37. See F. Dupont and T. Eloi, *Les jeux de Priape* (Paris, 1994), 7–18.

35. 'Decedo cacatum. verpa [num facta] est ueprecula?'

36. 'Urticae monumenta uides, discede, cacator: / non est hic tutum culu aperire tibi.' Pomponius 129 (Frassinetti 1967 = 130 Ribbeck). See Adams, *The Latin Sexual Vocabulary* (above, n. 22), 14, n. 2, *ad loc. CIL* (above, n. 26) IV 8899, 3f.

37. For *mentula*, see Adams, *The Latin Sexual Vocabulary* (above, n. 22), 9–12. In two attestations of *verpa* without sexual threats (*CIL* (above, n. 26) IV 4876; *CIL* (above, n. 26) IV Suppl. 3.8617), the term only seems to call the reader a nobody.

38. 'In quo si glans nuda est, uultque aliquis eam decoris causa tegere, fieri potest', Celsus, *De medicina* 7.25.1, cited in Jackson, Chapter Three in this volume. See also Rutilius Namatianus, *De reditu* 1.387–8, who qualifies the Jewish nation as shameless (*propudiosa*). For the restoration of the foreskin (*epispasmos*), see Paul, *Corinthians* 1.7.18–19; R.G. Hall, 'Epispasm: circumcision in reverse', *Biblical Review* 8.4 (1992), 52; N. Rubin, 'The stretching of the fore-skin and the enactment of *peri'ah*', *Zion* 54 (1989), 105–17.

39. See W.-R. Megow, 'Priapos', in *Lexicon iconographicum mythologiae classicae, supplement* (1997), 1028–44 and pls 71, 100, 156. In the iconography of gnomes (*moriones*), see J.-P. Cèbe, *La caricature et la parodie dans le monde romain antique des origines à Juvénal* (Paris, 1966), 354–9 and pl. 16.2. Compare with Dover, *Greek Homosexuality* (above, n. 28), 131–5; V. Doiteau, 'Comment faut-il porter le prépuce?

L'esthétique du prépuce selon l'art et les artistes', *Le Progrès Médical* 40 (Supplément illustré n. 1) (1925), 1–6.

40. Martial, *Epigrammata* 11.46.

41. Galen, 7.728, 10.967, 13.318 (trans. C.G. Kühn). See I. Papadopoulos and A. Kelami, 'Priapus and priapism: from mythology to medicine', *Urology* 32 (1988), 385–6.

42. Martial, *Epigrammata* 7.35.1–4. For the weighing of the priapean member (*priapus phallostates*) figured in the House of the Vettii in Pompeii (VI.15.1), see A. Varone, *Erotica pompeiana* (*Studia archaeologica* 71) (Rome, 1994), fig. 22. For the erotic meaning of weighing *genitalia*, see Adams, *The Latin Sexual Vocabulary* (above, n. 22), 71.

43. 'linges non mihi — nam proba et pusilla est — / sed quae de solymis uenit perustis / damnatam modo mentulam tributis', *Epigrammata* 7.55.6–8. See M. Grmek and D. Gourevitch, *Les maladies dans l'art antique* (Paris, 1998), 325–9 and nn. 69, 85. Philo's fourth argument in favour of circumcision in the famous *incipit* of his *De specialibus legibus* may answer the idea that a large organ is a sign of sterility; *De specialibus legibus* 1.7: 'Tetarton de kai anagkaiotaton tên pros polugonian paraskeuên; legetai gar hôs euodeî to sperma mête skidname-non mête perirrheon eis tous tês posthias kolpous; hothen kai ta peritemnomena tôn ethnôn polugonôtata kai poluanthrôpotata einai dokeî ('The fourth and most vital reason is its adaptation to give fertility of offspring, for we are told that it causes the semen to travel aright without being scattered or dropped into the folds of the foreskin, and therefore the circumcised nations appear to be the most prolific and populous'). (See also Chapter Five, text with n. 25.) See Aristotle, *De partibus animalium* 689a, and Olender, 'Priape, le dernier des dieux' (above, n. 33), 313.

44. 'Hi separati epulis, discreti cubilibus, proiectissima ad libidinem gens, alienarum concubitu abstinent; inter se nihil inlicitum. circumcidere genitalia instituerunt ut diuersitate noscantur.', Tacitus, *Histories* 5.5.

45. 'Epi hôn oligon endeî tô dermati tou aidoiou pros to kata fusin, epi toutôn pollakis monê tê tasei to deon eirgasamên.'

46. *Priapea* 37. See E.M. O'Connor, '*Sumbolum salacitatis*': a *Study of the God Priapus as a Literary Character* (*Studien zur Klassischen Philologie* 40) (Frankfurt, 1989), 130.

47. See M. Grant, *Eros à Pompei: le cabinet secret du musée de Naples* (Paris, 1975), 138–42.

48. For the use and significance of those phallic *tintinnabula*, see C. Johns, *Sex or Symbol? Erotic Images of Greece and Rome* (London, 1982), 67–70, esp. figs 51 (a terracotta showing a couple of phalluses cutting a large eye with a saw) and 55 (a bronze phallus pendant with human legs).

49. Adams, *The Latin Sexual Vocabulary* (above, n. 22), 35, 72–4, 76: *caput, cucutium, capillus, nasus*, see notes below. *Barbatus*, absent in Adams, is employed for a woman's genitals, see *Priapea* 12.14, and *barba* is similarly used by Martial, *Epigrammata* 10.90.10. See O'Connor, '*Sumbolum salacitatis*' (above, n. 46), 113.

50. See also *CIL* (above, n. 26) IV 7248. For other iconographical cases of paralleled noses and phalluses, see Johns, *Sex or*

Symbol? (above, n. 48), 94, fig. 77 (a centaur with similar nose and phallus in Leptis Magna).

51. For phallic silhouettes, see W. Deonna, *De télesphore au moine bourru: dieux, génies et démons encapuchonnés* (*Collection Latomus* 21) (Brussels, 1955), 32–5 and 111–15; Herter, 'Genitalien' (above, n. 30), 9–10.

52. Catullus 53.5 'Great gods, says he, what an eloquent manikin!' ('di magni, salaputium disertum!'). See Adams, *The Latin Sexual Vocabulary* (above, n. 22), 65, n. 1 and 2. *CIL* (above, n. 26) VIII 10570. See Herter, 'Genitalien' (above, n. 30), 15; Suetonius, *Divus Iulius* 51.

53. 'Mentula tam magna est quantus tibi, Papyle, nasus / ut possis, quotiens arrigis, olfacere', *Epigrammata* 6.36. The same use of metonymical caricatures exists in reference to women, see O'Connor, *'Symbolum salacitatis'* (above, n. 46), 33. Similarly, a Pompeian graffito makes obvious the equivalence between a man's glans and his skull; the blank face of the ithyphallic character stresses the mirror effect, and both of the man's heads are singularly drawn with the same line of contours, with a slight retouching for the top of the skull.

54. Herter, 'Genitalien' (above, n. 30), 29–34; Kajanto, *The Latin Cognomina* (above, n. 30), 100, 226, mentions *cognomina* formed on *mentula*, *uerpa*, *capulus* and *penis*. Cicero, *Pro Scauro* 23, gives *Mutto* as a *cognomen*. But those nicknames might also caricature somebody's nose or even stupidity. The use of anatomical *cognomina* was in general insulting and aggressive, especially for an élite Roman in public life.

55. 'Circumcidere Iudaeis filios suos tantum rescripto diui Pii permittitur: in [seruis] non eiusdem religionis qui hoc fecerit, castrantis poena irrogatur', *Digesta* 48.8.11 Modestin l.6 regularum (for the restoration of *seruis* in this passage, see S. Solazzi, *Note di diritto romano* (*Atti della Societa Reale di Napoli* 58) (Naples, 1937)). *Digesta* 48.8.3.4 Marcien l.14 Institutes; *Digesta* 48.8.4.2 Ulpianus l.7 *De officio proconsulis* and, in a different context, *Codex Theodosianus* 16.8.26, 16.9.1–3.

56. See Martial 6.67; Tacitus, *Annales* 4.10; P. Cordier, 'Tertium genus hominum: l'étrange sexualité des castrats', in P. Moreau (ed.), *Corps romains, Actes de la table ronde de la SFARA: Collège International de Philosophie — École Normale Supérieure, 28–30 Janvier 1999* (Paris, 2002), 61–75.

57. Cassius Dio 79(80).11.1.

58. See Rabello, 'Il problema' (above, n. 9), 187–214; Marotta, *Politica imperiale* (above, n. 4); G. Firpo, 'L'imperatore circonciso (Dio Cassius 79; *Jer. Meg.* 1.11) e la pace religiosa delle età antonina e severiana', *Miscellanea Greca et Romana* 11 (1987), 145–87; G. Firpo, 'Considerazioni sull'evoluzione della normativa relativa alla circoncisione tra Adriano e l'età severiana', *Miscellanea Greca et Romana* 12 (1987), 163–82. The *CTH* (above, n. 9) resumes the interdiction, see G. De Bonfils, *Gli schiavi degli Ebrei nella legislazione del IV secolo: storia di un divieto* (*Pubblicazioni della Facoltà Giuridica dell'Università di Bari* 103) (Bari, 1992), 19–23, and F. Lucrezi, '*CTH* 16.9.2: diritto romano-cristiano e antisemitismo', *Labeo* 40 (1994), 220–34.

59. 'Tôn de dê paranomêmatôn autoû kai to kata ton Elegabalon echetai; hoti te to aidoion perieteme, kai hoti choireiôn kreôn, hôs kai kaqarôteron ek toutôn thrêskeusôn, apeicheto (ebouleusato mn gar pantapasin auto apokopsai).'

60. 'Mouerunt ea tempestate et Iudaei bellum, quod uetabantur mutilare genitalia', Scriptores Historiae Augustae, *Hadrian* 14.2.

61. See also the later passage of Rutilius Namatianus, *De reditu suo* 1.387–8.

62. For Egyptians, see F. Preisigke, *Griechische Papyrus der Kaiser Universitäts- und Landesbibliothek zu Stassburg* (Leipzig, 1906–12), 60 (159 CE); H. Zilliacus, *Vierzehn Berliner Griechische: Urkunden und Briefe* (Helsingfors, 1941), 82 (185 CE), 347 (171 CE); B.P. Grenfell *et al.*, *The Tebtunis Papyri* (London/New York, 1902–76), 292 (189–190 CE), 293 (*c.* 187 CE), 314; N. Lewis, *Life in Egypt Under Roman Rule* (Oxford, 1983), 92–3.

63. Scriptores Historiae Augustae, *Hadrian* 22.2–3, 7, but see A. Chastagnol, *Histoire Auguste* (Paris, 1994), 48, n. 4; S. Stone, 'The toga: from national to ceremonial costume', in J.L. Sebesta and L. Bonfante (eds), *The World of the Roman Costume* (Madison (WI), 1994), 13–45, esp. pp. 24, 42, n. 52.

64. *CTH* (above, n. 9) 16.8.22 (Theodosius II, 20 October 415 CE). See A. Linder, *The Jews in Roman Imperial Legislation* (Detroit, 1987), 41. But even in late antique Christian literature, the image of circumcision retained certain particularities of its Roman features: according to Origenes and Saint Ambrose (*Ad Constantium* 72), like the phallus used as a *fascinus*, it possesses apotropaic powers and 'puts the prince of demons to flight'.

65. See, for example, Macrobius, *Saturnalia* 6.3–4.

66. Livy 45.39.18.

67. Contra, see S.A. Aldeeb Abu-Sahlieh, *Circoncision masculine, circoncision féminine: débat religieux, médical, social et juridique* (Paris, 2001), 395–6.

68. With the notable exception of the aforementioned passage of Oribasius (above, n. 45).

'IN THE FORESKIN OF YOUR FLESH': THE PURE MALE BODY IN LATE ANTIQUITY

Gillian Clark

INTRODUCTION: LATE ANTIQUE BODIES

IN CLASSICAL and late antique Roman culture, a tiny, dispensable, exclusively male part of the human body was a focus of group identity: the foreskin, *akrobustia* in Greek, *praeputium* in Latin. Men who had a foreskin mocked, and sometimes oppressed, those who did not, alleging that they had interfered with nature and were sexually excessive. Men whose foreskins had been removed claimed physical, moral and religious purity. This antagonism is well known to students of Roman-period Judaism, but seems not to have influenced the growing literature on classical and late antique Roman masculinity.[1] This chapter considers how interpretations of circumcision changed as Christianity became the established religion of the Roman world, how circumcision was appropriated for the uncircumcised, and what Christian exegesis may reveal about late antique representation of the male body.

Christian tradition had an ascetic strand, and in the fourth and fifth centuries, after Christianity became the religion professed and supported by Roman emperors, some Christians manifested intense concern for the condition of the body. They saw the body as evidence for the condition of the soul and they knew that the body could impede the progress of the soul. This preoccupation with body proved especially interesting for scholars in the late twentieth century, and the 1980s and 1990s saw an outpouring of work on the extreme ascetic practices that aimed to bring the body into harmony with the soul.[2] Attention focused on questions of sexuality and on the representation of women, who are assumed in most late antique texts to be more vulnerable to desire than men are and to provoke desire in men even without intending it.[3]

The male writers of late antique ascetic texts exhorted their male and female readers to resist the demands of the body for food and sex. Drastic reduction of food intake, admiration for the beauty of half-starved bodies, revulsion from sexual desire and from the reproductive body, were approved both in admonition and in the exemplary lives of saints. The authors of these texts were a vocal, rhetorically-expert minority, who wrote to persuade rather than to report. They claimed to have persuaded many, and argued that these ascetics were the authentic, committed Christians. To many present-day scholars, the mind-set they advocated seems all too recognizable as anorexia.[4] Anorexia chiefly (though not exclusively) afflicts women, and the majority of ascetic texts was addressed to women and written by men who claimed clerical or spiritual authority. The intact female body, protected from contact with men, its desires and discharges minimized or even eliminated by strict fasting, became an image of the pure and faithful church, the virgin bride of Christ.[5] But how was the male body interpreted? As David Brakke has observed in a pioneering paper, 'these Christian men seem not to have invested their own bodies with so much significance'.[6] It took some time for scholarly attention to return to men.

There was no ready-made imagery for the virgin or celibate male in Graeco-Roman culture or in Christian tradition.[7] He did not become Christ's bridegroom. But his soul (*anima*, grammatically feminine) could be Christ's bride, or spiritually pregnant by the word of God. He was exhorted to abandon the wealth and social status that allowed him to exercise male power and to practise rigorous fasting that undermined his male physical strength as well as his sexual desires.[8] In all these ways he was feminized, but his celibacy could also be a symbol of heroic male strength and resolution. Christians were familiar with the Biblical image of God's unfaithful people 'whoring after strange gods': the ascetic Christian male sternly resisted temptations to fornicate, whether with sexual partners, with heresies or with other gods. He was in strict training (*askesis* in Greek) as Christ's

soldier and Christ's athlete. In one of his recently rediscovered sermons, dating from the late fourth or early fifth century, the North African bishop Augustine (354–430 CE) exploited the feelings of chariot fans, much as present-day preachers deploy football metaphors. He used a familiar image, borrowed from Plato, of desire controlled as if by a charioteer: 'He [the celibate] is the victor over lust, he dominates the movement of the flesh, he holds the reins of temperance in a strong grip, he makes that movement go where he wants it like a horse, and does not lose the right to restrain it'.[9]

Ascetic writers were also concerned about the male physical responses that are not under voluntary control, namely erection and seminal emission, with or without sexual intercourse. Augustine thought that the involuntary presence or absence of erection manifests the condition of the human body after the Fall. Adam disobeyed God, and the human body, genetically linked to Adam, is disconnected from obedience to the will of God and no longer responds to reason. Emission was not a problem, according to Augustine: it was a natural phenomenon analogous to menstruation and, like menstruation, did not require formal purification as it did in Jewish tradition. But his contemporary Cassian interpreted emission as manifesting the condition of the soul, and gave detailed advice on strict fasting, informed by prayer, to reduce or eliminate it in months.[10] For late antique ascetic Christians, the ideal male body was like the ideal female body: lean, dry, controlled and asexual, appropriate for a spiritual athlete in training.[11]

CIRCUMCISION AND UNCIRCUMCISION: A CONCISE HISTORY OF PERCEPTIONS

Circumcision is not an uncontrolled physical response, but a deliberate modification of the male body. But for Greeks and Romans, circumcision was an alien cultural practice. The historian Herodotus, writing in the late fifth century BCE, traced circumcision (and much else) to Egypt: 'They practise circumcision, while men of other nations — except those who have learned from Egypt — leave their private parts as nature made them … They circumcise themselves for cleanliness' sake, preferring to be clean rather than comely'.[12] This brief comment sums up classical Greek and Roman attitudes to circumcision: it interferes with nature and it does not look good.[13] Both Greek and Latin have a word for a penis with the foreskin retracted or absent, and this word was used as an insult because retraction was

interpreted as a bodily marker of sexual arousal. The Greek word appears in crude Aristophanic comedy. The Latin word appears in graffiti and literature of the period (late first century BCE and first century CE) when the Romans established their political domination of Judaea, and it was sometimes used with reference to circumcision.[14] At a Roman public bath, or at a Greek gymnasium, circumcision was visible, and the poems of the Roman satirist Martial are proof that some Romans were only too ready to comment on the bodily appearance of others.[15]

So if a Roman baby boy was born with a minimal foreskin, something had to be done to rectify the problem and protect him from adverse comment when he grew up. The medical writer Soranus offered a solution. He was trained at Alexandria and practised in Rome, probably among the élite, in the early second century CE. His *Gynaecology*, a textbook for midwives and nurses, was influential even into the eighteenth century. It includes techniques of massage and binding designed to mould newborns into their proper masculine or feminine appearance. One of these is drawing over (*epispasthai* in Greek) the foreskin:

> If the infant is male and looks as though it has no foreskin, she [the nurse] should gently draw the tip of the foreskin forward or even hold it together with a strand of wool to fasten it. For if gradually stretched and continuously drawn forward it easily stretches and assumes its normal length, covers the glans and becomes accustomed to keep the natural good shape.[16]

In adults, more drastic methods were needed. Surgical reconstruction of the foreskin, as described in Chapter Three of this volume by Ralph Jackson, might be merely cosmetic; if so, it may have seemed necessary because of possible sexual insult. But the most obvious reason for undergoing the operation known as 'drawing over' (*epispasm*) was to avoid political danger or social discrimination as a Jew.

Removal of the foreskin by circumcision, traditionally on the eighth day of life, is the bodily sign that male Jews accept the covenant God made with Abraham (*Genesis* 17.9–14). Jews were mocked for being circumcised, but circumcision could also be used to affirm Jewish identity. The intact bodies of women were an image of the pure Christian church; the circumcised bodies of men were an image of the pure Jewish community.[17] Circumcision, as Shaye Cohen has pointed out, was 'neither infallible nor usable as a marker of Jewishness', for the obvious reasons that it

did not identify Jewish women and was not usually visible, and because men were also circumcised in other eastern Mediterranean cultures.[18] But the association of circumcision and Judaism was very strong. Circumcision was the clearest demonstration that a man with a strong sympathy for Judaism had decided to identify himself as a Jew.[19] In the first-century letters of Paul of Tarsus (Roman citizen, strict Jew and Christian convert), 'the circumcision' is a metonymy for Jews.

From the perspective of 'the circumcision', men who were not circumcised became the odd ones out, physically identifiable and excluded from the Jewish community, and Paul referred to them too with a metonymy. In older English translations of the Bible, such as the Authorized Version (1611, revised 1881), this metonymy for Gentiles is rendered as 'the uncircumcision'. It is a strange word. *Circumcisio* is obviously a Latin equivalent for Greek *peritome*, and may be a Christian coinage from the familiar verb *circumcidere*.[20] But it is difficult to imagine a Latin or a Greek equivalent of 'uncircumcision', and indeed there is none. 'Uncircumcision', used as a metonymy, is an English euphemism for Latin *praeputium* or Greek *akrobustia*. The absence of an absence means a presence: Gentiles were called 'the foreskin'. So Paul, writing to the church in Galatia, could say that the leaders of the Jerusalem church recognized that he, Paul, was responsible for evangelizing the foreskin, whereas Peter was responsible for evangelizing the circumcision (*Galatians* 2.7). That is, Paul would be a missionary to Gentiles and Peter a missionary to Jews.

Paul's contemporary and fellow-Jew, Philo of Alexandria, also attested the strong connection between circumcision and Judaism. He wrote to interpret Judaism for a Gentile, Greek-speaking audience, and he defended circumcision against mockery, and claimed for it the medical and moral high ground, with arguments that recognized the objections of Gentiles. He began his treatise *Special Laws* (*De specialibus legibus* 1.1–11) with a defence of the special law that was particularly mocked by 'the many':

> Circumcision of the genitals ('he ton gennetikon peritome') is mocked, though many other peoples, especially the Egyptians, practise it most zealously; and the Egyptians are thought to be the most prolific, most ancient and most philosophic of peoples. So it seems fitting to abandon childish insult, and to make a more thoughtful and serious investigation of the reasons why this custom has prevailed, rather than dismissing it out of hand and condemning the fortitude

of great nations. It is not to be expected, one should reflect, that so many thousands in each generation should undergo circumcision, inflicting severe pain in mutilating their own bodies and the bodies of those closest to them.[21] There must be many considerations urging them to maintain and carry out the practice introduced by the ancients.[22]

Philo acknowledged that circumcision was not natural. He accepted, and for the sake of his argument maximized, the belief that it was very painful; he even used the verb *akroteriazein*, which means 'mutilate' or 'maim'. He offered the example of the Egyptians because Greek tradition credited them with ancient wisdom (this belief, as in many more recent cases, coexisted with discrimination exercised by Greeks living in Egypt against the Egyptians of their own time).[23] He went on to provide four considerations in favour of circumcision:

> First, it avoids a disease of the foreskin that is serious and almost incurable. This disease is called anthrax, I think because it is a smouldering inflammation, and those who have a foreskin are more liable to develop it.[24] Second, circumcision provides cleanliness for the entire body, such as is fitting for the consecrated order. That is why priests in Egypt go even further and shave their bodies, for some things that ought to be cleaned away collect and are secreted under hair and foreskins. Third, the circumcised member ('tou peritmethentos merous') resembles the heart. Both are designed for generation, the spirit of the heart to generate thoughts, the generative organ living creatures. The earliest humans thought it right to make the visible organ, by which perceptible things are generated, resemble the greater invisible organ, through which intelligible things are understood. Fourth, and most necessary, circumcision provides for fertility: for (it is said) the seed travels the right road, without being dispersed or trickling into the folds of the foreskin, and that is why the circumcised peoples are the most prolific and numerous.[25]

These, according to Philo, were the reasons offered by an ancient tradition of exegesis.[26] To these arguments from physical and ritual cleanliness, physical symbolism, and enhanced fertility, he added an allegorical interpretation:

> I think, in addition to what has been said, that circumcision is the symbol of two most important

matters. First, the excision of pleasures that cast a spell on the mind. A man's mating with a woman wins the prize among all the enchantments of pleasure, so the legislators decided to mutilate the organ that serves such intercourse, signifying by circumcision the excision of excessive and superfluous pleasure. They did not mean that pleasure alone: that one most overpowering pleasure stood for all the other pleasures. The other reason is that a man should know himself and expel from his soul that serious illness, conceit. There are people who boast that they can create, like good sculptors, the finest of all living creatures, namely a human being. Puffed up with pride, they think they are gods, disregarding God who is the true cause of generation. Yet they could correct their delusion from the experience of people they know, for among them are many men without children, and many barren women, whose intercourse is without result and who grow old in childlessness. So this evil belief must be excised from the mind, as must all thoughts that do not show the love of God.[27]

Thus Philo's defence of circumcision countered, without actually mentioning, the association of an absent foreskin with excessive lust. He offered a rival interpretation, that circumcision symbolizes the excision of all lusts, sexual lust being the most powerful of all, and also the excision of pride and the commitment of heart and mind to God. But it is difficult to trace the influence of his arguments, except in early and late antique Christian exegesis of the Judaeo-Christian scriptures. They are not evident in later Jewish exegesis or in Roman perceptions of Judaism.

Until the great Jewish revolt of 135 CE, led by Simon Bar-Kokhba, antagonism between 'the circumcision' and 'the foreskin' was a war of words and of social discrimination. There is no clear evidence that circumcision was an offence in Roman law until after the revolt. The unreliable *Augustan History*, composed probably in the third century, said that the revolt broke out because under the Emperor Hadrian the Jews were (already) being forbidden to 'mutilate their genitals'. If this is a serious historical claim (something not to be taken for granted in this curious work), it is, to say the least, selective, and it may well be mistaken.[28] Hadrian is known to have confirmed a late first-century ban on castration that was inflicted, in the terse phrasing of the law, 'for lust or for profit': that is, not for medical reasons, but in order to make a eunuch who could be treated as a sexual object or sold for a high price.[29] This ban brought castration under the Cornelian law on

killing by weapon or poison (*de sicariis et veneficis*), presumably because castration was taken to be a violent assault even if the victim survived the shock, bleeding and possible infection. Hadrian specified that the penalties also applied to a doctor who carried out the operation and to a patient who voluntarily underwent it.[30] Around 150 CE, a Christian unsuccessfully petitioned the prefect of Alexandria to give permission for a doctor to remove his testicles, in the interests of chastity.[31]

There is no record that Hadrian also banned circumcision. His successor, Antoninus Pius, decreed in an official response (a rescript) that Jews might circumcise their own sons, but a Jew who circumcised anyone else (for instance, as *Genesis* required, his household slave) was liable to the same penalty as those who inflicted castration.[32] The response survives precisely because Pius specified this penalty. Hadrian had confirmed that castration came under the Cornelian law on killing, so the sixth-century law commission that compiled the *Digest of Roman Law* included the rescript of Antoninus Pius on circumcision, together with other miscellaneous but relevant material, under the heading of the Cornelian law on killing. But this evidence does not show that Hadrian imposed a total ban on circumcision and that Antoninus Pius moderated it to allow the circumcision of sons. There remains a question whether Hadrian made circumcision legally equivalent to castration because the recent revolt prompted repression of Judaism, or whether second-century Romans seriously believed that circumcision was a mutilation comparable to castration. It seems an unlikely belief, because circumcision has no comparable effect on the male body or (as Philo pointed out) on fertility. But traditional Roman distaste for circumcision may have been reinforced by natural anxiety about any kind of surgery on the genitals.[33] The vocabulary of 'cutting' was ambivalent. Its exploitation by Paul of Tarsus and his exegetes will be discussed in the next section. To take one non-Christian example, the poet Horace, writing in the 30s BCE, referred to 'docked Jews' (*curtis Iudaeis*) — a *curtus equus* is a castrated horse.[34]

Even if Hadrian did not ban circumcision, more Jews may have considered or attempted *epispasm* in the dangerous circumstances of the Bar-Kokhba revolt and its aftermath. There is some evidence for rabbinic debate on re-circumcision of those who had undergone *epispasm* and on a form of circumcision intended to make *epispasm* impossible. But (as often happens with rabbinic texts) it is not possible to give these debates

a precise historical context within late antiquity, or to decide whether the question was of practical or intellectual interest. By the fourth century, medical textbooks still included the operation, and mockery of circumcised Jews continued, but *epispasm* was not a live issue for Jews.[35] It was fourth-century Roman Christians who manifested concern about the presence or absence of a foreskin, and who made use of Philo's symbolic interpretation.

LATE ANTIQUE EXEGESIS OF CIRCUMCISION

In 395 CE, despite his heavy workload, Augustine wrote a commentary on the letter of Paul to the Galatians.[36] This letter attracted fourth-century commentary because it is concerned with faith and keeping the law, with the difference between Christianity and Judaism, and with a disagreement between the two great apostles Peter and Paul. All three questions relate to circumcision, to which Paul referred in plain language. English translations use 'uncircumcision' or 'disguising circumcision' where a literal translation of Paul (*Corinthians* 1.7.18–19) runs: 'Has someone been called [to Christianity] who is circumcised? Let him not draw over the foreskin. Has someone been called who has a foreskin? Let him not be circumcised. Circumcision is nothing, and a foreskin is nothing, but keeping the commandments of God [is what matters]'. Augustine found this passage useful in the exegesis of *Galatians*.[37] Although he often felt it necessary to apologize for discussing sexual topics, he did not apologize for discussing foreskins.[38] He had to deal with circumcision because, according to *Galatians* and to *Acts* (the New Testament account of the acts of the apostles), Peter and Paul had openly disagreed on whether converts to Christianity needed to keep Jewish law. The major questions at issue were food rules and circumcision.

The disagreement between Peter and Paul was embarrassing, both because the leaders of Christianity were apparently at variance, and because opponents of Christianity blamed Christians for rejecting the ancient Jewish law that would have given some credibility to their new religious movement. Jerome, who wrote a commentary on *Galatians* (386 CE) a decade before Augustine wrote his, said that the third-century philosopher Porphyry, who was notoriously hostile to Christians, had exploited the disagreement of the apostles: 'He wanted to brand Peter with error and

Paul with bad manners, and to charge the community with the falsehood of fake teaching, since the leaders of the churches differ among themselves'.[39] In the mid-fourth century, another opponent challenged Christian rejection of Jewish law. Julian 'the apostate', the only emperor after Constantine to reject Christianity, wrote an anti-Christian treatise, *Against the Galilaeans*. Its arguments survive only in so far as Cyril, bishop of Alexandria, saw fit to cite them a century later, but it is clear that Julian asked specifically why Christians did not circumcise.[40]

Jerome did not want to say, in his commentary on *Galatians*, that Peter might actually have been wrong, and Paul inconsistent, on Christian observance of Jewish law. He suggested that both were pretending, like two speakers in a court pretending to disagree for the sake of their clients. Peter, he said, knew that Jewish law was no longer binding, but stopped eating with Gentiles for fear of offending Jewish Christians. The Gentiles thought he meant that they too ought to observe the law, and Paul issued a rebuke to Peter to make it clear that they need not.[41] Augustine read Jerome when working on his own commentary and began a tense correspondence with him. He thought Jerome's explanation implied that Paul was lying, both in his rebuke and in his subsequent account of the disagreement, and if Scripture can lie, its authority is undermined.[42] Augustine's explanation was that there was a real disagreement and a real rebuke. According to Augustine, Peter was right to want Jewish sacraments respected, but wrong to think that Gentiles should also accept them; and Paul was not inconsistent when he circumcised his follower Timothy, who had a Jewish mother (*Acts* 16.1), but did not circumcise his Gentile follower Titus (*Galatians* 2.1). Nor was Paul inconsistent when he opposed the view that all converts should be circumcised, for Paul thought that it did not matter whether a man was circumcised or uncircumcised, and was therefore prepared to follow local custom for the sake of his mission.

Augustine explained circumcision as a sacrament (that is, an outward and visible sign of an inward and spiritual grace) given to the Jews by God and written in their law. After the coming of Christ, he argued, Jewish law and sacraments were no longer necessary; but Jewish *sacramenta* were to be ended with respect, not rejected with horror like idolatrous Gentile sacrifice. So in Paul's time Jewish sacraments were not forbidden to Jews, but were not to be required of unwilling Gentiles like Titus. Like Philo, Augustine recognized that (adult) circumcision is painful: 'Why would any Gentile

says, is interior continence, not 'external purity and evident circumcision'.[63]

Reinterpreted as a symbol of religious commitment, circumcision could in principle apply to females as well as males, since both are baptized and regenerated. Such uses of language need not have been disconcerting, for Christian preaching, like other forms of public speaking, addressed mixed audiences in the masculine, and rarely addressed either men or women explicitly.[64] Moreover, Hebrew metaphor, which was made familiar by Greek and Latin translations of the scriptures, transferred circumcision to other parts of the body that are common to males and females. The circumcised heart evoked by Philo was the most favoured: 'circumcision of the flesh has great importance as a sacrament, and from it circumcision of the heart is understood', as Augustine explained in a sermon.[65] But Scripture also offered circumcised ears, that the martyr Stephen did not find in those who killed him (*Acts* 7.51), and circumcised lips, that Augustine asked of God (*Confessions* 11.2.3). James O'Donnell, commenting on this passage of *Confessions*, has cited Jerome's commentary on *Galatians* (5.6), which in literal translation says:

> So in Christ the circumcision of the flesh is no advantage, but rather the circumcision of the heart and the ears, which removes that reproach to the Jews 'look, your ears are uncircumcised and you cannot hear' ('ecce incircumcisae aures vestrae et non potestis audire', *Jeremiah* 6.10), and the circumcision of the lips that Moses in his humility said he did not yet have: as the Hebrew scripture puts it, 'I have a foreskin on my lips' ('ego autem sum praeputium habens in labiis', *Exodus* 6.12).[66]

Male Christians could not use physical circumcision as a sign of religious commitment analogous to the intact female body, for that would have identified them with followers of the Jewish law. Spiritual circumcision, interpreted as the excision of desire, might seem an obvious analogue, but instead was used without specifically masculine or sexual reference. Circumcision was no longer clearly assigned to the male genitalia or even to the male body. That may explain why the question of (un)circumcision did not prompt displays of anxiety, and why foreskins could be mentioned without the apologies and circumlocutions that accompanied mentions of sexual intercourse, erection or seminal emission. Present-day audiences, though alert to gender questions, apparently do not find it strange when a paper by a woman is described as seminal. Late antique audiences had accepted Hebrew physical metaphors to the point that Augustine could argue without comment that 'God justifies the circumcision from faith and the foreskin by faith'.[67] The metonymic significance of (un)circumcision displaced the physical sense, so that foreskins became a metaphor as dead as the fragment of excised skin.

NOTES

I am indebted to Tessa Rajak; to Pierre Cordier, Ralph Jackson and Brook Pearson; and to Rebecca Flemming, Sean Gill, Duncan Kennedy and Helen King for their advice on bibliography (or its absence). Unattributed translations, and of course any remaining errors, are my own.

1. M. Gleason, *Making Men: Sophists and Self-presentation in Ancient Rome* (Princeton, 1995) is already a classic. Full anatomical discussion (but not of circumcision) in C. Williams, *Roman Homosexuality: Ideologies of Masculinity in Classical Antiquity* (New York, 1999). For late antiquity, see G. Clark, 'The old Adam: patristics and the unmaking of masculinity', in L. Foxhall and J. Salmon (eds), *Thinking Men: Masculinity and its Self-representation in the Classical Tradition* (London, 1998), 170–82; V. Burrus, *Begotten Not Made: Conceiving Manhood in Late Antiquity* (Stanford, 2000); M. Kuefler, *The Manly Eunuch: Masculinity, Gender Ambiguity and Christian Ideology in Late Antiquity* (Chicago, 2001). On Judaism, see S.J.D. Cohen, 'Those who say they are Jews and are not: how do you know a Jew in antiquity when you see one?', in S.J.D. Cohen and E.S. Frerichs (eds), *Diasporas in Antiquity* (*Brown Judaic Studies* 288) (Atlanta, 1993), 1–45; S.J.D. Cohen, 'Why aren't Jewish women circumcised?', in M. Wyke (ed.), *Gender and the Body in the Ancient Mediterranean* (Oxford, 1998), 136–54.

2. The classic study is P. Brown, *The Body and Society: Men, Women and Sexual Renunciation in Early Christianity* (London, 1988). See further T. Shaw, *The Burden of the Flesh* (Minneapolis, 1998). A full recent bibliography can be found in E.A. Clark, *Reading Renunciation* (Princeton, 1999). For the contrast between Jewish and Christian readings of the body in late antiquity, see D. Boyarin, *Carnal Israel: Reading Sex in Talmudic Culture* (Berkeley, 1993).

3. See especially A. Cameron, 'Early Christianity and the discourse of female desire', in L. Archer, S. Fischler and M. Wyke (eds), *Women in Ancient Societies: an Illusion of the Night* (London, 1994), 152–68.

4. V. Grimm, *From Feasting to Fasting: the Evolution of a Sin* (London, 1996). For the medieval period see R. Bell, *Holy Anorexia* (Chicago, 1985).

5. On the chaste female body as a symbol of the Roman community, see D. Trout, 'Re-textualizing Lucretia: cultural subversion in the *City of God*', *Journal of Early Christian Studies* 2 (1994), 53–70, esp. pp. 57–8.

6. D. Brakke, 'The problematization of nocturnal emissions in early Christian Syria, Egypt and Gaul', *Journal of Early Christian Studies* 3 (1995), 419–60, esp. p. 420.

7. On male celibacy in ancient romance, see S. Goldhill, *Foucault's Virginity: Ancient Erotic Fiction and the History of Sexuality* (Cambridge, 1995).

8. Clark, 'The old Adam' (above, n. 1). On 'brides of Christ', see further Kuefler, *The Manly Eunuch* (above, n. 1), 137–42.

9. *Sermones Mainz* 41.10 in F. Dolbeau (ed.), *Augustin d'Hippone: vingt-six sermons au peuple d'Afrique* (Paris, 1996).

10. For Augustine, see G. Clark, 'The bright frontier of friendship', in R. Mathisen and H. Sivan (eds), *Shifting Frontiers in Late Antiquity* (Aldershot, 1996), 217–29. For Cassian, see Brakke, 'The problematization' (above, n. 6), esp. pp. 446–58.

11. See Clark, 'The old Adam' (above, n. 1).

12. Herodotus 2.36–7 (trans. A. de Selincourt). Herodotus 2.104.2–4 gives the 'other nations' as Colchians, Egyptians, Phoenicians and 'Syrians in Palestine': these last are Jews, according to the first-century CE Jewish historian Josephus (*Jewish Antiquities* 8.10.3).

13. See M. Stern, *Greek and Latin Authors on Jews and Judaism* II (Jerusalem, 1980), 619–21, for some evidence that the Romans banned circumcision in Arabia and, except for priests, in Egypt. On whether Egyptian tradition survived under Greek and Roman rule, see D. Montserrat, *Sex and Society in Graeco-Roman Egypt* (London, 1996), 36–8.

14. On Greek *psolos* see N.V. Dunbar, *Aristophanes: Birds* (Oxford, 1995), 346–7; on Latin *verpa* see J.N. Adams, *The Latin Sexual Vocabulary* (London, 1982), 12–14, and on its use in Latin literature see Cohen, 'Those who say they are Jews' (above, n. 1), 14, and the discussion by Cordier, Chapter Four in this volume.

15. Martial 7.35.4 is a characteristic example.

16. Soranus, *Gynaecology* 2.34 (trans. O. Temkin). For modern techniques of foreskin reconstruction in adults, see N. Bradford, *Men's Health Matters* (London, 1995), 314–16. Adhesive tape and small fishing weights are used; the method is said to be painless but inconvenient, requiring at least three years and an understanding partner. It may not work.

17. See further L. Archer, 'Notions of community and the exclusion of the female in Jewish history and historiography', in Archer, Fischler and Wyke (eds), *Women in Ancient Societies* (above, n. 3), 53–69.

18. Cohen, 'Those who say they are Jews' (above, n. 1), 22.

19. Further bibliography in P. Fredriksen, 'Judaism, the circumcision of the Gentiles and the apocalyptic hope: another look at *Galatians* 1 and 2', *Journal of Theological Studies* 42 (1991), 533–64, at p. 536 nn. 11–12.

20. See Cordier, Chapter Four in this volume.

21. 'Tosautas muriadas kath' hekasten genean apotemnesthai, meta chalepon algedonon akroteriazousas ta te heauton kai ton oikeiotaton somata.'

22. Philo, *De specialibus legibus* 1.2–3.

23. On Egyptian wisdom, see G. Fowden, *The Egyptian Hermes* (Cambridge, 1986).

24. Greek *anthrax* is the equivalent of Latin *carbunculus*, 'charcoal'. For 'carbuncle' as the ordinary meaning of *anthrax*, see D.R. Langslow, *Medical Latin in the Roman Empire* (Oxford, 2000), 478 (although he does not discuss this passage).

25. Compare T. Laqueur, *Making Sex: Body and Gender from the Greeks to Freud* (Harvard, 1990), 101, for a later argument that circumcision reduces sexual stimulation and therefore makes conception less likely. (See also Chapter Four, n. 43.)

26. *De specialibus legibus* 1.8; the tradition is clearly influenced by Platonist distinctions between body and soul, perceptible and intelligible.

27. Philo, *De specialibus legibus* 1.4–10.

28. Scriptores Historiae Augustae, *Hadrian* 14, 'quod vetabantur mutilare genitalia'. This is taken seriously by Stern, *Greek and Latin Authors* (above, n. 13), and by E.M. Smallwood, 'The legislation of Hadrian and Antoninus Pius against circumcision', *Latomus* 18 (1959), 334–57, and E.M. Smallwood, 'Addendum', *Latomus* 20 (1961), 93–6. For causes of the revolt, see W. Eck, 'The Bar Kokhba revolt: the Roman point of view', *Journal of Roman Studies* 89 (1999), 76–89.

29. See further S. Tougher, 'Byzantine eunuchs: an overview', in L. James (ed.), *Women, Men and Eunuchs: Gender in Byzantium* (London, 1997), 168–84.

30. *Digesta* 48.8.3.4 (ban on castration); 48.8.4.2 (Hadrian).

31. Justin, *Apology* 29.2; referred to by D. Caner, 'The practice and prohibition of self-castration in early Christianity', *Vigiliae Christianae* 51 (1997), 396–415.

32. *Digesta* 48.8.11.

33. Thus Caner, 'The practice and prohibition' (above, n. 31), 398 n. 12, concluded from the legal evidence that 'Roman jurisprudence conceived castration as tantamount to murder and assimilated it to circumcision'. Kuefler, *The Manly Eunuch* (above, n. 1), 261, classed circumcision as 'genital mutilation as a religious rite', and commented, 'castration merely took the practice one step further'. I take this opportunity to regret the obvious unease provoked in male colleagues who kindly asked what I was working on.

34. *Satires* 1.9.69.

35. References to rabbinic texts in Smallwood, 'The legislation' (above, n. 28). E. Schuerer, *The History of the Jewish People in the Age of Jesus Christ* I *(175 BC–AD 135)* (rev. and ed. G. Vermes and F. Millar) (Edinburgh, 1973–87), 149, n. 28. See also, on re-circumcision and the treatment of the 'stretched', P. Schäfer, 'Hadrian's policy in Judaea', in P. Davies and R. White (eds), *A Tribute to Geza Vermes* (Sheffield, 1990), 293–5 (my thanks to Brook Pearson for this reference). The question is not discussed in Boyarin, *Carnal Israel* (above n. 2) because *epispasm* wasn't a live issue in late antique Judaism (personal communication from Daniel Boyarin). Medical texts include *Oribasius* 50.1.1 (my thanks to Pierre Cordier for this reference). On mockery, see Rutilius Namatianus 1.383–8 on a Jewish innkeeper.

36. For this text, see *Corpus scriptorum ecclesiasticorum latinorum* 84.54–141. See further E. Plumer, *Augustine's Commentary on Galatians* (*Oxford Early Christian Studies*) (Oxford, 2002).

37. Augustine's Latin text reads: 'circumcisus aliquis vocatus est? non adducat praeputium. in praeputio aliquis vocatus est? non circumcidatur. circumcisio nihil est, et praeputium nihil est, sed observatio mandatorum Dei'.

38. See, for instance, the concluding sentences of *City of God* 14.23. Compare Celsus, *De medicina* 6.18.1 (discussed by Jackson, Chapter Three in this volume), for the problem of

referring to *partes obscenae*: Greek had an accepted technical vocabulary, but the Latin equivalents were not used in polite conversation.

39. Jerome, *Commentarius in epistulam Pauli ad Galatas* 1 pref. (*PL* 26: 310–11); reference owed to Plumer, *Augustine's Commentary on Galatians* (above, n. 36).

40. Julian, *Contra Galilaeos* 351a; see further R.L. Wilken, 'Cyril of Alexandria's *Contra Iulianum*', in W. Klingshirn and M. Vessey (eds), *The Limits of Ancient Christianity: Essays on Late Antique Thought and Culture in Honor of R.A. Markus* (Michigan, 1999), 42–55.

41. Jerome, *Commentarius in epistulam Pauli ad Galatas* 2.11 (*PL* 26: 340b–c). See further Plumer, *Augustine's Commentary on Galatians* (above, n. 36). P. Fredriksen, '*Secundum Carnem*: history and Israel in the theology of Saint Augustine', in Klingshirn and Vessey (eds), *The Limits of Ancient Christianity* (above, n. 40), 37–9.

42. Augustine, *Epistulae* 28.3.4 (*Corpus scriptorum ecclesiasticorum latinorum* 34.1: 108). See further P. Brown, *Augustine of Hippo* (rev. ed., London, 2000), 449–51 on the related *Sermones Mainz* 27 in Dolbeau (ed.), *Augustin d'Hippone* (above, n. 9).

43. 'De gentibus autem quicumque crediderat, quando vellet circumcidi, cum audiret hoc non esse necessarium saluti? Forte vix ipsi Iudaei circumciderentur, nisi hoc parvuli paterentur'. *Sermones Mainz* 27.7, in Dolbeau (ed.), *Augustin d'Hippone* (above, n. 9).

44. *Sermones Mainz* 27.7, in Dolbeau (ed.), *Augustin d'Hippone* (above, n. 9), 'tenebantur inviti, ligabantur et circumcidebantur?'. See further Clark, *Reading Renunciation* (above, n. 2), 226–7, for Augustine's debates with Manicheans on Christians and Jewish law. Palladius, *Lausiaca historia* 29 (reference owed to Caner, 'The practice and prohibition' (above, n. 31)). On physical circumcision as a sacrament, see further Fredriksen, '*Secundum Carnem*' (above, n. 41), 35–7.

45. For Gregory's father, see S. Mitchell, 'The cult of Theos Hypsistos between pagans, Jews and Christians', in P. Athanassiadi and M. Frede (eds), *Pagan Monotheism in Late Antiquity* (Oxford, 1999), 81–148, at pp. 94–5. Nazareni: Jerome, *Epistulae* 112.13 (*Corpus scriptorum ecclesiasticorum latinorum* 55.381–2); Augustine, *Sermones Mainz* 27.10, in Dolbeau (ed.), *Augustin d'Hippone* (above, n. 9).

46. *Adversus Judaeos* 2.1.6 (*PG* 48.858). See further R. Wilken, *John Chrysostom and the Jews: Rhetoric and Reality in the Late Fourth Century* (Berkeley, 1983).

47. Some Coptic Christians maintained the Egyptian tradition of circumcision, but connected it with imitation of Christ rather than with keeping the Jewish law: T. Wilfong, 'Reading the disjointed body in Coptic', in D. Montserrat (ed.), *Changing Bodies, Changing Minds: Studies on the Human Body in Antiquity* (London, 1998), 116–36.

48. 'Non enim qui in manifesto Iudaeus, neque quae in manifesto in carne est circumcisio, sed qui in occulto Iudaeus, et circumcisio cordis spiritu non littera, cuius laus non ex hominibus sed ex Deo est.'

49. 'In quo et circumcisi estis circumcisione non manu facta in exspoliatione corporis carnis, sed in circumcisione Christi; consepulti ei in baptismo, in quo et resurrexistis per fidem operationis Dei, qui suscitavit illum a mortuis. et vos cum mortui essetis in delictis, et praeputio carnis vestrae, convivificavit cum illo.'

50. 'Videte canes, videte malos operarios, videte concisionem. nos enim sumus circumcisio, qui spiritui Dei servimus, et gloriamur in Christo Iesu, et non in carne fiduciam habentes.'

51. *Kings* 1.18.28; this suggestion is made in the Jerusalem Bible (1966) translation of *Philippians*.

52. See further M. Beard, J. North and S. Price, *Religions of Rome* I (Cambridge, 1998), 96–8.

53. 'Et adiecit elegantissima ambiguitate quasi sub specie maledictionis benedictionem dicens: utinam et abscindantur, qui vos conturbant. non tantum, inquit, circumcidantur, sed abscindantur. sic enim fierent spadones propter regnum caelorum et carnalia seminare cessabunt', Augustine, *Expositio epistulae ad Galatas* 42.19–20 (*Corpus scriptorum ecclesiasticorum latinorum* 84.116).

54. See further Kuefler, *The Manly Eunuch* (above, n. 1), esp. pp. 245–82. For changing assessments of eunuch Christians in later Byzantine tradition, see K. Ringrose, 'Passing the test of sanctity: denial of sexuality and involuntary castration', in L. James (ed.), *Desire and Denial in Byzantium* (London, 2000), 123–37.

55. *Q.in Exodus* 2.2; see further Boyarin, *Carnal Israel* (above, n. 2), 232.

56. Another range of readings in Clark, *Reading Renunciation* (above, n. 2), 225–30.

57. 'Numquid qui semel amputatum habet praeputium, potest si velit rursus illud adducere?', Jerome, *Adversus Iovinianum* 1.11 (*PL* 23 col. 235). For his Jewish advisers, see A. Kamesar, *Jerome, Greek Scholarship and the Hebrew Bible* (Oxford, 1993), 97–8.

58. 'Noli ducere uxorem, hoc est, noli adducere praeputium, ne circumcisionis et pudicitiae libertatem oneres sarcina nuptiarum', Jerome, *Adversus Iovinianum* 1.11 (*PL* 23 col. 235).

59. 'Ea pars corporis electa est, unde peritomen semel ablatum salutare in illis faceret signum, quod non potest iterum fieri', Optatus, *Against the Donatists* 5.1 (*Corpus scriptorum ecclesiasticorum latinorum* 26.119–20) (trans. M. Edwards). On the analogy, see J.P.T. Hunt, 'Colossians 2.11–12, the circumcision/baptism analogy, and infant baptism', *Tyndale Bulletin* 41 (1990), 227–44.

60. Resurrection: Ambrose, *Expositio evangelii secundum Lucam* 2.56 (*Corpus scriptorum ecclesiasticorum latinorum* 32.4, pp. 71–2).

61. Augustine, *De civitate Dei* 16.26. See further S. Poque, *Le langage symbolique dans la prédication d'Augustin d'Hippone* I (Paris, 1984), 188–90; C. Mayer, 'Circumcisio', in *Augustinus-Lexikon* I (Basel, 1986–96), 936–9.

62. Jerome, *Commentarius in epistulam Pauli ad Galatas* 2 pref.(*PL* 26: 353c); example owed to Plumer, *Augustine's Commentary on Galatians* (above, n. 36).

63. *Conferences* 21.36 (*Corpus scriptorum eccleslasticorum latinorum* 13.612–13).

64. See further G. Clark, 'Pastoral care: town and country in late-antique preaching', in T. Burns and J. Eadie (eds), *Urban Centers and Rural Contexts in Late Antiquity* (Michigan, 2001), 265–84, esp. pp. 272–3.

65. *Enarrationes in Psalmos* 74.12 (*CCL* 39.1033).

66. J.J. O'Donnell, *Augustine: Confessions* III (Oxford, 1992), 259; also available at http://www.stoa.org/hippo/

67. Mayer, 'Circumcisio' (above, n. 61), 938.

HEADHUNTERS OF THE ROMAN ARMY

Nic Fields

INTRODUCTION

IN TWO SCENES on Trajan's Column, clearly recognizable non-Roman soldiers, who are serving Rome as members of the *auxilia*, are represented holding the severed heads of Dacian warriors they have just slain in battle and decapitated. When this theme is mentioned in modern literature dealing with the monument, it is done almost as an aside.[1] One notable exception is Adrian Goldsworthy who, in a recent study of the Roman army, discusses at some length the taking of heads as trophies. Though he rightly associates the practice of headhunting with Gauls serving in the *auxilia*, his main purpose for doing so is to support the hypothesis that some members of the Roman army still engaged in the tradition of single combat.[2] This chapter aims at defining and examining the topic of the decapitation of battlefield corpses by certain individuals or units within the Roman army.

General definitions of headhunting equate it with 'the practice, among certain savage tribes, of making incursions for the purpose of procuring human heads as trophies'.[3] Here, however, headhunting is specifically interpreted as the ritual custom of preserving and displaying the severed human heads that were procured by means of decapitation upon the field of battle. This is in contradistinction also to straightforward decapitation, which took place on or off the battlefield, and which is defined as one of several mechanisms by which a corpse can be abused.[4] Headhunting as here defined appears to have been a customary practice among central and northern European peoples of the Iron Age. Herodotus, writing in the second half of the fifth century BCE, relates that the Scythians habitually flayed the heads of their enemies, making napkins from the scalps (4.64), while Tacitus, writing *c.* 100 CE, records how the Cherusci set up the skulls of Roman soldiers whose heads they had severed after the Varian disaster of 9 CE (*Annales* 1.61). The Alani were not only headhunters, according to Ammianus Marcellinus, writing in the late fourth century CE, but also used the flayed skins of their decapitated foes as trappings for their horses (31.2.23). Interestingly, in the first century CE Silius Italicus informs his readers that the Roman consul C. Flaminius proudly wore a helmet adorned with a Germanic Suebic scalp, taken after a battle against the Celtic Boii in 223 BCE (5.133–4). Yet for the Graeco-Roman commentators, it was the Celts themselves who were the most prominent practitioners of this custom.

HEADHUNTING IN CELTIC SOCIETY

The Celt as a headhunter was a theme that unquestionably filled Graeco-Roman commentators with fascination, Diodoros, writing in the second half of the first century BCE, not least of all:

> [The Gauls] cut off the heads of enemies slain in battle and fasten them about the necks of their horses. They hand over the bloodstained spoils to their attendants to carry off as booty, while striking up a paean over them and singing a hymn of victory. They nail up the heads on their houses, just as certain hunters do when they have killed wild beasts. They embalm in cedar oil the heads of their most distinguished enemies and keep them carefully in a chest. These they display, with pride, to strangers, declaring that one of their ancestors, or his father, or the man himself, refused the offer of a large sum of money for this head. They say that some of them boast that they refused the weight of the head in gold.[5]

Soon after, Strabo repeats the details given by Diodoros almost verbatim, but adds the claim that Posidonios, whose lost ethnographic work *History* was used by both Diodoros and Strabo as the

principle source here, had seen such heads displayed in many places. Posidonios had at first been disgusted by the sight but later got used to it (4.4.5).[6] We can thus consider such trophies, at least on a superficial level, as important prestige possessions, the ancestral treasure of an individual familial group. A trophy is also lasting evidence, to be exhibited on all appropriate occasions, and the displays mentioned by Diodoros served the purpose of acquainting visitors with their hosts' power and fame.[7]

Admittedly testimony of this sort is difficult to use, especially since observations were naturally filtered through a whole series of Graeco-Roman preconceptions. However, despite the tendency by Graeco-Roman writers to disparage the Celts, the archaeological evidence indicates that Celtic head-hunting was no mere ethnographic topos. Deploying literary (albeit often biased) sources and material evidence in tandem, it becomes evident that the practice of headhunting served a number of cultural functions for the Celts — the most obvious being that it provided tangible proof of their fighting prowess. Prior to the engagement at Sentinum in 295 BCE, the consuls received no news of the disaster that had befallen one of their legions, 'till some Gallic horsemen came in sight, with heads hanging at their horses' breasts or fixed on their spears, and singing their customary song of triumph'.[8] The severed heads were not ornamental but symbolic. The victorious Gauls not only paraded their bloody trophies in an overt tribal display, but also celebrated their prowess as individual warriors. Probably the best warriors would accumulate a particularly imposing collection of pre-served heads.

In Celtic society, a warrior was bound by an obligation of patronage and deference to an individual chieftain. His status was defined partly by his relationship with his leader and partly through his own prowess and honour relative to other members of the chieftain's war-band. Unlike Diodoros and Strabo, Polybios, writing in the second century BCE, only briefly mentions the Celtic custom of headhunting, but what little he does say illustrates the importance of a warrior demonstrating his mettle before his peers and his chieftain: 'In this action [at Telamon in 225 BCE] Caius the consul fell in the mêlée fighting with desperate courage, and his head was brought to the Celtic kings'.[9] Warfare was the principal means by which the Celtic warrior could gain status and recognition, thereby increasing his prestige relative to his peers.

That headhunting also had a cult function is demonstrated by the skull porticoes at Roquepertuse and Entremont (Aix-en-Provence), shrines that bear witness to the dedication of heads taken in battle as votive gifts to the gods. Indeed, the symbol of the *tête coupée* is also a constant theme in extant Celtic art and artefacts, and the motif of the human head had some cultic significance.[10] Both sanctuaries have produced remarkably homogeneous images of warrior-gods seated cross-legged. Entremont has, to date, the richest material. The sanctuary belonged to the hilltop settlement (*oppidum*) of the Celto-Ligurian Saluvii, sacked by the Romans around 123 BCE. The warrior-god figures are depicted wearing torques and body armour, often surrounded with severed heads, which are either stacked neatly to their front or carried in their hands. All the head carvings are distinctive in having closed eyes, which symbolize dead men. However, such pre-Roman sanctuaries were not confined to southern Gaul. Gournay-sur-Aronde (Oise) and Ribe-mont-sur-Ancre (Somme) were two cult centres belonging to the Belgae of northwestern Gaul, the most warlike of the Gauls according to Caesar (*Bellum Gallicum* 1.1). Although Gournay possesses skull porticoes similar to those found at Roquepertuse and Entremont, excavations at Ribemont have revealed an assemblage of well-preserved decapitated human corpses with their weapons. Since no skulls have been found at Ribemont, it seems evident that Belgae warriors kept the heads of their enemies, as Diodoros makes clear, leaving the decapitated warriors to serve as communal trophies at the sanctuary.[11]

These sanctuaries served a double function, cultic and martial. To the Celts the concept of the immortal soul, located in the head, was a fundamental belief that made the head a symbol of divine powers. By controlling the decapitated heads of their enemies, especially within a sacred precinct, the spirits of the slain were also controlled. Since spiritual power was deemed vital to success in battle, accordingly the removal of an enemy's head meant that the taker's own soul was greatly enhanced. Celtic hospitality also drew the attention of visitors to the heads of distinguished enemies, and headhunting was regarded as having religious significance for the Celts. For example, in 216 BCE, the Boii killed and decapitated the Roman commander Lucius Postumius, whose skull was taken to their most hallowed sanctuary. There it was gilded and used as a sacred vessel for libations or as a drinking cup by the priest and sanctuary attendants (Livy 23.24.11–13, cf. Polybios 3.118.6). Ammianus

Marcellinus, writing *c.* 390 CE, some three and a half centuries after Livy, also records that the Celtic Sordisci, whom he regards as 'a people formerly cruel and savage', used the hollowed skulls of enemies as drinking cups (27.4.4).[12]

The skull porticoes found in Roquepertuse, Entremont and Gournay demonstrate that the head not only had a great significance in Celtic beliefs as the seat of consciousness, but also as the source of strength and spirit.[13] With their decapitated skulls of young adult male battle victims, these war sanctuaries verify that the Celts had a belief system that sanctioned and legitimized the practice of headhunting, and that this was embedded in the fabric of Celtic society. In contrast, the Romans considered headhunting inhuman and savage, and Strabo (4.4.5) claims the Romans put an end to it.

CORPSE ABUSE IN ROMAN CULTURE

Roman condemnation of headhunting appears in the work of the first-century BCE writer Q. Claudius Quadrigarius. Although his history of Rome is lost to us, one of its fragments is preserved in the second-century CE pages of Aulus Gellius. Praising its literary style, Gellius goes on to reproduce verbatim the annalist's account of the single combat between Titus Manlius and the Gaul from whose torque he took the *cognomen* of Torquatus. Having overcome his opponent, Manlius cut off his head and placed the bloody torque around his own neck (*Noctes Atticae* 9.13.18). Clearly the head, like the torque, is considered by Manlius as part of the spoils, a trophy to be collected with no stigma attached. But this is not the perspective given in a later version of the same story by Livy. 'To the body of his fallen foe', says Livy, '[Manlius] offered no other indignity than to despoil it of one thing — a torque which, spattered with blood, he cast round his own neck'.[14] Even if the story is etiological, the message is clear. For the victorious Roman to have decapitated the corpse would be considered repugnant. For Livy, after all, the Romans were usually the heads, not the headhunters, and headhunting was used to draw a distinct line between civilized and savage forms of existence. This idea of the other's violent savagery was part of the script that, for Livy at least, legitimated conquest.[15] But what lies at the root of this Livian *volte-face*?

Manlius's duel, as described by Livy, fits neatly into the Homeric model of the honour-contest-trophy. It was Roman and Homeric epic custom to despoil a defeated enemy. The action brought nothing but praise (*laus*) to the perpetrator, who might hang such *spolia* proudly in the atrium of his house (for example, Livy 23.23.6). Spoils were the tangible proof and token of triumph, in Rome as in Graeco-Roman epic poetry. As such they greatly enhanced the fame and honour of the despoiler. For Livy's Manlius the honorific trophy was the blood-spattered torque, which served as an acceptable surrogate for the victim's head. Livy employed history like poetry, to honour the memory of ancient Roman valour. Equally, in the *Aeneid* of Virgil, armour replaced heads.

Virgil, who like Livy enjoyed the patronage of Augustus, wrote the *Aeneid* in imitation of Homer's *Iliad* and *Odyssey*, and in praise of Augustus and the idea of empire.[16] After decades of strife, Augustus, by his victory at Actium in September 31 BCE, promised peace and prosperity. According to Suetonius, writing in the early second century CE, he even fostered the talents of his generation in every possible way (*Divus Augustus* 89.3). Virgil thus composed his great patriotic poem, whose pious hero founded a great dynasty and future race, and this ambitious epic would tie the foundation of Rome to the fall of Troy.

After describing the death of Priam, Virgil dwells upon the contrast between the old king's squalid and miserable end and the glories of his former state, 'he who had once been proud ruler over so many lands and peoples of Asia'. Then he proceeds: 'his mighty trunk lay upon the shore, the head hacked from the shoulders, a corpse without a name'.[17] This passage echoes the end of Cn. Pompeius Magnus, once the greatest Roman of his day, conqueror of Asia, and the leading opponent of C. Iulius Caesar, treacherously murdered as a fugitive after his defeat at Pharsalus in August 48 BCE. As Pompeius stepped ashore as suppliant of the Egyptian pharaoh, L. Septimius who had once served under him, but now held high rank in the boy-king's Roman guard, stabbed him from behind. His head was cut off, taken to Ptolemaios XII Auletes and later presented to Caesar upon his arrival in Egypt, while his naked body was left unburied on the beach.[18]

Virgil deplores decapitation that occurred in battle.[19] Turnus, the young Rutulian king, decapitates his opponent Lynceus with 'one flashing stroke of his sword, a blow from close range that severed the head and sent it flying far from the body, helmet and all'. Turnus aims his sword blow 'between the bottom of the helmet and the top edge of the breastplate, cutting off his [Phegeus's] head and leaving the trunk on the

sand'. The motif of the helmeted severed head suggests abject dehumanization of the enemy.[20]

The *Aeneid* was inspired by Virgil's patriotic sense of Rome's destiny as a civilized ruler of nations, lead by Augustus, the 'Second Aeneas'.[21] Virgil's work offers direct ideological support for Augustus's regime, presenting Augustus as saving the lives of his fellow citizens by bringing the perpetual civil wars to an end and introducing peace (*pax romana* or *pax Augusta*). Tacitus also observes that Augustus bewitched 'the world by the amenities of peace',[22] and the theme of peace is crucial to the *Aeneid*.

Although peace had been achieved with blood and war (*Aeneid* 6.86–7), Augustus was no warrior. The paradigm is Aeneas, who for Virgil is the personification of the Roman ideal of the 'just war' (*bellum iustum*). He sets out to show Aeneas fighting only because he must to establish a lasting peace. Conversely, Virgil's Turnus, like Homer's Achilles, is a warrior at ease with himself on the field of battle. As one to whom warfare brings the greatest fulfilment, Turnus relishes battle as a means of enhancing his own glory and honour. To that end he fights most savagely on occasion (the word *violentia* is used of Turnus but of no other character) and in Turnus's battle scenes the cruel aspects of war are emphasized by the poet. Although the two are occasionally paired in their savagery, the hostile hero fights in a truly 'barbaric' style, especially when contrasted with that of Aeneas.[23] In one telling scene the impetuous Turnus actually collects and displays the heads of two of his victims:

> Turnus, now on foot, met Diores and his brother Amycus who had been unhorsed. As Diores rode at him he struck him with his long spear; Amycus he despatched with his sword. Then, cutting off both their heads, he hung them from his chariot and carried them along with him, dripping their dew of blood.[24]

Turnus, in an act of pure vengeance, has the freshly severed heads of Nisus and Euryalus impaled on spears (*Aeneid* 9.465–6). These trophies, 'dripping black gore' (*fluentia tabo*), are then paraded by the exultant Rutulians before the Trojans, who sit tight behind their defences (*Aeneid* 9.470–2). Turnus does to the heads of Nisus and Euryalus what Hektor wanted to do to the head of Patroklos. Hektor had attempted to drag the body of Patroklos away with a view to decapitating the corpse and 'give it to the dogs of Troy' (*Iliad* 17.125–7 (trans. R. Lattimore)). Iris, when she reports this news to Achilles, adds that Hektor not only intends to decapitate the corpse, but to fasten the head upon a stake for all to see (*Iliad* 18.175–7).[25]

In the *Aeneid*, Virgil's Homeric model obliged him to touch on the theme of decapitation, whereby the warrior driven by vengeance symbolizes the epitome of the savage warrior. Yet Virgil not only exploited a topos but also reflected on the horrors of the civil wars and the proscriptions he witnessed that marked the last years of the Republic. In the proscription of 43 BCE the triumvirs offered rewards for the heads of the leading Republicans, and Cicero's head and hands were left hanging on the rostra in the Forum for a considerable time as an insult. In due course, the heads of the assassins of Caesar were taken and a number of them brought to the Forum for abuse and display.[26] Other heads suffered further ignominy. For example Appian, writing in the second century CE, wryly notes that in Smyrna the Caesarian troops under Dolabella killed and decapitated Trebonius, and then kicked his head 'from one to another in sport along the city pavements like a ball till it was completely crushed' (*Bella civilia* 3.3.26 (trans. H. White)). Suetonius noted that after the battle at Philippi in November 42 BCE, the young Octavianus and the future Emperor Augustus decapitated Brutus and sent the head to Rome, 'to be cast at the feet of Caesar's statue'.[27] Rome had a strong tradition of abusing the bodies of defeated enemies, and even her own citizens were not immune from such treatment, nor later were her rulers. Suetonius (*Galba* 20.2, cf. Tacitus, *Historiae* 1.41, 44, Plutarch, *Galba* 27.2–3) tells us that after Galba was murdered in the Forum a legionary soldier decapitated him, but because the emperor was bald the soldier could not carry the head by its hair and instead simply stuffed it into his cloak. Presented to Otho, the new emperor then gave the trophy to his servants, who promptly put it on a spear and mocked it. A former freedman of Patrobius Neronianus purchased the head for 100 gold pieces, only to hurl it to the ground at the exact spot where Patrobius had been murdered on Galba's orders. Unusually, head and corpse were eventually reunited in decent burial.[28]

From Marius and Sulla to Octavianus and Marcus Antonius, quick and non-aggravated decapitation (*ad gladium*) at the edge of town was the most discrete form of execution, a privilege for citizens of status. Ironically, during proscription and civil war vengeance was carried out through post-mortem abuse and public exhibition. For members of the Augustan literati, such as Livy and Virgil, the distinction between headhunting and decapitation becomes blurred. Virgil's attitude to

decapitation, for instance, was shaped by his distinctive historical experience.[29]

HEADHUNTING IN THE ICONOGRAPHY OF THE PRINCIPATE

Despite Strabo's claim that the Romans put an end to headhunting, it is depicted on Trajan's Column (scene XXIV twice, scenes LXXII and CXIII), on the 'Great Trajanic Frieze' (slabs VI and VII), and on the Tropaeum Adamklissi (metope VII/51).[30] Such incidents are too prominent to have been simply invented by the artist.[31] These triumphal monuments, conceived and designed under imperial supervision, celebrated Trajan's victory in his two Dacian wars (101–2 CE and

105–6 CE) and his *virtus*, an essential ingredient of the Roman self-image.[32]

Trajan's Column illustrates the emperor's Dacian wars. In two scenes (XXIV and LXXII) a pair of auxiliary soldiers offer freshly severed heads to Trajan, who, at least in the second case, reaches out his right arm to accept the bloody human trophies (**Fig. 6.1**). In battle (scene XXIV), an auxiliary soldier, still clutching between his teeth the head of an earlier victim by its hair, turns on another Dacian opponent (**Fig. 6.2**). Later (scene CXIII) an auxiliary soldier is depicted climbing a scaling-ladder during the assault on some fortifications, holding in his shielded left arm a severed head, whilst striking a defendant on the battlements with the sword in his right hand. Finally (scene LVI), while legionaries are constructing a road, two severed

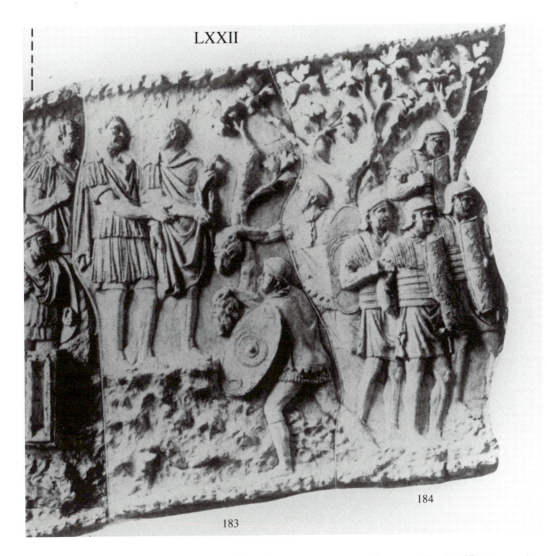

FIG. 6.1. **Trajan's Column, Rome, scene LXXII. Auxiliary troopers present the severed heads of Dacian warriors to their emperor — note Trajan appears to hold out his right hand in a gesture of acceptance.** *From F. Lepper and S.S. Frere,* Trajan's Column *(Gloucester, 1988), pl. LI. Reproduced courtesy of the authors and Sutton Publishing Ltd.*

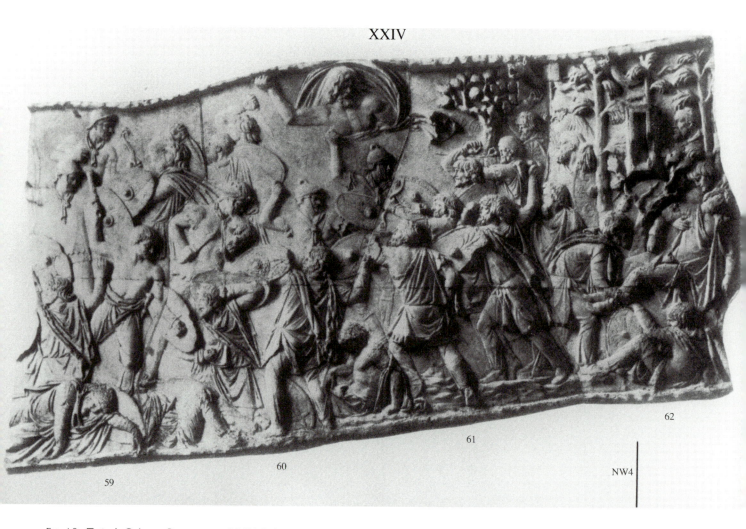

FIG. 6.2. Trajan's Column, Rome, scene XXIV. A dismounted auxiliary trooper fights on, whilst holding the severed head of a previous Dacian victim by the hair between his teeth. *From F. Lepper and S.S. Frere,* Trajan's Column *(Gloucester, 1988), pl. XIX. Reproduced courtesy of the authors and Sutton Publishing Ltd.*

heads, impaled on poles, stand behind them and in front of a fort or fortified settlement (**Fig. 6.3**). This scene can be variously interpreted as showing that the place had previously been a Dacian stronghold, that auxiliary troops had earlier fought an action here, or that the legionaries themselves followed such practices.[33]

Six decapitated human skulls were found in one of the ditches of the legionary fortress at Colchester (Camulodunum). One had a deep gash from a sword blow to the neck; another had a fracture caused by a sword pommel. These are the remains of local Trinovantian Britons beheaded by soldiers of *legio XX Valeria*; the sole garrison of the fortress until it was abandoned in 49 CE.[34] Their heads were presumably impaled on stakes outside the fortress as a warning, like those depicted on Trajan's Column (scene LVI).

It could be argued, however, that the use of foreign units within the Roman army encouraged practices that were normally alien to the Romans themselves. Although, surprisingly, there is no mention of the Celtic custom of headhunting by Caesar during his campaigns in Gaul, he does say (*Bellum Hispaniense* 32) that after the victory outside Munda in 45 BCE, his troops erected a palisade adorned with the severed heads of their Pompeian foes. The soldiers involved appear to be legionaries, although Caesar indicates that they were Gauls of 'the Larks' (*legio V Alaudae*).[35] Rather than headhunting in its true sense, Caesar clearly states that this spectacle was intended to intimidate the surviving Pompeians resisting at Munda.[36] Intimidation was the purpose of C. Claudius Nero's abusive treatment of Hasdrubal Barca's corpse after Metaurus (207 BCE). The consul ordered the corpse of the

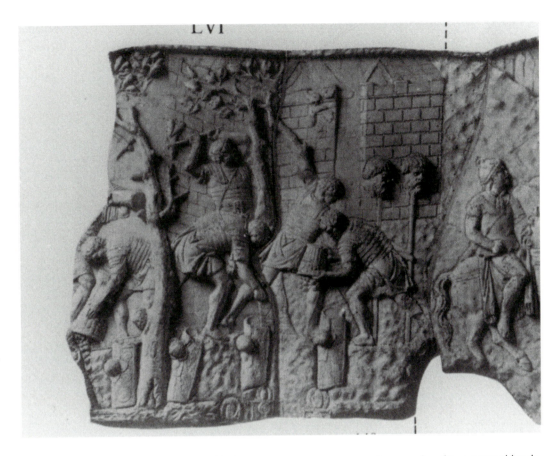

FIG. 6.3. Trajan's Column, Rome, scene LVI. Legionaries are seen constructing a road, and two severed heads, impaled on poles, stand behind them and in front of a fort or fortified settlement — note the two auxiliary troopers in the next scene. *From F. Lepper and S.S. Frere,* Trajan's Column *(Gloucester, 1988), pl. XL. Reproduced courtesy of the authors and Sutton Publishing Ltd.*

Carthaginian general to be decapitated and the severed head preserved. It was later thrown in front of the outposts guarding the camp of Hasdrubal's brother Hannibal (Livy 27.51.11).[37]

On occasions during the second Punic war, such as the battle of Beneventum (214 BCE), the Roman commander Ti. Sempronius Gracchus had to order his army of slave-volunteers (presumably Celts) to stop collecting heads and fight instead (Livy 24.15.4–6). Celtic contingents serving Rome, believing Hannibal's prospects were brighter, killed a number of Roman soldiers and, in the sober words of Polybios, 'cutting off the heads of the slain, went over to the Carthaginians' (3.67.3).[38] Thus the weight of evidence suggests that the practice of headhunting, as opposed to corpse abuse, should be associated more with the *auxilia* than with the legions, and other Trajanic reliefs seem to confirm this.

The so-called 'Great Trajanic Frieze' was almost completely re-set, in separate panels, into the Arch of Constantine.[39] The frieze itself is an allegorical presentation of Trajan's victories in Dacia, larger in scale but much shorter in content than that of Trajan's Column. On one panel (slabs VI and VII) a Roman soldier has his right arm raised and outstretched. He presents a severed head, grasping it by the hair. A soldier standing behind him echoes his pose, as does another soldier standing in front. Together, the three of them form a group that spans the border between the two slabs. These men wear body armour of mail and scale, carry hexagonal shields, and are almost certainly dismounted cavalrymen. Another auxiliary trooper (slab VI), just forward of the emperor, leans from his horse so as to reach his enemy standing on the ground. His left hand holds the enemy's hair, the right hand is raised, about to fall and administer a sword-blow. Although the gesture of grabbing the enemy's hair is one of the most universal of all battle motifs in Graeco-Roman art, here the suggestion is also one of head taking (Fig. 6.4).

On the Tropaeum Adamklissi, located in what was once the province of Moesia Inferior, the hands of

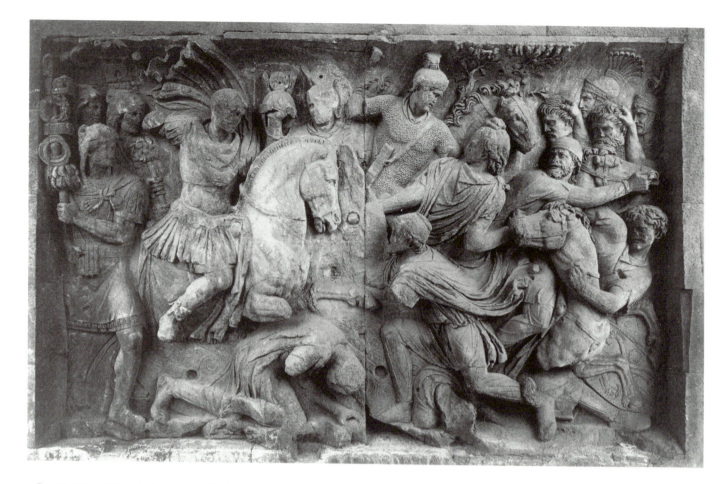

FIG. 6.4. 'Great Trajanic Frieze', slab VI. An auxiliary trooper, just forward of Trajan and leaning from his horse, grabs hold of an opponent's hair and raises his right arm so as to administer a sword-blow to the neck — note that two dismounted *equites singulares* to the left are presenting severed heads to the emperor. *Photo: Deutsches Archäologisches Institut, Rome, neg. no. 37.328. Reproduced courtesy of the Deutsches Archäologisches Institut, Rome.*

well-instructed yet comparatively unskilled military artisans executed the same theme as a series of separate battle pictures aligned side by side. An auxiliary cavalryman in scale body armour (metope VII/51) brandishes the head of his Dacian opponent while the headless corpse languishes in the background (Fig. 6.5).

Depictions of headhunting on two other imperial monuments, slightly later in date, add weight to the idea of associating the practice with the *auxilia*. The first monument is the easternmost slab on the Antonine Wall. Discovered at Bridgeness, it is the largest and most impressive found to date. The dedicatory inscription (*RIB* 2139) to Antoninus Pius, who reigned 138–61 CE, recording the building of '4652 paces' of the wall by *legio II Augusta*, is flanked by scenes of victory and ritual purification. The panel on the left, the scene of victory, depicts an auxiliary trooper riding down four local Britons. One of the four has just been decapitated; the victim's headless corpse has slumped into a seated position while the head falls to the ground. The second

monument is the Column of Marcus Aurelius in Rome. In conscious emulation of that of Trajan, the column's helical frieze records the campaigns of Marcus Aurelius north of the Danube, namely those against the Marcomanni (169–73 CE) and the Sarmatians (174–6 CE). It depicts a battle far more violent and cruel than that of Trajan's Column.[40] On one scene (LXVI), Marcus Aurelius, on a cushioned seat, listens to a man standing to his right. Two auxiliaries, one in mail and the other in scale armour, hold out severed heads to the otherwise distracted emperor.[41]

The scenes of headhunting on the sculptural reliefs from Rome might be dismissed as unrealistic; it would be extremely odd to associate such a grim practice so closely with the emperor whose glories were being commemorated, if it were not true. The depiction of the custom on the less heroic metopes at Adamklissi verifies that at least some individuals or units of the *auxilia* practised headhunting. It should come as no surprise, therefore, that since the days of Caesar large

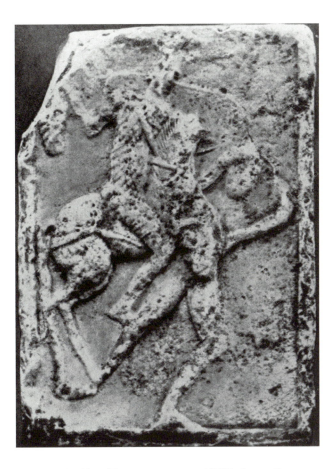

FIG. 6.5. Adamklissi Monument, metope VII/51. An auxiliary cavalryman has procured the head of his Dacian opponent and holds it aloft in triumph — note the headless corpse sinking into the background. *Photo: author's collection.*

numbers of Celts, principally Gallic horsemen, had been enlisted to serve Rome. It is a fair presumption that these auxiliary troopers, displaying severed human heads in time-honoured Celtic fashion, were Gauls.

From Entremont there is a pre-Roman relief that depicts a horseman carrying a severed head, with eyes closed in death, suspended from the neck of his mount, corresponding with Graeco-Roman commentary on the Gauls that describes their habit of hanging these spoils of war from the neck harnesses of their horses.[42] Another example, from Saint-Michel-de-Valbonne, shows a horseman, with a head of exaggerated size, riding over five severed human heads.[43] Actually, the lower Rhône valley has produced many other iconographic reminders of the horseman and headhunting theme. One in particular is the door-lintel from the pre-Roman town (*oppidum*) at Nâges (Nîmes), which possesses a frieze with alternate severed heads and galloping horses. As Brunaux suggests, headhunting may have been the prerogative of horsemen in Celtic society.[44]

CONCLUSION

It is the depiction of the bodyguard, the *equites singulares Augusti*, in battle on the 'Great Trajanic Frieze' that is most telling. The three dismounted auxiliary troopers (slabs VI and VII) presenting severed heads to their emperor are clearly members of Trajan's bodyguard, as indicated by the style of their crested helmets and hexagonal shields.[45] The military reforms of Augustus may have institutionalized the *auxilia*, but it was left to Trajan to advertise publicly its importance to the Empire and honour them accordingly. Thus in the iconography of the Dacian wars, depictions of headhunting are shown proudly and unapologetically. The scenes from Trajan's Column show Trajan with members of the *auxilia*, dismounted cavalrymen of Celtic origins, offering their 'chieftain' the freshly severed heads of slain Dacian warriors. Moreover, judging by the scene on the 'Great Trajanic Frieze', Celtic members of Trajan's own mounted bodyguard also practised headhunting, and did so with the emperor's blessing.

For a pre-Roman Celt, headhunting had been part of a set of ethical beliefs associated with patterns of ritual honouring his own warrior-gods. Likewise, for a Celt now serving in the Roman army, head taking was still an organized, coherent form of violence in which the severed head retained its specific ritual meaning. In a sense he was behaving as if he were a warrior in a chieftain's war-band, presenting the trophy of his fighting prowess to the warrior-emperor. A final relief worthy of mention, albeit privately sponsored, is that adorning the fragmentary tombstone of Aurelius Lucianus (*RIB* 522), a cavalryman who was buried outside the legionary fortress at Chester (Deva). Aurelius is shown in a funerary banquet repose, but wearing scale body armour and riding trousers. On the wall behind him hang his helmet with crest and cheek-pieces and his sheathed sword, notable for its large pommel. In the lower register of the scene stands Aurelius's groom displaying a war-trophy — the severed and preserved head of an enemy. What we are witnessing for the first time in the Trajanic state monuments, therefore, is a conscious exhibition of the traditional Celtic practice of headhunting, and not some Roman parody, despite the earlier Augustan prejudice.

NOTES

1. For example, see L. Rossi, *Trajan's Column and the Dacian Wars* (London, 1971), 142, 170; I.A. Richmond, *Trajan's Army on Trajan's Column* (London, 1982), 40–1; F. Lepper and S.S. Frere, *Trajan's Column* (Gloucester, 1988), 70–1; J. Bennett, *Trajan: 'Optimus Princeps'* (London, 1997), 92.

2. A.K. Goldsworthy, *The Roman Army at War 100 BC–AD 200* (Oxford, 1998), 271–6. See also J.-L. Voisin, 'Les Romains, chasseurs de tête', in *Du châtiment dans la cité: supplices corporels et peine de mort dans le monde antique* (*Collection de l'École Française de Rome* 79) (Paris, 1984), 241–93.

3. *The Oxford English Dictionary* VII (Oxford, 1989), 42.

4. See Varner, Chapter Seven in this volume.

5. Diodoros 5.29.4–5, author's translation.

6. Cf. Posidonios fr. 274 Edelstein-Kidd. The Stoic philosopher had travelled in southern Gaul at the turn of the first century BCE. On Posidonios, see D. Nash, 'Reconstructing Posidonios' Celtic ethnography: some considerations', *Britannia* 7 (1976), 111–26; K. Clarke, *Between Geography and History: Hellenistic Constructions of the Roman World* (Oxford, 1999), 129–92.

7. On the importance of glory and trophies, see M.R. Davie, *The Evolution of War: a Study of its Role in Early Societies* (New Haven, 1929), 147–59.

8. 'Quam in conspecta fuere Gallorum equites, pectoribus equorum suspensa gestantes capita et lanceis infixa ovantesque moris sui carmine', Livy 10.26.11 (trans. B.O. Foster).

9. Diodoros 2.28.10 (trans. C.H. Oldfather).

10. As no myths have survived from the Iron Age, none of the methods used to reconstruct Gallic cosmologies are wholly convincing. The best studies, therefore, limit their range, both geographically and temporally, as closely as possible. For an in-depth analysis, see especially G.D. Woolf, *Becoming Roman: the Origins of Provincial Civilization in Gaul* (Cambridge, 1998), 206–37. On the symbolism and portrayal of the head in pre-Roman Celtic art, see M.J. Green, *Symbol and Image in Celtic Religious Art* (London, 1994), 211–14; M.J. Green, *The Gods of the Celts* (Stroud, 1997), 216–20. For the post-colonial approach to 'Celtic religion', see especially J. Webster, 'Translation and subjection: *interpretatio* and the Celtic gods', in J.D. Hill and C. Cumberpatch (eds), *Different Iron Ages: Studies on the Iron Age of Temperate Europe* (Oxford, 1995), 170–83; J. Webster, 'Necessary comparisons: a post-colonial approach to religious syncretism in the Roman provinces', *World Archaeology* 28.3 (1997), 324–38.

11. On Roquepertuse, see S. Moscati (ed.), *The Celts* (New York, 1991), 362–3; M.J. Green, *Dictionary of Celtic Myth and Legend* (London, 1992), 116–18. On Entremont, see F. Benoît, *Le symbolisme dans les sanctuaires de la Gaule* (Brussels, 1970), 18–20; F. Benoît, *Entremont* (Paris, 1981), 51–99. On Gournay and Ribemont, see J.-L. Brunaux, *Les gaulois: sanctuaires et rites* (Paris, 1986), 13–21; J.-L. Brunaux, *Les religions gauloises: rituels celtiques de la Gaule indépendante* (Paris, 1996), 69–90. On Ribemont, see also J.-L. Brunaux,

'Ribemont-sur-Ancre (Somme)', *Gallia* 56 (1999), 177–283; J.-L. Brunaux, 'Gallic blood rites', *Archaeology* 52.2 (2001), 54–7. On pre-Roman Celtic war-gods, see Green, *Symbol and Image* (above, n. 10), 109–11.

12. 'Saevi quondam et truces.' The Scythians, likewise, made drinking cups out of skulls. The part beneath the eyebrows was sawn away and the remaining cranium cleansed. It was then covered on the outside with raw hide and, wealth permitting, gilded on the inside (Herodotus 4.65).

13. The Gaelic word for 'brain', *eanchainn* (Old Irish, *inchind*), was used to express 'boldness, audacity, impudence', and the derivative adjective *eanchainneach*, 'brainy', meant 'bold, audacious, impudent'. See, for example, E. Dwelly, *The Illustrated Gaelic–English Dictionary* (Glasgow, 1971), 582.

14. 'Iacentis inde corpus ab omni alia vexatione intactum uno torque spoliavit, quem respersum cruore collo circumdedit suo', 7.10.11 (trans. B.O. Foster).

15. Cf. B.D. Shaw, 'Eaters of flesh, drinkers of milk: the ancient Mediterranean ideology of the pastoral nomad', *Ancient Society* 13 (1982), 5–31, on the prejudice, almost an ideology, which stigmatized the barbarian as 'counter-civilizational'. On Graeco-Roman conceptions of barbarism, see L. Rawlings, 'Celts, Spaniards, and Samnites: warriors in a soldiers' war', in T.J. Cornell, B. Rankov and P. Sabin (eds), *The Second Punic War: a Reappraisal* (London, 1996), 84–6; Clarke, *Between Geography* (above, n. 6), 214–15, 237–9; S.P. Mattern, *Rome and the Enemy: Imperial Strategy in the Principate* (Berkeley, 1999), 70–80. For this theme with regard to the justification of the conquest of Celtic lands, see J. Webster, 'The just war: Graeco-Roman texts as colonial discourse', in S. Cottam, D. Dungworth, S. Scott and J. Taylor (eds), *TRAC 1994. Proceedings of the Fourth Theoretical Roman Archaeological Conference Durham 1994* (Oxford, 1995), 1–10; J. Webster, 'Ethnographic barbarity: colonial discourse and 'Celtic warrior societies'', in J. Webster and N. Cooper (eds), *Roman Imperialism: Post-colonial Perspectives* (Leicester, 1996), 1–18.

16. On the *Iliad* and *Odyssey* as models for Virgil's *Aeneid* see especially, T. Schmit-Neuerburg, *Vergils 'Aeneis' und die Antike Homerexegese: Untersuchungen zum Einfluß Ethischer und Kritischer Homerrezeption auf 'imitatio' und 'aemulatio' Vergils* (Berlin, 1999).

17. 'Tot quondam populis terrisque superbum regnatorem Asiae. iacet ingens litore truncus, avolsumque umeris caput et sine nomine corpus', *Aeneid* 2.555–7 (trans. D. West).

18. Valerius Maximus 1.8.9; Appian, *Bella civilia* 2.12.86; Plutarch, *Pompey* 80.1, *Caesar* 48.2.

19. On the theme of decapitation in the *Iliad*, see C. Segal, *The Theme of the Mutilation of the Corpse in the* Iliad (Leiden, 1971); J.F. Lendon, 'Homeric vengeance and the outbreak of Greek wars', in H. van Wees (ed.), *War and Violence in Ancient Greece* (London, 2000), 3–11.

20. 'Huic uno deiectum comminus ictu cum galea longe iacuit caput', *Aeneid* 9.770–1 (trans. D. West). 'inter galeam summi thoracis et oras abstulit ense caput truncumque reliquit

harenae', *Aeneid* 12.381–2 (trans. D. West). On battle scenes in the *Aeneid*, see R.D. Williams, *The 'Aeneid'* (London, 1987), 61–77; P. Levi, *Virgil: his Life and Times* (London, 1998), 205–22.

21. *Aeneid* 1.286–9, cf. 6.793–800, 8.714–23; Horace, *Epodes* 4.15; Propertius 2.10; *Res Gestae* 26.1. On the identity of Augustus in the *Aeneid*, see Williams, *The 'Aeneid'* (above, n. 20), 36–8; H.P. Stahl, 'The death of Turnus: Augustan Virgil and the political revival', in K.A. Raaflaub and M. Toher (eds), *Between Republic and Empire: Interpretations of Augustus and his Principate* (Berkeley, 1993), 174–9.

22. 'Cunctos dulcedine otii pellexit', *Annales* 1.2 (trans. J. Jackson).

23. On 'pious Aeneas' as a symbol of the idea of Augustan Rome, see V. Pöschl, *The Art of Virgil: Image and Symbol in the* Aeneid (Ann Arbor, 1962), 123–4; N. Hannestad, *Roman Art and Imperial Policy* (Aarhus, 1988), 73–4; P. Zanker, *The Power of Images in the Age of Augustus* (Ann Arbor, 1990), 201–10; G.K. Galinsky, *Augustan Culture* (Princeton, 1998), 247–53. On Aeneas as a 'new type of hero', see Williams, *The 'Aeneid'* (above, n. 20), 71–4, 78–101. On the Roman concept of the 'just war' and the discredited notion of 'defensive imperialism', see W.V. Harris, *War and Imperialism in Republican Rome 327–70 BC* (Oxford, 1986), 166–75; Mattern, *Rome and the Enemy* (above, n. 15), 184–6. On 'fiery Turnus' as a symbol of sacrifice, see R.D. Williams, *The 'Aeneid' of Virgil* (Bristol, 1985), 20–1; Williams, *The 'Aeneid'* (above, n. 20), 119–27; W.S.M. Nicoll, 'The death of Turnus', *Classical Quarterly* 51.1 (2001), 190–200. For the comparison between the character of Aeneas and that of Turnus, see R.D. Williams, *Aeneas and the Roman Hero* (London, 1977), 56–7.

24. 'Turnus equo deiectum Amycum fratremque Diorem, congressus pedes, hunc venientem cuspide longa, hunc mucrone ferit curruque abscisa duorum suspendit capita et rorantia sanguine portat', *Aeneid* 12.510–14 (trans. D. West).

25. Cf. Herodotus (7.238, cf. 9.78), who relates that when Xerxes saw how few Greeks there had been defending Thermopylai, he was consumed with rage and sent for the corpse of Leonidas, whereupon he commanded the head to be cut off and set up on a stake for all to see.

26. Appian, *Bella civilia* 4.2.5–4.20; Plutarch, *Antony* 20, *Cicero* 48–9. In an earlier proscription, that of Marius and Cinna in 87 BCE, the heads of a number of leading senators had suffered the same fate (Appian, *Bella civilia* 1.8.71). Incidentally, the young Pompeius had earned for himself the nickname 'the teenage butcher' ('adulescentulus carnifex') after his executions of Marian leaders. One of the heads, that of Carbo, was sent in grizzly triumph to Sulla in Rome (Valerius Maximus 6.2.8, cf. 9.13.2; Appian, *Bella civilia* 1.11.96; Plutarch, *Pompey* 10).

27. 'Ut statuae Caesaris subiceretur', *Divus Augustus* 13.1 (trans. J.C. Rolfe).

28. On political violence in Rome and corpse abuse, see D.G. Kyle, *Spectacles of Death in Ancient Rome* (London, 2001), 132–3, 220–4. See also Varner, Chapter Seven in this volume.

29. For the argument against Augustan poetry being anti-militarist, see D. Cloud, 'Roman poetry and anti-militarism', in J.W. Rich and G. Shipley (eds), *War and Society in the Roman World* (London, 1993), 112–38.

30. On Trajan's Column there is also scene CXLVII, where the head of Decebalus is displayed to the Roman troops. Trajan had the head sent to Rome and once there it was thrown on the Scalae Gemoniae for the public to gloat over and for the *fasti* to report it for posterity (Dio 68.14.3, *Fasti Ostienses* ad 106 CE). The severed head of the Dacian king became the very visual proof and symbol of Trajan's hard-won *victoria Dacia*. Incidentally, although badly damaged, some scholars would argue that in scene CXLVII Tiberius Claudius Maximus is actually presenting the severed head to Trajan. See, for example, M.A. Speidel, 'The captor of Decebalus: a new inscription from Philippi', *Journal of Roman Studies* 60 (1970), 148; Lepper and Frere, *Trajan's Column* (above, n. 1), 176–9.

31. Although no master's name can be linked with Trajan's Column, there is a strong argument for it being the work of Apollodoros of Damascus, who, as Trajan's chief engineer, was involved in both wars. See Hannestad, *Roman Art* (above, n. 23), 157.

32. On Trajan's Column, see Hannestad, *Roman Art* (above, n. 23), 154–67; Lepper and Frere, *Trajan's Column* (above, n. 1); S. Settis *et al.*, *La Colonna Traiana* (Turin, 1988); J.E. Packer, *The Forum of Trajan in Rome: a Study of the Monuments* (*California Studies in the History of Art* 31) (Berkeley, 1997), I, 113–20. On the 'Great Trajanic Frieze', see A.-M. Leander Touati, *The Great Trajanic Frieze: the Study of a Monument and the Mechanism of Message Transmission in Roman Art* (*Acta Instituti Romani Regni Sueciae* 4.45) (Stockholm, 1987); F. Coarelli, *La Colonna Traiana* (Rome, 1999). On the Tropaeum Adamklissi, see F.B. Florescu, *Die Trajanssäule: das Siegendenkmal von Adamklissi* (Bucharest/Bonn, 1965); L. Rossi, 'A historical reassessment of the metopes of the Tropaeum Traiani at Adamklissi', *Archaeological Journal* 129 (1972), 56–68. On the importance of *virtus* to the Romans and its intimate relationship with deeds of war, see Harris, *War and Imperialism* (above, n. 23), 20–1; Galinsky, *Augustan Culture* (above, n. 23), 84. On the two Dacian wars, see Rossi, *Trajan's Column* (above, n. 1), 130–212; Richmond, *Trajan's Army* (above, n. 1); Bennett, *Trajan* (above, n. 1), 85–103, 214–18.

33. Cf. Rossi, *Trajan's Column* (above, n. 1), 158, who believes these are Roman heads.

34. P.R. Sealey, *The Boudican Revolt Against Rome* (Princes Risborough, 2000), 17–19.

35. Raised by Caesar entirely in Transalpine Gaul eight years previously, this legion was made up of non-citizens (Caesar, *Bellum Gallicum* 6.1), hence the title as opposed to a definite number. Caesar enfranchised these Gauls later, probably in 47 BCE, and the legion thus received the number V (Suetonius, *Divus Iulius* 24.2).

36. Appian records the same incident, but also adds that the heads of Varus, Labienus and other distinguished Pompeians were

brought to Caesar after the fall of the town (*Bella civilia* 2.15.105).

37. See Plutarch (*Crassus* 26.4), who describes how the Parthians rode up to Crassus with the head of his son fixed on a spear, a sight that fills the Roman troops with dismay and panic.

38. Trans. W.R. Paton. Cf. Diodoros, who describes how the Gauls, having defeated the Romans outside Rome (386 BCE), 'spent the first day cutting off, according to their custom, the heads of the dead' (14.115.4) (trans. C.H. Oldfather). Likewise, Polybios (8.30.12) has the Gauls serving under Hannibal 'despoiling' the Roman corpses lying in the streets of Tarentum (212 BCE).

39. Erected in 315 CE to celebrate Constantine's ten years on the throne, the Arch was decorated both with reused sculptural reliefs, which included sections of the 'Great Trajanic Frieze', and with contemporary friezes honouring Constantine, including one depicting the battle of Milvian Bridge in October 312 CE. See H.P. L'Orange and A. von Gerkan, *Der Spätantike Bildschmuck des Konstantinsbogen* (Berlin, 1939); Hannestad, *Roman Art* (above, n. 23), 319–26.

40. According to Lucian (*Alexander* 48), Marcus Aurelius lost 20,000 men alone in the first offensive across the Danube. After this, the fighting took on the character of a war of extermination. See A.R. Birley, 'Die Aussen- und Grenzpolitik unter der Regierung Marcs Aurels', in R. Klein (ed.), *Marc Aurel* (Darmstadt, 1979), 473–502, at pp. 485–6.

41. See scene LXI, which depicts Germanic tribesmen, guarded by auxiliary cavalry, beheading their compatriots. On the Column of Marcus Aurelius, see C. Caprino, A.M. Collini, G. Gatt, M. Pallottino and P. Romanelli, *La Colonna di Marco Aurelio* (Rome, 1955); Hannestad, *Roman Art* (above, n. 23), 236–44.

42. Diodoros 5.29.4; Strabo 4.4.5; Livy 10.26.11; cf. iron age silver *phalerae*, which once decorated Gallic horse-harnesses, depicting severed human heads (Museo Civico Romano, Brescia).

43. See the iron age bronze fibula in the form of a naked Celtiberian horseman with his horse trampling a severed human head (Museo Arqueológico Nacional, Madrid).

44. Brunaux, *Les gaulois* (above, n. 11), 109–10. For the image of the horseman in pre-Roman Celtic art, see M.J. Green, *Animals in Celtic Life and Myth* (London, 1992), 72–6. On Nâges, see M. Py, 'Les fanums de Castels à Nâges et de Roque-de-Viou', *Documents d'Archéologie Méridionale* 15 (1992), 44–9.

45. Leander Touati, *The Great Trajanic Frieze* (above, n. 32), 44–5. On the *equites singulares Augusti* see, especially, M.P. Speidel, *Riding for Caesar: the Roman Emperors' Horse Guards* (London, 1994).

Execution in effigy: severed heads and decapitated statues in imperial Rome

Eric R. Varner

INTRODUCTION: ROMAN PORTRAITS AS BODY DOUBLES

REPRESENTATIONS of Roman emperors and empresses crafted in marble or bronze functioned as surrogates for real imperial bodies, artistic evocations of the imperial presence that were replicated and disseminated everywhere in the Empire. Just as the corporeal being of the emperor, as supreme ruler of the Mediterranean, was endowed with his divine essence or *genius*, and came to be elevated conceptually above the bodies of his subjects, so too imperial images were conceived differently from those of private individuals. Unlike most of their subjects, the emperor or empress could exist as effigies in multiple bodies that took the form of portrait statues populating every kind of Roman environment such as *fora, basilicae*, temples, baths, military camps and houses.

Rome's first emperor, Augustus, claimed for himself the tribunician powers (*tribunicia potestas*) in perpetuity, which brought with it the inviolability of his physical person (*sacrosanctitas*). In an extraordinary extension of this right, his wife Livia and his sister Octavia were also granted *sacrosanctitas* in perpetuity in 35 BCE.[1] Significantly, the decree that confirmed the inviolability of Livia and Octavia's bodies also conferred on them the privilege of public honorific portraits. All subsequent emperors continued to hold the tribunician powers, and prominently stressed the fact and its attendant rights (like inviolability) in their honorific inscriptions on monuments and coins, which invariably include the abbreviations *trib pot* (or *tr p*). Indeed *sacrosanctitas* became a prerogative essentially limited to the imperial family, firmly underscoring the different status and inviolability of the imperial body.[2]

Roman law and custom also carefully prescribed the correct treatment of imperial images. Already in the early imperial period, during the Principate of Rome's second emperor, Tiberius, a citizen was prosecuted for removing the head from a portrait statue of Augustus and replacing it with another likeness. Subsequently, beating a slave in the presence of an image of Augustus, changing clothes near his portraits, and carrying his image on a coin or ring into a latrine or brothel were all proscribed as capital crimes.[3]

By the early second century CE, the equation between imperial portrait statues and physical bodies was firmly established. When Trajan died at Selinus in Cilicia on 8 August 117 CE, his body was cremated there and his ashes were returned to Rome by the army. Here, another funeral (and consecration) was held for Trajan, and it included a second cremation in which a wax portrait of the emperor was burned on a pyre, effectively a funeral of portraits or images (*funus imaginarium*).[4] In addition, Trajan was awarded a posthumous triumph for his Parthian victories and, despite his death, he was able to participate in the celebrations at Rome as an effigy when his portrait statue rode in the four-horsed chariot (*quadriga*) at the head of the triumphal procession.[5] Later, obsequies involving images, rather than corpses, were presumably held for emperors who died and were cremated outside Rome, including Lucius Verus, Marcus Aurelius, Septimius Severus and Caracalla.[6]

The elision between artistic effigies and real bodies was often strengthened during moments of political instability or transition, also explaining the important role of images in imperial funerals.[7] Bahrani considers that Freudian concepts of the uncanny can be read in ancient Near Eastern approaches to royal images as *doppelgängers* of the ruler, and the uncanny may similarly be an underlying aspect of Roman animistic responses to imperial portraits.[8] The animism that seems to have enlivened Roman popular perceptions of images continued into the late Roman period, as witnessed by the Byzantine attitudes towards earlier pagan sculptures that endowed them

with magical or demonical properties.[9] In Roman aesthetic terms, the confusion between image and reality surfaces in Callistratus, where artistic objects are described as sentient, animate beings that breathe, move, speak and express emotion.[10] In social, psychological and political terms, the animistic apprehension of images meant that the treatment of a portrait was exactly analogous to the treatment of an individual's physical body.[11]

Imperial bodies and the sculpted images that were their index could be reviled as well as revered. Roman imperial portraits were often mutilated or destroyed deliberately as a result of *damnatio memoriae*. *Damnatio memoriae* is a modern term that covers a list of flexible sanctions that could be enacted by the Senate, emperor or army, and were designed to censure or distort the posthumous memory and reputation of a condemned individual.[12] The list of emperors, empresses and individuals connected with the imperial family who suffered some form of posthumous condemnation, often encompassing the mutilation of their images, is impressively long and spans the late first century BCE into the fourth century CE.[13]

Pliny the Younger appeals to his audiences by employing an animistic rhetoric in his anthropomorphic description of the destruction of Domitian's portraits after his assassination on 18 September 96 CE. In Pliny's account the gold and silver portraits of Domitian are hacked to pieces and dismembered 'as if blood and pain would follow every single blow', and Domitian was effectively murdered again in effigy multiple times.[14] In the *Octavia*, the historical drama that details the downfall of Nero's first wife, the disgruntled populace attacks the images of Octavia's rival Poppaea as surrogates for assaulting her living body.[15] The substitution of portraits for real, physical bodies was further underscored in Dio's account of the mutilation of the statues of Tiberius's praetorian prefect, Sejanus, where again an angry mob assaults and dismembers his images as if they were the man himself (58.11.3).

In an inversion of the celebratory rights of funeral or triumph that could employ sculptural effigies, the *Historia Augusta* recounts the crucifixion of a portrait of Celsus, a probably fictitious usurper of the mid-third century. Celsus is reported to have been a rival emperor, for seven days, to Gallienus. Following Celsus's murder, the inhabitants of Sicca (modern el-Kef in Tunisia) crucified one of his images: 'and in a new kind of outrage, his portrait was hoisted on a cross, with the crowd running around as if they were

seeing Celsus himself on the gibbet'.[16] Not coincidentally, crucifixion was associated in the mind of ancient Romans with the severest form of execution, known as *summum supplicium*.[17] Although it is likely an invention of the author of the *Historia Augusta*, the crucifixion of Celsus's portrait dramatically reveals the interchangeability of physical bodies and artistic representations, and powerfully illustrates the concept of execution in effigy (*executio in effigie*).[18]

As Trajan's second funeral demonstrates, sculpted portraits not only acted as artistic substitutes for living bodies, but also for dead ones. The role of effigies in imperial funerary ritual may also have developed because it was deemed inappropriate or even traumatic for the public to view the physical corpse of the deceased ruler, which was therefore replaced with an artistic effigy. Indeed, as apotheosis was one of the intended outcomes of imperial funerary ritual, effigies, 'untainted by human mortality and corruption', are in some ways more appropriate for the ceremonial than the corpse itself.[19] As part of the process and praxis of *damnatio memoriae*, the deliberate disfigurement of images representing Rome's 'bad' emperors and empresses (such as Caligula, Messalina, Nero, Domitian, Commodus and Elagabalus) reflects the practice of corpse abuse (*poena post mortem*). When an emperor, empress or rival for imperial power was overthrown or assassinated, their memories were invariably condemned and their artistic monuments attacked, destroyed or altered. In some instances their physical remains were also publicly mutilated.[20]

As alternative, artistic bodies, portraits of overthrown Roman rulers existed in many copies and were vulnerable to the disfigurement and defilement that imperial corpses often escaped. Intentionally mutilated marble and bronze images of the 'bad' emperors, and many others, all attest to the widespread nature of this kind of 'surrogate corpse abuse'.[21] Violent attacks on imperial images were usually concentrated on the face and destroyed the vital sensory organs of the eyes, nose, mouth and ears, thus negating any metaphorical power of the image to 'see', 'hear' or 'speak', as an effigy. A disfigured representation of Macrinus now at Harvard is paradigmatic of the process of sculptural mutilation (Fig. 7.1).[22] The ears, eyes, nose and portions of the mouth have all been attacked and obliterated with a chisel. The rest of the marble surfaces, however, including the finely textured hair and beard and the smoothly polished skin, are exceedingly well preserved. Such defaced images still retain enough of

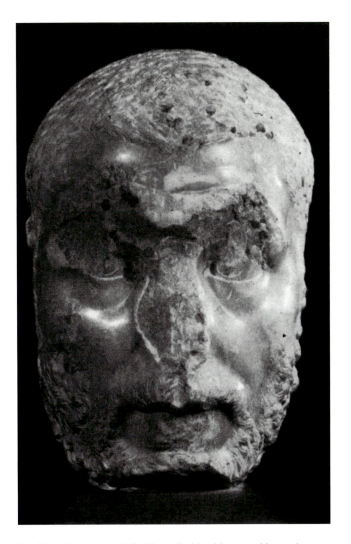

FIG. 7.1. Macrinus, c. 215–17 CE, Sackler Museum, Harvard University, Harvard, inv. 1949.47.138. *Photo: Photographic Services, © 2004 President and Fellows of Harvard College. Reproduced courtesy of the Arthur M. Sackler Museum, Harvard University Art Museums, Alpheus Hyatt Purchasing Fund.*

their original identity to be recognizable as likenesses of the condemned individual, and some are likely to have continued to have been displayed publicly as powerful visual signifiers of posthumous denigration. Moreover, the violation of crafted portrait bodies through mutilation that mirrored the desecration of corpses also represents a transgression of physical boundaries, further serving to blur the lines between animate and inanimate.[23]

BODILESS HEADS

Corpses and portraits were also abused by decapitation. For living bodies, decapitation (*capitis amputatio*) was considered the third most severe form of capital punishment after the fork (*furca*, which can be associated with crucifixion) and burning alive.[24] Well-known examples of decapitation from the end of the Republic include Pompey, Cicero and Brutus. Following the Battle of Phillipi, Pompey fled to Egypt, where he was stabbed to death on 28 September 48 BCE and his corpse beheaded; the severed head was eventually mummified as a perpetual trophy (Lucan 8.663–91). Cicero was decapitated in 42 BCE and his severed head and hands were sent back to Rome for display on the rostra in the Forum Romanum.[25] Cicero's amputated head is itself even described as a portrait (*imago*), further problematizing and dissolving the distinctions between dismembered bodies and their mimesis in art.[26] After the Battle of Phillipi, also in 42 BCE, Brutus's severed head was sent to Rome by Octavian, where it was thrown at the feet of a portrait of Julius Caesar, providing another symbolically charged interaction between bodily parts and sculpted effigies (Suetonius, *Divus Augustus* 13). Indeed, Richlin has argued perceptively that the proscriptions and decapitations of this period are themselves monuments.[27]

Although the only recorded instance of the execution of an imperial person by decapitation does not appear until the fourth century, with the death of the junior emperor Constantius Gallus, who was Caesar under Constantius II, several earlier imperial corpses were beheaded in acts of *poena post mortem*. This politically charged form of corpse abuse carried with it the connotations of public executions, and was also often inflicted on the bodies of failed political rivals and defeated national enemies, such as the Dacian leader Decebalus. After Decebalus's suicide in 107 CE, his severed head and right hand were sent to Rome and thrown down the Gemonian steps, which led from the Capitoline Hill to the Forum Romanum, a traditional location for the display of mutilated bodily remains of political victims.[28] Execution by decapitation and corpse abuse are also closely intertwined in Ammianus Marcellinus's account of the death of Constantius Gallus, in 354 CE: 'He [Constantius II] marked him [Gallus] out for capital punishment. As a result, with his hands tied up in the way of a convicted thief, the neck severed, and the respectability of face and head ripped away, he was left a disfigured cadaver'.[29]

Lollia Paulina, a former wife of Caligula, is the first person associated with the imperial sphere whose corpse is recorded to have been decapitated after her death in 49 CE.[30] Interestingly, the second imperial

corpse recorded as having been decapitated was also that of a woman, Claudia Octavia, Nero's first wife, who was executed on the island of Pandateria and whose severed head was brought to Rome and displayed to Nero's second empress, Poppaea.[31] The decapitations of Lollia Paulina and Claudia Octavia invested the female power struggles in which these women were involved with the physical rhetoric of corpse abuse previously associated almost exclusively with male political rivalries.

The charged political climate following Nero's overthrow witnessed two imperial decapitations in 69 CE. After the murder of Nero's immediate successor, Galba, his head was cut off and carried to the new Emperor Otho, who allowed it to be stuck on a pole and reviled. Eventually the head was reunited with the cadaver and interred in Galba's private gardens on the Via Aurelia.[32] The corpse of Otho's successor, Vitellius, was similarly abused and his severed head paraded through Rome (Dio 64.21.2).

The later second and third centuries witnessed a dramatic increase in the number of beheaded bodies as well as corpse abuse in general, which is paralleled by the increased frequency of mutilated images, perhaps caused by the political, social, economic and military instability of the Empire during this period. In 172 CE, approximately 100 years after the decapitations of 69 CE, Avidius Cassius (who had declared himself emperor in opposition to Marcus Aurelius) was apprehended and killed. Soldiers amputated the head of Avidius Cassius from his body and presented it to Marcus Aurelius, who is recorded to have expressed his disgust at this corpse abuse (Dio 71[72].27.2–3). Later, in 193 CE, the Emperor Pertinax was murdered by disaffected troops who then abused his corpse by decapitation; Dio, an eyewitness, described the elaborate funeral that Septimius Severus ultimately awarded Pertinax several months after his death.[33] Like Trajan, a sculpted effigy replaced the emperor's body in the obsequies. Dio also recounts details of the young male attendant who tended the effigy of Pertinax with a peacock feather fan to keep the flies away, 'as if it were a real sleeping person'. Although his physical corpse had been mutilated through decapitation, the effigy allowed Pertinax to have an official state funeral and consecration.

Two rivals of Septimius Severus, Pescennius Niger and Clodius Albinus, were both proclaimed official enemies of the Roman state (hostes) and were posthumously decapitated.[34] Later in the Severan period, forces loyal to Elagabalus also beheaded the corpses of the usurper Macrinus and of his son and heir Diadumenianus, after their defeat on 16 May 218 CE.[35] Four years later, however, Elagabalus and his mother, Julia Soemias, were themselves murdered and their corpses publicly mutilated in Rome and decapitated.[36] The Severan dynasty was brought to an end by the soldier emperor Maximinus Thrax in 235, who was himself defeated and killed in 237 CE, when his remains and those of his son Maximus were mutilated and exposed as carrion. Their corpses were further violated by decapitation and their severed heads are said by Herodian to have been paraded through the streets of Rome in a parody of the triumphal procession (8.5.9). Decapitation as corpse abuse was still being practised in the early fourth century, when the body of Maxentius was recovered from the Tiber and beheaded after his defeat by Constantine at the Battle of the Milvian Bridge on 28 October 312.[37] Maxentius's head was placed on a pole, carried throughout the capital and reviled by his former subjects.

The political rationale for decapitating an overthrown emperor's or defeated rival's corpse and displaying the severed head to the public was obvious, as it unequivocally proclaimed in the most graphic and visual terms that the enemy was dead and no longer posed a threat to public order and well-being.[38] In addition, it unambiguously marked the disintegration of their corporeal power. Indeed, without the incontrovertible proof of death provided by decapitation, popular doubts could ensue about the demise of an overthrown ruler, as happened to Nero, a popular and charismatic leader whose body was not decapitated. The lack of physical evidence concerning his death engendered several posthumous impostors, the so-called 'false Neros'.[39] Heads decapitated outside Rome may have been treated carefully with preservatives such as cedar oil in order to prevent them from decaying beyond recognition, before being shipped to the capital for public display.[40] Decapitation acted as a powerful deterrent and successful strategy for inculcating terror in the enemy, but it also can have held important religious implications; if the head and body become separated, funerary rituals cannot be enacted properly, nor the remains properly interred.[41] Ultimately, defeated corpses subjected to decapitation, dismemberment and mutilation were no longer citizen bodies with their attendant rights and privileges, but branded as outside Roman societal boundaries, disgraced (infamis), harmful and guilty (noxius).[42] Literary descriptions of successful assassinations also attempt to represent emperors who had been condemned as

tyrants, as outside societal margins, and to dehumanize them by employing language associated with the hunting and destruction of dangerous wild beasts.[43]

Audiences in Rome would have interpreted the display of severed heads of failed emperors and imperial rivals partially within the context of the visual rhetoric of decapitated foreign enemies memorialized on major public monuments, such as the Great Trajanic Frieze and the Columns of Trajan and Marcus Aurelius.[44] The triumphal imagery of imperial conquest as expressed in the display of severed enemy heads on the Great Trajanic Frieze and the two columns was also reflected in private funerary art, including the Portonaccio sarcophagus carved c. 180–90 CE.[45] The Roman trophy at the left side of the body of the sarcophagus appears to be surmounted with a severed enemy head wearing a helmet. Heads of Gauls resembling theatrical masks are also used to decorate the corners of Roman sarcophagus lids, as for instance that of the Ludovisi sarcophagus in Mainz, or a lid of Thasian marble from the necropolis at Ostia, which also depicts personifications of provinces including Germania, an African province and possibly Vindelicia.[46] The Ostian lid additionally includes the grisly detail of a burning torch on its left side thrust up against the long hair of the Gaul's head.

Mythological severed heads, like those of Medusa, were also prominently displayed throughout the city of Rome, and they would have provided additional visual and ideological referents against which Roman audiences could interpret and understand the display of real severed heads.[47] Augustus employed the image of Medusa's severed head in several major building projects. For instance, polychrome terracotta plaques depicting Perseus presenting Medusa's severed head to Minerva formed an important component of the iconography of the Temple of Apollo Palatinus, where they allude to the defeat of the foreign queen Cleopatra. In addition to their apotropaic function, the severed Medusa heads also symbolize the triumph of order over chaos and the successful neutralization of the dangerous and threatening other.

Although countless imperial Roman portrait heads and their original statue bodies have been separated accidentally or incidentally, or even deliberately in the post-antique period, several surviving heads of condemned emperors and empresses were intentionally severed from their bodies in antiquity. This intentional decapitation of imperial images mirrors in effigy the beheadings of real bodies in executions or in the abuse of corpses. Two bronze heads of Nero were amputated

from their original statue bodies in just such acts of execution or abuse. A youthful portrait, created between 54–9 CE and now in the British Museum, was thrown into the River Alde after its decapitation, and a mature and gilded portrait, apparently created in Rome from 64–8 and now in a private collection, was buried after having been violently detached from its statue (**Fig. 7.2**).[48] Nero himself committed suicide in June of 68 CE, and his corpse was not defiled, but these two images, from geographically diverse locations of the Empire, both centre and periphery, allowed him to be executed and abused in effigy following his condemnation as a *hostis* and the attendant sanctions against his memory and monuments.

The third century provides several striking examples of statues beheaded in effigy. A marble portrait of Plautilla clearly has been severed from its body, as traces

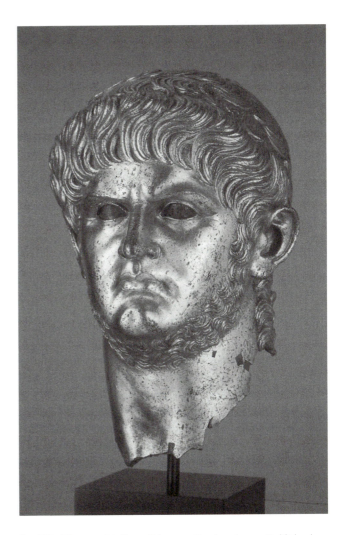

FIG. 7.2. **Nero, c. 64–8 CE. Private collection.** *Image © Michael C. Carlos Museum of Emory University. Reproduced courtesy of the Michael C. Carlos Museum.*

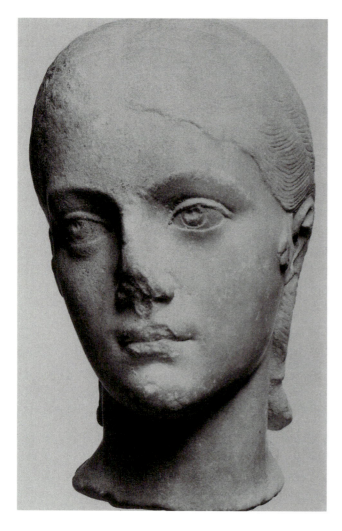

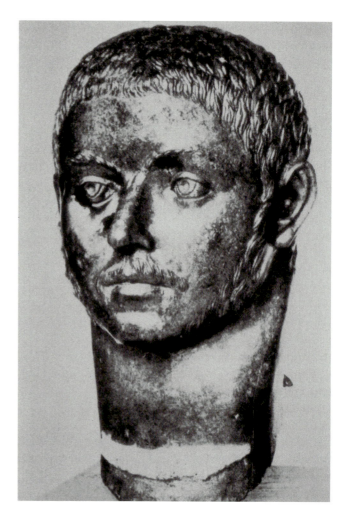

FIG. 7.3. **Plautilla**, *c.* 203–5 CE, The J. Paul Getty Museum, Villa Collection, Malibu, California, inv. **72.AA.118**. *Photo: © The J. Paul Getty Museum. Reproduced courtesy of The J. Paul Getty Museum.*

FIG. 7.4. **Severus Alexander**, *c.* 225–35 CE, Bochum, Kunstsammlungen der Ruhr-Universität. *Photo: after B Andreae, 'Der Bronzekopf des Kaisers Severus Alexander in der Sammlung Paul Dierichs', in M. Imdahl and N. Kunish (eds), Plastik: Antike und Moderne Kunst der Sammlung Paul Dierichs (Kassel/Bonn, 1979), 99.*

of drapery are still discernible at the right of the neck close to the clavicle (**Fig. 7.3**).[49] A bronze portrait of Macrinus now in Belgrade also has been decapitated from its statue, just as his physical corpse was despoiled of its head.[50] Two additional bronze portraits, representing Severus Alexander (**Fig. 7.4**)[51] and Gordian III,[52] were both mutilated and decapitated during spontaneous demonstrations against these emperors' memories. Although neither emperor was officially condemned, and in fact Severus Alexander was later deified, their portraits were vandalized in the periods of political uncertainty that occurred immediately after their murders. Like the bronze Nero from the Alde, the Gordian III was thrown into a river, the Jantros, after its amputation. A bronze portrait of Philip Minor, son of Gordian III's successor, Philip the Arab, reportedly from Asia

Minor,[53] was also subjected to decapitation, while two bronze heads of Philip the Arab's successor, Trajan Decius, in Florence[54] and Deva,[55] have been similarly amputated. Later in the third century, a bronze head of Gallienus was hacked from the body to which it originally belonged and then thrown into a well.[56] Like the head of Macrinus in Belgrade, the decapitation of this image of Gallienus reflects in effigy the physical mutilation of his corpse mandated by the senate.

Not only were the images of reviled emperors severed from their bodies, but representations of revered Roman rulers could also fall into enemy hands and be decapitated, including a severed bronze head of Augustus captured by the Ethiopians *c.* 25–20 BCE. Amputated from its original cuirassed body, the head was placed beneath the steps of a sanctuary of Victory at

Meroe in the Sudan, where it could be literally trampled and symbolically defiled by visitors to the site.[57]

The great number of bronze heads in the corpus of decapitated images of condemned emperors is striking. These portraits could have been recycled by being melted down, as Pliny indicates was the case with the gold and silver representations of Domitian. Nevertheless, these bronze images were instead amputated from the bodies to which they belonged and then buried or discarded in bodies of water, which suggests that the act of decapitation and the execution in effigy it reflects, as well as the subsequent disposal of the severed head, was of greater value than the metal content of the portrait itself. Presumably many of the bodies to which these decapitated likenesses belonged were reused through the addition of a new portrait head, most often representing the victorious successor of the condemned emperor. Ironically, the decapitation and subsequent disposal of the bronze heads preserved them for posterity, while it left their bodies vulnerable to being melted down or otherwise destroyed in the post-classical period.

HEADLESS BODIES

Portrait bodies in commemorative reliefs and paintings were also decapitated and left in their headless state as signifiers of posthumous denigration. Several heads of Geta have been systemically severed from their bodies in a variety of contexts after his murder and subsequent condemnation late in 211 CE. On the southwest face of the attic of the Arch of Septimius Severus at Leptis Magna, Geta's portrait head has been detached from a relief representing imperial harmony (*concordia*) and buried near the arch (**Fig. 7.5**).[58] In the central scene

Geta's father, Septimius Severus, and his elder brother, Caracalla, clasp right hands (*dextrarum iunctio*) as Geta stands between them. Behind Geta, the goddess Concordia confirms the theme of imperial harmony. The relief preserves no evidence for the attachment of a new marble likeness, and Geta's conspicuously headless figure continued to stand at the direct centre of the relief flanked by the intact images of his father and brother (**Fig. 7.6**). In potent contrast to their untouched images, the mutilated likeness of Geta is a powerful visual testament to his murder and condemnation at the hands of Caracalla and belies the message of imperial harmony that the relief professes to avow. Geta's likeness also has been deliberately beheaded from the northwestern panel depicting Septimius and his two sons in the triumphal *quadriga*, as well as in at least two of the vertical panels from the internal faces of the arch's four piers.[59] In all, the Leptis arch appears to have contained at least six decapitated representations of Geta, and they stood as grim and multiple reminders of his murder, condemnation and subsequent execution in effigy.

In Rome, relief portraits of Geta may also have been beheaded in two scenes on the Arch of Septimius Severus in the Forum Romanum, as well as in the Palazzo Sachetti relief. In the southeastern panel, which represents an imperial address (*adlocutio*) at Nisibis (scene I.C), the head and upper section of the torso belonging to a figure flanking Septimius Severus have been severed, and this figure is likely to have originally represented Geta.[60] On the southwestern panel, Geta appears to have been similarly decapitated in another scene of *adlocutio*, this time at Ctesiphon, where Geta appears to his father's left (scene IV.B). Although these two figures of Geta are badly damaged and weathered, there is again no evidence that the heads were replaced

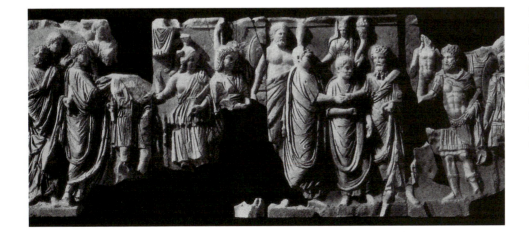

FIG. 7.5. **Scene of imperial *concordia* (Septimius Severus, [Geta,] and Caracalla), c. 206–11 CE, Arch of Septimius Severus, Leptis Magna, now in Archaeological Museum, Tripoli.** *Photo: Deutsches Archäologisches Institut, Rome, neg. no. 61.1701, Koppermann. Reproduced courtesy of the Deutsches Archäologisches Institut, Rome.*

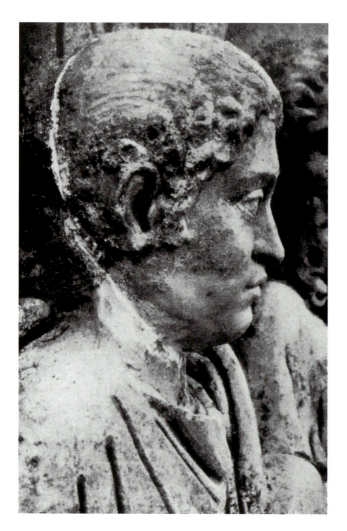

FIG. 7.6. Detail of the scene of imperial *concordia*, showing the break line where the head of Geta was removed and a copy has now been reattached. *Photo: Deutsches Archäologisches Institut, Rome, neg. no. 61.1701, Koppermann. Reproduced courtesy of the Deutsches Archäologisches Institut, Rome.*

with new likenesses. The Palazzo Sachetti relief derives from an officially sponsored monument, probably commemorating Caracalla and Geta's joint consulship of 205.[61] The shorter headless figure flanking the seated emperor is likely to have represented Geta, and his head has been severed at the base of the neck.[62] As at Leptis Magna, the multiple mutilated images of Geta on the Forum Arch, as well as his headless figure in the Palazzo Sachetti relief, would have been graphic mementoes of his downfall and condemnation.

Geta's image was also decapitated in the only surviving painted imperial portrait, a wooden tondo discovered in the Fayum and now in Berlin (**Fig. 7.7**).[63] The tondo depicts the founding members of the Severan dynasty: Septimius Severus, Julia Domna and their two sons, Caracalla and Geta. Geta's head has

been erased from the painting but his upper torso has been left as a beheaded image. As in the relief monuments, the juxtaposition of the decapitated figure of Geta with the unmarred likenesses of his entire immediate family (father, mother and brother) transforms the painting into a discordant and startling image of family disharmony and dynastic disunity. All of these headless representations of Geta expressed visually the cancellation of his imperial authority and identity and the ascendant power of his older brother as sole emperor. The act of beheading Geta's portraits and executing him in effigy simultaneously disavowed any former support for the murdered and condemned brother, as well as affirming loyalty to Caracalla's new regime. The headless figures of Geta left in the reliefs and painting become the visual testament to the act, and the resulting disruptions of the artistic compositions are of far less conceptual importance than the act of decapitation itself.

Just as images could be left headless in reliefs and painting, free-standing portrait bodies may have been publicly displayed in decapitated form, at least for a time. In Roman portraits, identity resides in the head, centred on the individual configuration of the facial features. As a result, the conceptual focus of effigies that are mutilated is the face.[64] Evidence suggests that disfigured heads, attached to bust forms or bodies, remained on public view for a time as denigrative memorials. For instance, the unusual method of reuse employed in a colossal marble portrait of Severus Alexander in Naples, refashioned from a statue of Elagabalus, suggests that the original image was disfigured and allowed to remain on public view in the Baths of Caracalla for at least three years.[65] In this image, the facial features of Elagabalus have been cut from the head and replaced with a new face of Severus Alexander. The original face of Elagabalus was likely to have been mutilated, making re-carving of the features impossible and necessitating the mask-like addition. The portrait type employed for Severus Alexander was not introduced until *c.* 225, suggesting that the disfigured Elagabalus may have been left on display in the baths from the time of his murder in 222 until its reuse approximately three years later.

Decapitated statue bodies left on public display functioned as denigrative memorials. Bodies were stock types that served as visual props to add additional iconographic meaning to the portrait. Emperors and other imperial males could be represented as generals in armour, wearing the toga, in heroic nudity, or in the guise of various deities. For empresses and other

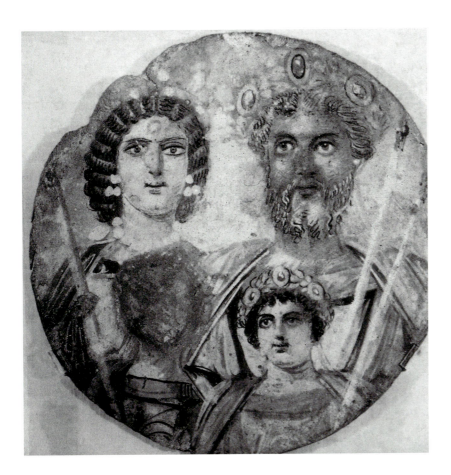

FIG. 7.7. **Septimius Severus, Julia Domna, [Geta,] and Caracalla**, c. 198–205 CE, Staatliche Museen, Berlin, inv. 31.329. *Photo: Deutsches Archäologisches Institut, Rome, neg. no. 69.159. Reproduced courtesy of the Deutsches Archäologisches Institut, Rome.*

imperial women, there were a variety of draped and divine body types. Within the conventions of Roman portrait sculpture, a headless statue body has been largely deprived of its identity and its function as a representation of a specific individual. Nevertheless, accompanying inscriptions could have attested to the former identities of these decapitated bodies. In particular, a cuirassed statue of Nero in Istanbul, originally carved from a single block of marble, has been deprived of its head (**Fig. 7.8**).[66] If the statue was allowed to remain on public view after Nero's suicide, its surviving dedicatory inscription: 'To Nero Claudius, son of the god Claudius', would have confirmed, to literate audiences, the headless body's identity as a derogatory image of the recently condemned emperor executed in effigy.

A headless cuirassed statue that formed part of a large Julio-Claudian dynastic dedication from the Roman theatre at Caere may be a similarly decapitated likeness of Nero.[67] Although the body could conceivably have been reused through the addition of a new likeness, no portrait head that can be associated with this statue was discovered in the excavations at Caere. It is the only one of the six surviving statue bodies from the statuary cycle to be missing its corresponding head. The blatantly Neronian imagery of the reliefs decorating the breastplate, which depict the sun god Apollo Helios assimilated to Nero's fourth portrait type, perhaps reflecting the designs woven into the purple and gold covering created for the Theatre of Pompey in Rome during the visit of Tiridates in 66, may have precluded the co-option of the statue by another imperial personage.[68] If so, the statue could have continued to be displayed as a powerful decapitated icon of Nero against the backdrop of the intact representations of his predecessors and ancestors. Even if the statue was eventually reconfigured through the addition of a new portrait head, it is plausible that it was displayed in headless form while awaiting its new likeness.[69]

Although more difficult to date precisely than cuirassed bodies, togate statues belonging to Rome's 'bad' emperors also may have been left for a time in a decapitated state. For instance, the togate body into which a veiled head of Nero was originally inserted, from the Palatine, may have been displayed as a headless image before a replacement likeness was added.[70] Indeed the time required for the production of

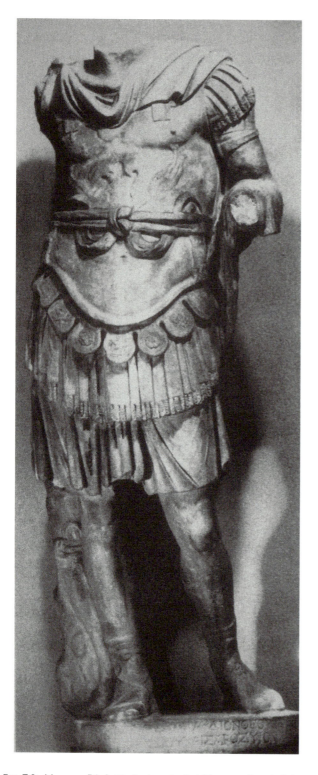

FIG. 7.8. **Nero,** c. 54–9 CE, Archaeological Museum, Istanbul, inv. 584. *From K. Stemmer,* Untersuchungen zur Typologie, Chronologie und Ikonographie der Panzerstatuen *(Berlin, 1978) no. 185.*

marble images of the new victorious ruler following the overthrow of a condemned emperor (in Nero's case, Galba) strongly suggests that some decapitated images

must have remained publicly visible, at least for a short while. The Palatine head of Nero was discovered in a cryptoporticus of the Temple of Apollo Palatinus, and the original statue is likely to have been displayed, in both its intact and decapitated states, within the architectural context of the temple.

Caligula's images also were not immune from decapitation. Indeed an attempt was made to decapitate an over-life-sized togate statue now in Richmond, Virginia. Carved from a single block of Luna marble, the statue reputedly was discovered in the vicinity of the Theatre of Marcellus at Rome. A deep chisel gouge runs around the base of the neck, along the border of the toga, and is evidence for an abandoned attempt to detach the head from the body.[71] A second togate portrait of Caligula, which was part of a cycle of Julio-Claudian portraits decorating a building dedicated to the imperial cult at Velleia, was also decapitated prior to its reconfiguration as a likeness of Claudius. In its original incarnation, the statue was carved from a single block of marble; severe chipping and missing sections from the top of the shoulders have been caused by hammer blows that detached Caligula's portrait head from the body. Eventually, a mortis was prepared in the chest to receive the current, separately worked, likeness of Claudius. A statue of Claudius's (second) wife Messalina from the same cycle of portraits at Velleia was decapitated and transformed in an identical manner into a likeness of Claudius's third wife, Agrippina the Younger.[72] Before the substitution of the new heads of Claudius and Agrippina the Younger, these statues also may have been displayed at Velleia as decapitated images.

The portrait statues that mirrored the physical reality of imperial bodies consisted of two conceptually distinct parts: the head, in which individual portrait identity and power resided, and the statue bodies, which functioned as props to convey additional iconographic meaning. Indeed, for marble portrait statues, head and body were often carved separately, making 'decapitation' a simple matter of removing the offending head (and usually replacing it with a new likeness). Thus, the physical separation of head and body should not be surprising in times of political crisis or transition for the Roman state. What is perhaps more controversial is the notion that these beheaded marble and bronze bodies may have remained on public view, emphatically punctuating the visual landscape of the empire. Headless statue bodies would have borne eloquent testimony to the death and disgrace of the condemned individual, and, in the case of emperors,

their permanent removal, through assassination or death, as head of state. Decapitations deliberately dissociate head and body, and served to deprive the statue of its original incarnation as a representation of the overthrown and repudiated ruler or imperial individual, and were most often preparatory to the addition of a new portrait likeness, usually a victorious successor. Furthermore, the substitution of heads allowed the new emperor to reclaim the artistic body of the statue as his own.

CONCLUSION: METAPHORICAL BODIES

When an emperor was overthrown, the *sacrosanctitas* that had protected his physical being was obviously also cast aside, leaving his body and its artistic index vulnerable to mutilation and decapitation. The bodies of 'bad' emperors who were perceived to have violated the body politic, or other political entities like the Senate, were mutilated in metaphorical retaliation.[73] Indeed, the *Historia Augusta*, purportedly quoting from the earlier historian Marius Maximus, makes the relationship between conceptual bodily compensation and mutilation explicit in its account of the senatorial deliberations concerning the abuse of the corpse of Commodus: 'he who murdered the Senate, let him be dragged by a hook',[74] referring to the dragging of a corpse through the streets of Rome before throwing it in the Tiber. The connection between the violation of physical bodies and the destruction of the Roman body politic is also vividly explored by Lucan when he employs graphic and grotesque scenes of death and dismemberment to invoke symbolically Caesar's destruction of the Republic.[75]

Rome was the head of the world (*caput mundi*), and the emperor was its acknowledged head. Again, Lucan explicitly acknowledges the linkages between the concepts of a head of state (in this case *caput orbis*) and the physical beheading of a ruler when Gnaeus Pompey, unaware of the death and decapitation of his father, ironically asks of his brother Sextus: 'Tell me, brother, where is our father; does he remain the *summa* and head of the world?'.[76] The assassination or forced suicide of the emperor figuratively decapitated the Roman state by depriving it of its head, and was re-enacted in effigy through the decapitation of images.

The evident importance placed on the execution in effigy of the portrait statues of condemned rulers underscores the performative aspect of the Roman life.[77]

Indeed, re-enactment is at the heart of Roman cultural experience and artistic practice. For instance, capital punishments staged as mythological re-enactments were a major component of arena spectacles, vividly recreating myths through the staging of grisly deaths.[78] In the realm of commemorative monuments, the Arch of Titus in the Roman Forum encourages a conceptual re-enactment of Titus's triumphal procession of 70 CE on the part of the viewer, while the helical band of relief sculpture on the Column of Trajan allows the viewer the possibility of recreating the *circumambulatio* (a key feature of Roman funerary ritual) around Trajan's ashes, which were contained in the Column's base.[79] Even the placement of sculptures in sites associated with historical or mythico-historical events could be deliberately evocative and designed to simulate the original experience. The experiential component of ancient Roman art is a driving force behind violent attacks on imperial likenesses and executions in effigy. As surrogate bodies, portrait statues allowed the populace of Rome physically to vent their violence and bloodlust against overthrown rulers and actively to engage, albeit in a highly negative manner, with the omnipresent imperial image.

Notes

Many thanks are due to Ann Kuttner for countless stimulating suggestions and observations on the topic of decapitation. As always special thanks to Brad Lapin for much needed editorial assistance and moral support. All translations are my own.

1. Dio, *Roman History* 49.38.1–2; N. Purcell 'Livia and the womanhood of Rome', *Proceedings of the Cambridge Philological Society* 32 (1986), 78–105, esp. p. 85; M.B. Flory, 'Livia and the history of public honorific statues for women in Rome', *Transactions of the American Philological Association* 123 (1993), 287–308, esp. pp. 293–4; E. Bartman, *Portraits of Livia: Imaging the Imperial Woman in Augustan Rome* (Cambridge, 1999), 62, 94; S. Wood, *Imperial Women: a Study in Public Images, 40 B.C.– A.D. 68* (Leiden, 1999), 32, 77, 92.

2. The Vestal Virgins also enjoyed *sacrosanctitas*, see Bartman, *Portraits* (above, n. 1), 94.

3. Suetonius, *Tiberius* 58. See also *Digesta* 48.4.4.1–6; M.H. Crawford, 'Roman coin types and the formation of public opinion', in C.N.L. Brooke (ed.), *Studies in Numismatic Method Presented to Philip Grierson* (Cambridge, 1983), 47–64, esp. p. 49.

4. J. Arce, *Funus imperatorum: los funerals de los emperadores romanos* (Madrid, 1988), 49, 171–2. On the Roman tradition of the *funus imaginarium* before Trajan, which may have had Spartan precedents, see V.H. Chantraine, "Doppelbestattun-gen' römischer Kaiser', *Historia* 29 (1980), 75–82. Apuleius goes so far as to criticize artistic images for their similarity to corpses in their rigid and fixed expressions, *Apologia* 14; Y.L. Too, 'Statues, mirrors, and gods: controlling images in Apuleius', in J. Elsner (ed.), *Art and Text in Roman Culture* (Cambridge, 1996), 133–52, esp. p. 133.

5. Scriptores Historiae Augustae, *Hadrian* 6.3; Aurelius Victor, *Epitome de Caesaribus* 13.11; J.-C. Richard, 'Les funérailles de Trajan et le triomphe sur les Parthes', *Revue des Études Latines* 44 (1966), 351–62. The statue and *quadriga* are illustrated on Hadrianic *aurei* of 117–18: H. Mattingly, *Coins of the Roman Empire in the British Museum* III (London, 1936), 244, n. 47; S. Settis *et al.* (ed.), *La Colonna Traiana* (Turin, 1988), 78–9, fig. 33. An effigy of Cleopatra was also featured in Octavian's triple triumph (Dio 51.21). See also M. Beard, 'The triumph of the absurd: Roman street theatre', in C. Edwards and G. Woolf (eds), *Rome the Cosmopolis* (Cambridge, 2003), 21–43, esp. p. 33.

6. Lucius Verus (Scriptores Historiae Augustae, *Marcus* 20.1. *Verus* 9.11, 11). Marcus Aurelius (Scriptores Historiae Augustae, *Marcus* 18.1–3, 28; Aurelius Victor, *De caesaribus* 16.14; Aurelius Victor, *Epitome de caesaribus* 16.12, 17.2; Dio 71[72]. 33.4²–34.1; Herodian 1.3–4). Septimius Severus (Scriptores Historiae Augustae, *Severus* 19.1–4; Dio 76[77].15.3; Herodian 3.15.7). Caracalla (Scriptores Historiae Augustae, *Caracalla* 8.10, 9.1, 12; Dio 78[79].5.5, 9.1; Herodian 4.13.5, 8). See also S.R.F. Price, 'From noble funerals to divine cult: the consecration of the Roman emperor', in D. Cannadine and S.R.F. Price (eds), *Rituals of Royalty: Power and Ceremonial in Traditional Societies* (Cambridge, 1987), 56–108, esp. pp. 64, 96–7.

7. P.J.E. Davies, 'The phoenix and the flames: death, rebirth and the imperial landscape of Rome', *Mortality* 5.3 (2000), 237–58, esp. pp. 239–41. For statues' potent power to recall what they represent, see C. Edwards, 'Incorporating the alien: the art of conquest', in C. Edwards and G. Woolf (eds), *Rome the Cosmopolis* (Cambridge, 2003), 44–70, esp. p. 46.

8. A. Bahrani, 'Assault and abduction: the fate of the royal image in the ancient Near East', *Art History* 18 (1995), 363–82, esp. pp. 375–6.

9. C. Mango, 'Antique statuary and the Byzantine beholder', *Dumbarton Oaks Papers* 17 (1963), 55–75.

10. *Descriptions* 1.3, 11.2; *Descriptions* 2.3, 3.2, 6.3; *Descriptions* 7.3, 9.1; *Descriptions* 8.5, 11.4, 13.1, 14.1. See also *Descriptions* 3.2, 5.5, 8.2, 11.1. The evidence in Callistratus is discussed by Too, 'Statues, mirrors, and gods' (above, n. 4), 135 and n. 10.

11. T. Pekáry, *Das Römische Kaiserbildnis in Staat, Kult und Gesellschaft* (*Das Römische Herrscherbild* 3.5) (Berlin, 1985), 134–42; J. Huskinson, "Unfinished portrait heads' on later Roman sarcophagi: some new perspectives', *Papers of the British School at Rome* 66 (1998), 133; Wood, *Imperial Women* (above, n. 1), 17–18.

12. For the various aspects of *damnatio*, see F. Vittinghoff, *Der Staatsfeind in der Römischen Kaiserzeit* (Berlin, 1936); M. Bergmann and P. Zanker, "Damnatio memoriae' umgear-beitete Nero- und Domitiansporträts: zur Ikonographie der Flavischen Kaiser und des Nerva', *Jahrbuch des Deutschen Archäologischen Instituts* 96 (1981), 317–412; H. Jucker, 'Iulisch-claudische Kaiser- und Prinzenporträts als Palimp-seste', *Jahrbuch des Deutschen Archäologischen Instituts* 96 (1981), 236–316; J. Pollini, "Damnatio memoriae' in stone: two portraits of Nero recut to Nero in American museums', *American Journal of Archaeology* 88 (1984), 547–55; K. Mustakallio, *Death and Disgrace: Capital Penalties with Post Mortem Sanctions in Early Roman Historiography* (Helsinki, 1994); D. Kinney, 'Spolia: damnatio and renovatio memoriae', *Memoirs of the American Academy in Rome* 42 (1997), 117–48; H. Flower, 'Rethinking *damnatio memoriae*: the case of Cn. Piso Pater in A.D. 20', *Classical Antiquity* 17 (1998), 155–86; P. Stewart, 'The destruction of statues in late antiquity', in R. Miles (ed.), *Constructing Identity in Late Antiquity* (London, 1999), 89–130; C.W. Hedrick, *History and Silence: the Purge and Rehabilitation of Memory in Late Antiquity* (Austin, 2000), 89–130; E.R. Varner (ed.), *From Caligula to Constantine: Tyranny and Transformation in Roman Portraiture* (exhibition catalogue (Michael C. Carlos Museum), Atlanta, 2000).

13. Individuals who suffered some form of posthumous condem-nation include: Julia the Elder, Julia the Younger, Agrippa Postumus, Agrippina the Elder, Nero Caesar, Drusus Caesar, Sejanus, Livilla, Caligula, Milonia Caesonia, Messalina, Domitia Lepida, Agrippina the Younger, Claudia Octavia,

Antonia Claudia, Nero, Poppaea, Galba, Otho, Vitellius, Domitian, Avidius Cassius, Lucilla, Crispina, Commodus, Plautianus, Plautilla, Geta, Macrinus, Diadumenianus, Elagabalus, Julia Soemias, Maximinus Thrax, Maximus, Pupienus, Balbinus, Aemilian, Cornelia Supera, Gallienus, Carinus, Magnia Urbica, Maxentius, Valeria Maximilla, Fausta, Prisca and Galeria Valeria.

14. 'However, his [Domitian's] countless [golden] statues, in a heap of rubble and ruin, suitably propitiated the public joy. It was a delight to smash those arrogant faces to pieces in the dust, to threaten them with the sword, and savagely attack them with axes, as if blood and pain would follow every single blow. No one controlled their joy and long awaited happiness, when vengeance was taken in beholding his likenesses hacked into mutilated limbs and pieces, and above all, in seeing his savage and hideous portraits hurled into the flames and burned up, in order that they might be transformed from things of such terror and menace into something useful and pleasing (for mankind)' ('illae autem [aureae] et innumerabiles strage ac ruina publico gaudio litaverunt. iuvabat illidere solo superbissimos vultus, instare ferro, saevire securibus, ut si singulos ictus sanguis dolorque sequeretur. nemo tam temperans gaudii seraeque laetitiae, quin instar ultionis videretur cernere laceros artus truncata membra, postremo truces horendasque imagines obiectas excoctasque flammis, ut ex illo terrore et minis in usum hominum ac voluptates ignibus mutarentur'), *Panegyricus* 52.4–5.

15. 'Now Poppaea's portrait shines, joined to Nero, but let a violent hand crush them to the ground, all too similar to the face of their mistress' ('iam Poppaeae fulget imago/iuncta Neroni!/affligat humo violenta manus/similes nimium vultus dominae'), 684–7. And 'Whatever representation displaying the face of Poppaea had been erected, whether of bright marble or shining in bronze, now lies destroyed by rabble hands and overturned by cruel iron; they drag the limbs, dismembered by ropes, all over and they continually obscure them, trampled in the nasty filth' ('quaecumque claro marmore effigies stetit / aut aere fulgens, ora Poppaeae gerens / afflicta vulgi manibus et saevo iacet / eversa ferro; membra per partes trahunt / deducta laqueis, obruunt turpi diu / calcata caeno'), 794–9.

16. 'Et novo iniuriae genere imago in crucem sublata persultante vulgo, quasi patibulo ipse Celsus videretur', *Tyranni Triginta* 29.4.

17. R. Bauman, *Crime and Punishment in Ancient Rome* (London, 1996), 151.

18. J. von Schlosser, 'Geschichte der Porträtbildnerei in Wachs', *Jahrbuch der Kunsthistorischen Sammlungen des Allerhöchsten Kaiserhaus* 29 (1910–11), 171–258, esp. p. 184; W. Brückner, *Bildnis und Brauch: Studien zur Bildfunktion der Effigies* (Berlin, 1966), 192; D. Freedberg, *The Power of Images: Studies in the History and Theory of Response* (Chicago/London, 1989), 259; E.R. Varner 'Punishment after death: mutilation of images and corpse abuse in ancient Rome', *Mortality* 6.1 (2001), 45–64, esp. pp. 58–9.

19. Price, 'From noble funerals' (above, n. 6), 97.

20. Sejanus: Dio 58.11.5. Vitellius: Suetonius, *Vitellius* 17.2; Tacitus, *Histories* 3.85. Plautianus: Herodian 3.12.12. Elagabalus and Julia Soemias: Scriptores Historiae Augustae, *Elagabalus* 17.4–7, 23.7; *Epitome de Caesaribus* 23.5–7; Dio 80.20.2; Herodian 5.89. Pupienus and Balbinus: Herodian 8.8.7; Scriptores Historiae Augustae, *Maximinus et Balbinus* 14.5. Gallienus: Aurelius Victor, *De caesaribus* 33.31–4. Varner, 'Punishment' (above, n. 18), 57–8.

21. Images of Caligula, Messalina, Nero, Poppaea, Domitian, Commodus, Lucilla, Crispina, Plautilla, Geta, Macrinus, Diadumenianus, Severus Alexander, Julia Mamaea, Maximinus Thrax, Maximus, Maxentius and Valeria Maximilla were all mutilated: Varner, 'Punishment' (above, n. 18). For the extremely apt term 'surrogate corpse abuse', see D.G. Kyle, *Spectacles of Death in Ancient Rome* (London, 1998), 183, n. 106.

22. Sackler Museums, inv. 1949.47.138, height 0.28 m. M. Donderer 'Irreversible Deponierung von Grossplastik bei Griechen, Etruskern und Römern', *Jahreshefte des Österreichischen Archäologischen Instituts in Wien* 61 (1991–2), 193–276, esp. p. 222, n. 123; Varner (ed.), *From Caligula* (above, n. 12), 191–3, n. 49, with figs; Varner, 'Punishment' (above, n. 18), 53, fig. 4.

23. S. Bartsch, *Ideology in Cold Blood: a Reading of Lucan's* Civil War (Cambridge (MA), 1997), 12–13, 17.

24. Bauman, *Crime and Punishment* (above, n. 17), 151; A. Richlin 'Cicero's head', in J.I. Porter (ed.), *Constructions of the Classical Body* (Ann Arbor, 1999), 190–211, esp. pp. 197–200.

25. Appian, *Bellum civile* 4.19–20; Elder Seneca, *Suasoriae* 6.17; Valerius Maximus 5.3.4; Velleius Paterculus 2.64.3–4; Dio 46.55–6, 48.1–19; Plutarch, *Antony* 20, *Cicero* 48–9; Richlin, 'Cicero's head' (above, n. 24), 191.

26. Elder Seneca, *Suasoriae* 6.26.2 (quoting from Cornelius Severus); Richlin, 'Cicero's head' (above, n. 24), 203.

27. Richlin, 'Cicero's head' (above, n. 24), 192.

28. Dio 68.14.3; *Fasti Ostienses* 106 CE; I.M. Ferris, *Enemies of Rome: Barbarians through Roman Eyes* (Phoenix Mill, 2000), 81. Vitellius was tortured to death and his corpse mutilated on the Gemonian steps (Suetonius, *Vitellius* 17.2) and Gallienus's remains were thrown down the Gemonian steps (Aurelius Victor, *De caesaribus* 33.31–4). Tiberius boasts of his clemency in not executing Agrippina the Younger and refraining from having her corpse thrown on the Gemonian steps: Suetonius, *Tiberius* 53.2; Tacitus, *Annales* 25; Kyle, *Spectacles* (above, n. 21), 232, n. 34. On the site of the Gemonian steps, see F. Coarelli, 'Scalae Gemoniae', in E.M. Steinby (ed.), *Lexicon Topigraphicum Urbis Romae* IV (Rome, 1999), 241.

29. 'Eum capitali supplicio destinavit, et ita colligatis manibus in modum noxii cuiusdam latronis, cervice abscisa, ereptaque vultus et capitis dignitate, cadaver est relictum informe', 14.23.

30. Dio 60.32.4; J.L. Voisin, 'Les Romains, chasseurs des têtes', in *Du châtiment dans la cité: supplices corporels et peine de mort dans le monde antique (Collection de l'École Française de Rome 79)* (Rome, 1984), 241–93, esp. p. 250; E.R. Varner,

'Portraits, plots and politics: *damnatio memoriae* and the images of imperial women', *Memoirs of the American Academy in Rome* 47 (2001), 41–93, esp. pp. 71–2.

31. Tacitus, *Annales* 14.64.2; Voisin, 'Les Romains' (above, n. 30), 251; Suetonius, *Nero* 35.2; Tacitus, *Annales* 14.60, 63–4, *Oct.* 107; Bauman, *Crime and Punishment* (above, n. 17), 89; Tacitus, *Annales* 14.64.2.

32. Suetonius, *Galba* 20.2; Voisin, 'Les Romains' (above, n. 30), 251.

33. Dio 73.10; Voisin, 'Les Romains' (above, n. 30), 252; Dio 75.4.2–5.5; Price, 'From noble funerals' (above, n. 6), 61; see also Schraven, Chapter Twelve in this volume.

34. Scriptores Historiae Augustae, *Severus* 8.13 and *Pescennius Niger* 5.7; A.R. Birley, *Septimius Severus: the North African Emperor* (New Haven, 1988), 112–25; Scriptores Historiae Augustae, *Pescennius Niger* 6.1 ('huius caput cirumlatum pilo Romam missum'); Dio 74.8.3; Voisin, 'Les Romains' (above, n. 30), 252. Niger was killed at Antioch in April 194. In 195 Albinus was declared emperor in opposition to Severus, who responded by declaring him a *hostis*: Scriptores Historiae Augustae, *Severus* 10.2; *Clodius Albinus* 9.1. Defeated at Lugundum on 19 February 197, Albinus took his own life. His dead body was decapitated, the head sent to Rome and, allegedly, further abused when Severus trampled it with his horses. The body was left to rot for several days and was mangled by dogs before being thrown into the Rhône along with the remains of Albinus's murdered wife and sons: Herodian 3.7.6–7; Dio 75[76].7.1–8; Scriptores Historiae Augustae, *Severus* 11.6–9; *Clodius Albinus* 9.7; C. Wells, *The Roman Empire* (London 1992), 283. In one version, Albinus is still partially alive (*seminecis*) when he is beheaded (Scriptores Historiae Augustae, *Severus* 11.6).

35. Scriptores Historiae Augustae, *Diadumenianus* 9; Herodian 5.4.11.

36. Dio 79[80].20; Voisin, 'Les Romains' (above, n. 30), 252.

37. *Panegyrics* 9.18.3; Voisin, 'Les Romains' (above, n. 30), 252; *Panegyrics* 10.31.5.

38. Voisin, 'Les Romains' (above, n. 30), 269–72.

39. Suetonius, *Nero* 57.2; Tacitus, *History* 2.8–9; Dio 66.19.3; B.W. Jones, 'C. Vettulenus Civica Cerialis and the 'false Nero' of AD 88', *Athenaeum* 61 (1983), 516–21; Voisin, 'Les Romains' (above, n. 30), 270.

40. Voisin, 'Les Romains' (above, n. 30), 262–3. The Gauls preserved the severed heads of their enemies with cedar oil: Strabo 4.4.5.

41. Elder Seneca, *Controversiae* 9.25; Voisin, 'Les Romains' (above, n. 30), 268; Bauman, *Crime and Punishment* (above, n. 17), 19; Voisin, 'Les Romains' (above, n. 30), 274–5.

42. Kyle, *Spectacles* (above, n. 21), 213–28; Richlin, 'Cicero's head' (above, n. 24), 195–6; Varner, 'Punishment' (above, n. 18), 57.

43. J. Scheid, 'La mort du tyran: chronique de quelques morts programmées', in *Du châtiment dans la cité: supplices corporels et peine de mort dans le monde antique* (*Collection de l'École Française de Rome* 79) (Rome, 1984), 181–90.

44. See Fields, Chapter Six in this volume, with bibliography. The Column of Marcus Aurelius (*c.* 180–92 CE) depicts renegade Quadii beheaded by Germans loyal to Rome. See C. Caprino, A.M. Collini, G. Gatt, M. Pallattino and P. Romanelli, *La Colonna di Marco Aurelio* (Rome, 1955), 102–3, fig. 76.

45. Rome, Museo Nazionale Romano, Palazzo Massimo alle Terme, inv. 112327. E. Calandra, in A. La Regina (ed.), *Museo Nazionale Romano: Palazzo Massimo alle Terme* (Milan, 1998), 162–3.

46. Mainz lid: Römische-Germanisches Zentralmuseum; D.E.E. Kleiner, *Roman Sculpture* (New Haven/London, 1992), 390. Ostia lid: Palazzo dei Conservatori, inv. 2829, 2311 (Centrale Montemartini 3.1).

47. For the range of Medusa imagery in public and private Roman monuments, see O. Paoletti, 'Gorgones romanae', in *Lexicon Iconographicum Mythologiae Classicae* 4 (Zurich, 1988), 345–62. For the Perseus and Medusa plaques from the Temple of Apollo Palatinus, see B. Kellum, 'Sculptural programs and propaganda in Augustan Rome: the Temple of Apollo on the Palatine', in R. Winkes (ed.), *The Age of Augustus* (Providence, 1985), 169–76.

48. London, British Museum, PRB, inv. 1965.12–1.1; height 0.33 m; Jucker, 'Iulisch-claudische' (above, n. 12), 307–9, figs 75–6 (with earlier literature); Donderer, 'Irreversible Deponierung' (above, n. 22), 260, n. 6. Formerly Sammlung A. Guttmann; height 0.377 m; H. Born and K. Stemmer, *'Damnatio Memoriae': das Berliner Nero-porträt. Sammlung Axel Guttmann* (Frankfurt am Mainz, 1996).

49. Los Angeles, J. Paul Getty Museum, inv. 72.AA.118; height 0.305 m; Varner (ed.), *From Caligula* (above, n. 12), 180, n. 42, with figs (with earlier literature).

50. City Museum, inv. 2636, height 0.33 m; V. Kondic, 'Two recent acquisitions in Belgrade museums', *Journal of Roman Studies* 63 (1973), 47–8, pls 5–7; D. Salzmann, 'Die Bildnisse des Macrinus', *Jahrbuch des Deutschen Archäologischen Instituts* 98 (1983), 362–5, 371–9, figs 13, 17, 21, 28–30; K. Fittschen and P. Zanker, *Katalog der Römischen Porträts in den Capitolinischen Museen und den Anderen Kommunalen Sammlungen der Stadt Rom* 1. *Kaiser- und Prinzenbildnisse* (Mainz, 1985), 113, n. 2; S. Wood, *Roman Portrait Sculpture 217–260 AD* (Leiden, 1986), 30–1, 123; A. Oliver, 'Honors to Romans: bronze portraits', in C. Mattusch (ed.), *The Fire of Hephaistos: Large Classical Bronzes from North American Collections* (Cambridge (MA), 1996), 138–60, esp. p. 149. The head includes a slit in the left earlobe that comprised a very specific physiognomic trait allegedly signalling Macrinus's Mauritanian origins. Dio 79[78].11.1.

51. Bochum, Kunstsammlungen der Ruhr–Universität, height 0.485 m; B. Andreae, 'Der Bronzekopf des Kaisers Severus Alexander in der Sammlung Paul Dierichs', in M. Imdahl and N. Kunish (eds), *Plastik: Antike und Moderne Kunst der Sammlung Paul Dierichs* (Kassel/Bonn, 1979), 98–111, with figs; Varner, 'Punishment' (above, n. 18), 55.

52. Sofia, National Archaeological Museum, inv. 1497, height 0.37 m; M. Wegner, J. Bracker and W. Real, *Gordianus III*

bis Carinus (*Das Roümische Herrscherbild* 3.3) (Berlin, 1979), 28–9 (with earlier literature); V.P. Vasilev, 'Untersuchungen zu Bronzekopf Gordian III aus Nicopolis ad Istrum', in N. Bonacasa and G. Rizza (eds), *Ritratto ufficiale e ritratto privato: atti della II conferenza internazionale sul ritratto romano, Roma 26–30 settembre 1984* (Rome, 1988), 541–6, figs 1–6; Donderer, 'Irreversible Deponierung' (above, n. 22), 222, fig. 3, 262, n. 17; Varner, 'Punishment' (above, n. 18), 56.

53. J. Paul Getty Museum, inv. 79.AB.120, height 0.22 m; Wood, *Roman Portrait* (above, n. 50), 132.

54. Museo Archeologico, inv. 14013, height 0.32 m; Wegner, Bracker and Real, *Gordianus* (above, n. 52), 65, 84–6, 87–8 (with earlier literature); Wood, *Roman Portrait* (above, n. 50), 133.

55. Deva Museum, inv. 19.903, height 0.25 m; Wegner, Bracker and Real, *Gordianus* (above, n. 52), 64–5, pl. 27 (with earlier literature); Wood, *Roman Portrait* (above, n. 50), 133.

56. Kephallenia, Museum; A.M. McCann, 'Beyond the classical in third century portraiture', in H. Temporani (ed.), *Aufstieg und Niedergang der Römischen Welt* 2.12.2 (Berlin, 1981), 636, pls 10.19, 11.21; Oliver, 'Honors to Romans' (above, n. 50), 153.

57. London, British Museum, inv. 1911.9.–1.1, height 0.43 m. Oliver, 'Honors to Romans' (above, n. 50), 153, fig. 9; S. Walker, in S. Walker and P. Higgs (eds), *Cleopatra: regina d'Egitto* (exhibition catalogue (Palazzo Ruspoli, Rome), Milan, 2000), 190–1, n. 3.49, with fig. In addition, it also has been speculated that a bronze head of Hadrian discovered in the Thames was decapitated by those in opposition to the Roman government of Britain. London, British Museum 1834.11–31; Oliver, 'Honors to Romans' (above, n. 50), 152.

58. Tripoli Museum; F. Ghedini, *Giulia Domna tra Oriente e Occidente: le fonti archeologiche* (Rome, 1984), 63–8; N.B. Kampen, 'Between public and private: women as historical subjects in Roman art', in S.B. Pomeroy (ed.), *Women's History and Ancient History* (Chapel Hill, 1991), 218–48; Kleiner, *Roman Sculpture* (above, n. 46), 340–3, figs 307–10. For the *concordia* relief, see A. Bonanno, *Portraits and Other Heads on Roman Historical Relief up to the Age of Septimius Severus* (*British Archaeological Reports Supplementary Series* 6) (Oxford, 1976), 150–5 (with earlier literature); Donderer, 'Irreversible Deponierung' (above, n. 22), 250–1, n. 40; Birley, *Septimius* (above, n. 34), 150, fig. 20.

59. Bonanno, *Portraits and Other Heads* (above, n. 58), 153, pls 307–8. Although the portrait is badly weathered, the treatment of the hair and facial features recall Geta's likeness from the *dextrarum iunctio* scene. Geta has also been decapitated in a second, fragmentary interior panel representing the imperial family and deities arranged in front of a temple façade with a scene of sacrifice in the lower register — see Bonanno, *Portraits and Other Heads* (above, n. 58), 151, pls 300–1; Ghedini, *Giulia Domna* (above, n. 58), 76–80, fig. 10.

60. R. Brilliant, *The Arch of Septimius Severus in the Roman Forum* (*Memoirs of the American Academy in Rome* 29) (Rome, 1967), 186–8.

61. Palazzo Ricci–Sachetti, Via Giulia 66, height 1.575 m, width 2.335 m; Kleiner, *Roman Sculpture* (above, n. 46), 332–3, fig. 299.

62. The headless states of other figures in the relief, including Septimius Severus, appear to be the result of incidental damage or breakage, as they preserve much of their necks, in distinction to the presumed figure of Geta.

63. Berlin, Staatliche Museen, inv. 31.329, diameter 0.305 m; A. Datsuli-Stavridis, 'Damnatio memoriae', *Athens Annals of Archaeology* 9 (1976), 225–39, esp. pp. 228–9, fig. 4; H. Heinen, 'Herrscherkult im römischen Ägypten und *damnatio memoriae* Getas. Überlegungen zum Berliner Severertondo und zu Papyrus Oxryhynchus XII 1449', *Mitteilungen des Deutschen Archäologischen Instituts, Römische Abteilung* 98 (1991), 263–98, colour pl. 68; Kleiner, *Roman Sculpture* (above, n. 46), 321–2, fig. 284.

64. Stewart, 'The destruction of statues' (above, n. 12), 165.

65. Museo Nazionale Archeologico, inv. 5993, height 3.79 m; C. Maderna, *Iuppiter Diomedes und Merkur als Vorbilder für Römische Bildnisstatuen* (*Archäologie und Geschichte* 1) (Heidelberg, 1988), 59, 64, 138, ns. 378, 381, 207–8, n. D 6, pl. 21.3; Kleiner, *Roman Sculpture* (above, n. 46), 363, fig. 323.

66. Istanbul, Archaeological Museum, 584. Born and Stemmer, *Damnatio Memoriae* (above, n. 48), 100, 102, fig. 36; M. Fuchs, 'Besser als sein Ruf', *Boreas* 20 (1997), 83–96, esp. pp. 92–3.

67. Musei Vaticani, Museo Gregoriano Profano, inv. 9948; height 2.30 m; C.B. Rose, *Dynastic Commemoration and Imperial Portraiture in the Julio-Claudian Period* (Cambridge, 1997), 83–6, cat. 5, pl. 64 (identification as Germanicus), and 83–6 lists the other statues depicted as Tiberius, Augustus, Diva Drusilla, Drusus Maior and Nero Caesar.

68. Dio 53.6.2. The imagery also has obvious parallels with Nero's Colossus. See M. Fuchs, P. Liverani and P. Santoro, *Il teatro e il ciclo statuario giulio-claudio* (*Caere* II) (Rome, 1989), 69.

69. Another Neronian cuirass that lacks its original head, discovered at Susa, is nearly identical to the Caere statue: Turin, Museo di Antichità, without inventory number, height 1.95 m; Rose, *Dynastic Commemoration* (above, n. 67), 85 and n. 17. Other cuirassed statues that are likely to be Neronian in date and have been deprived of their heads include pieces in Schloss Erbach no. 20; Berlin, Staatliche Museen, inv. 368; Sassari, Museo Sanna 7890; formerly Sikyon; Grosseto, Museo Archeologico e d'Arte della Maremma; Durres, Museum; and the Palazzo Colonna in Rome. K. Stemmer, *Untersuchungen zur Typologie, Chronologie und Ikonographie der Panzerstatuen* (*Archäologische Forschungen* 4) (Berlin, 1978), 19, no. I.18, pl. 94; 19, no. 5.18, pl. 36.4; 24, no. 2.2, pl. 11.2–3; 28, no. 2a 3, pl. 14; 87–8, no. 7.23, pl. 61.3; A. Kuttner, *Dynasty and Empire in the Age of Augustus: the Case of the Boscoreale Cups* (Berkeley, 1995), 166, nos. 16–17; Rose, *Dynastic Commemoration* (above, n. 67), 118. It is also within the realm of possibility that some of the cuirassed statue bodies of Domitian that have become

dissociated from their original heads, including pieces in the Vatican (Galleria delle Statue, 248), the Palazzo Farnese, the Louvre (inv. MA 1150), London, Auch (inv. MA 1154), Boston (Museum of Fine Arts, inv. 99.346), Los Angeles and Merida (Museo Arqueologico, inv. n. 1.138), may have been displayed for a time as decapitated likenesses. See also R. Gergel, 'Costume as geographic indicator: barbarians and prisoners on cuirassed statue breastplates', in J.L. Sebesta and L. Bonfante (eds), *The World of Roman Costume* (Madison (WI), 1994), 199–203.

70. Museo Palatino, Sala 7, formerly Museo Nazionale Romano delle Terme, inv. 616, height 0.43 m; Born and Stemmer, *Damnatio Memoriae* (above, n. 48), 72, 92–3, 102–3, fig. 22; M.A. Tomei, *Scavi francesi sul Palatino: le indagini di Pietro Rosa per Napoleone III (1861–1870)* (Rome, 1999), 171, fig. 111.

71. Richmond, Virginia Art Museum, accession no. 71–20, height 2.032 m, head, 0.27 m; D. Boschung, *Die Bildnisse des Caligula (Das Römische Herrscherbild* 1.4) (Berlin, 1989), 29, n. 12, 38, 53–5, 61, 89, 109–10, n. 11, sketch 11, pls 11.1–4, 42.1–4, 43 (with previous literature).

72. H. Jucker, 'Caligula', *Arts in Virginia* 13.2 (1973), 17–25, esp. p. 19.

73. Varner, 'Punishment' (above, n. 18), 60.

74. 'Qui senatum occidit, unco trahatur', *Commodus* 18.5.

75. Bartsch, *Ideology in Cold Blood* (above, n. 23), 10–47.

76. 'Dic, ubi sit, germane, parens; stat summa caputque / orbis', 9.123–4. See also Lucan, *De bello civili* 8.608, 674, 722, 753–4, 9.14, 53; Bartsch, *Ideology in Cold Blood* (above, n. 23), 16 and n. 13. For a range of meanings of *caput* in this and similar contexts, see Richlin, 'Cicero's head' (above, n. 24), 193–5.

77. On the 'performance art' of the Roman triumph, see Beard, 'The triumph' (above, n. 5), 29.

78. K. Coleman, 'Fatal charades: Roman executions staged as mythological enactments', *Journal of Roman Studies* 80 (1990), 44–73.

79. P.J.E. Davies, 'The politics of perpetuation: Trajan's Column and the art of commemoration', *American Journal of Archaeology* 101 (1997), 52–8.

CHURCH: DISABLEMENT, TRANSFORMATION AND VENERATION

Disabled bodies: the (mis)representation of the lame in antiquity and their reappearance in early Christian and medieval art

Livio Pestilli

If it is true that 'those members of society castigated for their 'otherness' ... are relegated to the margins of the community in an effort to ignore their existence', and that art reflects, 'with varying iconography and creative emphasis', the changes that occur in popular beliefs and taste, then ancient Roman society provides a superlative example of how the 'other' was not just relegated to the margins but practically cast into oblivion.[1] Images of the disabled that have survived from classical Roman art are limited primarily to representations of the smith-god, Vulcan, whose distinctive trait was the infirmity of his feet.[2] This paucity of archaeological evidence is certainly at odds with what must have been the historical reality of communities where congenital deformities, illnesses, disease and war indelibly altered human bodies.

On the one hand, the near absence of depictions of the lame in Roman art may be indicative of a *forma mentis* that generally ignored defective bodies but, on the other hand, it raises the question of the circumstances in which images of disabled humans were retrieved from the margins of art and what these depictions reveal about the society that produced them. The issue is an important one, because the increasing occurrence of representations of the disabled in the visual arts corresponds to a change from the pagan to the Christian world view.[3] Indeed, in a classical world so concerned with the beautiful (*to kalon*), artists probably had little interest in portraying the misshapen, since lameness was considered 'a defect or deformity' (Plato, *Lesser Hippias* 374d) and deformity defined as a 'want of measure, which is always unsightly' (Plato, *Sophist* 228a). Although Christianity also equated the beautiful and the good because 'only one thing is sacred, and that is human fellowship', the frequent depiction of the paralytic, the crippled and the lame became for the faithful the reassuring sign of universal acceptance.[4]

Indicative of the Roman response to the disabled body are two statements by Cicero. In one instance, using bodily disease, sickness and defect as terms of comparison for similar 'ailments' of the soul, he defines corporeal defect (*vitium*) as a lack of symmetry of the parts of the body, which engenders 'crookedness of limbs, distortion, ugliness'.[5] In another context, while arguing against the anthropomorphic view of the gods, he writes that 'at Athens there is a much-praised statue of Vulcan made by Alcamenes, a standing figure, draped, which displays a slight lameness, though not enough to be unsightly'.[6] As these statements clearly indicate, lameness was considered a deformity that, especially in the statue of a god, was indecorous and should be dissimulated. This view was reiterated by Valerius Maximus, who also praised Alcamenes's statue because it displayed 'a slight trace of lameness indicated under the drapery'.[7] Alcamenes's artistic tactfulness is better understood if one considers depictions of Vulcan's disability dating to the sixth century BCE that were far more explicit. These images, closely following Homer's epithets for the god, do in fact depict one or both of Vulcan's feet turned backwards, if not altogether withered and deformed.[8]

Alone among the gods in having a physical defect, the Roman Vulcan, like the Greek Hephaistos and the Etruscan Sethlans, was the god of fire. His lameness was explained either as a malformation from which he had suffered from birth or a deformity caused by having being cast down to earth from Olympus by Zeus.[9] In Roman art Vulcan is depicted mostly with the cap and short garment typically worn by workmen (*pilos* and *exomis*) and his lameness, when represented, follows Alcamenes's understatement and not the deformed, backward twist of the feet present in Greek archaic tradition.[10] In fact, at times one is left in doubt as to whether the seeming disparity in the rendition of the right

FIG. 8.1. Vulcan, Albani Puteal, marble relief, second century CE, Capitoline Museums, Rome. *Photo: Archivio Fotografico dei Musei Capitolini inv. MC. 1919/5. Reproduced courtesy of the Sovraintendenza Comunale, Comune di Roma.*

and left leg is an artistic aberration or is meant to hint at the god's infirmity. At least in the case of the Albani Puteal relief, a marble relief from the second century CE in the Capitoline Museums, Vulcan's disability is clearly indicated by a slight inward twist of the left foot and an underdeveloped calf muscle (Fig. 8.1).[11]

Although some Roman works characterize Vulcan's lameness, and a few Greek and Hellenistic examples depict deformed or infirm humans, to my knowledge there are no Roman artefacts that attest to a presence of lame mortals in the visual tradition.[12] This does not mean that such images did not exist, but the near absence of surviving images of the disabled in Roman art seems to indicate a rejection of the imperfect body in the Roman world view, perhaps as too base a subject.[13]

This is not surprising, since in antiquity even natal malformation apparently was not always tolerated. It is not known, for example, whether in cases of infant deformity the practice of death by exposure (*ekthesis*) was indeed a reality in Athens but, according to Plutarch (*Lykourgos* 16.1–2), the Spartan state actually demanded it.[14] That a similar practice appears to have been followed in Rome is asserted by Dionysios of Halikarnassos (2.15.1–2), Cicero (*Laws* 3.8, 19) and Seneca (*Controversiae* 10.4, 16).[15] Exposing the newly born was not just an indication of the child's uselessness to the state, but the fact is that, at least in Greece, lameness was traditionally associated with deviancy, vacillation and a threat to the established

order, as demonstrated by Labdacids's line: Labdacus (the lame) engendered Laius (the left-handed) whose lineage is cursed to extinction because of his homosexual and violent behaviour; his son Oedipus (swollen foot), commits patricide and incest, whereas his two sons, Eteocles and Polyneices, kill each other.[16]

Whereas in Greek history and legend lameness was a 'way of marking the anticipated break-up of order and the failure of rule', in everyday Greek and Roman life it was also a sign of 'divine displeasure'.[17] Especially for the Romans, lameness was certainly a matter of derision and ridicule, as intimated by Augustus's letter to Livia about the appropriateness of a public role for her grandson, Claudius. Public opinion was heartless about a man whose gait was gravely affected by weak knees that 'gave way under him', and whose mother reportedly described him as 'a monster of a man, not finished but merely begun by Dame Nature'.[18] Augustus asks:

> Now we [Augustus and Tiberius] are both agreed that we must decide once for all what plan we are to adopt in his [Claudius's] case. For if he be sound and so to say complete, what reason have we for doubting that he ought to be advanced through the same grades and steps through which his brother has been advanced? But if we realize that he is wanting and defective in soundness of body and mind, we must not furnish the means of ridiculing both him and us to a public which is wont to scoff at and deride such things.[19]

Of course, in keeping with Julio-Claudian imperial portraiture, statues of Claudius that display his physical shortcomings are nowhere to be found.

The absence of the disabled in Roman art makes the sudden depiction of the paralytic and the lame in the third century all the more striking. Indeed, their appearance in art occurred only when their presence could be appropriated by artists for the ideological needs of the Christian Church. In the hands of craftsmen with an innate talent for narrative painting, the disabled body would become a poignant reinforcement of their beliefs for the faithful and a persuasive tool of proselytization for the clergy.

Originally located in the Syrian desert near the River Euphrates, the baptistery frescoes from the Dura Europos 'Christian House' in the Yale University Art Gallery represent the tendencies of the earliest examples of Christian art (*c*. 200 CE). One of the preserved scenes is of a young beardless Christ gesturing towards

a paralytic figure who is lying in bed while, within the same scene, the paralytic is also shown cured and walking away with a bed on his shoulders (**Fig. 8.2**).[20] Like other frescoes in the baptistery, this depiction of the miracle attests to Christ's healing power. But in a religion that promised eternal life and equality after death, the miracle of the paralytic probably spoke more directly than others to the neophyte, because miracles involving the physically impaired became 'the assuring sign of faith in eschatological vindication'.[21]

Of course, miracles also occurred in the pagan world, especially in connection with the cults of Asklepios and Isis. Accounts of healing at Epidauros in the Hellenistic period, for example, most commonly refer to injuries or malformation of the limbs, wounds from weapons or blindness.[22] The cure came in the form of an epiphany or a dream while the infirm spent days in the sacred precinct, but there is no indication that the supplicants experienced 'a spiritual transform- ation or a promise of anything transcendent'.[23] Such was the case with the supposedly successful cure of the blind and the lame who went to Vespasian 'begging for the help for their disorders which Serapis had promised in a dream; for the god declared that Vespasian would restore the eyes, if he would spit upon them, and give strength to the leg, if he would deign touch it with his heel'.[24] There is some evidence of a change of attitude around the middle of the second century, when records indicate that, in the eyes of the faithful, Asklepios and Isis were concerned with the 'fulfilment of their destinies', in addition to their physical welfare.[25]

For Christians, miracles had a universal and eternal resonance. In late antiquity the miracle of the paralytic, while referring to Christ's healing power over body and soul, was also interpreted as a wondrous event that most tangibly gave hope for a more equitable world. In fact, if seen against the Judaic tradition that connected defect to sin, Christ's miracles involving the disabled were also a revolutionary way of breaking the link 'between disability and individual fault'.[26]

Despite this more accepting view of the disabled, the disabled body is not depicted in representations of the 'Healing of the paralytic', in examples including a fourth-century Roman glass bowl (Corning Museum, New York State), a Roman ivory plaque 410–20 CE with the miracles of Christ (Louvre, Paris) (**Fig. 8.3**), the sixth-century mosaic with the 'Healing of the paralytic at Capernaum' in Sant'Apollinare Nuovo in Ravenna, and the early eighth-century fresco of the same subject from the oratory beneath the Roman basilica of San Saba (**Fig. 8.4**): the disability of the

physically impaired may only be inferred from the bed- ridden figure or the healed paralytic as he walks away carrying his bed. In other words, depictions of the paralytic from late antiquity and early Christian times are 'abbreviated representations' that project the formerly ill or disabled as already admitted into 'normal', healthy society.[27]

The more realistic portrayal of disabled bodies, shown prior to any miraculous cure, probably first occurs in depictions of the 'Healing of the infirm' in which the lame, the crippled and other suffering humans appear in cycles of the life of Christ. An example of this 'neo-realism' is present in the sixth- century throne of Maximian in the Museo Arcivesco- vile in Ravenna, where the artist's rendition of the cripple in *Christ Healing the Blind Man* comes very close to the way the archaic Greek artists had depicted Vulcan's infirmity (**Fig. 8.5**). It is possible that it was through illuminated manuscripts executed in the Byzantine East, such as the ninth-century manuscript *Parisinus Graecus* 923 and even more so the famous eleventh-century manuscript *Graecus* 74 from the Bibliothèque Nationale in Paris, with 361 miniatures from all four Gospels, that the depiction of visibly disabled bodies made its way to the West.[28] This might have been because in manuscript illumination there were fewer spatial restrictions and a fuller account of Christ's miracles was possible. Therefore, alongside the 'before and after' narration of the miracle of the paralytic, artists could give vent to a more realistic representation of all those infirm members of human- kind who sought a miraculous cure. Indeed, this might have been the case on the walls of the church of San Saba, on the Aventine Hill, since the patron of the fresco cycle was an immigrant monastic community that had left the Holy Land and established itself in Rome. Even though, among the fragments that have come to light, there is no evidence that this scene was represented, the fact that these frescoes reflect so closely Palestinian art of the mid-seventh century makes the likelihood of its inclusion in the cycle feasible.[29] In these works the realistic representation of the lame is consistently differentiated from the 'proleptic' depictions of the paralytic. It is this starker realism that was transmitted to the art of the Middle Ages, as indicated by the crippled who drag their bodies with the aid of mini-crutches in an Italian fourteenth-century manuscript of the *Meditations on the Life of Christ*.[30]

By the early thirteenth century a major change had occurred, for scenes of the life of Christ began to be

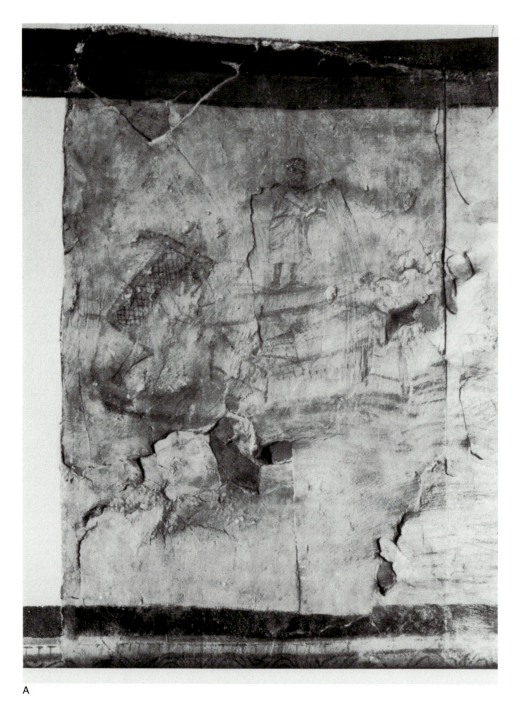

FIG. 8.2A. Healing of the *Paralytic, Christian House*, frescoes from Dura Europos, *c.* 200 CE. Yale University Art Gallery, Dura Europos Collection, Z71.
Reproduced courtesy of the Yale University Art Gallery, New Haven.

A

substituted with greater frequency by scenes of the lives of the saints.[31] Between the twelfth and the fifteenth centuries the majority of those who were raised to the rank of sainthood in Europe was of aristocratic lineage.[32] Quite antithetically, in thirteenth-century southern Europe, especially in Italy but also in the north, the faithful seem to shift their devotion 'spontaneously' towards the less aristocratic sainthood embodied by the poor and those whose lives imitated the sufferings of Christ. Although by the end of the twelfth century a sanctity of 'charity and labour' had become manifest, with the rise of the mendicant orders in the thirteenth century compassion and charity toward all the suffering and the ill became the evident sign of a holy person.[33] Indeed, to the majority of people at the time of Innocent III (1198–1216) sanctity was essentially identified with a number of supernatural powers, chief among them that of healing the sick.[34] As the disabled became the preferred supporting cast for the new 'miracle workers', it comes as no surprise that

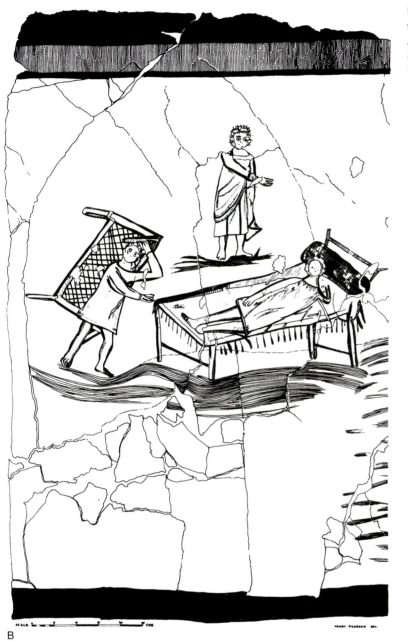

FIG. 8.2B. *Healing of the Paralytic, Christian House,*
frescoes from Dura Europos, *c.* 200 CE. Yale University
Art Gallery, Dura Europos Collection, Y298. *Drawing
by Henry Pearson. Reproduced courtesy of the Yale
University Art Gallery, New Haven.*

B

among the earliest realistic depictions of the lame in the
late Middle Ages one should find a number of panels of
the life of Saint Francis, the ultimate *alter Christus*.[35]

In altarpieces executed soon after Saint Francis's
death (1226) and canonization (1228), such as
Bonaventura Berlinghieri's *Saint Francis* (Pescia,
1235) and the Bardi altarpiece in Santa Croce
(Florence, *c.* 1245–50), the subsidiary scenes represent
various stories from the saint's life. Most significant
among them are two depictions of miracles involving
the disabled: *The Healing of the Lame by the Tomb of
Francis*, in which the miracle-seeking supplicants are
singled out by the mini-crutches so prominently placed

in the foreground, and *The Healing of Bartolomeo da
Narni*.[36] One example is a panel by Giunta Pisano or a
follower dating to *c.* 1255 (Pinacoteca, Vatican City)
that depicts *The Healing of Bartolomeo da Narni* in the
lower left-hand panel.[37] There cured lameness is
represented in the spirit of earlier depictions of Christ's
'Miracle of the paralytic', and Bartolomeo walks away
with crutches on his shoulder. It is not accidental that
these scenes depict posthumous miracles by the saint.
Ever since the canonization of Saint Homobonus in
1199, Innocent III had declared in a bull that for the
militant Church two things were essential before
anyone be declared a saint: 'virtue of morals and

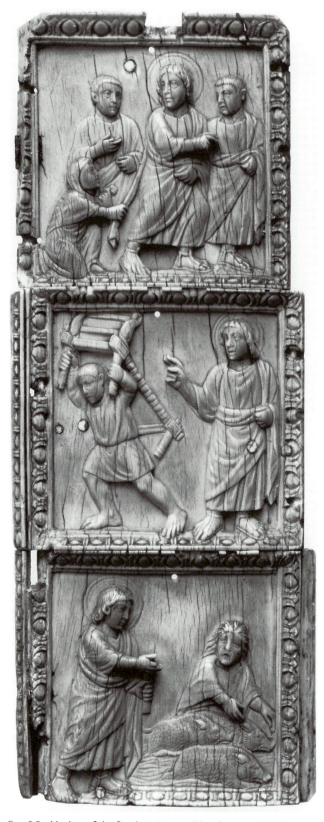

FIG. 8.3. *Healing of the Paralytic*, ivory tablet, Roman 410–20 CE. **Louvre, Paris.** © Photo RMN- Daniel Arnaudet. Reproduced courtesy of Réunion Musées Nationaux.

truth of signs, that is, works of piety in life and evidence of miracles after death'.[38] It is quite logical that these altarpieces should include cripples by the saint's death-bed as the only lay representatives of a bereaving humankind, for the mendicant saint's exaltation of poverty would find its obvious iconographic counterpart in those who begged for a living. The lame, as much as the blind, because of their obvious inability to work, might be considered the 'professional poor' of the Middle Ages.[39]

Although in the medieval period voluntary poverty was considered commendable, by the early fourteenth century pontifical documents cease to refer to poverty as the greatest of virtues.[40] Probably in response to the conflict that arose within the bosom of the mendicant order over the interpretation of Saint Francis's prohibition against money and property, saints were now officially praised more for their piety and obedience to the Church than for their indigence.[41] This attitude is understandable, as the excessive exaltation of poverty reflected adversely on the papacy and its curia.[42] As the thirteenth-century evangelical ideal represented by the mendicant orders was superseded in the fourteenth century by the Church's valorization of culture and orthodoxy, the realistic character of evangelical poverty was replaced by the more vague concept of 'spiritual poverty' — in fact, indigence was now seen as a distraction to the contemplative man.[43] Although poverty in the religious man was no longer held as a desirable characteristic, the lame retained their place in the art of the fourteenth century as symbols of human misery and recipients of charity.[44]

One of the roles that the Church performed at this time was that of mediator between the rich and the poor by allotting part of ecclesiastical revenues to the indigent or by managing donations of affluent citizens to monasteries. Despite the Church's prominent role, alms-giving in the Middle Ages was a widespread phenomenon that also involved lay institutions. In fact, with the growing wealth stimulated by fourteenth-century commercialism and the development of a money economy, alms-giving ultimately became a 'ritualized and institutionalized form of charity … useful in expiating the sins of wealth and power; at the same time it assured a stable existence, in the form of a prebend, to a number of people, for whom poverty was in a sense the professional justification of that stability'.[45] It was at this time that the most common depiction of a beggar became the cripple who dragged his body through the streets with small wooden

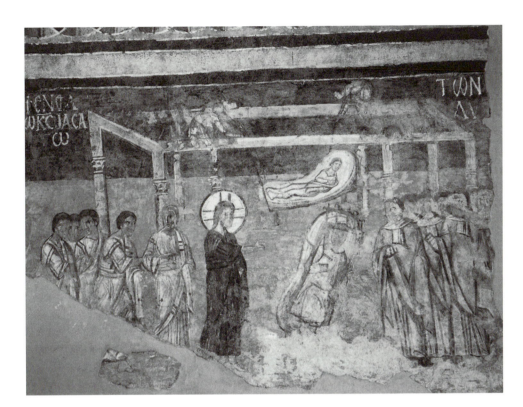

FIG. 8.4. *Healing of the Paralytic at Capernaum*, fresco, early eighth century CE, San Saba, Rome. *Photo: author.*

crutches to ask for charity from his benefactors.[46] As such, the lame and the mutilated became the protagonists of one of the most memorable Roman fresco cycles of the fifteenth century (**Fig. 8.6**).

The Chapel of Nicholas V in the Vatican, painted by Fra Angelico *c.* 1448–50, was decorated with major scenes from the lives of two proto-martyrs: Saint Stephen and Saint Laurence. The former, one of the first seven deacons elected by the Christian community, was stoned to death for having upheld the superiority of the Christian over the Jewish faith in the Sanhedrin, the Jewish legislative body.[47] Saint Laurence was ordained deacon by Sixtus II, and before the pope's death in 258 was instructed to give the Church treasures to the poor. When he refused to surrender the treasures to the imperial authorities he was martyred by burning on a gridiron.[48]

It has been noted that the iconography of the Chapel of Nicholas V reaffirmed the authority of the papacy.[49] In fact, the attempt to reassert the papacy's religious leadership had been the most salient aspect of the pontificates of Eugene IV (1431–47) and Nicholas V (1447–55). The latter, especially, would see the Church of Rome through the last phase of the power struggle known as the 'Age of the Councils'.[50] After the Great Schism of the fourteenth century, which had divided Europe between allegiance to the Avignonese or the Roman line of popes, the ensuing Age of Councils saw

the conciliarist cardinals try to undermine papal power by claiming that Peter's authority had not been superior to that of the other apostles. Their goal was to establish a more parliamentary constitution in opposition to the

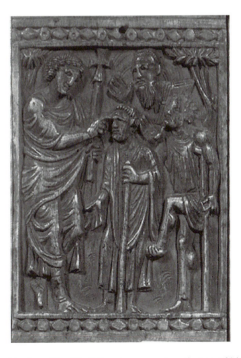

FIG. 8.5. *Healing of the Blind Man*, ivory carving, throne of Maximian, sixth century CE, Museo Arcivescovile, Ravenna. *Reproduced courtesy of the Diocesi di Ravenna-Cervia.*

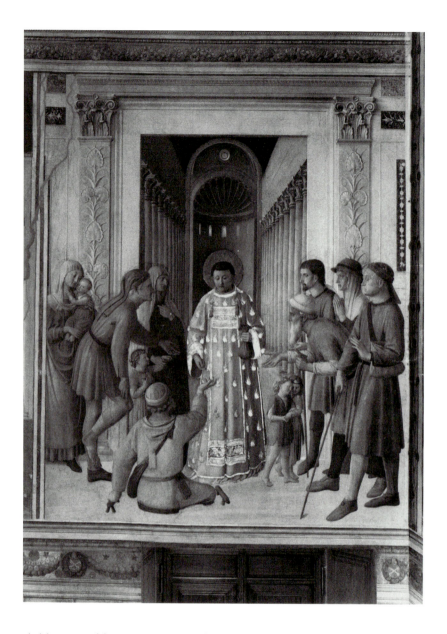

FIG. 8.6. **Fra Angelico (1395/1400–55),** *The Charity of Saint Laurence,* 1448–50, fresco, Chapel of Nicholas V, Vatican Palace, Vatican City. *Photo: Musei Vaticani, no. MVIP031. Reproduced courtesy of the Direzione dei Musei, Vatican City.*

rigid monarchic government upheld by the Church of Rome.[51] Through the political manoeuvres of Nicholas V, the papacy prevailed, and by 1449 the 'separatist' cardinals had recognized Nicholas V's authority and the seat of Peter once again became the sole centre of Catholic authority.[52]

By commissioning Fra Angelico to depict scenes from the lives of the two proto-martyrs, Nicholas and his advisers chose to reassert graphically the legitimacy of papal supremacy by showing that, contrary to the conciliarists' allegations, papal authority was founded on the continuity between the primitive Church in Jerusalem led by Peter (upper register) and the early Christian Church of Rome led by the popes (lower register).[53] The iconographic programme for the chapel specifically avoided any references to the principal

biblical references employed to support claims of papal superiority.[54]

Given the political and religious tensions of the first half of the fifteenth century, three frescoes from the life of Saint Laurence play a significant role in the papal chapel: *Saint Laurence is Ordained Deacon by Sixtus II, Sixtus II Confides to Saint Laurence the Treasures of the Church* and *The Charity of Saint Laurence.* These scenes address the problematic issue of ecclesiastical governance raised by the conciliarists who would have agreed with Marsilius of Padua in claiming that 'it is ... clear that neither Saint Peter nor any other apostles had pre-eminence or power over the others in the distribution of the temporal offerings'.[55] As the frescoes make clear, continuity existed between the present-day papacy and early Christian papal

governance of the ministries and its treasure. Any educated individual entering the chapel would have understood the parallel narratives in the upper and lower register: just as Saint Peter had ordained Saint Stephen in Jerusalem, so Sixtus II ordained Saint Laurence in Rome. Both Peter and Sixtus are shown offering the chalice and paten to Stephen and Laurence who, as deacons of the church, were responsible for the daily masses and the administration of the church. In both instances, the act of proffering the treasures of the church to the two proto-martyrs signalled that only the 'Vicar of Christ' had the authority to ordain priests and that only these could officiate the Eucharist.[56] Lest one miss the point that the pope was the legitimate heir of Peter, the painter twice replaced the portrait of Sixtus II in the lower register with that of Nicholas V. What is more important in the context of this paper, however, is that the lame are featured as co-protagonists in the scene of *The Charity of Saint Laurence*. When asked by the prefect of Rome for the Church treasure, Saint Laurence indicated 'the decrepit, the blind, the lame, the maimed, the lepers, orphans, widows and maidens', and responded: 'Here are the treasures of the Church'.[57]

It is obvious that, despite the primary role played by the mutilated and the lame in Fra Angelico's fresco of *The Charity of Saint Laurence*, they remained subservient to the papal ideological agenda. In fact, their presence was dictated by the need to depict scenes that exalted the pope as the ultimate religious authority and the legitimate heir to the Petrine tradition. Far from constituting the subject of a work of art in their own right, the lame in Nicholas V's fresco would have reminded the viewer of the pope's charity towards the Romans since he had created a large almshouse in the Vatican.[58] But it is remarkable that a consistent part of humanity, which traditionally had been kept on the margins of society and practically ignored by ancient Roman artists, should now be exalted ideologically and pictorially as the Church's most valuable 'capital'. In keeping with the enhanced early Christian appreciation of the disabled, in this Roman fresco the defective body asserted its presence at the centre of society's visual field.

To follow the unbalanced gait of the lame from antiquity through the early Christian and medieval periods is to apprehend not only how the physically impaired were perceived by the able-bodied, but also to understand the motivations on which those views were founded. The Romans' lack of interest in the defective body was not just a matter of aesthetic inadequacy, dysfunction or deviancy from the norm. It was also the consequence of religious beliefs that made disability the inauspicious sign of divine displeasure. With the rise of Christianity and its promise of a more equitable life, the lame became more frequently depicted because they most effectively suited the new ideology. In their refusal of paganism, the Christians adopted as a symbol of physical and spiritual regeneration that which had been considered the very negation of that concept: the disabled body. As recipients of miraculous cures, the paralytic, the lame, the cripple and the mutilated became the reassuring sign of hope and salvation in this life and the next. Through the Middle Ages and thereafter, depictions of the lame continued to serve other ideological needs by clearly representing individuals at the margins of the respectable community. The greater role assigned to them in Western art signalled a transition from the unresponsive pagan to the compassionate Christian view of disabled bodies.

NOTES

1. In the context of this paper, the term 'disabled bodies' will be used in a rather restricted sense. The focus of my research has been limited to depictions of individuals whose ambulatory capability was impaired either by malformation, mutilation or illness. Thus, this study will concentrate specifically on the lame, the crippled and the paralytic. The citation is from P. Baumann, 'Margins/outsiders', in H.E. Roberts (ed.), *Encyclopedia of Comparative Iconography: Themes Depicted in Works of Art* II (Chicago, 1998), 545–51, esp. pp. 547 and 550, but see also A. Jones, 'Body' and N. Athanassoglou-Kallmyer, 'Ugliness', in R.S. Nelson and R. Schiff (eds), *Critical Terms for Art History* (Chicago, 2003), 251–66, 281–95; S. Farmer and B.H. Rosenwein (eds), *Monks and Nuns, Saints and Outcasts: Religion in Medieval Society: Essays in Honour of Lester K. Little* (Ithaca/London, 2000), and for northern examples, R. Mellinkoff, *Outcasts: Signs of Otherness in Northern European Art of the Late Middle Ages* (Berkeley, 1993).

2. On the smith-god's lameness, 'a common disability of smiths in mythology', see J. Boardman, *Intaglios and Rings: Greek, Etruscan and Eastern* (London, 1975), 38.

3. P. Brown, *Poverty and Leadership in the Later Roman Empire* (Hanover (New Haven), 2002).

4. H.J. Stiker, *A History of Disability* (Ann Arbor, 1999), 34.

5. 'Pravitas membrorum, distortio, deformitas', Cicero, *Tusculanae disputationes* 4.13.29.

6. 'Et quidem laudamus Athenis Volcanum eum quem fecit Alcamenes, in quo stante atque vestito liviter apparet claudicatio non deformis', Cicero, *De natura deorum* 1.30.83. See also E.B. Harrison, 'Alkamenes' sculptures for the Hephaisteion: part I, the cult statues', *American Journal of Archaeology* 81.2 (1977), 137–78, at p. 147.

7. 'Quod stat dissimulatae claudicationis sub veste leviter vestigium repraesentans', *Facta et dicta memorabilia* 8.11.3. Harrison, 'Alkamenes' (above, n. 6), 147, fig. 3, points out that this phrase simply may be Valerius Maximus's own embellishment or interpretation as otherwise he merely reiterates Cicero's statement. The statue of the god may have looked the way it is depicted on a lamp in the Athens National Museum.

8. *Iliad* 18.371: *kyllopodion*, 'the crook foot'; 18.397: *kynopidos*, 'lame'; 18.607: *amphigueeis*, a term of difficult interpretation but that seems to imply that his feet were turned backwards. *Lexicon Iconographicum Mythologiae Classicae* [hereafter *LIMC*] IV (Zurich, 1988), 1, 628. For images of Hephaistos, see *LIMC* IV, 2, figs 103a, 129, 198 and Hephaistos/Sethlans, fig. 18a.

9. Vulcan became assimilated to Hephaistos during a period of Hellenization, towards the late third century BCE. There are several reasons given for Hephaistos's lameness. Hesiod, for example (in *Homeric Hymns* III, *To Pythian Apollo*, vv. 308–33 (trans. H.G. Evelyn-White)), claims that it was congenital and for this reason he was cast down from heaven by his mother, Hera: 'But my son Hephaestus whom I bare was weakly among all the blessed gods and shrivelled of foot, a shame and a disgrace to me in heaven, whom I myself took in my hands and cast out so that he fell in the great sea'. Homer, instead, has Zeus throw Hephaistos from the sky into the sea because he took his mother's side (*Iliad* 1.586). See Y. Bonnefoy (ed.), *Mythologies* I (Chicago, 1991), 384–6 and 645–6.

10. Harrison, 'Alkamenes' (above, n. 6), 147.

11. For a thorough discussion and extensive reproductions of Vulcan in antiquity see *LIMC* (above, n. 8) VIII (Zurich, 1997), 1, 283–97 and 2, figs 1–140. A fascinating chapter on 'Hephaistos's feet' is to be found in M. Detienne and J.-P. Vernant, *Les ruses de l'intelligence* (Paris, 1974), 242–58.

12. A denarius minted in 84 BCE for Publius Furius Crassipes or Crassupes (Splay Foot) commemorates his curule aedileship by showing on the obverse a small deformed foot (but not his deformed body) beside the head of the goddess Cybele. See R. Garland, *The Eye of the Beholder: Deformity and Disability in the Graeco-Roman World* (Ithaca/New York, 1995), 79, where, however, no reference is given. My thanks to Annie Ravenhill-Johnson for having brought this passage to my attention.

13. There are very few images of lame mortals even from the Greek world. Garland, *The Eye of the Beholder* (above, n. 12), figs 20 and 22, shows details from black- and red-figure vases dating from the sixth to the fourth century BCE with depictions of a club-footed dancer and an actor playing the role of an amputee. Fig. 32, possibly depicting Aesop, shows no real deformity of the legs, only a crutch, and fig. 35 is unconvincingly interpreted as the depiction of a cripple. Fig. 60 is the one startling, outstanding image: a statuette from Sicily of a 'grossly deformed or disabled man' (c. 600 BCE).

14. R. Garland, *The Greek Way of Death* (London, 1985), 80–1.

15. As cited by Garland, *The Eye of the Beholder* (above, n. 12), 16–17.

16. J.-P. Vernant, 'From Oedipus to Periander: lameness, tyranny, incest in legend and history', *Arethusa* 15.1 (1982), 19–38.

17. M.H. Jameson, 'Labda, lambda, labdakos', in M.A. Del Chiaro (ed.), *Corithiaca (Studies in Honour of Darrell A. Amyx)* (Columbia (MO), 1986), 10; Garland, *The Eye of the Beholder* (above, n. 12), 59, but also see p. 72 in reference to humans with birth defects: 'Whereas the Greeks tended to treat monstrous births as mere aberrations in the natural order, the Romans interpreted them as eminently suggestive of divine displeasure. Indeed few areas of human experience are more illustrative of the essential difference in religious outlook between the two cultures'.

18. 'Mater Antonia portentum eum hominis dictitabet, nec absolutum a natura, sed tantum incohatum', Suetonius, *Divus Claudius* 3.9 (trans. J.C. Rolfe) (Cambridge (MA), 1914).

19. Suetonius, *Divus Claudius* 4.9–11 (trans. J.C. Rolfe).

20. For the 'Miracle of the paralytic', see *Matthew* 9.6; *Mark* 2.21; *Luke* 5.25; *John* 5.5.

21. H.C. Kee, *Miracle in the Early Christian World* (New Haven, 1983), 159.

22. Kee, *Miracle* (above, n. 21), 86; M. Barasch, *Blindness: the History of a Mental Image in Western Thought* (New York/London, 2001).

23. Kee, *Miracle* (above, n. 21), 84–5.

24. Suetonius, *Divus Vespasian* 7.299 (trans. J.C. Rolfe).

25. Kee, *Miracle* (above, n. 21), 104.

26. Stiker, *A History of Disability* (above, n. 4), esp. pp. 25, 27 and 33.

27. For a brief but useful compendium of some of these images see K. Weitzman, *Age of Spirituality: Late Antique and Early Christian Art, Third to Seventh Century* (exhibition catalogue (The Metropolitan Museum of Art, New York), New York, 1979), esp. figs 401–2, 405, 407. For the frescoes from the oratory of San Saba, see F. Gandolfo, 'Gli affreschi di San Saba', in *Fragmenta picta: affreschi e mosaici staccati del medioevo romano* (exhibition catalogue (Castel Sant'Angelo, Rome), Rome, 1989), 186; R. Krautheimer, S. Corbett and W. Frankl, *Corpus Basilicarum Christanarum Romae* IV (Vatican City, 1970), 51–71.

28. For these images, see K. Weitzmann, *The Miniatures of the Sacra Parallela Parisinus Graecus 923* (Princeton, 1979), fig. 425; H.A. Omont (ed.), *Évangiles avec peintures byzantine du XIe siècle* II (Paris, 1908), figs 27 and 41v.

29. On the stylistic affinity between the frescoes at San Saba and Palestinian art of the seventh century, see Gandolfo, 'Gli affreschi' (above, n. 27), 186. Depictions of *The Healing of the Mute Man* in the monastery church of Saint John, Müstair (*c.* 800 CE), and *The Healing of the Sick* in the church of Saint Georg, Oberzell/Reichenau (*c.* 980 CE), testify to the wide-ranging influence exerted by Byzantine art on cycles of the Miracles of Christ, for which see, A. Wyss, 'Müstair, Kloster St. Johann. Zur Pflege der Wandbilder in der Klosterkirche', and D. Jakobs, 'Die Wandmalereien von St. Georg in Reichenau — Oberzell: Untersuchung — Dokumentation — Kontroversen', in *Wandmalerei des Frühen Mittelalters* (*Icomos* 23) (Munich, 1998), 49–55, 161–90; K. Koshi, *Die Frühmittelalterlichen Wandmalereien der St. Georgskirche zu Oberzell auf der Bodenseeinsel Reichenau* (Berlin, 1999).

30. *Meditations on the Life of Christ* (trans. F.X. Taney) (Asheville (NC), 2000), figs 143–4 and 189. A similar iconography can be found in the late twelfth-century mosaics in the cathedral of Monreale of 1182, for which see E. Kitzinger, *The Mosaics of Monreale* (Palermo, 1960).

31. É. Mâle, *The Gothic Image: Religious Art in France of the Thirteenth Century* (New York, 1972), 176.

32. A. Vauchez, *Sainthood in the Later Middle Ages* (trans. J. Birrell) (Cambridge, 1997), 158: all references are to the English translation that is based on the second, revised French edition. D. Weinstein and R.M. Bell, *Saints and Society: the Two Worlds of Western Christendom, 1000–1700* (Chicago/London, 1982), 194–204; A. Vauchez, *Saints, prophètes et visionnaires: le pouvoir surnaturel au Moyen Âge* (Paris, 1999), 67–78.

33. Vauchez, *Sainthood* (above, n. 32), esp. pp. 141–4, 157–8, 197, 199, 342, n. 293.

34. Vauchez, *Sainthood* (above, n. 32), 36.

35. R. Goffen, *Spirituality in Conflict: Saint Francis and Giotto's Bardi Chapel* (University Park (PA), 1988), 31. The classic accounts are K. Kruger, *Der Frühe Bildkult des Franziskus in Italien: Gestalt- und Funktionswandel des Tafelbildes im 13. und 14. Jahrhundert* (Berlin, 1992), and C. Frugoni, *Francesco e l'invenzione delle stimmate* (Turin, 1993), esp. pp. 325–34. For the visual arts see M.A. Pavone, *Iconologia francescana: il Quattrocento* (Todi, 1988), and S. Prosperi Valenti Rodinò and C. Strinati (eds), *L'immagine di San Francesco nella Controriforma* (exhibition catalogue (Calcografia, Rome), Rome, 1983), 74, cat. 8. For the Roman context see W. Cook, 'Early images of St Francis of Assisi in Rome', in B. Baker and J. Fischer (eds), *'Exegisti Monumentum Aere Perennius': Essays in Honour of John Frederick Charles* (Indianapolis, 1994), 19–34, esp. pp. 21–2; W. Cook, *Images of Saint Francis of Assisi in Painting, Stone and Glass from the Earliest Images to c. 1320 in Italy* (Florence, 1999), 183–96.

36. R. Wolff, *Der Heilige Franzsikus in Schriften und Bildern des 13. Jahrhunderts* (Berlin, 1996), 141–200, esp. p. 186 and pl. 38.

37. Cook, *Images* (above, n. 35), esp. cat. 163, pp. 192–3.

38. Vauchez, *Sainthood* (above, n. 32), 36; A. Vauchez, *Omobono di Cremona (1197): laico e santo, profilo storico* (Cremona, 2001).

39. B. Geremek, *Poverty: a History* (Oxford, 1994), esp. p. 169; C.M. de la Ronciere, 'Pauvres et pauvreté à Florence au XIVe siècle', in M. Mollat (ed.), *Études sur l'histoire de la pauvreté (Moyen Âge–XVIe siècle)* II (Paris, 1974), 661–745, esp. pp. 662, 734–5 for the lack of rigour attached to the word 'poverty', its equation with 'indigence' and for the use and understanding of the word 'poor' by the rich and the clergy on the one hand and the indigent wage-earners on the other hand, in fourteenth-century Florence. See also B. Geremek, *Inutiles au monde. Truands et misérables dans l'Europe moderne (1350–1600)* (Paris, 1980); B. Geremek, *The Margins of Society in Late Medieval Paris* (Cambridge, 1987); T. Riis, 'I poveri nell'arte italiana (secoli XV–XVIII)', in G. Politi, M. Rosa and F. della Peruta (eds), *Timore e carità: i poveri nell'Italia moderna* (Cremona, 1982), 45–58; E. Menestò (ed.), *La conversione alla povertà nell'Italia dei secoli XII–XIV* (Spoleto, 1991); M. Mollat, *Les pauvres au Moyen Âge* (Paris, 1978), and the important work by J. Henderson, *Piety and Charity in Late Medieval Florence* (Oxford, 1994), esp. pp. 243–6 for beggars. See also Barasch, *Blindness* (above, n. 22), 116–21. For a valuable analysis of the problem posed by 'false beggars' north of the Alps, see S. Farmer, 'The beggar's body: intersections of gender and social status in high medieval Paris', in S. Farmer and B.H. Rosenwein (eds), *Monks and Nuns, Saints and Outcasts: Religion in Medieval Society: Essays in Honour of Lester K. Little* (Ithaca/London, 2000), 153–71, esp. p. 162. For the Church's response to false beggars see E. von Kraemer, 'Le type du faux mendiants dans les littératures romanes depuis le moyen âge jusqu'au XVIIe siècle', *Societas Scientiarum Fennica Commentationes Humanarum Litterarum* 13.6 (1944), 1–338, esp. pp. 15–20.

40. Geremek, *Poverty* (above, n. 39), 32; Vauchez, *Sainthood* (above, n. 32), 394.

41. Goffen, *Spirituality in Conflict* (above, n. 35), 30; Vauchez, *Sainthood* (above, n. 32), 394.

42. C.W. Previté-Orton (ed.), *The Defensor Pacis of Marsilius of Padua* (Cambridge, 1928), xx, states that Pope John XXII promulgated two bulls in 1322 and 1324 respectively, *Ad conditorem canonum* and *Cum inter nonnullus*, in which he 'condemned the spiritual Franciscan belief in absolute poverty of Christ and in the necessity of absolute poverty for the perfect Christian'.

43. Vauchez, *Sainthood* (above, n. 32), 395–6; Geremek, *Poverty* (above, n. 39), 31: 'The rule was that poverty could reach its apotheosis only as a spiritual value, while real, physical poverty, with its visible degrading effects, was perceived, both doctrinally and by society, as a humiliating state, depriving its victims of dignity and respect, relegating them to the margins of society and to a life devoid of virtue'.

44. For comparative material see M. Merback, *The Thief, the Cross and the Wheel: Pain and the Spectacle of Punishment in Medieval and Renaissance Europe* (London, 1999).

45. For the issues raised in this paragraph see Geremek, *Poverty* (above, n. 39), 36–42. Paradoxically, those very individuals who had practised and preached voluntary poverty helped to propagate a morality that justified the commercial nature of their society. See L.K. Little, *Religious Poverty and the Profit Economy in Medieval Europe* (London, 1978), 216. On the 'painful birth' of this new economic, social and spiritual order see L.K. Little, 'Evangelical poverty, the new money economy and violence', in D. Flood (ed.), *Poverty in the Middle Ages* (Werl/Westphalia, 1975), 11–26; de la Ronciere, 'Pauvres et pauvreté' (above, n. 39), 734: 'À l'égard des pauvres reconnus comme tels, les obligations des riches sont limitées: on les fait vivre, on ne les sort pas de leur conditions. C'est que la réflexion sur la pauvreté est courte et subordonnée à la réflexion sur le riche et la richesse: les pauvres sont pitoyables, mais il sont utiles au salut du riche: il faut des pauvres'.

46. M. Camille, *Image on the Edge: the Margins of Medieval Art* (London, 1992), 133, figs 70–1.

47. *Acta Sanctorum*, Augusti II (Antwerp, 1735), 496, no. 56, *De recognitione*, 15; G. Kaftal, 'The fabulous life of a saint', *Mitteilungen des Kunsthistorischen Institutes in Florenz* 17 (1973), 123–8; *Acts* 6.5–8.3; 'De recognitione corporum SS. Laurentii et Stephani', *Analecta Bollandiana* 5 (1886), 192.

48. *Acta Sanctorum*, Augusti. H. Leclercq, 'Laurent', in F. Cabrol and H. Leclercq (eds), *Dictionnaire d'archéologie Chrétienne et de liturgie* 8, 2 (Paris, 1929); A. Benvenuti and E. Giannarelli, *Il diacono Lorenzo tra storia e leggenda* (Florence, 1998).

49. A. Greco, *La cappella di Niccolò V del Beato Angelico* (Rome, 1980), 20; R. Colella, 'Die Kapelle Papst Nikolaus' V. Zu ihrer Geschichte und Funktion inner halb des Vatikanischen Palastes', in C. Striker (ed.), *Architectural Studies in Memory of Richard Krautheimer* (Mainz, 1996), 37–41; R. Colella,

'Hagiographie und Kirchen politik — Stephanus und Laurentius in Rom', in R. Colella *et al.* (eds), *Pratum Romanum: Richard Krautheimer zum 100. Geburtstag* (Wiesbaden, 1997), 75–96; F. Cantatore, 'Niccolò V e il Palazzo Vaticano', in F. Bonatti and A. Manfredi (eds), *Niccolò V nel sesto centenario della nascita* (*Studi e testi* 337) (Vatican City, 2000), 399–410; M. Calvesi, 'Gli affreschi del Beato Angelico nella Cappella Niccolina', and I. Venchi, 'Il messaggio teologico della cappella Niccolina', in F. Buranelli (ed.), *Il Beato Angelico e la cappella Niccolina: storia e restauro* (Novara, 2001), 45–62, 63–76.

50. Greco, *La cappella* (above, n. 49), 71; B. Tiernay, *Foundations of the Conciliar Theory* (Leiden, 1998). For the fundamental texts of Cajetan, Almain and Mair now see J.H. Burns and T.M. Izbicki (eds), *Conciliarism and Papalism* (Cambridge, 1997). In the context of the Nicholas V Chapel see R. Colella, *Päpstliche Suprematie und Kirchliche Reform. Die Fresken Fra Angelicos in der Kapelle Papst Nikolaus' V. — ein Päpstliches Programm in Spät Konziliarer Zeit* (Ph.D. thesis, Munich, 1993); C. Bonfigli, *Niccolò V: papa della rinascenza* (Rome, 1997), 133–6.

51. P. Palazzini (ed.), *Dizionario dei Concili* (Rome, 1963–8), I, 149.

52. L. von Pastor, *Geschichte der Päpste* I (Freiburg, 1886); G. Pelliccia and G. Rocca (eds), *Dizionario degli istituti di perfezione* (Rome, 1974–2003); G.L. Coluccia, *Niccolò V umanista, papa e riformatore* (Venice, 1998), 115–30.

53. A. Cavallaro, 'La pittura a Roma al tempo di Nicolò V (1447–1453)', in G. Fossi (ed.), *La storia dei Giubilei* II (Rome, 1998), 76. In keeping with the pacifying nature of his papacy, Nicholas V chose scenes from the lives of Saint Stephen and Saint Laurence, thus tactfully side-stepping the issues raised in the fourteenth century by Marsilius of Padua and William Ockham, who claimed that the very existence of the papacy was not a creation of divine providence. See Previté-Orton, *The Defensor* (above, n. 42), xx; Palazzini (ed.), *Dizionario dei Concili* (above, n. 51), I, 149. Had Nicholas V chosen to tackle the issue in a more polemical way, he would have required that two scenes from the life of Christ be represented in his chapel: Christ's charge to Peter to 'Feed my sheep' and 'The handing of the keys to Peter'. These, indeed, had been the traditional events that stressed Christ's choice of Peter as the 'rock' on which to build the Christian Church — see A. Molho, 'The Brancacci Chapel: studies in its iconography and history', *Journal of the Warburg and Courtauld Institutes* 40 (1977), 53.

54. Molho's statements with reference to the Florentine chapel are just as pertinent to the Chapel of Nicholas V: 'The fact that the two principal biblical references used to support claims of papal superiority were excluded from the Chapel's iconographic programme suggests that the sponsor's and iconographer's intention was to avoid raising the enormously controversial question of the superiority of the Church over the State, and to focus the contemporary viewer's attention on the different range of problems, all of which referred to the internal

administration of the Church, or to the undisputed position of the Papacy at the apex of the ecclesiastical hierarchy', Molho, 'The Brancacci Chapel' (above, n. 53), 53.

55. Molho, 'The Brancacci Chapel' (above, n. 53), 54.

56. Colella, *Päpstliche Suprematie* (above, n. 49).

57. *Acta Sanctorum*, Augusti II (above, n. 47), esp. pp. 491–3; J. de Voragine, *The Golden Legend* II (ed. and trans. W. Granger Ryan) (Princeton, 1993), 65–6.

58. Colella, *Päpstliche Suprematie* (above, n. 49).

TRUTH, PERCEPTION AND THE PAGAN BODY IN THE ROMAN MARTYR NARRATIVES

Kristina Sessa

In him was life and the life was the light of men. The light shines in the darkness and the darkness has not overcome it.

John 1.4–5

There exists in the soul though the medium of the same bodily senses, a cupidity which does not take delight in carnal pleasure but in perceptions acquired through the flesh. It is a vain inquisitiveness dignified with the title of knowledge and science …

Augustine, *Confessions* 10.35.54 (trans. H. Chadwick)

I used to think to be false what is true, and I used to consider true what is false. I used to think the shadows are light, and the light I believed was shadows. But my senses have been purged of the pollution of idols.

Passio S. Clementis episcopi et martyris 14

Few epistemological debates have been more central to the development of early Christian thought than the relationship between the physical senses and the knowledge of God. How can one perceive the 'light' of truth through organs so vulnerable and imperfect as the senses? This paper examines a spectrum of late antique responses to the problem of perception, with a focus on a corpus of late Roman martyr narratives known collectively as the *Gesta martyrum*.[1] Written anonymously in Rome during the fifth and sixth centuries CE, the Roman martyr narratives depict the last days and deaths of the city's pre-Constantinian martyrs.[2] As a number of chapters in this volume demonstrate, depictions of the martyr's own Christ-like body have been variously interpreted as culturally resonant media through which Christian practices and ideologies were both reflected and produced.[3] Yet the martyr's is not the only body whose sufferings can be read as discourses about Christian knowledge and truth. While frequently seen as simply the martyr's antipode and agent of death, the pagan persecutor and his sensually-disabled body (blind, deaf or simply unable to perceive) stands out in several of these martyr narratives as an ambivalent metaphor through which Roman Christian writers attempted to negotiate the limitations and possibilities of sacred knowledge and divine truth.[4]

In order to navigate a course through so large a topic as the metaphorical import of sensory knowledge in early Christian thought, attention will be focused primarily on a particular narrative 'scene', wherein a character experiences a complete hermeneutic breakdown: what he 'sees' as reality is not the reality that we the readers see, nor is it the reality experienced by the other characters in the narrative.[5] Among the many such scenes in the Roman martyr narratives, two *passiones* with diametrically opposed resolutions will be considered here.[6] In the first, the Latin version of the *Passion of Saints Agape, Chionia and Irene*, the Roman *dux* Dulcitius's sensory disablement is causally related to his perpetration of the most debased sensory sin: lust for the sight and sound of three Christian virgins. The second text, the *Passion of Saint Clement Bishop and Martyr*, presents the case of the pagan aristocrat Sisinnius, whose world is radically destabilized when he falls prey to

his own uncontrollable curiosity to see and to hear the celebration of the Christian liturgy by the bishop of Rome.

The work of two additional authors, one pagan and one Christian, will help to underscore the relationship of the *passiones* to broader moral and epistemological discussions about the problem of perception. First, the writing of Augustine (354–430 CE) provides intellectual depth to the issues transposed by the authors of the martyr narratives into a more dramatic register. In addition to the lengthy discussion in book 10 of the *Confessions* of his own battle with the senses and their capacity to incite sin, Augustine's marked ambivalence towards the senses and man's capacity to 'know' divine truths offers a sobering counterweight to the bald certainty expressed in the martyr narratives. Second, in order to highlight the cognitive implications of the often comic and undeniably entertaining depiction of the pagans' sensory disablement, a brief comparison is made between the Roman martyr narratives and a seemingly inappropriate, though generically related, *comparandum*, the Latin novel *The Golden Ass*, by the pagan writer Apuleius (*c.* 125–80 CE). As recent scholarship has shown, Christian hagiography was strongly influenced by ancient romance literature, and often featured novelistic themes and narrative devices (such as shipwrecks and kidnappings, the separation and reunion of loved ones, recognition scenes and *ekphrases*) that were redirected to convey a more explicitly Christian message.[7] The hermeneutic confusion depicted in the wine skins episode in *The Golden Ass* (2.32–3.16), a book renowned for its interest in the problem of perception and knowledge, closely parallels the scenes of sensory confusion portrayed in the martyr narratives.[8] Without adducing a direct interdependence between the two, attention to the workings of the trope of misperception in *The Golden Ass* illuminates discussions of epistemology and perception in the Roman martyr narratives that might otherwise remain occluded.

THE SENSES AS METAPHORS OF TRUTH AND CHANNELS OF SIN IN EARLY CHRISTIAN DISCOURSE

Considerable disagreement existed among the ancients regarding the ability of the physical senses to apprehend divine truths.[9] For Platonists, divine knowledge was intelligible but not corporeal; hence, the physical senses played no role in man's apprehension of truths that lay exclusively in the divine realm of ideal forms. Alternatively, Stoic epistemology denied an intelligible realm and held that knowledge arose directly from objects that are known by the senses.[10] Deeply influenced by both Platonic and Stoic thought, Christian thinkers registered problems surrounding the role of the senses in the apprehension of knowledge, particularly with respect to certain core theological beliefs. The third-century Christian theologian Origen, for example, preserved in the *Contra Celsum* a record of criticisms launched by pagans against the claim made in the New Testament that some of the apostles had seen, heard and even touched a post-resurrected Christ.[11] The paradox that arose from the simultaneous claim to a God that is both non-corporeal and omnipotent on the one hand, and a sensually apprehensible Christ on the other, was seen by some Christians and their critics as deeply problematic.[12] Reacting against such epistemological critiques, Origen attempted to transfer the process of acquiring true knowledge out of the realm of the senses and external perception into the interiority of the soul, where divine wisdom could be 'known' without the mediation of the physical senses.[13]

Despite, or perhaps because of, these metaphysical critiques of Christian theology, Christians drew heavily on the senses as metaphors with which to describe the experience of perceiving the divine.[14] One well-known example of the metaphorical use of the senses germane to the Roman martyr narratives is the story of the apostle Paul's conversion experience in *Acts* 9.1–19. As Saul (Paul's former name) approached the city of Damascus, a great flash of light struck him from above and literally knocked him off his horse. Instructed by Jesus to continue on his course, Saul stood up, but was now blind. Without sight for three days, it was not until Christ's disciple Ananias placed his hands on Saul, filling him with the Holy Spirit, that 'something like scales fell from Saul's eyes, and he could see again'.[15] Healed of his physical and spiritual blindness, Paul's recovery of sight precipitated his baptism and his acceptance of Christ's charge to preach to the Gentiles. Sight and blindness thus serve to underscore a radical spiritual and epistemological reorientation, from Christian persecutor to Christian proselytizer. The common use in later Latin Christian literature (and especially in the Roman martyr narratives) of the verb *illuminare* to denote the ritual act of baptism underscores the semantic nexus of sight, conversion and divine knowledge.

While often employed to describe an experience or apprehension of the divine, the senses could alternatively be seen as potential impediments to salvation. For

Augustine, as well as for the authors of the Roman martyr narratives, the senses were highly vulnerable to external stimuli that could lure the soul from its path of virtue. Demons, food, wine, perfumes, games in the arena, even the singing of psalms could pose grave threats to the purity of the mind. In book 10 of the *Confessions*, Augustine discusses the pleasures that the senses (and particularly the eyes) enable and their ability to incite sin if indulged and unmonitored.[16] Specifically, he closely identified the senses with his own three great sins, lust of the flesh (*concupiscentia carnis*), curiosity or 'lust of the eyes' (*concupiscentia oculorum*) and pride (*ambitio saeculi*).[17] Curiosity, he continued, is perhaps the most insidious, for while it seemingly posits a good (knowledge) as its goal, it is in reality a more base desire for knowledge as an end in itself, and, at that, a desire that inevitably and ineluctably leads to pride.[18] Commenting on how easily he becomes enraptured by the minutiae of the created world, Augustine reflects on his own daily struggle 'in such an immense forest filled with traps and dangers'.[19] Though he now more carefully monitors his *concupiscentia oculorum*, refraining from the grisly sights of the *spectacula*, his mind could still be all too easily lured by the chance sight of a dog chasing a rabbit along the road. Even a lizard catching a fly or a spider spinning a web, he confesses, held the capacity to grip his attention and turn him away from God. Such distractions, he concludes, are unavoidable without God's assistance.[20]

MISPERCEPTION IN THE ROMAN MARTYR NARRATIVES: THE CASES OF DULCITIUS AND SISINNIUS

Augustine's ruminations on the particular vulnerability of the senses with respect to the sins of lust and curiosity are dramatically echoed in the depiction of the pagan persecutors' sensory disablement in the *Passion of Saints Agape, Chionia and Irene*, whose martyrdom comprises a discrete episode of the *Passion of Saint Anastasia*.[21] The story of the three virgin sisters, Agape, Chionia and Irene, opens with their arrest and presentation before a lecherous Roman governor with the fittingly ironic name of Dulcitius (from the Latin *dulcis* meaning 'sweet' or 'agreeable').[22] Upon seeing the three young girls, Dulcitius finds himself 'bound by the sight' ('captu oculorum astrictus', *Passio S. Anastasiae* 12) and so offers the girls what he sees as an irresistible deal: their freedom in return for sexual favours. They unanimously reject his proposition and, as a result, are

imprisoned by Dulcitius in a small storage room filled with various cooking utensils, where they spend the evening praying and singing psalms. Compelled by the delightful sound of their psalm singing, Dulcitius enters the room only to succumb immediately to a crisis of the mind and of the senses:

> His mind rendered delirious, he began to embrace the pots and kiss the frying pans; deluded in these matters for a long time, a man blackened and soiled like a cooking pot, he resembled in his clothing and appearance the sort of man who was possessed in the mind by the devil.[23]

Virtually unrecognizable in this blackened and soiled state, Dulcitius puts even his own attendants to flight, as they gaze upon his frightful and manic appearance by the light of their lamps.

Dulcitius's moral turpitude thus emerges as the cause of a severe perceptual crisis, one that not only causes him to mistake kitchen-ware for psalm-chanting virgins, but also renders him blind to his own physical state of disarray. Confused by the disrespectful reaction of his subordinates, Dulcitius decides to head for the imperial palace in the hope of consulting the emperor. Once there, however, he finds little respite, as he is flogged, beaten and spat upon by the imperial attendants. Even his domestic servants protest his physical appearance: 'Look at yourself!' ('respice te!', *Passio S. Anastasiae* 13), they sneer, as they lead him home. Still, the *dux* remains fully unaware, 'for the devil had shut his eyes'.[24] His mind seals off even from the physical reality of his own person. Dulcitius's sensory disablement culminates in absolute self-delusion: 'for it seemed to him that he was dressed in snow-white clothing, walking along perfectly clean'.[25] Spurned by both peers and subordinates, Dulcitius's social dislocation and physical disarray accentuate his mind's acute disjunction from his own senses: 'The man's mind was healthy but his eyes alone were held by Satan, whose sight the wretched man met when he looked upon the martyrs of God with a lewd exertion of the mind'.[26]

Dulcitius's shameful desire for the sight and sounds of the three virgin sisters and the sensory disablement that ensues can be compared to the plight of the aristocratic pagan Sisinnius in the *Passion of Saint Clement Bishop and Martyr*.[27] Sisinnius appears in a lengthy middle section of the passion as the pagan husband of a Christian wife, Theodora. An upper-class Roman couple, Sisinnius and Theodora find their

marriage threatened by Theodora's zealous devotion to her faith and to her bishop, Clement. Overcome by jealousy at his wife's frequent visits to Clement, Sisinnius plots to ambush Theodora on her way to church. However, his plan is soon thwarted by his own unbridled curiosity:

> Having followed her through a separate entry as she went inside the church, Sisinnius began to pay attention, listening to and watching attentively what was taking place there. But, when Clement poured forth a sermon and the people said 'Amen', Sisinnius was immediately struck blind and deaf, and could neither see nor hear.[28]

Rendered completely disabled inside the church, Sisinnius must be carried out on the shoulders of his slaves, a detail that further emphasizes the once able-bodied aristocrat's humiliation and degradation.

Due in part to Theodora's interventions, Sisinnius's eyesight and hearing are quickly restored when Bishop Clement visits the aristocrat at home and heals him. However, although Sisinnius regains his physical sight and hearing, his ability to perceive reality via the senses remains stymied. Enraged and suspicious that Clement had deliberately disabled him through magic so as to gain control over his wife, Sisinnius's first act upon the restoration of his senses is to order his servants to shackle Clement and to prepare him for execution. In a scene whose humour rivals that of Dulcitius's comic embrace of dirty pots and pans, Sisinnius and his men are duped by their own senses into tying up columns instead. While believing they have detained Clement, the servants actually 'tied together columns lying around and dragged them around, at one time from the inside to the outside, and at another time from the outside to the inside. Even to Sisinnius himself it seemed that they had detained and dragged away a bound Saint Clement'.[29] Like Dulcitius, Sisinnius's senses remain blocked and his mind deluded, apposite punishment for an unauthorized spectator of the sacred and secret rituals of the Christian liturgy who in turn fails to recognize the exalted spiritual power of the bishop.

AN APULEIAN INTERLUDE: MISPERCEPTION AND THE HERMENEUTICS OF VISION IN *THE GOLDEN ASS*

The stories of Dulcitius and Sisinnius feature a particular narrative strategy, whereby scenes of sensory confusion and incapacitation are catalyzed by the 'sensory sins' of lust and curiosity. However, while the moral implications of the pagans' inability to see and hear are manifest, it remains to be seen how the trope of misperception specifically addresses the epistemological relationship between the senses and cognition. Leaving Dulcitius and Sisinnius aside, I turn briefly to the trope of misperception as an inherited narrative strategy, which similarly appears in a second-century CE Latin novel known as *The Golden Ass*. By all accounts, *The Golden Ass* stands among the most popular and enigmatic works of ancient literature. Scholars continue to contest the meaning of the novel as a whole and in particular the relationship of the first ten books, which feature the protagonist Lucius in a series of adventures, including his famous transformation into an ass, to the final eleventh book, when the novel itself suddenly and seemingly metamorphoses into an account of Lucius's own religious conversion to the cult of Isis.[30]

The novel's fascination with hermeneutic instability and its delight in depicting misperception is structured by a series of scenes wherein reality and appearance become inextricably intertwined and where no single authorizing point of view (authorial or otherwise) can be easily, if at all, ascertained.[31] Consider, for example, the famous wine skins episode (2.31–3.18).[32] Returning home one evening drunk, after a lengthy feast (*convivium*), Lucius encounters in a dark alley what he believes to be a band of desperadoes. Seeing them attack the front door of his host's home, Lucius 'kills' the three men in what appears at first, to both protagonist and reader, as a desperate but justified act of self-defence. However, it is quickly revealed in the beginning of book 3 that what he has in fact 'killed' were not thieves but a bunch of wine skins. Brought to trial before the entire city of Hypata, Lucius protests his innocence (while concocting a grossly embellished defence in the process). But as the trial descends into a circus-like spectacle, the crowd's boisterous laughter reveals the larger context of the event as part of the city's annual Festival of Laughter.[33] Lucius is thus condemned not as a murderer, but as the butt of a practical joke elaborately staged by the locals, who have been privy to the lifeless state of his would-be assailants. Lucius and the reader have been duped, or have they?

Among numerous moments of interpretative confusion in *The Golden Ass*, the wine skins episode directly engages with the problem of perception.[34] While Lucius is shown to have misapprehended the objective nature of his attackers, the Hypatan crowd who feigned

Lucius's trial also, it turns out, misperceived the 'truth' in Lucius's story. We quickly learn from Lucius's lover, the slave girl Fotis, that Lucius did 'see' what he thought were three 'thieves' on the previous night (3.16–18), just as he claimed in his testimony. Unknown to the people of Hypata, the wine skins, so Fotis explains, had been drawn to life by the magic of her mistress who, in an attempt to attract a young lover through an erotic spell, accidentally animated the goat bladders that Lucius encountered outside her front door. It was the wine and the darkness, she claims, that fooled her lover into participating in what was, in the end, only a harmless manipulation of reality.[35] Yet the tale's final reckoning raises the hermeneutic confusion to yet another pitch: is it only darkness and drink that have the power to deceive the eyes? What force do demons and magic have on our perceptions of reality? Did Lucius simply misperceive reality, as the plaintiffs at his trial so claimed, or did he, in fact, correctly perceive a play of magical forces that held the power to pervert his senses, as Fotis's story suggests? By withholding authorization of any one explanation of the events, Apuleius underscores the essentially untrustworthy status of the senses as channels through which empirical reality is mediated.[36]

The adventure of Lucius with the wine skins in *The Golden Ass* offers a striking and constructive parallel to Dulcitius's and Sisinnius's experiences in the later Roman martyr narratives. Although it is unlikely that the Christian authors of the fifth- and sixth-century martyr narratives directly modelled their scenes of sensory delusion on *The Golden Ass*, their portraits of the pagan persecutors' perceptual crises recall Apuleius's use of the trope of misperception as a narrative strategy geared towards 'hermeneutic entertainment'. The use of this inherited conceit in the *passiones* maintains its primary function as a humorous and ironic means with which to underscore epistemological instability; just as the narrative logic is contorted in *The Golden Ass*, so are reality and appearance hopelessly jumbled in the world of Roman martyr narratives. We find in both sources, for example, objects (kitchen-ware, columns and wine skins) that, in the deluded minds of the protagonists, take on human shape and life. These animated anthropomorphic objects, perceived as human beings, are attacked by the protagonists in an expressly aggressive manner. Moreover, in each of the three cases presented here (Dulcitius, Sisinnius and Lucius), the characters commonly experience a semantic collapse when their senses have been impeded: intoxication and magic in the case of Lucius, lust,

curiosity and, more generally, the interference of satanic powers in the case of the pagan persecutors.[37] Finally, it is worth emphasizing that all three texts reflect a broader shared cultural context, in which the ubiquitous presence of demonic forces was not simply a representational strategy but a cosmological reality.

The match between pagan novel and martyr narrative is by no means exact, as there are crucial points of divergence that underscore the very different sets of intentions and expectations of the respective authors and audiences. While Apuleius's scenes of sensory confusion retain a great deal of ambiguity and actively resist any single authorizing interpretation, the epistemological implications of Dulcitius's and Sisinnius's incapacitation are comparatively clear. In both cases, a pagan (versus Christian) status is the basic but crucial criterion in their experiences of delusion. Thus Dulcitius's humorous confusion of kitchen-ware with nubile virgin, conjoined with his complete misapprehension of his own physical state, illustrate the pagan's spiritual and intellectual depravity with respect to his shameful treatment of the three virgins. Likewise, Sisinnius's inability to differentiate between a stone column and the bishop of Rome mirrors his mind's unwillingness to distinguish between Clement's spiritual power and his own domestic authority over his wife. In both cases, the multiple levels of misperception and hermeneutic confusion that so characterize Lucius's misperceptions in the wine skins episode are collapsed into a single, manifest and confessional meaning. In the process of refashioning the trope of misperception for a Christian context, irony gives way to the spiritual certainty that pagans are uniquely susceptible to the problem of perception.

Finally, it is useful to draw attention to Apuleius's epilogue, which bears direct relevance to the larger discussion of the martyr narratives. Book 11, as is well known, depicts Lucius's re-transformation back into a human by way of a vision of the Egyptian goddess Isis and his subsequent initiations into her priesthood. This unexpected narrative development has prompted several scholars to address the question of Lucius's putative religious 'conversion' and, more specifically, to suggest that it can be interpreted as a solution to the problem of truth and knowledge that had plagued the protagonist for the entire novel.[38] While we must consider with scepticism the suggestion that Apuleius offers any single authoritative conclusion to a novel that celebrates a multiplicity of interpretations, the idea that religious conversion has an epistemological, as well as moral, dimension is germane and indeed illuminating with

respect to the conclusions of the stories about Dulcitius and Sisinnius presented in the Roman martyr narratives, to which we must now return.[39]

RESOLVING THE PROBLEM OF PERCEPTION IN THE ROMAN MARTYR NARRATIVES: DEATH OR CONVERSION

Having identified both the moral and epistemological dimensions of the trope of misperception, it remains to consider the resolution of the problem of perception in the Roman martyr narratives. Let us resume with the story of Dulcitius, who, when last seen, was wandering around in a state of complete self-delusion. Lustful after the three virgin sisters until the very end, the *dux* orders them to appear before him at a public tribunal. When the girls enter praying and singing psalms, Dulcitius commands that they be stripped naked, 'so that he might gaze upon their nude bodies'.[40] In this final attempt to indulge his lustful eyes the evil pagan is once again thwarted, as the girls' clothing miraculously clings to their virginal bodies. Both unrepentant and unremitting in his quest to see what must not be seen, Dulcitius falls into a fatal sleep, his eyes permanently 'shut' and his soul eternally damned. The pagan's baleful behaviour and pathetic death appropriately gloss the character of the persecutor as the recalcitrant and unenlightened judge, who cannot or will not comprehend the divine truth that is so clearly articulated in confessions of Christian martyrs and that is so visibly instantiated in their virginal bodies. For Dulcitius, however, who 'sees' the girls only as objects of desire, such divine truths remain occluded and permanently misperceived. Presented in this final scene slumped over his tribunal chair in an eternal state of spiritual and cognitive blindness, the problem of perception proves to be the pagan's fatal flaw.

Not all pagans are destined to suffer the fate of Dulcitius. As the story of Sisinnius dramatically illustrates, misperception can also be represented in the Roman martyr narratives as a temporary experience that serves in part to underscore the pagan's dramatic conversion to the 'correct' epistemological and liturgical framework. Unlike Dulcitius, who died thinking the world is something other than what it really is, Sisinnius abruptly discovers his own error in the course of conversion to Christianity. Soon after Sisinnius's conflation of column with bishop, the aristocrat is visited in a dream by none other than Saint Peter. Just as Lucius's vision of Isis propels him towards

a resumption of an anthropomorphic state, so it is at this precise moment that Sisinnius comes to 'see the light' through eyes now correctly reoriented towards 'the truth' of Christ and Christianity:

> Indeed, I give thanks to the all-powerful God, who blinded me so that I may see and took away my hearing so that I may hear the truth, at which, ignorantly, I used to laugh. I used to think to be false what is true, and I used to consider true what is false. I used to think the shadows are light, and the light I believed was shadows. But my senses have been purged of the pollution of idols. For truly I know that demons deceive men so that deaf and mute stones lord over those men who do not believe that Christ is the Lord, just as they lorded over me up until this time.[41]

Metaphorically recasting Sisinnius's deafness and blindness as spiritual error, the writer of the *Passion of Saint Clement* draws attention once again to the pagan body as a barometer of the mind and soul. Like Dulcitius, whose transformed physical appearance mirrored his deluded mental and spiritual state, Sisinnius's body is similarly portrayed as a human parody of the very 'deaf and mute stones' (*saxa muta et surda*) that he used to worship.[42] While Dulcitius dies unenlightened, Sisinnius's *confessio* underscores the degree to which the 'purging of his senses' is presented as a viable option for the pagan whose sincerity and desire warrants it. The vaguely Platonic language of Sisinnius's evocation of light and shadows as the poles of a now manifest philosophical and spiritual framework signals the passion's interest in depicting conversion not simply as a process of moral purification, but also as an event with epistemological implications.

AUGUSTINE: CERTAINTY, THE SENSES AND THE LIMITATIONS OF CONVERSION

In the imaginative world of the Roman martyr narrative, the senses emerge as deeply problematic but ultimately controllable organs through which divine knowledge potentially can be channelled. Conversion is presented (in the case of Sisinnius) as a radical and permanent reorientation of the mind and the soul, wherein the convert is at last able to apprehend that which he had previously misperceived. The stark optimism expressed in the Roman martyr narrative belies what was for some a far more taxing

and prolonged process. In the *Confessions*, Augustine reflects repeatedly on the fleeting nature of his own 'brushes' with divine knowledge. His vision at Ostia with his mother Monica is perhaps the clearest illustration of the deep reservations the bishop held about his own ability to know God. Drawing on the language of the senses, Augustine describes how he and Monica were able to 'touch' wisdom 'in some small degree by a total thrust of the heart'.[43] However, the vision was fleeting.[44] For Augustine, complete knowledge of God lay beyond the reach of man, who, in this life, can only ever see 'through a darkened mirror' ('per speculum in enigmate', 1 *Corinthians* 13.12).[45]

The role played by the senses in Augustine's process of 'knowing' is deeply ambivalent. In depicting his vision at Ostia, Augustine speaks of 'touching' God in the 'spiritual sense', much in the same way as Origen did.[46] While the senses could perform positively as metaphors with which to describe mystical experiences, they were often presented as potential stumbling blocks. Again, his discussion of *curiositas* in book 10 is illustrative. Augustine regards curiosity as the 'lust of the eyes' (*concupiscentia oculorum*). For Augustine, as for most western thinkers of his day, vision is privileged as the sense most closely connected to the rational faculties of the mind. This explains how he can recognize in curiosity an 'eminently intellectual character' and thus view it as a sin with far more serious repercussions than bodily lust (*concupiscentia carnis*), which, while also a sensory experience, did not so directly engage the mind.[47] Consequently, the pursuit of knowledge and experience as ends in themselves — Augustine's basic definition of curiosity in the *Confessions* — appears as tantamount to turning away from God, and as concomitant with disorder and instability.[48]

In the end, God is presented as man's only hope, whose mercy will transform his mind and soul, and root out the vitiating pride that inevitably follows from such unmitigated sensory freedom. The senses, it seems, potentially can be controlled.[49] Yet, there remains a lingering sense of equivocation in Augustine's thought about the possibilities of the senses. Even if one can control the sinful stimuli the senses are wont to channel, God cannot be found in the external world; at best, all we can gather are images and appearances, and even these are subject to demonic interference. Indeed, demons are perhaps the strongest link that connects the thoughts of Augustine on the senses and cognition to Lucius's antics in *The Golden Ass* and to the portraits of the pagan persecutor in the Roman martyr narratives. While the *passiones* idealize the power of the priest to emancipate the senses from Satan's insidious snares (as we saw in the case of Sisinnius), Augustine, like Apuleius, sees no respite from man's constant bombardment by forces that are often outside his control. In *The City of God*, written many years after he published the *Confessions*, Augustine addresses the phenomenon depicted in *The Golden Ass* and elsewhere in pagan literature, wherein men are seemingly transformed into animals.[50] Augustine asks the sceptic's question: can these things really happen? While he rejects the possibility that any force other than God holds the power to change the physical nature of a body, he acknowledges that demons can make such metamorphoses seem apparent and real.[51] Yet for a thinker who increasingly registered doubts about his (or anyone's) ability to purge the soul permanently of sins incited by life in the earthly city, Augustine's measured suspicion towards the senses and divine knowledge comes as little surprise.[52]

CONCLUSIONS

The Roman martyr narratives convey scenes of sensory disablement to make a number of baldly moral and epistemological points about conversion and belief. The senses are represented as the pagan's Achilles's heel, as they are vulnerable at all times to demonic interference, which can pollute sights and sounds that are objectively holy and pure (such as the bodies of virgins, psalm singing and the prayers and ritual acts of a Christian mass). Tied to the precarious nature of the senses is a starkly bifurcated but quasi-Platonic system of knowledge, whereby pagan idolatry is associated with the shadowy, artificial and patently false world of images, while Christian belief is grounded in the true and expressly *real* divine Light. Truth is thus presented in the Roman martyr narratives as both an objective and divine principle, and one potentially apprehensible through the senses so long as they are properly purged. As demonstrated in the story of Sisinnius, such purgation, when accompanied by conversion, is indeed possible, and its effects on the intellectual orientation of the pagan are absolute. However, as Dulcitius's sufferings and death so dramatically show, the problem of perception in the *passiones* is a zero-sum game. In electing to pleasure his senses over knowing God, Dulcitius fails to perceive the path to salvation and certainty. Human will thus is not wholly excised from these portraits of death and deliverance in which the pagan persecutor, like the martyr, must also freely choose his fate.

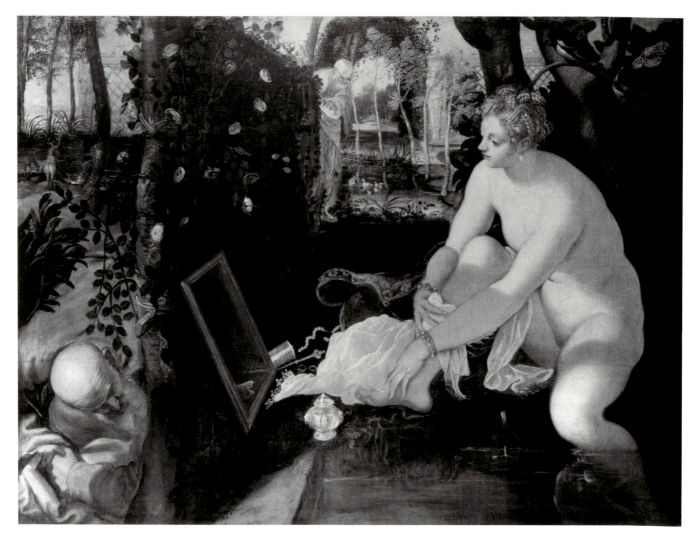

FIG. 10.5. Jacopo Tintoretto (1519–94), *Susanna and the Elders*, 1560, oil on canvas, 146.5 × 83.5 cm, Kunsthistorisches Museum, Vienna, inv. Nr. GG1530. *Photo: Kunsthistorisches Museum Archivphoto no. A.3790. Reproduced courtesy of the Kunsthistorisches Museum, Wien oder KHM, Vienna.*

young girl is seen by the prefect's son; his response is to fall in love with her instantly.[51] Agnes's response might seem rather unusual: she stresses that she already has a lover. This theme of the virgin's lover is to recur throughout the accounts. It is the narratives of Agnes's death, however, that are the most striking in this respect.

In Ambrose's hymn to Saint Agnes, a connection between marriage and sacrificial death looms large. Ambrose compares Agnes's march to the scaffold to a bridal cortège, and describes her martyrdom as a mystical marriage: 'You would think she was on her way to a wedding, with such a joyous expression she went forth, bearing a new treasure for her husband in the precious blood of her dowry'.[52] Here we find clear echoes of other, comparable virgins, particularly in the light of the seminal readings of Nicole Loraux.[53] Virgin sacrifice is a powerful theme in ancient mythology

and tragedy, and its conventions, as so persuasively delineated by Loraux, are also resonant in the case of Agnes, our Christian virgin. It is in classical mythology that we first find the ironic, paradoxical connection between marriage and death in the sacrificial end of the virgin.[54] The comparison between Agnes and her classical mythological forebears, particularly as Latinized, was certainly not lost on her late antique biographers, nor, presumably, her late antique readers. The figure of Polyxena, a virgin sacrificed at the orders of the shade of Achilles, for example, is clearly an important forebear. Polyxena was a familiar figure in Latin literature, having been treated by both Ovid and Seneca.[55]

Agnes's death is particularly, strikingly sexual. Her virgin sacrifice is consummated with the penetration of a naked sword that clearly evokes a deflowering penis.[56] Ambrose, discussing the story of Agnes in his

treatise *On Virgins* asks in wonderment: 'Was there room for a wound in that small body?'.[57] The symbolic significance of this wound, made, crucially, to the previously intact body as the consummation of sacrifice, could scarcely be clearer.[58] It is, however, the virgin's own desire for this penetration that is most striking.

Prudentius's Agnes makes a speech to her executioner that many readers have found highly distasteful.[59] The virgin's discourse challenges her executioner, who is now explicitly identified, by Agnes, as a lover. There is play at gender-reversal, which highlights the 'shocking' nature of the virgin's behaviour. This is not unique to our Christian virgin, however. Seneca's Polyxena is described as an *audax virago* in her behaviour as she faces her executioner undaunted (*Troades* 1151). Ovid describes the girl as 'plus quam femina virgo' (*Metamorphoses* 13.451).[60] Ambrose's Agnes is stronger than her executioner, whose hand trembles (*De virginibus* 1.2.9).[61] Prudentius's Agnes scorns the notion of 'a listless, soft, womanless youth, bathed in perfume'.[62] She rejoices at the erectness of the sword that is to kill her, joyful that she will be met with a 'savage, cruel, wild man at arms', declaring, 'this lover, this one at last, I confess it, pleases me. I shall meet his eager steps half-way and not put off his hot desires'.[63] We are presented with a beautiful virgin, who has rejected an earthly husband in favour of her heavenly spouse, now willing death as consummation at the hand of her explicitly phallic executioner.[64] If we turn to the manner of the execution, we will come to the crux of the paradoxical status of the virgin martyr.

Prudentius's Agnes offers her breast, her bosom (both *papilla* and *pectus*) to her executioner.[65] The significance of the manner of her execution becomes clearer with reference again to Loraux's work on the death of virgins. Loraux notes, firstly, that 'death lurks in the throats of women': unlike the varied topography of male death, women tend to die by the throat.[66] The significance of the throat is twofold: firstly, the (animal) sacrificer always cuts the throat; secondly, the throat has special significance for women, linked as it is in ancient gynaecological theory to the womb.[67] Euripides's Polyxena offers her executioner, Neoptolemus, a choice — either breast or throat. He picks the latter, the traditional option (*Hecuba* 342–437). For Loraux this is crucial, because convention demands that women be kept feminine (even) in death. However, when Ovid's Polyxena proffers the same choices (*iugulum* or *pectus*), her executioner chooses the breast (*praecordia*): the male way of dying, indeed the most male, the most Roman death (*Metamorphoses* 13.458–71).

Prudentius, despite his use of Polyxena as an exemplar, chooses not to follow up Ovid's emendation. In fact, the final mode for executing Agnes is somewhat surprising. Having made her strident speech, and despite her bold, masculine-like behaviour, we are told that the virgin 'bowed her head and humbly worshipped Christ, so that her bending neck should be readier to suffer the impending blow'.[68] Agnes's executioner strikes her throat, cutting off her head in one stroke. The virgin has been denied a masculine death and given a properly feminine end. She is re-feminized in the final act of sacrifice.[69] Like her classical forebears, moreover, Ambrose's Agnes shows her concern for a chaste, feminine end by rearranging her dress to preserve her modesty as she falls (*Hymn* 8.8).[70]

The idea that Agnes is in need of *re*-feminizing takes us back to our notion of Agnes's *paradoxical* body. Agnes's behaviour before her executioner is, in many ways, strikingly masculine. In fact, it can be argued plausibly that the virgin martyr is not a fully female figure.[71]

One approach to understanding the ambiguous gender of the virgin martyr is to look to the intended audience for such representations, and hence to consider the question of audience identification. Feminist scholars working on hagiography have made comparisons with the 'last girl' (the final, always female, survivor) of the slasher movie — a figure considered to be not fully feminine and even, according to Carol Clover, a 'male surrogate'. Clover argues that the (configured male) audience requires a figure to identify with, a 'stand in': this is why the 'final girl', or indeed the virgin martyr, does not function, structurally, as a true woman.[72] The question of the audience is perennially difficult for our late antique texts. How far we can compare the viewing processes between late antique consumers of hagiography and contemporary cinema audiences is clearly a moot point.[73] Crucially, in most cases we simply lack the kind of information scholars working in later periods take for granted. In the absence of such information, scholars are divided regarding the intended audience.

One approach is, as above with cinema, to assume a male audience. Daniel Boyarin, for example, discussing the idea of 'Thinking with virgins', claims that Agnes functions as a model for male ascetics.[74] Meanwhile, other studies seek to establish a fairly specific,

Roman aristocratic female readership for the later *passiones* at least and, further, to propose that these texts could provide figures of identification for these female readers.[75] A complementary trend wishes to absolve virgin martyr stories from being labelled 'religious pornography' and to look towards more empowering, non 'masculinist' readings.[76]

It will not suffice to maintain one of two opposing positions: seeing the virgin martyr either as a figure for empowering female audiences or as the object of a 'totalizing' patriarchal discourse. The whole question of audience identification on a simple gender basis is problematized by the virgin martyr text, where the only male figures available for identification are the pagan villains. We must also ask whether the reader/viewer cannot, in fact, identify with a subject of different gender. A more fruitful approach is to allow for different levels of audience, different layers of reading, to allow for artful, as well as pious, reading and writing. When Ambrose, supposedly addressing a congregation of female virgins, says, 'all at once my discourse is ashamed … Stop your ears, virgins', it is not difficult to see a highly disingenuous tactic at play.[77] Even if the text was originally delivered before a female, virgin audience, it was then edited, rewritten and made available to different readerships.[78] Ultimately, all these possibilities of audience reading and identification only give strength to the notion of a figure of unstable gender.

Perhaps we can compare profitably a figure whose cultural and religious resonance was far from extinguished at the time our texts were written: the Vestal Virgin. If we recall, the prefect in the *Passio* threatens to send Agnes to join the Vestals (*Passio Agnetis* 5). Moreover, it is interesting that Ambrose still feels the need to assert the superiority of Christian virgins, by attacking the 'temporary' virginity of the Vestals (*De virginibus* 1.415). Indeed, Kate Cooper suggests that the Christian adoption of the holy virgin was in part 'an attempt to furnish the *plebs dei* with some of the rich complexity of religious identity available within the polytheist system'.[79] The Vestal Virgins were figures of ambiguous sexual and social status, as can be seen from different aspects, such as their legal rights and privileges, their dress and their role in religious cult.[80]

The body of Agnes can be defined as paradoxical in a number of ways. Vision and voyeurism are entangled in a complex fashion: the virgin is presented to us as a spectacle, but one that is highly problematic, indeed dangerous. The narratives of the saint's passions twist

and turn, all the while pivoting around paradoxes and inversions: the virgin in the brothel and the concealed nude. The descriptions of the execution of the virgin continue these unresolved paradoxes, as the girl struggles to resist unambiguous definition even in death, which should, by rights, provide the ultimate closure.[81] It is clear that it would be wrong to consider all these aspects to be unique, as products of a peculiarly Christian discourse: the figure of Agnes gained extra power and resonance from its association with her forebears. However, Christianity was not slow to utilize the gamut of existing associations in the construction of a whole host of female saints, of whom Agnes is only the most striking late antique Roman exemplar, whose sanctity is inextricably bound up with their sexuality.

In Greek tragedy the sacrificed virgin defied the usual socio-sexual categorization, neither woman (*gynē*) nor virgin (*parthenos*), but instead something liminal and anomalous, a bride without a husband (*nymphē anymphòs*).[82] Another anomalous ancient body, particularly resonant in the city of Rome, was the Vestal Virgin. The virgin martyr also can be seen as a deliberately anomalous figure, as such providing the ideal subject for a poet such as Prudentius, so absorbed in ideas of transformation and transgression.[83] However, it is not just Prudentius who presented the virgin martyr in this way. The added and crucial significance here lies in the fact that religious power is derived from just such anomalies, from just such paradoxes. Christianity provides us with some crowning examples: the virgin mother, God who became a man, the victorious martyr. In the art historical record, as we saw, Agnes is portrayed consistently as an orant, as a figure of intercessory power.[84] As well as the iconographical depictions, she is also configured as something of a verbal icon, as in the *Passio Agnetis* that describes 'the blessed Agnes spreading out her hands in the midst of the fire'.[85]

The beautiful, spectacular body of the virgin martyr (a body that nevertheless fights back against its spectators) is transformed into a religious icon. This is perhaps the final visual and textual transformation in a story that is so preoccupied both with special bodies and the issues of viewing such bodies. Agnes appears to offer a figure available for voyeurism, identification and, ultimately, crucially, veneration. It is her special dual power and her special anomalous status that make the virgin martyr. Agnes is the virgin martyr *par excellence*, a highly powerful and resonant figure in the history of the Church.

NOTES

I would like to thank Kristina Sessa for her helpful comments.

1. 'Agnes sepulcrum est Romulea in domo, / fortis puellae, martyris inclytae.'

2. The literary dossier for the saint in this period is impressively rich: we have accounts of her martyrdom provided by Ambrose, *De virginibus*; Hymn 8; Damasus, *Epigram* 37, and Prudentius, *Peristephanon* 14, as well as the pseudo-Ambrosian *Passio Agnetis*.

3. Agnes inspired a whole host of near identikit virgin martyrs in late antiquity and the Middle Ages, firstly in the Roman *Gesta*, discussed by Sessa, Chapter Nine in this volume. On these women, see F.E. Consolino, 'Modelli di sanità nelle più antiche Passioni romane', *Augustinianum* 24 (1984), 83–113. On the popularity of virgin martyrs in late medieval English literature see K.A. Winstead, *Virgin Martyrs: Legends of Sainthood in Late Medieval England* (London, 1997). The twentieth century produced its own virgin martyrs, three of whom were beatified in 1987. The most famous exemplar is the teenage attempted-rape victim Maria Goretti, on whom see K. Norris, 'Maria Goretti — cipher or saint?', in S. Bergman (ed.), *A Cloud of Witnesses* (London, 1996), 300–11.

4. Recent scholarly work on the *Peristephanon* includes M.A. Malamud, *Poetics of Transformation: Prudentius and Classical Mythology* (London, 1989); A.-M. Palmer, *Prudentius on the Martyrs* (Oxford, 1989); M. Roberts, *Poetry and the Cult of the Martyrs* (London, 1993). On Prudentius, *Peristephanon* 14 in particular (as well as other Agnes literature), see D. Boyarin, *Dying for God: Martyrdom and the Making of Christianity and Judaism* (Stanford, 1999); V. Burrus, 'Reading Agnes: the rhetoric of gender in Ambrose and Prudentius', *Journal of Early Christian Studies* 3 (1995), 25–46; M.A. Malamud, 'Making a virtue of perversity: the poetry of Prudentius', *Ramus* 19 (1990), 64–88, some of whose concerns inevitably overlap with those of this paper.

5. See M.R. Salzman, *On Roman Time: the Chronograph Calendar of 354 and the Rhythms of Urban Life in Late Antiquity* (Oxford, 1990), 42–50.

6. See A.P. Frutaz, *Il complesso monumentale di Sant'Agnese* (Rome, 1969).

7. On the work of Borromini and of Girolamo and Caro Rainaldi at Sant'Agnese in Agone see G. Eimer, *La Fabbrica di Sant'Agnese in Navona: Römische Architekten, Bauherren und Handwerker im Zeitalter des Nepotismus* (Stockholm, 1971); R. Bösel and C.L. Frommel (eds), *Borromini e l'universo barocco* II (exhibition catalogue (Palazzo delle Esposizioni, Rome), Milan, 2000), 173–91.

8. It was in the aftermath of the Peace of the Church that the cult of the martyrs really began to develop. The classic account of late antique martyr cult remains P. Brown, *The Cult of the Saints: its Rise and Function in Latin Christianity* (London/Chicago, 1981). See also L. Grig, *Making Martyrs in Late Antiquity* (London, 2004).

9. See L. Grig, 'Portraits, pontiffs and the Christianization of fourth-century Rome', *Papers of the British School at Rome* 72 (2004), 203–30.

10. For drawings of the extant Agnes glass see R. Garrucci, *Vetri ornati di figure in oro* (Rome, 1864), pls XXI–XXII.

11. It has, at least, been generally assumed that this relief depicts Agnes. C. Pietri, *Roma Christiana: recherches sur l'Église de Rome, son organisation, sa politique, son idéologie de Miltiade à Sixte III (311–440)* (Rome, 1976), 47–51, strikes a note of scepticism.

12. On early Christian funerary art, see C. Murray, *Rebirth and Afterlife: a Study of the Transmutation of some Pagan Imagery in Early Christian Funerary Art* (Oxford, 1981). More specifically, see H. Belting, *Likeness and Presence: a History of the Image before the Era of Art* (trans. E. Jephcott) (London, 1994).

13. The Catacomb of San Gennaro in Naples has striking images of this type.

14. Cf. Ambrose, *De virginibus* 1.2.9.

15. 'Apellabo martyrem, praedicabo virginem', Ambrose, *De virginibus* 1.2.6.

16. 'Habetis igitur in una hostia duplex martyrium, pudoris et religionis', Ambrose, *De virginibus* 1.2.9.

17. 'Purgabor oris propitiabilis / fulgore, nostrum si iecur inpleas. / nil non pudicum est quod pia visere / dignaris almo vel pede tangere', Prudentius, *Peristephanon* 14.130–3.

18. 'O veneranda mihi sanctum decus alma pudoris / ut Damasi precibus faveas precor inclyta martyr', Damasus, *Epigram* 37.9–10.

19. Introducing Agnes, Damasus begins *Epigram* 37: 'According to tradition' ('fama refert'). Likewise, Ambrose (*De virginibus* 1.2.7) uses *traditur* when mentioning the girl's age. For an interesting comparison see W. Rordorf, 'Tradition and composition in the acts of Saint Thecla: the state of the question', *Semeia* 38 (1986), 43–66 on identifying oral tradition in the textual accounts of another famous early female saint. The most thorough treatment of the Agnes traditions remains P. Franchi de' Cavalieri, 'Sant'Agnese nella tradizione e nella leggenda', in P. Franchi de' Cavalieri, *Scritti agiografici* (*Studi e testi* 221) (Vatican City, 1962), 293–379.

20. This is the version from the fifth-century *passio*. Cf. the version in the vastly popular thirteenth-century J. de Voragine, *Golden Legend* (ed. and trans. W. Granger Ryan) (Princeton, 1993). The *Passio Agnetis*, unlike the Prudentian account, has yet to receive contemporary critical attention.

21. In Prudentius's version she must supplicate before the altar of another famous virgin, Minerva: 'ac de Minerva iam veniam rogat, / quam virgo pergit temnere virginem', *Peristephanon* 14.26–8.

22. This combination death is perhaps a way to iron out the inconsistencies in the earliest accounts: while Damasus's Agnes dies by the flames, in the accounts of Prudentius and Ambrose she is killed by the sword alone. This kind of inflation is also common in the *passiones* of the period: see here H. Delehaye,

Les passions des martyrs et les genres littéraires (Brussels, 1921), 236–315, esp. pp. 273–87.

23. Similar strategies were favourites of the Greek novelists, to be considered further below.

24. See R. Adler, 'The virgin in the brothel and other anomalies: character and context in the legend of Beruriah', *Tikkun* 3 (1988), 28–32, 102–5, esp. p. 102, where Adler aptly describes the Talmud story as 'a picaresque narration that explores the connection between sexuality and power'.

25. A later, Latin version of the story of the three sisters is embedded in the *Passio Anastasiae* discussed by Sessa, Chapter Nine in this volume. See also the story (roughly contemporary to Prudentius) of a wily Christian virgin from Corinth who put off her would-be clients by telling them that she had a terrible, foul-smelling sore in a 'hidden place': Palladius, *Lausiac History* 65.

26. Note that while Prudentius refers twice to Agnes's purification of the brothel, he actually sets her exposure in the public square (*in plateae*), presumably to heighten the drama and shock of the episode.

27. It is for this reason, of course, that stripping played a role in public punishment in the Roman world—see for instance K.M. Coleman, 'Fatal charades: Roman executions staged as mythological enactments', *Journal of Roman Studies* 80 (1990), 44–73. Note also the apt comment of P. Brown, *The Body and Society: Men, Women and Sexual Renunciation in Early Christianity* (London, 1988), 315: 'Nudity and sexual shame were questions of social status: the way people felt about being naked, or seeing others naked, depended to a large extent on their social status'.

28. This tactic is evident in Ambrose's narration of the Antioch episode to his supposedly virgin audience: 'iamdudam verecundatur oratio mea . . . Claudite aurem, virgines', *De virginibus* 2.4.26. For an interesting comparison, see B. Leyerle, 'John Chrysostom on the gaze', *Journal of Early Christian Studies* 1 (1993), 159–73, on how another famous late antique preacher offered his audience 'thinly veiled offers of voyeuristic pleasure'.

29. Mary Magdalene's hair grew to cover her nudity when she was living a repentant life in the desert, as it did also in iconographic depictions of Mary of Egypt, another popular 'harlot' saint. See L. Coon, *Sacred Fictions: Holy Women and Hagiography in Late Antiquity* (Philadelphia, 1997); S. Haskins, *Mary Magdalene: Myth and Metaphor* (London, 1993).

30. Cf. the ubiquitous classical *pudica* images of Venus, where the goddess shields, and thus highlights, her pubis. Salomon discusses how this image makes the viewer a voyeur while constructing female sexuality according to the ancient active/passive sexual dichotomy: N. Salomon, 'Making a world of difference: gender, asymmetry, and the classical Greek nude', in A.O. Koloski-Ostrow and C.L. Lyons (eds), *Naked Truths: Women, Sexuality and Gender in Classical Art and Archaeology* (London, 1997), 197–219. Note the connection *pudica/pudenda* and cf. Prudentius's description of how the virgin

martyr Eulalia's hair flowed to cover her maidenhood and her modesty: 'crinis odorus ut in iugulos / fluxerat involitans umeris, / quo pudibunda pudicitia / virgineusque lateret honos, / tegmine verticis opposito', *Peristephanon* 3.151–5.

31. Museo della Collegiata di Sant'Andrea, Empoli. Donatello's roughly contemporary sculpture of a similarly hair-clad Magdalene (Museo dell'Opera del Duomo, Florence) provides an interesting counterpart in that the saint is depicted as gaunt, ravaged and scrawny.

32. Louvre, Paris. Again see Haskins, *Mary Magdalene* (above, n. 29) for discussion of Magdalene images.

33. By contrast it was very rare for non-harlot female saints to be depicted unclothed. On female nudity, see M. Miles, *Carnal Knowing: Female Nakedness and Religious Meaning in the Christian West* (Boston, 1989).

34. Women's hair possessed a number of symbolic associations in the ancient world; for the religious meanings, see Miles, *Carnal Knowing* (above, n. 33), 48–51.

35. However, Prudentius does ascribe this element to the other virgin martyr he celebrates, Saint Eulalia: *Peristephanon* 3.151–5. On the relationship of Eulalia to Agnes, see J. Petruccione, 'The portrait of Saint Eulalia of Merida in Prudentius's *Peristephanon* 3', *Analecta Bollandiana* 108 (1990), 81–104. Damasus's account (probably known to Prudentius) has a less embroidered, less dramatic version: 'and naked she let her loosened hair fall over her limbs' ('nudaque profusum crinem per membra dedisse'), *Epigram* 37.7.

36. 'Stantem reguit maesta frequentia, / aversa vultus, ne petulantius / quisquam verendum conspiceret locum. / intendit unus forte procaciter / os in puellam nec trepidat sacram / spectam formam lumine lubrico', *Peristephanon* 14.40–5.

37. 'En ales ignis fulmnis in modum / vibratur ardens atque oculos ferit. / caecus corusco lumine corruit / atque in plateae pulvere palpitat', *Peristephanon* 14.46–9.

38. J. Wogan-Browne, 'The virgin's tale', in R. Evans and L. Johnson (eds), *Feminist Readings in Middle English Literature: the Wife of Bath and all her Sect* (London, 1994), 165–94, esp. p. 174.

39. The story of Susanna was inserted into the book of *Daniel* in antiquity, chapters 13ff.

40. Ambrose praises Susanna for preferring death rather than violation: *De virginibus* 1.8.45; 2.4.28–9 although, as noted, she was not a virgin.

41. It is a popular theme in third- and fourth-century catacomb paintings, including a narrative frieze in the Capella Greca, Catacomb of Priscilla. The famous casket known as the Brescia Lipsanotheca features episodes from the story of Susanna, alongside iconography of the deliverance of Jonah and Daniel, as well as central Christological images. See further K.A. Smith, 'Inventing marital chastity: the iconography of Susanna and the elders in early Christian art', *Oxford Art Journal* 16 (1993), 3–24.

42. For the fresco see, A. Ferrua, 'Un nuovo cubiculo dipinto della via Latina', *Rendiconti della Pontificia Accademia Romana di*

Archeologia 45 (1972–3), 171–87. For the glass see D.B. Harden, 'The Wint Hill hunting bowl and related glasses', *Journal of Glass Studies* 2 (1960), 45–82, esp. nos. 15 and 20.

43. Miles, *Carnal Knowing* (above, n. 33), 123–4. The painting is in the Kunsthistorisches Museum, Vienna. Contrast this with Smith's reading of the early fourth-century depiction of Susanna as a clothed orant in the Catacomb Maius, 'Inventing marital chastity' (above, n. 41), 12: 'The viewer becomes Susanna's judge; her pious chastity is clearly indicated by her placement entirely within the space created by the trees and by her cry/prayer for help'.

44. The Susanna images provide a somewhat piquant version of this relationship: the viewer is positioned as desirous, and therefore as liable, like the elders, to punishment. Feminist scholarship is clearly voluminous, but see for the ancient world: Koloski–Ostrow and Lyons, *Naked Truths* (above, n. 30).

45. Although it is also undercut, as in the *Passio Agnetis* 1: 'She was beautiful in appearance, but more beautiful in faith, and more elegant in chastity' ('pulchra facie, sed pulchrior fide, et elegantior castitate'). It is interesting to note that versions of this snippet of rhetorical dichotomizing appear again and again in patristic literature in relation to Susanna, for example Pseudo-Cyprian, *De bono pudicitiae* 9: 'fuit, ut legimus, Susanna … pulcherrima facie, pulchrior moribus'. Visual images displaying Agnes's (semi-)nudity are not numerous but include the fourteenth-century cycle in Santa Maria di Donna Regina in Naples (Agnes sent naked to the brothel and the miracle of the hair) and the seventeenth-century painting of Jusepe de Ribera in the Dresden Gemäldegalerie, which depicts Agnes kneeling, her hair falling to her knees, as an angel covers her with a white cloth. Generally, it was 'harlot' saints alone that were depicted nude, as discussed above.

46. This double game is not unique to the Agnes texts even within a patristic context. A striking example of a highly wrought, eroticized Christian text from the same period is Jerome's *Epistulae* 22, on which see P.C. Miller, 'The blazing body: ascetic desire in Jerome's letter to Eustochium', *Journal of Early Christian Studies* 1 (1993), 21–45. See also N. Henry, *Eroticism and Asceticism in* The Song of Songs and Virginity: *the Study of a Paradox in Early Christian Literature* (Ph.D. thesis, University of Cambridge, 1999).

47. For now classic discussions along this line see J. Berger, *Ways of Seeing* (London, 1972), 47; L. Mulvey, 'Visual pleasure and narrative cinema', in L. Mulvey, *Visual and Other Pleasures* (Bloomington, 1989), 14–26, esp. pp. 19–21; E.A. Kaplan, 'Is the gaze male?', in A. Snitow, C. Stansell and S. Thompson (eds), *Desire: the Politics of Sexuality* (London, 1983), 321–38. Scholarship has moved on, to encompass, for instance, female possession of the gaze. See, for example, J. Mayne, *Cinema and Spectatorship* (London, 1993), esp. pp. 22–6.

48. See here E. Castelli, 'Visions and voyeurism: holy women and the politics of sight in early Christianity', *Protocol of the Colloquy of the Center for Hermeneutical Studies* 2 (1995), 1–20, which considers female martyrs who function both as objects of vision and as visionaries in their own right.

49. Wogan-Browne, 'The virgin's tale' (above, n. 38), 179, comments, 'to gaze on the heroine is to confront a transforming source of power'.

50. 'Cui posse soli cunctiparens dedit / castum vel ipsum reddere fornicem', Prudentius, *Peristephanon* 14.128–9.

51. *Passio Agnetis* 2. This theme of love at first sight is taken up enthusiastically by late antique hagiographers, as in the case of the hapless Dulcitius, discussed by Sessa, Chapter Nine in this volume (*Passio Anastasiae* 12).

52. 'Prodire quia nuptem putet, / sic laeta vultu ducitur, / novas viro ferens opes, / dotata censu sanguinis', *Hymn* 8.13–16. Cf. the very similar language, in relation to Saint Pelagia, at *De virginibus* 3.7.34. See also how in Prudentius's account of the martyrdom of Eulalia the pagan governor tries to dissuade the girl from her premature death by reminding her of the joys of earthly marriage that she is rejecting: *Peristephanon* 3.104–13.

53. N. Loraux, *Tragic Ways of Killing a Woman* (trans. A. Forster) (London, 1987).

54. See Loraux, *Tragic Ways* (above, n. 53), for her reading of virgin sacrifice as marriage 'à l'envers'. Also see H.P. Foley, 'Marriage and sacrifice in Euripides' Iphigenia in Aulis', *Arethusa* 15 (1982), 159–80.

55. Ovid, *Metamorphoses* 13.439–93; Seneca, *Troades* 938ff.; Malamud, *Poetics of Transformation* (above, n. 4). Malamud, 'Making a virtue of perversity' (above, n. 4), is especially interested in tracing the mythological connections in Prudentius's account.

56. Prudentius, *Peristephanon* 14.68. What we have here, therefore, is penetration that is not. We can make parallels with episodes from Greek fiction, most strikingly Achilles Tatius's *Leucippe and Clitophon* (3.16; 5.7), where the author playfully offers several striking images of violent penetration while all the while preserving the heroine's chastity. See, on this theme, S. Goldhill, *Foucault's Virginity: Ancient Erotic Fiction and the History of Sexuality* (Cambridge, 1995), 118.

57. 'Fuitne in illo corpuscolo vulneri locus?', Ambrose, *De virginibus* 1.2.7.

58. Parallels can be found also in the deaths of traditional Roman heroines. A.M. Keith, *Engendering Rome: Women in Latin Epic* (Cambridge, 2000), 123, sees Ovid's Polyxena's concern to preserve her modesty in death (a detail also taken up with regard to Agnes: for example, *Hymn* 8.7–8) as implying 'that the piercing with a sword is analogous to the sexual defloration of the virginal bride'. Moreover, P.K. Joplin, 'Ritual work on human flesh: Livy's Lucretia and the rape of the body politic', *Helios* 17 (1990), 51–70, esp. p. 67 claims that the stab to the heart, 'the showable wound, serves as a double for the vagina, the natural opening that must be covered'. B. Shaw, 'Body/power/identity: passions of the martyrs', *Journal of Early Christian Studies* 4.3 (1996), 269–312, esp. p. 305, meanwhile, sees the piercing of the neck (in the context of Saint Perpetua) as a symbolic oral rape.

59. For example, the French editor Lavarenne complains that the speech 'manque fâcheusement de simplicité'.

60. Boyarin, *Dying for God* (above, n. 4), 75, comments that our late antique texts construct a complicated gender structure, 'in which both the masculinized aggressivity of the female martyr as *virago* and an almost contradictory feminized passivity as *virgo* are produced simultaneously'. We can see that this is not new to the Christian texts.

61. This recalls another famous female martyr, Perpetua, who has to direct her own death blow: *Passio Perpetuae* 21.

62. 'Languidis ac tener / mollisque ephebus tinctus aromate', *Peristephanon* 14.71–2.

63. 'Vesanus, atrox, turbidus armiger', *Peristephanon* 14.70; 'hic, hic amator iam, fateor, placet: ibo inruentis gressibus obviam, / nec demorabor vota calentia', *Peristephanon* 14.74–5.

64. Malamud, *Poetics of Transformation* (above, n. 4), 170, compares Agnes's phallic death wish to that of Seneca's Phaedra (*Phaedra* 710–14).

65. The *papilla* is nipple, hence metonymic for breast, whereas *pectus* signifies breast or breastbone, or, more poetically, the seat of courage and affection.

66. Loraux, *Tragic Ways* (above, n. 53), 'Regions of the Body'.

67. See here P. Armstrong and A.E. Hanson, 'The voice of the virgin', *Bulletin of the Institute of Classical Studies* 33 (1986), 97–100.

68. 'Sic fatus Christum vertice cernuo / supplex adorat, / vulnus ut inminens / cervix subiret prona paratius', *Peristephanon* 14.85–8.

69. Burrus, 'Reading Agnes' (above, n. 4), 46; Malamud, *Poetics of Transformation* (above, n. 4), 171; Malamud 'Making a virtue of perversity' (above, n. 4), 81–2, read Agnes's beheading as an emasculating act (even a symbolic castration), as re-feminizing a potentially subversive virgin in relation to a phallic Christ.

70. Cf. Ovid, *Metamorphoses* 13.479–80; Euripides, *Hecuba* 568ff.

71. Note also Ambrose's use of the *puer senex* motif, for which see T.C. Carp, '*Puer senex* in Roman and medieval thought', *Latomus* 39 (1980), 736–9 in relation to Agnes in *Hymn* 8.7–8: 'nutebat in viris fides / cedebat et fessus senex'. This version of the motif is clearly gendered male: cf. Pliny on an adolescent girl, *Epistulae* 5.16.2: 'suavitas puellaris, anilis prudentia, matronalia gravitas'.

72. Clover wants us to see the 'final girl' as 'a male surrogate in things oedipal, a homoerotic stand-in, the audience incorporate': C. Clover, 'Her body, himself: gender in the slasher film', in R.H. Bloch and F. Ferguson (eds), *Misogyny, Misandry and Misanthropy* (London, 1989), 187–228, esp. p. 213. Clover is taken up by Wogan Browne, 'The virgin's tale' (above, n. 38), 179. Cf. the criticism of the use of such theory in this context by E.G. Clark, 'Bodies and blood: late antique debate on martyrdom, virginity and resurrection', in D. Montserrat (ed.), *Changing Bodies, Changing Meanings: Studies on the Human Body in Antiquity* (London, 1998), 99–115.

73. For Castelli, 'Visions and voyeurism' (above, n. 48), 3–4, the comparison is valid because 'the genres in which women are made most spectacular in late antique literature function in part analogously to popular visual forms in our own culture'.

74. Boyarin, *Dying for God* (above, n. 4). In this vein see Ambrose's *Epistulae* 37.36–8, where he aims the example of heroic maidens specifically at men; cf. Augustine, *Sermones* 345.6.

75. For example, K. Cooper, *The Virgin and the Bride: Idealized Womanhood in Late Antiquity* (Cambridge (MA), 1996), 67; Consolino, 'Modelli di sanità' (above, n. 3), esp. p. 100.

76. On medieval martyrology as 'religious pornography' see Miles, *Carnal Knowing* (above, n. 33), 156. For the riposte (dealing with late medieval texts) see J. Wogan Browne, 'Saints' lives and the female reader', *Forum for Modern Language Studies* 27 (1991), 165–94.

77. 'Iamdudum verecundatur oratio mea ... Claudite aurem, virgins', *De virginibus* 2.4.26. The work is indeed dedicated to his sister Marcellina, a consecrated virgin.

78. See here Y.-M. Duval, 'L'originalité du *De virginibus* dans le mouvement ascétique occidental: Ambroise, Cyprien, Athanase', in Y.-M. Duval (ed.), *Ambroise de Milan. XVIᵉ centenaire de son élection épiscopale* (Paris, 1974), 9–66, esp. p. 11.

79. Cooper, *The Virgin and the Bride* (above, n. 75), 76–7.

80. According to one formulation, 'The Vestals were not *either* virgins *or* matrons; they were both, and ... they were also men', see M. Beard, 'The sexual status of Vestal Virgins', *Journal of Roman Studies* 70 (1980), 12–27, esp. p. 18. See also M. Beard, 'Re-reading (Vestal) virginity', in R. Hawley and B. Levick (eds), *Women in Antiquity* (London, 1995), 166–77.

81. Prudentius's beheading of Agnes can, of course, be read as providing this closure.

82. Loraux, *Tragic Ways* (above, n. 53), 40–1.

83. As stressed by Malamud, *Poetics of Transformation* (above, n. 4), *passim*.

84. In all the gold-glass representations but one (where she is depicted in bust form, facing Mary) Agnes is depicted as an orant.

85. 'Beata Agnes extendens manus suas in medio ignis', *Passio Agnetis* 13.

THE RELIC TRANSLATIONS OF PASCHAL I: TRANSFORMING CITY AND CULT

Caroline Goodson

The apse mosaics of the churches of Santa Prassede and Santa Cecilia in Trastevere depict the standing figure of Paschal I (817–24), the pope responsible for the reconstruction of these churches, among a host of heavenly figures including Christ, Peter and Paul, and the titular saints of each church. When Paschal himself stood in the presbytery celebrating mass in these titular churches (and even today when the priest stands at the altar), he presided over the bodies of thousands of saints. In a reversal of previous papal policy, he had translated the bodies of over 2,000 popes, deacons, martyrs and virgins from their tombs in the periphery of Rome to his new churches in the city. Indeed, Paschal's papacy marked a revolution in the handling of sacred bodies: under Paschal, the veneration of saints in basilicas and underground chapels at their place of burial was transformed into a highly organized, urban cult scheme (**Fig. 11.1**). These new methods of veneration recrafted the intramural topography of Rome around new *loca sancta*.

Paschal's two newly-renovated urban titular churches housed the papal stational liturgy in addition to regular presbyterial and monastic services.[1] Through his translations these churches became saints' shrines, officiated by new monasteries equipped for the chanting of the divine office over the new tombs. The architectural vocabulary employed in these churches reflects their new role as shrines, replete with lavish marble ornament, mosaics and frescoes depicting the passions of martyrs, and crypts enabling the pious to venerate the tombs. Of Paschal's reconstruction projects, the church of Santa Prassede provides the clearest evidence for his new programme of intramural pilgrimage.[2] The material fabric of the church is well preserved, including the crypt, mosaics in the apse and triumphal arch, and a cycle of sanctoral narratives painted in the transept. The church also houses a long contemporary inscription listing the bodies translated, and there is documentary evidence of their later rediscovery. Although the church of Santa Cecilia has been drastically restored on several occasions, the skeleton of Paschal's church and mosaics remain, and Paschal's biographer in the *Liber pontificalis* provided a reliable and lengthy description of the relic translations to the church.[3]

Although the relic translations have never been explored in modern studies of these buildings, Paschal's relic translations and basilica foundations were both aspects of his successful campaign for personal self-aggrandizement and the glorification of the Holy Roman See. Conventional studies of the buildings situate them within a trend in Rome towards the construction of monumental basilical-plan buildings, which were demonstrably larger, more regularly planned and more ornate than those of the previous century, reflecting a period of prosperity and growing solidarity in the See of Saint Peter. This trend has been described as the Carolingian Revival, though not without considerable debate and revision.[4] Paschal's buildings were proclamations of growing papal strength, coupling the architecture of the period with a sanctoral presence. Through the introduction of corporeal remains, Paschal imported the sacred sites of the catacombs into his titular churches, transforming the scattered melodies of sanctoral veneration and architecture in late eighth- and early ninth-century Rome into a controlled symphony of Roman primacy and papal self-authorization.

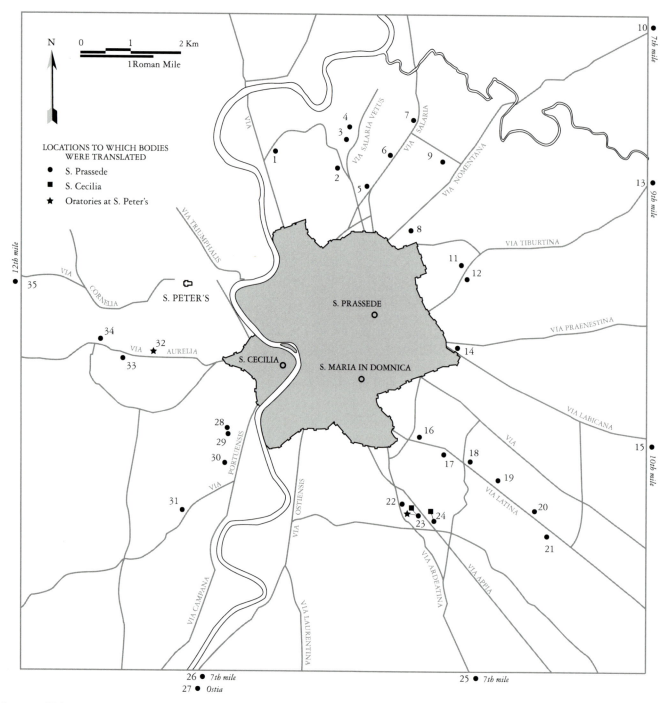

1 Cemetery of Valentinus: Zeno

2 Cemetery of Basilla: Basilla

3 In Clivum Cucumeris: Blastus, Iohannis

4 Ad Septem Palumbas: Diogenis, Festus

5 Cemetery of Maximus: Silanus

6 Cemetery of Iordani: Alexander, Chrysantius,
Daria, Iason, Martial, Maurus, Paulina, Vitalis

7 Cemetery of Priscilla: Caelestinus, Felix and
Phillipus, Praxedis, Pudentiana, Maurus, Siricius

8 Via Nomentana: Nicomedis

9 S. Agnese: Emerentiana

10 7th mile of the Via Nomentana: Alexander,
Eventius, Theodulus

11 Cemetery of Yppolitus: Yppolitus

12 Via Tiburtina: Crescentius, Iustinus

13 9th mile of the Via Tiburtina: Simferosa

14 Cemetery of Castulus: Castulus, Stratonicus

15 10th mile of the Via Labicana: Amantius,
Hereneus, Iachinthus, Zoticus

16 Cemetery of Gordianus and Epimachus:
Epimachus, Gordianus

17 Cemetery of Tertullinus: Tertullinus

18 Cemetery of Apronianus: Nemesius

19 Cemetery of Stephanus: Stephanus

20 Via Latina: Basilius, Bonosus, Faustus, Maurus

21 2nd mile of the Via Latina: Servilianus, Sulpicius

22 Cemetery of Balbina: Marcellianus, Marcus

23 Cemetery of Callixtus: Antherius, Lucius,
Meltiades, Favianus‡, Optatus, Pontianus,
Urban, Xystus, Xystus II‡

24 Cemetery of Praetextatus: Ianuarius, Cecilia‡‡,
Maximus‡‡, Tiburtius‡‡, Valerianus‡‡

25 7th mile of the Via Ardeatina: Felicula

26 Cemetery of Cyriacus: Crescentionis, Cyriacus,
Iuliana, Largus, Smaradgus, Memmia

27 Ostia: Honoratus

28 Cemetery of Pontianus: Cyrinus, Miles, Polionis

29 Cemetery of Candida: Candida, Paulina

30 Ad Ursum Pileatum: Arthemius

31 Via Portuensis: Anastasius

32 Cemetery of Processus and Martinien:
Processus ‡, Martinien‡

33 Duo Felices: Felix

34 Cemetery of Calepodius: Iulius

35 12th mile of the Via Cornelia: Abbacuc, Audifax,
Martha, Marus

UNKNOWN LOCATION: Calumniosus, Castus,
Cyrillus, Exsuperantius, Felix, Iacheus, Leucius,
Marina, Maurus, Pontianus, Theodosius, Tiburtiadis, Zoë

‡ Translated to an oratory in S. Peter's

‡‡ Translated to S. Cecilia

FIG. 11.1. **Map of the catacombs from which Paschal I translated relics.** *Drawing: author, M. Hopkins, after Reekmans.*

RELICS IN ROME

Paschal's actions represent a transformation of previous practices of relic translation and veneration in Rome.[5] In the early Middle Ages, saints' bodies were venerated at their different places of burial outside the city walls. Pilgrim itineraries itemized the places with shrines for the veneration of particular saints in the catacombs; sometimes the location of burial is included with a saint's name in early *Martyrologia*. The opinions of Gregory the Great (590–604) on the subject confirmed a long-standing papal policy: the growing numbers of faithful requesting Roman remains should be appeased with contact relics, rather than be allowed to touch or move the bodies of the saints themselves.[6] These contact relics were strips of fabric consecrated by proximity both to the saint's tomb and the Eucharist, or vials of oil that had burned in lamps near the body of the saint; they bore the full miracle-working *virtus* of the saint's body, and were even sometimes referred to as *corpora* or *membra* of the saints.[7] Of course, contact relics were not simply the result of pilgrimage, but had long been used to supply the necessary relics to consecrate altars.[8] While in the East, and to a certain extent north of the Alps, bodies of the saints were relocated, dismembered and disseminated to multiple places of worship, Roman bodies remained immobile and untouched through the early seventh century. At this time, a few popes, most from Greek-speaking parts of the empire, translated small groups of saints to churches within the walls.[9] Under Boniface IV (608–15), the Pantheon was converted to the church of Santa Maria *et Omnium Martyrum*, though the cart-loads of relics brought from the catacombs for the dedication are figments of later legend.[10] These new translations and dedications reflect a growing interest in sanctoral veneration that sparked a certain attention to the sacrality of the holy body itself.[11] While the saints were still celebrated at the catacombs and Gregory III (731–41) restored several cemeterial basilicas outside the walls, a change in attitude to bodies of saints in the city was clearly in action.[12]

Paul I (757–67) translated the remains of about 50 saints into the city, after the alleged Lombard desecration of the catacombs during the tenure of his predecessor Stephen II (752–7).[13] The *Liber pontificalis* records that because the cemeteries had been reduced to ruin, Paul had the bodies of saints brought inside the city and deposited in various unnamed ecclesiastical charity centres (*diaconiae*), monasteries and titular churches, and in the church and oratory of Santi Stefano e Silvestro (San Silvestro in Capite), formerly his family palace.[14] The inscription preserved in the atrium of San Silvestro lists the *Dies nataliciorum* (feast-days) of the translated saints, separated into male and female groups.[15] Another inscription, missing its first few lines, comes from the Vatican: it names the same saints, but adds on Popes Stephen and Silvester, who the *Liber pontificalis* specifies were also translated to the church of Santi Stefano e Silvestro.[16] Paul's biographer explains that the bodies were translated because they had been lying neglected in the cemeteries — this neglect surely arose from the Lombard siege, though this particular source did not mention it. Interestingly, Paul's translations did little to alter the veneration of these saints in extramural burial sites: Hadrian (772–95) restored the cemetery shrines at the catacombs of some of the same saints whose tombs had been emptied 30 years previously by Paul, as well as many others.[17]

Paul's translations might be understood better in the context of his relationship with the Carolingian court. His brother and predecessor, Stephen II, forged the first union between the Franks and the papacy, which Paul undoubtedly sought to develop.[18] Political aims seem to have motivated the translations: he desired not only to protect the bodies, but also to stress the very real threats to the spiritual life of the Roman Church — Paul could preserve a certain number of relics by bringing them into the city and in the process invigorate the cult of Roman saints, but he needed Frankish help in order to keep the threatening Lombards at bay.[19] Shortly after Paul's translations, a considerable number of fragments of some of the same bodies was sent to important Carolingian monasteries north of the Alps.[20]

PASCHAL I AND HIS BUILDING PROGRAMME

The circumstances, ceremony and impact of Paschal's translations were distinctly different from any of these prior translations. The magnitude of even Paul's translations pales in comparison to Paschal's programmatic translations of over 2,300 bodies. Indeed, the very first pontifical action recorded by Paschal's biographer in the *Liber pontificalis* is his translation of many bodies of the saints into the city: 'This most blessed prelate, seeking many bodies of saints, found them, which he placed very attentively and becomingly into the city for the honour and glory of God'.[21]

His first projects, constructed in Saint Peter's, the martyrial basilica *par excellence*, were two oratories, now lost, that were provided with the bodies of Saint (and Pope) Sixtus and Saints Processus and Martinianus. Both oratories were decorated with mosaics, marble panels and (at the latter) silver images of the saints, placed at the window into the relic chamber of the altar (*fenestella*).[22] The lavish ornament and images of the saints emphasized the presence of the martyrs' relics enclosed in the altar, beyond touch, yet emphatically there in a new devotional context.

Paschal's next building project was the complete reconstruction of the titular church of Santa Prassede (**Fig. 11.2**).[23] Prassede was the daughter of the senator

paintings are located on these walls

Fig. 11.2. **Plan of Santa Prassede, Rome.** *Plan: author.*

Pudens and the sister of Saint Pudenziana and the disciple Timothy. According to the *Vita Praxedis*, the ancient *titulus*, one of the original 25 presbyterial churches of Rome, was founded by Saint Prassede and her confessor, Pope Pius I (?140–?54), in the house and baths of her other brother Novatus.[24] Prassede dedicated herself and her family's property to the Christian poor, the conversion of pagans and the proper burial of persecuted Christians. The details of Prassede's *Vita* were surely known to Paschal, and I suggest that his choice to restore the church reflects a desire to associate himself with her pious devotion.

Paschal found the ancient church in ruins and replaced it with the basilica still standing today. He furnished the church with marbles and mosaic, and established a monastery of Greek monks who chanted psalms day and night over the thousands of bodies he had placed inside. The most explicit testimony to his translations is a ninth-century inscription, now immured in one of the diaphragm arches of the church, describing the important event:

> In the name of the Lord our Saviour Jesus Christ, in the times of holiest and thrice blessed and apostolic lord Pontiff Paschal, bodies of saints worthy of veneration were brought into this holy and venerable Basilica of the Virgin of Christ, Praxedis. The above mentioned Pontiff, bearing those resting neglected out of cemeteries or crypts, with his own hands he placed [them] under this sacred altar, with the greatest care, in the month of June, the twentieth day, in the tenth indiction [817]. Truly the names of the bishops are Urban, Stephen, Antherius, Miltiades, Faianus, Iulius, and ...[25]

Eighty-six saints are identified by name, while 2,165 others are identified in nameless numbered groups of martyrs, whose names are 'known only to God', or whose names are 'in the Book of Life', two formulae that also appear in contemporary dedicatory inscriptions and litanies.[26] In fact, the format of the list, with names divided into groups, follows the order of the Litany of the Saints — a responsorial prayer invoking the intercessions of a host of saints.[27] In reciting the litany, the intercession of the saintly hierarchy of heaven was sought, starting with the Trinity or the Virgin, the archangels, ranks of angels, apostles, martyrs, confessors, virgins and so on. Just like a hierarchically organized litany, our inscription records the names

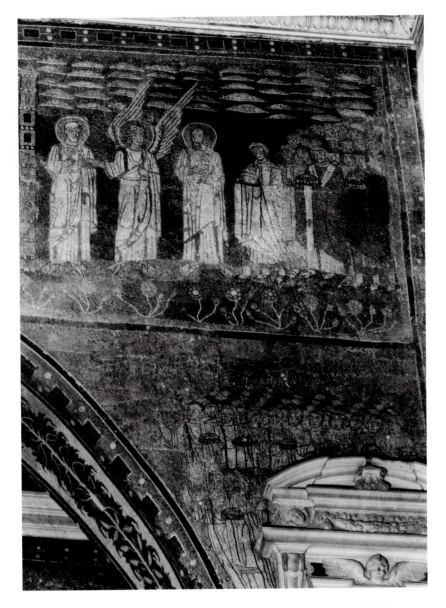

FIG. 11.3. **Detail of mosaic (*Crowds of Saints Entering the Heavenly City*), 817–24,** Triumphal Arch, Santa Prassede. *Photo: Archivio Fotografico Soprintendenza Speciale per il Polo Museale Romano, neg. no. 69829. Reproduced courtesy of the Soprintendenza Speciale per il Polo Museale Romano, Ministero per i Beni Culturali e Ambientali.*

Contemporary Roman antiphons also describe the scene: saints approaching the city of God, the new Church, which has been prepared for them, and celebrating holy relics as the protectors of the city.[28] In elaboration of the imagery of the chants, these mosaics feature the multitudes of saints whom Paschal brought into Santa Prassede now entering the walls of heaven — which in this case also represent the walls of Rome — with Peter and Paul, the patrons of Rome, personally welcoming them on the right-hand side. These mosaics proclaim for perpetuity the triumphal entry of the relics into the city: never before had such a multitude of bodies been brought into the walls, and Paschal himself appears in the apse, just visible beyond the triumphal arch, standing ready to claim the honours for his actions. Thanks to him, prayers directed at these saints, who were present in this church, would be taken to the ears of God. Just as the angels and apostles welcomed the saints into the heavenly city, Paschal brought them into the eternal city of Rome. Thus his church became an earthly embodiment of the heavenly Jerusalem — not just allegorically, but literally, as these walls depict and contain a representative multitude of saints of Christ, with Paschal himself standing as conductor.

Paschal also translated a group of saints to another church he constructed, Santa Cecilia in Trastevere (Fig. 11.4).[29] Paschal placed the bodies of Saints Cecilia, Valerianus, Tiburtius and Maximus, together with those of Popes Lucius and Urban, under the altar of the new basilica built to replace the ancient titular church. The saints Paschal chose were all relevant to Cecilia's life as recorded in her *passio*: according to this source, Cecilia remained chaste though married to Valerianus and converted him and his brother Tiburtius. Valerianus and Tiburtius buried many Christian martyrs, but were soon condemned to death for their actions. Maximus was sent to kill them, and he too was converted by Cecilia and subsequently martyred for his faith. Cecilia honourably buried all three, but then herself was

of translated saints by group, and the choice of format stresses the intercessory function that these saints served in their new shrines.

The figural mosaics of Santa Prassede reflect the same event that this inscription records. In the mosaics of the triumphal arch (Fig. 11.3) the heavenly figures of the litany are shown standing in and around the gates of the heavenly Jerusalem. Christ, the Virgin and apostles stand inside the heavenly gates, and crowds of figures line up outside the gates on both sides: bishops and priests, clerics and laity, and men and women, all processing towards the walls of the city of heaven.

FIG. 11.4. **Plan of Santa Cecilia and underlying structures, Rome.**
Drawing: author.

personally collected the body of this highly-venerated Roman virgin, along with bodies of the cast of characters from her passion and her confessor, the co-founder of her church in Trastevere, Pope Urban — reuniting a community of saints who had been dispersed in burial.

Within these two churches Paschal brought together the mortal remains of the saints whose souls had long been joined together in heaven. Just as Cecilia was reunited with her companions through Paschal's translations, scores of other saints named in the inscription in Santa Prassede were translated with their companions in martyrdom. In both of these basilicas, Santa Prassede and Santa Cecilia, Paschal enacted on earth what had transpired already in heaven — the unification of the community of saints in Christ. The sheer number of saints amounts to a condensation of sacral power in these churches. Yet the particular attention Paschal paid to keeping groups of saints together suggests that he wanted to stress his role in a divine action. According to contemporary theology, the remains translated by Paschal would, at the Second Coming, rejoin the spirits of the saints and be made whole again.[32] His actions thus stress Paschal's sacral pre-eminence — only he could touch and move the relics of the saints — the true treasure of the See of Saint Peter, gathering them together here on earth just as Christ had gathered their souls together in heaven.

One hundred and three of the names of saints translated by Paschal can be identified in contemporary hagiographic sources. These holy persons were celebrated on 56 different feast-days (some shared the same day of martyrdom) and in at least 36 different locations outside the walls, according to sources predating Paschal's translations. The choices of his translations were not arbitrary, nor made from efficiency; quite the opposite — he removed only one saint each from ten different sites.[33] Rather Paschal purposefully took bodies from a great variety of cemeterial sites outside Rome. His systematic exhumation, unprecedented in scope and breadth, drew from almost every artery road outside of Rome and relocated saints who had been venerated at precise locations in the catacombs for hundreds of years (**Fig. 11.1**). Through this programmatic disruption of sanctoral veneration, conscientious spoliation of so many catacombs and construction of new shrines to the saints in the city, Paschal asserted both his dominion in Rome and out to the *campagna* and the primacy of the See of Saint Peter in the Carolingian Empire.

executed. She only succumbed to the wounds delivered by the Roman soldiers after three days, during which time she persuaded Pope Urban (222–30), her confessor, to dedicate her home in Trastevere as a church.[30]

Writing in the ninth century, Paschal's biographer explains that Cecilia came to Paschal in a vision during a night vigil, and they discussed Paschal's fruitless search for her body, rumoured to have been stolen by Lombards (notice the *topos* of Lombard blasphemy!). She told him to go to the cemetery of Praetextatis, and searching there, Paschal found Cecilia's remains wrapped in a blood-soaked shroud, next to the body of her husband, Valerianus. Carrying her body with his own hands and with the divine sanction granted by the saint herself, Paschal moved Cecilia and her husband to the newly-rebuilt church dedicated to her. He also transferred there the bodies of her companions and of Popes Urban and Lucius, who were all buried across the Appia in the Catacombs of Callixtus.[31] Paschal

NEW SHRINES TO THE SAINTS

In the catacombs, local devotees as well as pilgrims visited the grave of each saint individually and took away lamp oils in ampoules (*ampullae*) or left inscriptions or graffiti. Groups met in the oratories and basilicas constructed over or next to the tombs of the saints on their feast-days and listened to the reading of their passions, but by the late eighth century feast-days also might have been celebrated at the intramural churches, creating tension between the sites of burial and sites of veneration.[34] Tension also developed between the growing desire for urban places of veneration and rural sites where the bodies of the martyrs lay, which culminated in Paschal's translations; the bodies were moved from the vast network of catacombs and cemeterial basilicas into condensed deposits inside papal-built *tituli*. Most of the bodies were enclosed together under the main altar of the church or oratory, while a few others were placed in subsidiary oratories and chapels. An eighteenth-century manuscript describing the renovations of the altar of Santa Prassede describes in great detail the mix of skulls, bones and dust discovered piled together in Paschal's marble urns and two sarcophagi stacked in the *confessio*.[35] There, in the city, monks from the attached monasteries, as well as pilgrims and local laity, venerated the saints and celebrated the regular papal, presbyterial and monastic liturgy. Thus four distinct patterns of Christian celebration were merged at the high altar of Paschal's churches.

As befitted papal commissions, the mosaic decorations on the apses and walls of Santa Prassede and Santa Cecilia depict the titular saints of the basilicas, as well as their companions, Saints Peter and Paul, and Paschal himself (**Figs 11.5–6**).[36] Paschal's biographer describes the interior ornament of the churches around the presbytery, each with marble decoration, precious metals and rich textiles. Although most of these elements have disappeared over the course of time,

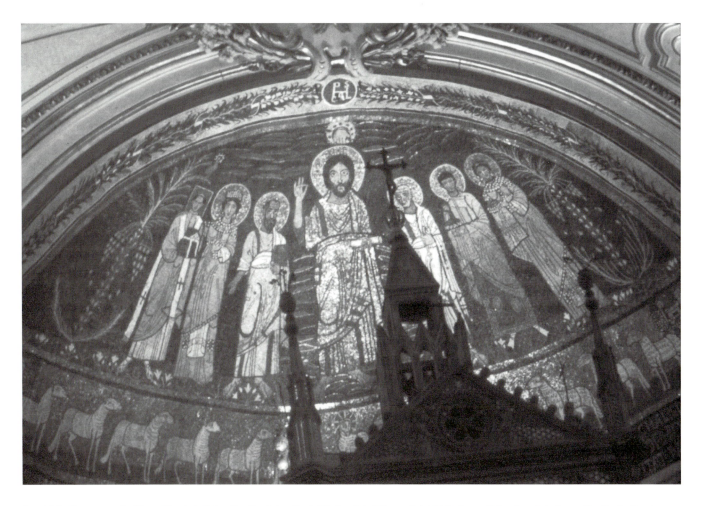

FIG. 11.5. **Apse mosaic (Pope Paschal, Saint Cecilia, Saint Paul, Christ, Saint Peter, Saint Valerianus, Saint Agatha), Santa Cecilia in Trastevere, Rome.** *Photo: author.*

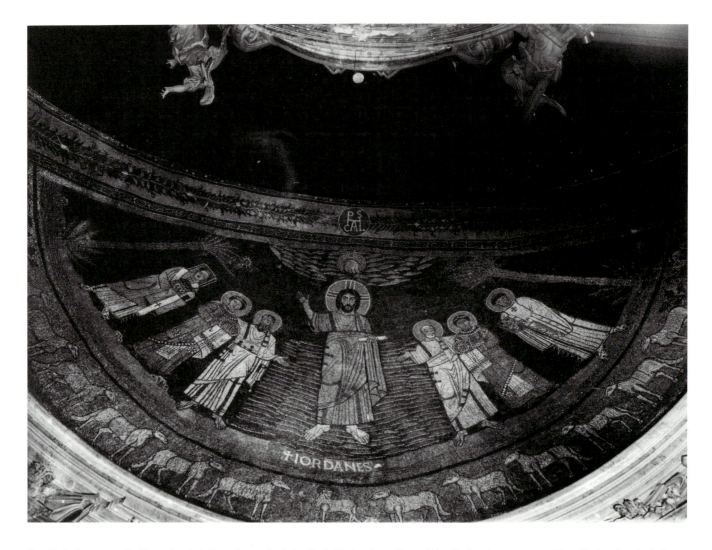

FIG. 11.6. **Apse mosaic (Pope Paschal, Saint Prassede, Saint Paul, Christ, Saint Peter, Saint Pudenziana and an unidentified male saint), Santa Prassede, Rome.** *Photo: Archivio Fotografico Soprintendenza Speciale per il Polo Museale Romano Gabinetto Fotografico, neg. no. 136298. Reproduced courtesy of the Soprintendenza Speciale per il Polo Museale Romano, Ministero per i Beni Culturali e Ambientali.*

evidence demonstrates that the presbyteries of Santa Prassede and Santa Cecilia were especially rich with spoliated furnishings; they were lined with coloured marble revetment and cornices, and opulent with diversely coloured spoliated columns for the raised shrines around the altars (*ciboria*) and pergolas.[37] Panels of gold and silver lined the front of the window giving onto the cavity under the altar (*fenestella confessionis*, also described as the *propitiatorium*).[38] In both churches, silver panels with figures of the saints also were placed at the altar.[39] Textiles of various colours, notably red and purple, hung from the *ciboria*, in the column screens and down the naves of the churches.[40] This conglomeration of precious materials around the altar created a glowing centre over the holy bodies. Simultaneously, the luminous metals and

revetment testified to Paschal's own resources and authority — it was he who could collect such *spolia* riches and exquisitely valuable metals — and proclaimed the glory of these martyrs. The ornament around the bodies celebrated their presence below the altar, while the figural depictions of the martyrs themselves at the *confessio* gave a glorious face to the caskets of shapeless remains inside. The bodies of the titular saints of the church are shown resurrected and glorious at the *confessio* inside the crypt. A painting of Saint Prassede, Saint Pudenziana and the Virgin was found in the relic chamber, and Paschal had donated a silver image of Prassede, like the image at Santa Cecilia, at the *confessio*.[41]

The basilicas of Santa Prassede and Santa Cecilia were furnished with annular crypts, along the model of

Gregory the Great's crypt at Saint Peter's. These crypts allowed a visitor a mediated proximity to the holy bodies — mediated because the building itself invited a pilgrim's approach to its sacral centre, though the bodies there were concealed under the marble and silver of the building. At least in the case of Santa Prassede, there was a clear programme for the visit (Fig. 11.2). After entering the church through the atrium, worshippers would have seen the glittering altar of the church, veiled behind the column screens and the chancel barriers of the church. They would note the figure of Paschal in the apse mosaic and his monogram in the intrados of the triumphal arch. Passing through a set of veils into the side aisle, they could have advanced toward the column screen of the transept arm and towards the stairs to the crypt on one side of the presbytery.[42]

Preserved in the left (west) arm of the transept are the fragments of fresco cycles of martyrdoms of saints, which would have been visible as pilgrims neared the stairs to the crypt (Fig. 11.7A–C).[43] Photographs taken before 1916 preserve many details lost today. The two registers of paintings preserved cover three walls of the left (west) transept arm (Fig. 11.2), and extended perhaps from floor to ceiling. The lowest register visible is preserved only in *tituli*, the identifying texts running above each register, which read, 'Saint Pudens is taught by Paul the apostle' and 'Where Pudens teaches his daughters Praxedis [and Pudenziana]'.[44] From these fragments it is clear that one of the lower registers depicted scenes from the life of Saint Prassede, stressing her father Pudens's direct contact with the apostle Paul, and perhaps continuing representations of her later good works: Saint Prassede collected the bodies of those killed in the church that she founded, the original *Titulus Praxedis*, and gave them appropriate burial. She was not martyred, but rather sanctified because of these good works.

The next two registers feature the martyrdoms of two groups of saints. Both centre around love stories between Christians who married yet remained chaste: Iulianus and Basilissa, and Chrysanthus and Daria.[45] Both couples opened their homes as Christian hospices, and converted countless pagans, the first in Egypt and the second in Rome. The scenes of Iulianus, Basilissa and Celsus (the governor's son whom they converted) are highly abraded, but the group of saints portrayed can be identified securely from their *tituli*.[46] The next register features Chrysanthus and Daria, who submitted to various tortures and whose steadfast faith so impressed

the Roman prefect Claudius that he, his wife Ilaria and their children, Iason and Maurus, converted.[47]

These paintings depict the acts and passions of groups of saints that do not directly correspond to the saints translated to the crypt.[48] Three common genres of saint narratives can be discerned: loving couples living chastely, saints providing proper burial for martyrs, and their dedication of property and wealth to the Church (and it should be noted that these themes also appear in the story of Saints Cecilia and Valerianus). Through these paintings with popular genre appeal, we are reminded of the exemplary piety of these saints and their good works. Saint Prassede herself received reward in heaven, because she collected the bodies and blood of saints and founded a church on her property. Saint Ilaria was martyred because she collected the bodies of martyrs, and Iulianus was martyred because he provided sanctuary in his home. Similarly at Santa Cecilia, Valerianus, Tiburtius and Cecilia collected the bodies of martyrs and gave them burial. Cecilia, before she succumbed to the soldiers' blows, founded the titular church in Trastevere in her own home.

In the most general sense, Paschal was the spiritual shepherd of the Roman flock and was concerned for the salvation of Roman souls, so he made holy bodies of saints available to the faithful, enshrined in a single location rendered accessible through visiting the crypt and looking through the *fenestella*, yet preserved inside the *confessio*, watched and prayed over by monks.[49] A particularly judicious use of *spolia* reminded the pilgrim upon entering the crypt of the promise of salvation awaiting the faithful: above the entrance a fragment of an ancient Jonah sarcophagus, showing Jonah cast up (an overt metaphor for the resurrection), formed the lintel of the crypt portal.

Paschal's programme here has an important secondary meaning: while emphasizing the piety of the saints and the salvation available to all through the veneration of their bodies, the subtext of the stories in the paintings, as well as in the life of Saint Cecilia, is that Paschal has recapitulated the good works of the saints, out of his own piety and for his own salvation. Founding a hospice or church, collecting the decayed remains of martyrs to Christ and giving them glorious, precious shrines — these are not only the actions of the saints celebrated in Paschal's churches, but also the actions of Paschal himself. He had clearly hoped he would be rewarded in heaven for these good works, as the apse inscription at Santa Prassede makes clear:

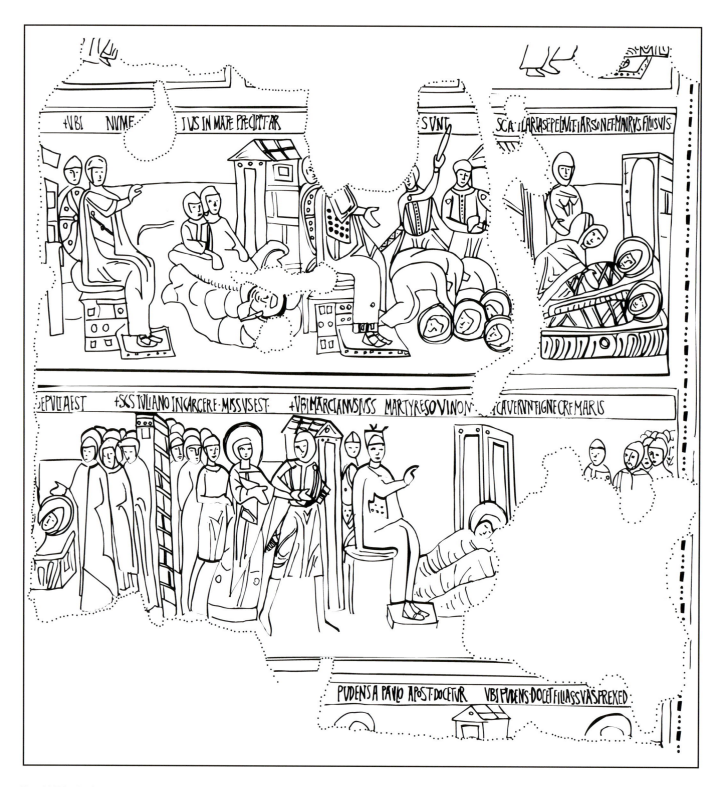

FIG. 11.7A–C. Schematic drawings of the remains of frescoes from (A) southeast wall, (B) west wall and (C) northwest walls of the transept of Santa Prassede, Rome. The registers continue horizontally from A to B to C, though several sections of each are lost. First (lowest extant) register: the life of Saint Prassede. Second register from the bottom: Saints Iulianus and Basilissa, who invoked the ire of the governor Marcianus and were condemned to various tortures. Basilissa died early in the story, and Iulianus was tortured by stoning. After converting the governor's son Celsus, Iulianus was finally executed by the governor, though in the process converted many soldiers, who were also condemned to death. Third register: Saints Chrysanthus and Daria. Emperor Numeranius orders Claudius to be thrown into the sea with a rock around his neck, and his children and some of the soldiers who were converted with Claudius and his family are decapitated. Ilaria then buries her martyred children, Iason and Maurus. In the next wall, Ilaria is seized by soldiers, then Chrysanthus is taken to prison. Meanwhile, Daria had been put in a brothel, but her virginity was protected by a lion who escaped from the Colosseum and stood as her guard. Ilaria is imprisoned after burying her children. Numeranius orders Chrysanthus onto the catasta. The last scene features Chrysanthus and Daria (finally) being buried alive. *Drawings: author.*

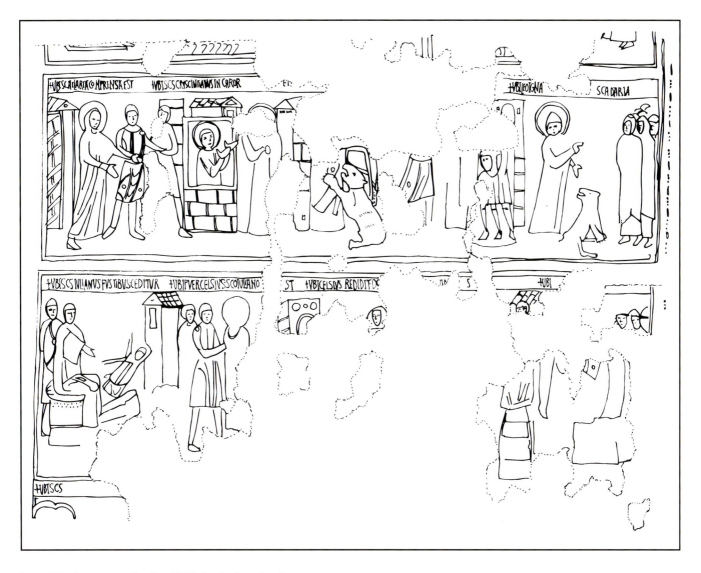

FIG. 11.7B. **See caption for Fig. 11.7A for further details.**

The hall shines, decorated with precious materials in honour of the saintly Praxedis, who pleases in heaven, through the zeal of Pontiff Paschal, servant of the Apostolic See, who collected the bodies of many saints and buried them under these walls, in honour of the Apostolic throne, in order that he may be more eligible to approach the threshold of the heavens.[50]

Paschal also sought redemption on behalf of his mother, whose remains were placed in the San Zeno chapel at Santa Prassede. Paschal placed the bodies of Saint Zeno and two other saints with Theodora, 'episcopa, genetrix sua', according to the marble inscription. She appears in the mosaics, above a lateral niche, with the Virgin Mary and Saints Prassede and Pudenziana, just as Paschal himself is featured in the apse mosaic.[51]

The meaning of these images is not masked — Paschal's decision to be depicted in the apse mosaic clearly indicates his desire be seen by the living as among the holy and after death to enjoy the company of saints, just as he hoped his mother already did.

Paschal rebuilt these churches in honour of the original founders and he deposited their actual corporeal remains, as well as those of 2,300 other saints, inside the churches, as a way of situating himself with Saints Prassede and Cecilia and their papal co-founders, Popes Pius and Urban. At the same time he presented himself as an ideal protector of the Roman Church and placed himself in the august company of these saints in the apse mosaics of the churches, visible to all who enter the church. This is a triumphal celebration of his own pious deeds, and an anticipation of the rewards he

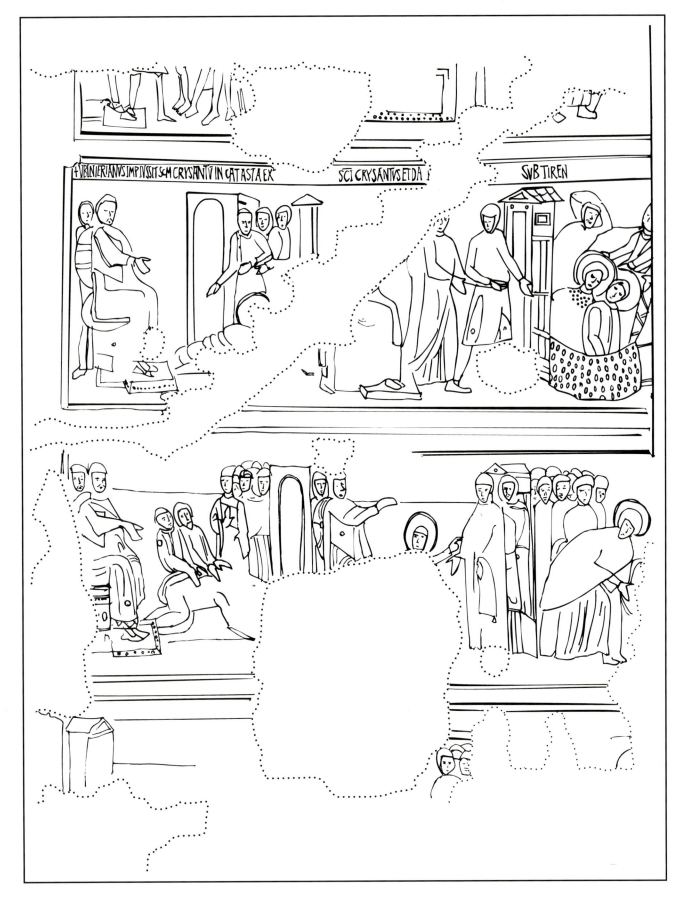

FIG. 11.7C. **See caption for Fig. 11.7A for further details.**

would receive for them (**Fig. 11.5**). Indeed, he positioned himself as the intercessor between Romans, pilgrims (even emperors) and heavenly figures, facilitating access to the bodies in his churches, following the paradigms of pious church foundations. Just as these saints intercede on behalf of the living, by taking prayers straight to the ears of God, the saint-like Paschal gives us access to the saints inside his churches, so that they may hear our prayers.[52] Major saints of the Roman calendar could now be venerated in the course of one's regular observance, in a church well within the urban fabric of Rome. Rather than going to shrines scattered out in the countryside, pilgrims could now visit Paschal's new churches, integrated into the city itself, where they lived and worked. The churches of Santa Prassede and Santa Cecilia were constructed in areas of dense urban occupation; the Esquiline since antiquity had been crowded with different kinds of housing, and during the course of the Middle Ages Trastevere became a thriving *borgo*.[53] Paschal stamped these neighbourhoods with his insignia, his portrait and the sacred bodies he personally had translated.

TRANSLATIONS AS POLITICAL ACTION

Paschal had good reason to stress his authority both in the city and in the empire. A recent predecessor, Leo III (795–816), had been the target of civic uprising led by a group of aristocratic Romans, and the factious antinomy in Rome was hardly quelled under the subsequent brief reign of Stephen IV (816–17) or under Paschal.[54] Further, Paschal's relationship with the reform-minded Emperor Louis the Pious was contentious to the degree that Louis sent envoys from Aachen to Rome to investigate Paschal's suspected involvement in scandalous murders of Lateran officers.[55] Upon Paschal's death, the *Constitutio romana* was issued, a legislative document that inserted Frankish supervision into papal affairs in an attempt finally to curb papal claims of imperial grandeur.[56]

Louis the Pious appears to have been quite interested in ecclesiastical and specifically monastic reforms, perhaps to a greater degree than Charlemagne and Pepin.[57] This reform mentality extended to architectural projects: his private place of repose and prayer was a monastery near Aachen limited to 30 monks, constructed as a prototype for a new brand of small-scale abbeys designed almost exclusively for monastic observance, as opposed to large abbey churches intended to include significant lay participation.[58]

Louis also reformed construction on the huge abbey basilica of Fulda because the laborious task of building the new church (which echoed Saint Peter's in size and form) had been the subject of complaints by the monks since the reign of Charlemagne, who had not intervened. Instead, Louis replaced the abbot and claimed to bring to an end the 'superfluous work of erecting structures of inordinate size'.[59] While numerous factors may have contributed to Louis's actions, his administration of architectural projects reflects a decidedly scaled-down, reserved tone. Conversely, Paschal's grandiose buildings, greater in scale than those of his predecessors and even greater than the emperor's projects, might be seen as emphatic contradictions of Louis's reforms.

Lastly, we should not forget that the contemporary reinstantiation of Byzantine iconoclasm in 815 discouraged the veneration of relics as well as images. Frankish sources on relic veneration are somewhat muddled, though the Roman stance on the subject is extremely clear.[60] Paschal's opposition to Byzantine iconoclasm is well known from his actions and writings on the subject. His relic translations and invigoration of the cult of saints in Rome explicitly affront the Eastern interdictions.[61] By ensconcing such numbers of corporeal relics in his new churches of Santa Prassede and Santa Cecilia, Paschal went against the tide of centuries of papal policy concerning relics in Rome and against the waves of ecclesiastical restraint in the north. In the most general sense, Paschal's churches and relic translations adroitly served his own particular concerns — stressing the primacy of the city of Rome, the burial site of the earliest martyrs and an unparalleled repository of relics, for all of Christendom.

The bold move of these relic translations and the great architectural shrines constructed to house them were designed to have multiple and specific meanings: to stress Paschal's rule over the city of Rome and the See of Saint Peter, to encourage the piety of his flock, to affirm his own exceptional piety, and to save his soul. Remains of the saints spread throughout the extensive labyrinth of underground burial places outside Rome were gathered together inside the city of Rome, inside the walls of Paschal's new churches, just as the souls of those saints were gathered together in heaven. The faithful of Rome and pilgrims to the city came now to churches inside the walls and to churches programmed for the veneration of relics (**Fig. 11.1**).[62] After Paschal's redirection of the veneration of saints, the liturgy of sanctoral celebrations — such as the chanting of the double monastic offices

in honour of saints' feast-days and the feast of All Saints — developed later in the ninth century as urban celebrations in city churches.[63]

After Paschal's translations, the demand for corporeal relics escalated to fever pitch, and Roman pontiffs and even some clerics were able to provide corporeal relics surreptitiously to petitioners. The practices of dismemberment, translation and theft that so characterize the medieval cult of relics only developed after Paschal's interventions. To take an example, corporeal relics of Saint Cecilia appear in at least eleven different places between 830 and 1204 — fingers, teeth, arms, bones and her head — all after Paschal's translation of her body to his church in Trastevere and despite sixteenth-century claims to the integrity of the body of Cecilia at Rome. This fragmentation and dispersal of holy bodies came directly out of a desire for Roman relics that was encouraged by Paschal's dramatic shift in the patterns of veneration. Yet it is clear that these are all developments subsequent to and separate from Paschal's original intentions. His actions were clearly aimed to proclaim (literally, allegorically and eschatologically) his authority and piety, as well as Rome's supremacy and sacrality, and to ensure his own eternal salvation, all through the appropriation of the power of sacred bodies.

<small>APPENDIX</small>

NOTES ON THE INSCRIPTION IN SANTA PRASSEDE[64]

The inscription is carved on *pavonazzetto* marble measuring 2.24×0.89 m, much fragmented (Fig. 11.8). It is presently immured in the pier of the northernmost diaphragm arch of the church, facing the presbytery, and it has been there since *c.* 1450, when John Capgrave saw it and commented upon it.[65]

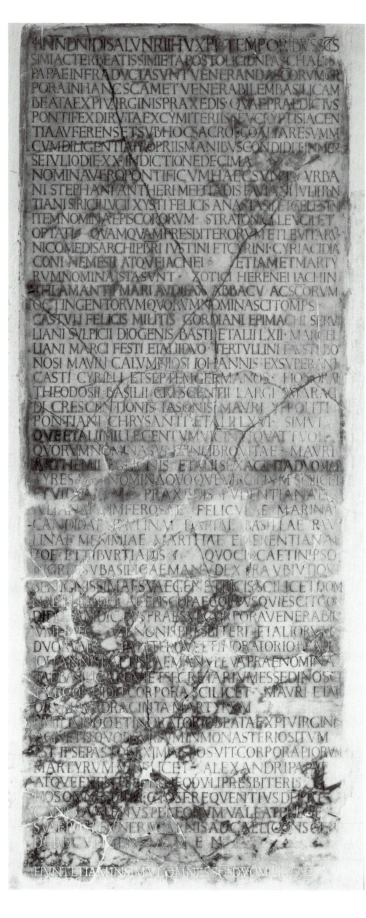

FIG. 11.8. **Inscription recording Paschal's relic translations, Santa Prassede, Rome.** *Photo: Archivio Fotografico Soprintendenza Speciale per il Polo Museale Romano, neg. no. 69820. Reproduced courtesy of the Soprintendenza Speciale per il Polo Museale Romano, Ministero per i Beni Culturali e Ambientali.*

Early Renaissance citations of the tablet seem to conflict with an eighteenth-century recounting of the tradition that the tablet was placed at the altar, though reduced to pieces, and was transferred to its present location, perhaps under the initial renovations of Cardinal Carlo Borromeo (1564–84).[66] The inscription appears in numerous antiquarian descriptions of the church, and an analysis of those sources (as well as the text itself) led the prodigious hagiographer and historian Felice Grossi Gondi to believe that the inscription was an eighteenth-century copy of a medieval parchment (he suggested a date in the thirteenth century because antiquarians mention a text 'antichissima scritta in forma quasi gotica'!).[67] His thesis has been soundly refuted three times, on the basis of earlier antiquarian mentions of the text (though none has taken into account the two *quattrocento* notices of the tablet) and palaeography.[68]

Ursula Nilgen argued that the tablet we see today is the product of two restorations, one undated and one, comprising the last twenty lines, dated to the latter half of the fifteenth century. The current consensus accepts the text on the whole as having been generated in Paschal's time:[69] *pace* Nilgen, I suggest that the entire inscription might date to Paschal. The subtle differences in palaeography could be accounted for by different hands carving sections and different qualities of preservation. The question awaits expert epigraphic analysis.

Notes

Research was conducted in Rome funded by a Rudolf J. Wittkower Fellowship from Columbia University. Translations are my own unless otherwise noted. I owe a debt of gratitude to Fabio Barry, Dorigen Caldwell, Kathleen Christian, Beate Fricke, Marshall Hopkins, Tobias Kämpf, Emma Stirrup, Erik Thunø and Brandie Ratliff, who graciously heard and read the paper in its initial stages, and to Richard Brilliant, Robert Coates-Stephens, Adam Kosto, John Osborne and Chris Wickham, who read and suggested improvements to the article. Since the conference, three new studies that touch on the subject have become available: E. Thunø, *Image and Relic: Mediating the Sacred in Early Medieval Rome* (*Analecta Romana Instituti Danici, Supplementum* 32) (Rome, 2002), J. Crook, *The Architectural Setting for the Cult of Saints in the Early Christian West c. 300–c. 1200* (Oxford, 2000), and F.A. Bauer, 'La frammentazione liturgica nella chiesa romana del primo medioevo', *Rivista di Archeologia Cristiana* 75 (1999), 385–446.

1. J. Baldovin, *The Urban Character of Christian Worship: the Origins, Development, and Meaning of Stational Liturgy* (*Orientalia Christiana Analecta* 228) (Rome, 1987), esp. pp. 37, 105–66, 197–202.

2. Paschal constructed two oratories in Saint Peter's: Santi Sisto e Fabiano and Santi Processo e Martiniano. He reconstructed two titular basilicas (Santa Prassede and Santa Cecilia in Trastevere) and one *diaconia* church (Santa Maria in Domnica). Corporeal relics were translated into each of these buildings, with the apparent exception of the *diaconia* church, for which no trace of a ninth-century relic deposit exists. See C. Goodson, 'L'architettura e l'arredo liturgico della *diaconia* di S. Maria in Domnica', in A. Englen (ed.), *Caelius I Santa Maria in Domnica, San Tommaso in Formis e l'area circostante* (*Palinsesti Romani* 1) (Rome, 2003), 205–18.

3. L. Duchesne, *Le Liber pontificalis: texte, introduction et commentaire* [hereafter *LP*] (Paris, 1886–92), II, 100, 14–21. The format for citations from the *LP* will be as follows: number of the biography, chapter number according to Duchesne and Davis's two volumes: R. Davis, *The Lives of the Eighth-Century Popes* (*Translated Texts for Historians* 13) (Liverpool, 1992); R. Davis, *The Lives of the Ninth-Century Popes* (*Translated Texts for Historians* 20) (Liverpool, 1995).

4. The most influential study of Rome's early medieval architecture is R. Krautheimer, 'The Carolingian revival of early Christian architecture', *Art Bulletin* 24.1 (1942), 1–38, but see also his 'Postscript', in *Early Christian, Medieval, and Renaissance Art* (New York, 1969), 254–6 and 'Postkript 1987', in *Ausgewählte Aufsätze zur Europäischen Kunstgeschichte* (Cologne, 1988), 272–6. Also see W. Jacobsen, 'Gab es die karolingische 'Renaissance' in der Baukunst?', *Zeitschrift für Kunstgeschichte* 51.3 (1988), 313–47, for one of numerous critiques of Krautheimer's idea of revival.

5. There is thus far no comprehensive analysis of the development of intramural relic translations in Rome. The most complete study to date is F. Grossi Gondi, *Principi e problemi di critica agiografica: atti e spoglie dei martiri* (Rome, 1919).

S[an]C[t]A DARIA; VBI NIERIANVS IMP[erator] IVSSIT S[an]C[tu]M CRYSANTV[m] INCATASTA EX (ENO??); S[an]C[t]I CRYSANTIVS ET DA[RIA?]; SVB T[...].

48. Saints Prassede and Pudenziana of course were translated, as were Chrysanthus, Daria, Iason and Maurus. However, the bodies of Saints Ilaria, Claudius, Celsus, Iulianus and Basilissa were not translated into the church, though a different Roman Saint Basilissa was. Interestingly, Ilaria had been translated by Paul I, according to the inscription in San Silvestro in Capite, along with Chrysanthus and Daria. This duplication of translations testifies to the enduring presence in the catacombs of saints, and attitudes towards multiplicatable sanctoral *virtus*.

49. There exists a vast literature on the spiritual rewards of relic veneration. For a start, see P. Geary, *Furta Sacra: Thefts of Relics in the Central Middle Ages* (Princeton, 1990).

50. 'EMICAT AVLA PIAE VARIIS DECORATA METALLIS/ PONTIFICIS SVMMI STVDIO PASCHALIS ALVMNI/ PLVRIMA S[an]C[t]ORVM SVBTER HAEC MOENIA PONIT/PRAXEDIS D[omi]NO SVPER AETHRA PLACENTIS HONORE/SEDIS APOSTOLICAE, PASSIM QVI CORPORA CONDENS/FRETVS VT HIS LIMEN MEREATVR ADIRE POLORVM'.

51. G. Mackie, 'The Zeno chapel: a prayer for salvation', *Papers of the British School at Rome* 62 (1989), 172–99.

52. J.-M. Sansterre, 'Les justifications du culte des reliques dans le haut Moyen Âge', in E. Bozóky and A.-M. Helvétius (eds), *Les reliques: objets, cultes, symbols* (Actes du colloque international de l'Université du Littoral-Côte d'Opale (Boulogne-sur-Mer) 4–6 septembre 1997) (Turnhout, 1999), 81–93, esp. p. 88, citing the relevant texts of Jonas d'Orléans and Dungal.

53. R. Coates-Stephens, 'Housing in early medieval Rome, 500–1000', *Papers of the British School at Rome* 64 (1996), 239–59.

54. Noble, *The Republic of St Peter* (above, n. 18), 197–204.

55. Thegan, 'Vita Hludowici', *MGH* (above, n. 6), *Scriptores rerum germanicarum* 64.416–22; 'Annales regni francorum', *MGH* (above, n. 6), *Scriptores rerum germanicarum separatim editi* 6.161–4.

56. *MGH* (above, n. 6), *Capitularia regum francorum*, n. 161, 323–4; Noble, *The Republic of St Peter* (above, n. 18), 308–19. Contrary to previous scholars, Noble interprets the *Constitutio* as a logical extension of the *Pactum Ludovicianum* of 816–17, though he notes the differences in the documents and the 'turbulence and unsavory behavior' that engendered the *Constitutio*, pp. 308–9. While we must understand the *Constitutio* as an attempt to ensure a certain kind of autonomy for the pope, it clearly lays down as law the Franks role as overseers of the city, in order presumably to prevent any resurgence of Paschal's extreme self-government.

57. T. Noble, 'The monastic ideal as a model for empire: the case of Louis the Pious', *Revue Bénédictine* 96 (1976), 235–50.

58. W. Jacobsen, 'Benedikt von Aniane und die Architektur unter Ludwig dem Frommen zwischen 814 und 830', in A. Schmid (ed.), *Riforma religiosa e arti nell'epoca carolingia* (*Atti del XXIV congresso internazionale di storia dell'arte*) (Bologna, 1979), 15–22.

59. Candidus, 'Vita Eigilis abbatis Fuldensis', *MGH* (above, n. 6), *Scriptores* 15, pars 1, 221–33. Translation and discussion in C. McClendon, 'Louis the Pious, Rome, and Constantinople', in C. Striker (ed.), *Architectural Studies in Memory of Richard Krautheimer* (Mainz, 1996), 103–6.

60. V. Grumel, 'Les relations politico-religieuses entre Byzance et Rome sous le règne de Léon V l'Arménien', *Revue des Études Byzantines* 18 (1960), 19–44; J. Wortley, 'Iconoclasm and leipsanoclasm: Leo III, Constantine and the relics', *Byzantinische Forschungen* 8 (1982), 253–79; Appleby, 'Holy relic and holy image' (above, n. 32); Sansterre, 'Les justifications du culte' (above, n. 52), esp. pp. 81–7.

61. On the letter of Paschal, see A. Englen, 'La difesa delle immagini intrapresa dalla Chiesa di Roma nel IX secolo: note sulla lettera di Papa Pasquale I all'imperatore Leone V l'Armeno' in Englen (ed.), *Caelius I* (above, n. 2), 257–84, including translation of the letter. My thanks to Erik Thunø for sharing with me sections of his Ph.D. dissertation, now published as Thunø, *Image and Relic* (above, introduction to notes).

62. The catacombs were never entirely abandoned, even without their bodies, as demonstrated by J. Osborne, 'The Roman catacombs in the Middle Ages', *Papers of the British School at Rome* 53 (1985), 278–328.

63. For the history of double offices in Rome, see J. Dyer, 'Double offices at the Lateran in the mid-twelfth century', in J. Daverio and J. Ogasapian (eds), *The Varieties of Musicology: Essays in Honor of Murray Lefkowitz* (Warren (MI), 2000), 27–46, esp. pp. 27–8.

64. The most comprehensive study of the inscription is U. Nilgen, 'Die große Reliquieninschrift von Santa Prassede', *Römische Quartalschrift* 69 (1974), 7–29.

65. 'We rede in ye cronicles yat in yis praxedis cherch ly byried ii ml martires and iiii hundred. yis is writyn in ye marbil as we com in at ye dore', J. Capgrave, *Ye Solace of Pilgrimes* (ed. C.A. Mills) (London/New York, 1911), 148. Why he remembers the number of martyrs as 2,400, one can only guess. Another pilgrim to Rome in 1450, Nikolaus Muffel, notes that 2,300 martyrs were buried at Santa Prassede, perhaps a reference to the inscription. G. Wiedmann (ed.), *Descrizione della città di Roma nel 1452* (*Der Ablas und die Heiligen stet zu Rom*) (Bologna, 1999), 102–3.

66. Aloisi, 'Relazione della fabrica' (above, n. 35), fol. 25v.

67. F. Grossi Gondi, 'La celebre iscrizione agiografica della basilica di Santa Prassede in Roma', *Civiltà Cattolica* 1 (1916), 443–56. Silvagni follow Grossi Gondi's dating of the inscription, *Monumenta epigraphica* (above, n. 15), tab. 29, n. 1, as did R. Krautheimer, S. Corbett and W. Frankl, *Corpus Basilicarum Christianarum Romae* III (New York/Vatican City, 1937–77), 235–6, and Davis, *Ninth-Century Popes* (above, n. 3), 11, n. 23. However for Marucchi, the inscription dates to the ninth century: O. Marucchi, *Epigrafia cristiana* (Milan, 1910), n. 490. Nilgen cites transcriptions of

the inscription in her study, to which should be added the following minor corrections: 'Acta Sacrae Visitationis SDN Urbani VIII,' Archivio Segreto Vaticano, Sacra Congregazione della Visita Apostolica 2 (formerly Arm. VII, n. 111), actually fol. 345; B. Mellini, 'Dell'antichità di Roma', Biblioteca Apostolica Vaticana, Vat. Lat. 11905, actually fols 425r–426r. In addition to those cited by Nilgen, the inscription is referred to in F. Del Sodo, 'Compendio delle chiese con le loro fondatione ...', Bibliotheca Vallicelliana, G. 33 (formerly G. 24), fols 104r–6, and Pesarini, Biblioteca Apostolica Vaticana, Vat. Lat. 13128, fol. 239v (which records Panvinio, Vat. Lat. 6780, fol. 55).

68. Federici dates it to before the eleventh century: V. Federici, 'La notitia martyrum di Santa Prassede', *Bullettino dell'Archivio Paleografico Italiano* 8 (1949), 25–38. Ferrua places it within Paschal's pontificate: A. Ferrua, 'Il catalogo dei martiri di Santa Prassede', *Atti della Pontificia Accademia Romana di Archeologia. Rendiconti* 30–1 (1957–8), 129–40.

69. Osborne, 'The Roman catacombs' (above, n. 62), 293, n. 65.

Majesty and Mortality: Attitudes Towards the Corpse in Papal Funeral Ceremonies

Minou Schraven

The death of a ruler generally constitutes an immediate threat to social and political stability, for it inaugurates the interregnum, a crucial test of the resilience and credibility of ideologies and institutions. Medieval and early modern societies responded to the threat of imminent chaos with elaborate rituals, designed to create order and continuity, or at least their appearance. The study of the funerary rituals of the ruling classes in early modern Europe allows us to see the mechanisms of state at work during one of their weakest moments, where recurrence to ritual and tradition aimed to guarantee a smooth transition of power and maintenance of the status quo.[1] In Rome, the death of the pope signalled the beginning of the elaborate ritual of the Novenas, and an examination of the treatment of the papal corpse during this period reveals important aspects of the ambiguous status of the papal body.

Although both royal and papal funeral ceremonials came into being in the early twelfth century, the two ceremonials developed according to their distinct institutional and ideological needs. The royal funeral ceremonies in early modern France were deeply rooted in the concept of the king's two bodies, developed at Tudor chanceries in order to establish the legitimacy of royal succession. In this juridical construction, the king is a conjunction of a Natural Body, human and therefore destined to die, and the Body Politic, divine, immortal and perpetuating itself through dynastic succession. At his death, the king receives a double burial: his Natural Body is interred, while the Body Politic is proclaimed immortal. From here it is a short way to the French maxim 'Le roi est mort — Vive le roi!', documented for the first time in 1515 at the funeral of King Louis XII. The continuity of the king's jurisdiction was also visualized in the royal effigy, carried in procession and laid in state in the royal palace. During the interregnum in sixteenth-century France, ritual meals were served daily to the corpse, as if the king were still alive. This ritual also served to visualize the continuity of authority, believed necessary to guarantee a legitimate succession of power.[2]

By contrast, at the death of a pope, the funeral ceremonies seemed designed to emphasize the end of each individual pope's authority over Rome and the world. Immediately after the official announcement of the pope's death, his seals and fisherman's ring were broken, preventing any papal bull or edict from being issued. As a result, during the papal interregnum — the 'Vacant See' — papal government came to a standstill, and consequently the keys were omitted from the papal coats of arms made as mourning decorations for Saint Peter's. While the king was considered to have two bodies, again and again ceremonial writings underline the fact that the pope had but one mortal body, and at his death returned to the status of a mere mortal.[3] Yet at the same time, it was felt that the pope's body deserved to be mourned and buried according to the majestic status he had enjoyed when alive. Therefore, the solemn lying in state, considered the highest tribute to the deceased, was viewed as an indispensable element of papal funerals from the earliest sources onwards.

The papal funeral rites were the result of a long but consistent historical process of development, in which important ideological and institutional views about the papacy were incorporated. Although the institution of the papacy and its impact on European politics were subject to historical change, a remarkable continuity within the papal funeral ceremonial has prevailed over an extremely long period, from the late Middle Ages until today. The first section of this chapter examines the origins and development of papal funeral ritual; the second is dedicated to the treatment of the pope's body during the funeral ceremonies in Saint Peter's.

THE ORGANIZATION OF THE VACANT SEE AND PAPAL FUNERAL CEREMONIES

Papal funerals are highly institutionalized events and are firmly imbedded within the ritual programme of the Vacant See. Their general outline was established as early as 1274, in Pope Gregory X's bull *Ubi periculum*, which, save for minor adjustments, has been respected ever since.[4] Pope Gregory X himself had been elected after a conclave that lasted for three years due to rivalries and discord within the College of Cardinals. The purpose of Gregory's bull was to reduce the length of this dangerous period of the Vacant See by locking up the cardinals and forcing them to elect a successor as soon as possible. So, once a pope had died, any cardinal wishing to participate in the forthcoming election was expected to present himself at the papal palace within nine days. By the fifteenth century, these nine days had grown into an autonomous ritual period called the Novenas. During this official mourning period, masses for the dead pope were celebrated daily in Saint Peter's by the College of Cardinals, who were responsible for the continuity of the church's institutions. All necessary preparations were taken for the imminent conclave: the cardinals appointed city and church officials as deputies of the Vacant See, they received ambassadors and published decrees, striving to maintain civil order during this period.[5] After the ninth and last death mass of the Novenas, the cardinals entered the conclave, held within the papal palace in complete isolation from the outside world. They voted twice a day in the Sistine Chapel, until a two-thirds majority in favour of one candidate was reached. The newly-elected pope was then taken to Saint Peter's basilica and officially presented to the people. Through this act, the Vacant See had reached its conclusion and a new *Sede plena* was established. Shortly afterwards, the new pope would take official possession of the city of Rome with a festive procession, the so-called *Possesso*.[6]

Popes were, by definition, old and powerful men at the apex of long careers: in the sixteenth century the average age of a pope at his ascension was 61, and his reign lasted on average six years. The inhabitants of Rome were all too aware that the fate of the city and its hybrid population was bound up with that of the Roman pontiff. As a result, rumours about the presumed sickness or death of a pontiff spread quickly, causing a general excitement at both court and in the city. The accumulated tensions exploded at the proclamation of the Vacant See, which were notorious for their uncontrolled violations of civil order throughout the medieval and early modern period. When the machinery of papal government came to a standstill, nothing could prevent mobs sacking palaces and the properties of cardinals and papal families. Violent acts perpetrating long-standing blood feuds were deliberately committed in this period, as there was a general expectation that the new pope would, upon his ascension, grant a general pardon for crimes committed during the Vacant See.[7]

CEREMONIAL THEORY AND PRACTICE

In his book *The Pope's Body*, Paravicini Bagliani provides a thorough and learned analysis of attitudes towards the papal body in the later Middle Ages: a crucial period for the definitive dissociation of the perpetual papal office and the pope as a mortal human being.[8] Treatises of this period repeated over and over again that at death the pope's body lost authority and returned to the status of a mere mortal. A set of apposite rituals underlined the mortality of the pope's body to both the pope and to the Christian community. During the papal coronation, flax was burnt in front of the pope, while the following words were pronounced: 'Holy Father, thus perishes all worldly glory'; these same words would be repeated at his deathbed.[9] After the coronation ceremony, the newly-elected pope was invited to walk past the tombs of his predecessors in the nave of old Saint Peter's.[10] But nowhere was the concept of the pope's mortality more fully elaborated than in the papal funeral ritual, which started to be documented from the early twelfth century onwards. Our only evidence regarding papal funeral ceremonies of this early period is a single reference in early twelfth-century documents to an *ordo*, now lost. This *ordo* must have contained detailed information on the preparation and vestment of the papal corpse and the requirement of the College of Cardinals to be present at the funeral ceremonies.[11]

The first extensive manual to set out the correct procedures of a papal funeral was written some three centuries later by Pierre Ameil (d. 1410) at a moment when the papal court had just returned to Rome from exile in Avignon.[12] Ameil divides the papal funeral ritual into three parts, starting with the agony and death of the pope, followed by the preparation of the corpse in the papal apartments. The second part deals with the private lying in state and funeral services in the great palace chapel. He concludes with the description of the public lying in state and burial in Saint Peter's and of the organization of the Novenas. Although subject to

later minor refinements, this tripartite scheme has remained in place to the present day.

Once the general procedures of papal funerals and successions had been established, the main concern of the early modern papacy was to guarantee their proper and decorous execution. They entrusted the Master of Ceremonies with this difficult task. The office of Master of Ceremonies was instituted at the papal court at the end of the fifteenth century, in order to manage the increasingly complicated set of liturgical rites and court ritual. The first Master of Ceremonies, Agostino Patrizi Piccolomini (d. 1492), revised both the 'Pontifical' (1488) and the *Caeremoniale Romanum* (printed in Venice in 1516), editions that would remain in use until the twentieth century.[13] In addition to ceremonial treatises and manuals, his colleague, Johannes Burckard (d. 1506), started to keep a ceremonial diary, 'to more easily account for the office committed to us'. These diaries offer an invaluable source of information on papal court ceremonial to the present day.[14]

With his bull of 1474, Sixtus IV entrusted the Master of Ceremonies with the organization of all funerals at the Roman curia. From then on, they would be responsible for all aspects of papal funerals, such as the preparation and vestment of the corpse, the appointment of a funeral orator, the obtaining and distribution of candles and mourning dress, and the organization of the temporary decorations used during the Novenas. These mourning decorations consisted of hundreds of papal coats of arms and torches, attached to both the interior and façade of Saint Peter's for the papal funeral ceremonies. The visual and liturgical focal point of the festive funerary mass was the *castrum doloris*, constructed within the nave of the basilica. This *castrum* was a temporary wooden baldachin structure of considerable dimensions and topped with many candles. It stood over the bier and was decorated with gold cloth and papal regalia. At the end of the funerary mass absolution was given to the deceased.[15]

Apart from the responsibility of providing all requisites in time, it was the task of the Master of Ceremonies to put an end to the chaos and disorder characteristic of papal and cardinals' funerals in the late medieval and early modern period. The infamous scandals at the funeral of Cardinal d'Estouteville, who died in Rome in 1483, may serve here as an example. During the funeral procession that went from the cardinal's palace to Sant'Agostino for burial, the clergy of two churches clashed on the street in a violent dispute over the cardinal's precious gold cloth. The bloodshed continued well into the church, where

the body of the late cardinal was abducted from the sacristy, and his ring and mitre were stolen.[16] Burckard's diaries also reveal mistakes during the funerals of popes and cardinals, reminding us that ceremonial theory and its realization in everyday court life were still poles apart. Masters of Ceremonies despaired for the lack of necessary utensils: upon the death of Sixtus IV in 1484, there was nothing at hand to wash and clothe the pope's body properly.[17] Another scandal occurred in 1503, when Burckard decided to bury the body of Alexander VI without delay, as it had started to decompose during the lying in state. No clerics were present during this hurried interment, no lights were lit and carpenters forced the corpse into the coffin, which was far too small to contain the pope's body. With regard to the funeral services, the list of abuses grows even longer: either too many or too few guests were invited, and general indifference towards the correct seating order for guests prevailed. Funeral decorations, such as torches, the *castrum doloris* and gold cloth, were not ready in time, or were stolen before the service had ended properly, as happened to the *castrum doloris* at the Novenas for Alexander VI — Burckard witnessed the numerous hands of canons and clergy fighting over one torch.[18] This desperate state of affairs was hardly improved under Burckard's successors, despite the continued composition of treatises on funerals at the Roman curia.[19]

Given this state of affairs, it is no surprise that Julius II (d. 1513) was anxious to settle the arrangements for his funeral with his Master of Ceremonies, Paris De Grassis (d. 1528), some weeks before he died. Julius remembered seeing too many pontiffs being abandoned at their death and deprived of their belongings by their kin and servants. To avoid the indecorous treatment of his corpse, Julius offered to pay his Master of Ceremonies in advance, and insisted that his white shroud had to be set off with gold, as a sign of the majesty he had been invested with during his lifetime:

> Moreover, he said he remembered having seen many popes at their deathbeds despoiled of their own properties and their belongings, and that their corpses were lying indecently, even naked, with their private parts uncovered. So, the man, who had been elevated to the highest office, [at his death] fell into a state unworthy of such majesty. Therefore, he wanted me ... to take willingly all the necessary care of his body, because he thought it a wise and true thing to do, in order to die, to be laid out and to be buried in an honourable way.[20]

The *topos* of naked papal bodies proved to be a persistent one. The Roman diarist Giacinto Gigli recounts how, after the death of Innocent X in 1655, his family and intimates abandoned the pope's body in his emptied apartments. On top of that, they refused to pay for his coffin after the lying in state. The corpse was provisionally put in a storeroom infested with rats, until two courtiers provided the necessary sum.[21] The sole purpose of Gigli's anecdote was to cast unfavourable light on the Pamphilj family, for all other contemporary evidence indicates that Innocent's funeral was celebrated in perfect accordance with mid-seventeenth-century standards.[22] By that time, the scandals of the early sixteenth century seemed to have been relegated once and for all to the past. In Counter-Reformation Rome, papal funerals and the Vacant See became less and less violent. Organizational and logistic problems apart, the events themselves were carried out according to plan. Disorder was banished from the papal court, for it harmed the carefully constructed image of the triumphant and self-assured papacy. Although rhetorical rejection of splendour at papal funerals remained a recurring theme in ceremonial texts, it did not seem to correspond with seventeenth-century practices.

By the seventeenth century the Church had dedicated itself to splendid and well-orchestrated ceremonies with the pope at their centre. The peculiar rituals of the Vacant See became a major attraction to visitors of early modern Rome, contributing to its reputation as the 'grand theatre of the world'. The rituals of the papal court were described in guidebooks and pamphlets issued during the Vacant See. The printing industry in Rome responded to this interest with the invention of the so-called 'conclave prints', a highly successful print genre issued at each Vacant See from the middle of the sixteenth century until well into the nineteenth century. At the centre of these prints was an up-to-date plan of the Vatican Palace with the names of all participating cardinals, an indispensable scorecard for all those interested in the outcome of the papal election. At its borders, these prints had a series of attractive images of the rituals of the Vacant See, such as the death masses celebrated during the Novenas, and the inauguration of the newly-elected pope (**Fig. 12.1**).[23]

By the force of repetition, the ritual schemes of the Vacant See had become sacrosanct in themselves, and change was avoided at all costs. After the death of Alexander VII (d. 1667) plans to hold the conclave in

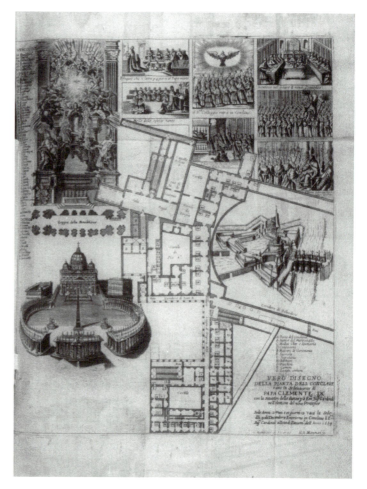

FIG. 12.1. Conclave print issued for the Conclave of Pope Clement IX in December 1669, engraved by M.A. Marinari. The print represents a plan of the Vatican Palace with the names and rooms of the Cardinal-electors, scenes of various rituals pertaining to the papal funeral ceremonies, and views of Saint Peter's, the Cathedra Petri and Castel Sant'Angelo. *Photo: Archivio di Stato, Rome, Fondo Cartari Febei, busta 82, fol. 210. Reproduced courtesy of the Archivio di Stato, Rome.*

the much more comfortable Quirinal Palace were obstructed. Despite the increased number of the College, and the old age and weak constitutions of its members, more importance was attached to tradition, and the cardinals retired once again within the narrow labyrinths of the Vatican Palace.[24] Until the conclave of 1978, cardinals used to sleep on emergency beds in temporary cells built within the corridors and halls of the Vatican Palace. For over eight centuries, the guiding principle behind the endurance of this hardship was that uncomfortable lodgings would increase the speed with which the cardinals would reach agreement on their choice for the papal throne.

With the apostolic constitution *Universi dominici gregis* of February 1996, Pope John Paul II ended this

very long-standing tradition. As per tradition, the cardinals remain responsible for determining the day, hour and manner of the lying in state and burial of the papal body, and making all necessary arrangements for the funeral rites of the deceased pope, the so-called Novenas, and for the election of his successor. But the new constitution states that, during the next conclave, most cardinals will stay at Saint Martha's House, a brand-new hotel for highly-placed prelates with 130 suites and rooms, located within the Vatican territory just behind the Paul VI audience hall. From their lodgings at Saint Martha's, the cardinals will convene daily in the Sistine Chapel to elect the next pope, 'in the strictest secrecy with regard to everything that directly or indirectly concerns the election process itself'. Apart from the lodgings of the cardinal electors, the constitution has established a revolutionary change in the voting procedures: if there is still no agreement after 34 ballots, the cardinals are allowed to adopt another electoral system, which requires only an absolute majority instead of a two-thirds majority.[25] The constitution also contains a section on the papal funeral rites and the proper treatment of the pope's body, in which one encounters resonances of the pre-occupation for the 'naked body' expressed by Julius II five centuries earlier. It has been established that it is no longer permissible to photograph or film the supreme pontiff either on his sickbed or on his deathbed, and if any photographs are to be taken for documentary purposes, they may only show the body in papal vestments.

The most striking feature of the eight centuries of papal funeral ceremonial is its continuity from the Middle Ages until today. Although during future conclaves cardinals will enjoy lodgings with 21st-century standards, the procedures of the funeral and the election are still closely bound up with traditions that were set out centuries ago. The following pages will discuss the treatment of the papal corpse during the funeral ceremonies, mediating between theory, as laid down in ceremonial treatises, and practice, as documented in the diaries of Masters of Ceremonies.

PREPARATION AND DISSECTION OF THE CORPSE

In medieval and early modern societies, no one died alone, and dying a good death resulted in admiration and veneration. In his chapter on 'The agonizing pope', Ameil underlines the special position of the pope in this

respect: his controlled conduct on his deathbed served as an example to mortals of all ranks — kings, princes, the laity and clerics alike.[26] On his deathbed, the pope ideally recommended the Church to the cardinals, announced his testament and his place of burial, and gave his benediction to those present. Then the cardinals withdrew and the dying pope remained with his chamberlains, confessor and palace prelates. While the penitentiaries recited psalms and prayers, the pope's confessor constantly held a crucifix in front of his eyes, reminding him of the Passion of Christ. When the pope died and the cardinal chamberlain had ascertained that death had indeed occurred, he hit the pope on the head three times with a little silver hammer pronouncing him by his first name and proclaiming: 'The pope is truly dead'.[27] The jurisdiction of the late pope ended immediately, with the breaking of his seals and fisherman's ring, and the proclamation of the Vacant See.

To both the Romans and the outside world, however, there was only one indisputable proof of the actual death of the pope, namely the display of his dead body. Unless it was clear to all that the pope had actually died, the cardinals were not allowed to proclaim the Vacant See and elect a successor. This state of affairs explains the great importance attached to the prolonged lying in state of the papal body, preferably with both his face and hands uncovered.[28] To this end, the corpse was prepared in the papal apartment during the first hours after death. Friars washed and shaved the body, using herbs and hot water, to the accompaniment of the reading of the *Office of the Dead* and psalms. Then the court apothecary took over, carefully filling all body openings, such as the nose, mouth, ears and anus, with bombazine and flax, 'so no scandal would occur' during the lying in state.[29] The corpse was then washed with herbs and wine 'of good quality' and finally covered with good balsam, especially the hands.[30]

Although Ameil's account is limited to exterior preservation, and dissection is not mentioned, there is evidence that fourteenth-century practices did include evisceration in order to preserve the papal body over a limited period of time, initially even for the full length of the Novenas. In the later Middle Ages, embalming practices of this kind were fairly common both in Italy and north of the Alps for those of elevated rank or presumed sanctity.[31] In his treatise on surgery, Guido de Chauliac, the personal physician of Clement VI (d. 1352), describes a method of evisceration that he had learned from an apothecary in Avignon, who 'had prepared many corpses of the Roman Pontiffs'.[32] A Bolognese pupil of de Chauliac's, Pietro Argellata,

boasts of having preserved the body of Alexander V (d. 1410) for a period of eight days, thus coinciding with the full length of the Novenas.[33] This clearly indicates that a strict papal ban on dissection never existed, even if the bull *Detestandae feritatis* promulgated by Pope Boniface VIII in 1297 has often caused confusion in this respect.[34]

The corpse of Julius II (d. 1513) was certainly opened, as his Master of Ceremonies informs us in his diary: 'the surgeon eviscerated the body, which was then covered with balsam'.[35] All later popes would undergo the same treatment, in accordance with contemporary practices for the dead of elevated rank. The purpose of evisceration was twofold. First of all, it aimed at the preservation of the papal body for a limited period of time, principally the public lying in state in Saint Peter's. All papal bodies did eventually decompose, as was revealed during the clearance of papal graves at the beginning of the seventeenth century in old Saint Peter's.[36] A second purpose of evisceration was the medical autopsy. The post mortem enabled papal doctors to diagnose the cause of death and to silence eventual rumours that a pope had been poisoned. Palmer cites eight examples of papal post mortems for the sixteenth century alone, and many more were documented in subsequent centuries.[37]

During the preparation of the corpse, papal intestines, or *praecordia* as they were called, were stored in a vessel inscribed with the name of the pope, which was buried near the corpse (**Fig. 12.2**).[38] This practice underwent change at the end of the sixteenth century when, during the hot summer months, popes preferred to reside at the Quirinal Hill instead of the damp and unhealthy atmosphere of the Vatican Palace. In August 1590, Sixtus V was the first pope to die at the Quirinal, and his body was prepared there for the private lying in state in the palace chapel. It was only on the following night that the corpse was brought in procession to the Vatican for the public lying in state and burial in Saint Peter's.[39] The *praecordia* of Sixtus V, however, were buried separately from his corpse, in the parish church of the Quirinal Palace, Santi Vincenzo e Anastasio at the Trevi Fountain. This new practice would occur only for popes who died at the Quirinal, while the *praecordia* of popes who died at the Vatican continued to be interred in the grottoes under Saint Peter's.

Originally, the urns with papal *praecordia* were stored in two subterranean niches below the main altar of Santi Vincenzo e Anastasio. In the twentieth century, they were removed to two modest cells

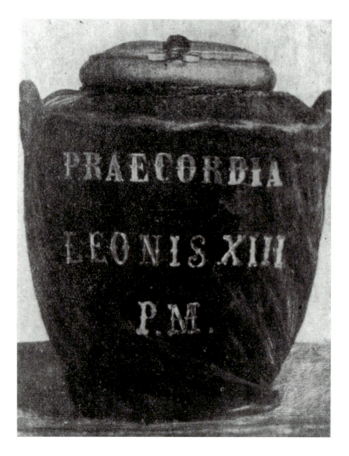

FIG. 12.2. **Vessel containing the *praecordia* of Pope Leo XIII (d. 1903).** *From R. Cecchetelli Ippoliti, 'I precordi dei papi', Rivista d'Italia 20 (1917).*

along a narrow staircase at the right-hand side of the presbytery, where they are still preserved today, invisible and inaccessible to visitors (**Fig. 12.3**). Although in this way numerous papal *praecordia* had a common location, they never appear to have been the subject of cult veneration, as was the case with the hearts of the French kings and queens.[40] Large marble slabs in the church of Santi Vincenzo e Anastasio today contain the names of all 23 popes whose *praecordia* are retained at this parish. The list ends abruptly in the early twentieth century, for Pope Pius X (d. 1914) broke with the custom of evisceration, requesting that his corpse after his death remained untouched. Although the systematic retrieval of papal *praecordia* was thus abandoned, teams of surgeons and doctors continued to prepare papal bodies for the lying in state.[41] That the body of Pope John XXIII (d. 1963) was, at his canonical recognition in March 2001, still in a perfect state and its facial traits perfectly recognizable, might bring this pope yet a step closer to canonization.[42]

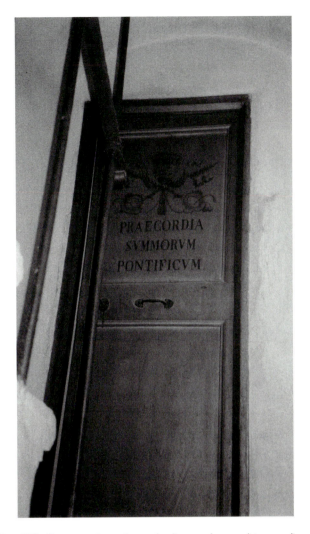

FIG. 12.3. **Door on the staircase leading to the papal** *praecordia* **storage room, Santi Vincenzo e Anastasio, Rome.** *Photo: author.*

VESTMENT OF THE CORPSE

Once prepared, the penitentiaries vested the papal corpse in pontifical garments, as if the pope were about to celebrate mass. All later sources confirm Ameil's prescription of a red robe with white sandals, gloves and mitre.[43] Many scholars have remarked on how closely the vestment of effigies on late medieval tombs corresponds to contemporary ceremonial prescriptions. Even specific details are represented, such as the way of folding the veil, or the three jewelled pins that were prescribed in order to attach crosses of black silk to the *pallium*.[44] Once attired, the corpse was laid on a newly-made bier with a mattress 'of good quality' covered with red silk cloth. Two cushions, preferably of gold cloth, supported both the head and feet of the corpse. Two papal hats, representing temporal and spiritual

jurisdiction, were laid at the dead pope's feet. Around the bier coats of arms, made in black or purple silk, of both the dead pope and the Church were to be on display, and candles should be burning around the papal corpse at all times.[45]

LYING IN STATE: *IMITATIO IMPERII*

The public lying in state of the papal corpse in Saint Peter's was the maximum tribute to the earthly glory and authority with which the pope had been invested during his lifetime. It referred overtly to the concept of *imitatio imperii* and represented the appropriation of the imagery and insignia of the Roman emperors by the self-assured papacy of the Middle Ages.[46]

The papal funeral rites prescribed two moments of lying in state: the first was reserved for kin and curial officials and took place in the papal apartments immediately after the preparation of the corpse. From the sixteenth century onwards the Sistine Chapel in the Vatican Palace was used for this function, where up to twelve continuously burning torches were put around the corpse.[47]

After liturgical functions and prayers, the cardinals, clergy and canons of Saint Peter's went in solemn procession with the corpse to Saint Peter's, lit by many torches and accompanied by the chapel singers, as the church bells rang continuously.[48] This second lying in state in Saint Peter's had a public character and usually lasted two or three days, so that everyone could see that the pope was indeed dead. This explains the utmost importance attached to the successful embalming of the corpse. The use of an effigy is documented only once, during the Novenas of Leo XII in 1829. It was decided to inter the rapidly decaying corpse immediately, before the lying in state had even started. In the following days, an effigy patiently received the tributes of the populace.[49]

According to an ancient custom, the populace paid its last respects to the late pope by kissing his feet or hands during the public lying in state (**Fig. 12.4**).[50] In old Saint Peter's, the public lying in state took place behind the grates of the main altar, while in new Saint Peter's the Sacrament Chapel was used. The pope's feet were put through the grill of the gate in order to protect the body from the hectic crowd in search of a relic, but still enable part of the pope's body to be touched. The permanent presence of the Swiss Guards could not always prevent people being trampled to death by the anxious crowd trying to get close to the corpse.[51]

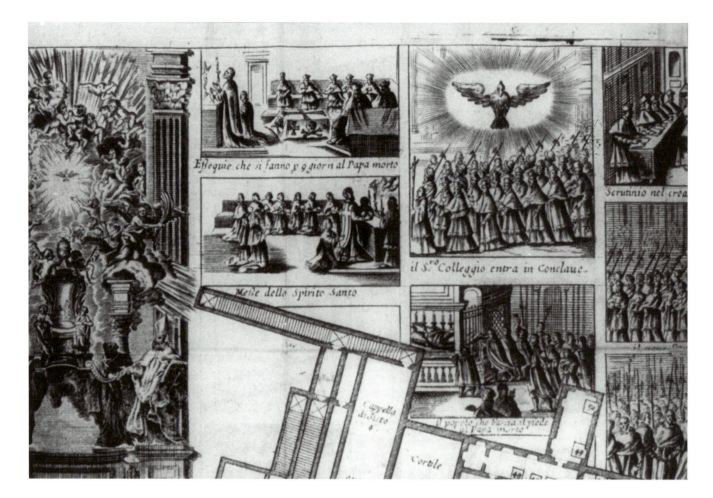

FIG. 12.4. **Detail of the conclave print of Fig. 12.1, showing the populace of Rome kissing the feet of the late pope.** *Photo: Archivio di Stato, Rome, Fondo Cartari Febei, busta 82, fol. 210. Reproduced courtesy of the Archivio di Stato, Rome.*

The appeal of this venerable tradition explains why so many papal tombs of the later Middle Ages and Renaissance represent the moment of majestic lying in state. The magnificent tomb of Sixtus IV (d. 1484) represents the effigy of the pope on a precious cloth of gold, decorated with heraldic motifs of the Della Rovere family, with two cushions below its head, exactly as had been prescribed by Ameil. In accordance with ceremonial texts, the corpse has been dressed in rich pontifical vestments, as if to celebrate mass. The presence of the tiara (or *triregno*), as a clear sign of supreme papal authority in both temporal and spiritual matters, was the sole and deliberate deviation from actual ceremonial practices, where the mitre was required.

Finally, early modern sources often mention the presence of young *palafrenieri* standing at both sides of the corpse, waving away flies with *flabella* — enormous liturgical fans — in this case made of peacock feathers.[52] This curious act was performed both in the presence of the papal corpse and also with its substitute, the empty *castrum doloris*, during the Novenas. The presence of these bearers of the *flabellum, flabelliferi*, again may be taken as a revival of *imitatio imperii*, for this practice is earlier documented for imperial funerals in ancient Rome.[53]

BURIAL OF THE PAPAL CORPSE

Usually after two or three days the corpse was buried in a rather modest overnight ceremony in Saint Peter's. It is significant that little importance was attached to the actual burial. Ameil does not even mention it, while Patrizi Piccolomini and Burckard both indicate the night after the public lying in state as the opportune moment for burial, and this has remained current practice.[54]

In new Saint Peter's, the corpse was taken for burial from the Sacrament Chapel into the Choir Chapel on the night the public lying in state had ended. After the mass for the dead was recited in the presence of some members of the papal household, cardinals and relatives, the corpse was put in a cypress coffin and the face was covered with a veil. Three purses of red silk filled with gold, silver and bronze coins minted during the pontificate were put inside the coffin, together with a written record of the pope's achievements. The coffin was then sealed and put inside a second lead coffin and a third one made of wood. The ceremony ended with the closure of this wooden coffin with the seven seals of the chamberlain, the major-domo and the chapter of Saint Peter's.[55]

Gregorio Leti informs us that papal corpses should always remain in Saint Peter's for at least one year. After that, the pope's family could undertake a separate burial in the family chapel or another location.[56] Within Saint Peter's there has always been a provisional place for the most recently deceased pope, although this has changed from time to time.[57] In the last three centuries, most popes have preferred a tomb in Saint Peter's.

NOVENAS: *IMITATIO IMPERII*

The institution of the Novenas at papal court funerals may have been an expression of *imitatio imperii*, as the ancient Romans observed a nine-day mourning period, the Novemdiale. This tradition was maintained in the imperial court of fourteenth-century Byzantium, where mourning clothes were worn for nine days after a member of the imperial family died.[58] From the fifteenth century onwards, Novenas were observed equally for popes and cardinals. For cardinals it was sufficient to start the Novenas at any time within 40 days after their deaths, while for popes the schedule was much tighter, due to the requirements imposed by the organization of the imminent conclave. Both ceremonials, however, became increasingly alike, as in the late fifteenth century the *Caeremoniale Romanum* obliged all cardinals to attend Novenas celebrated for fellow members of their College — a serious revaluation of cardinals' obsequies.[59]

At this point, it was of serious concern to the papacy that cardinals' funerals were becoming too similar to their own. In May 1514, Leo X issued the bull *Supernae dispositionis arbitrio*, in which he made clear distinctions between the two funeral ceremonials, reserving major pomp for the papal Novenas.[60] But in an age of social ascension through curial offices, the immense wealth of some cardinals would continue to rival the pope's finances, and it required more than a bull to prevent ambitious families from giving up the advantages pompous public obsequies had to offer. Some wealthy families also looked beyond the actual funeral and organized festive obsequies with unprecedented pomp: those celebrated in the Gesù in Rome in 1589 for Cardinal Alessandro Farnese outshone any papal funeral celebrated at the Vatican. For the mourning decorations in the Gesù, the Farnese exhibited the new taste for opulent funerals by the aristocracy of Europe: a majestic and monumental catafalque, 12.5 m high, rose proudly in the crossing of the church, with eight statues of stucco depicting the virtues attributed to the deceased.[61]

Obviously, papal Novenas could not be less magnificent. From the late sixteenth century onwards, papal funerals became increasingly sumptuous and costly enterprises, initially commissioned by a generation of wealthy cardinal-nephews.[62] From the middle of the seventeenth century onwards, huge catafalques were built inside Saint Peter's, to add lustre to the final three extravagant masses for the dead of the Novenas. Confronted with astronomic expenditure, Alexander VIII (d. 1691) decided to cut down costs by imposing the reuse of his catafalque, designed for permanent use by Mattia De Rossi, on his successors.[63] This act of parsimony was not welcomed by later popes, who all preferred to have masses for the dead celebrated with their own personal catafalque in Saint Peter's, either in the nave or in the choir, as is the current custom. The long-standing tradition of papal funeral rites guaranteed suitably majestic obsequies for the authority these bodies had been invested with during their lifetimes.

Notes

My thanks are due to the Warburg Institute in London and the Dutch Institute in Rome for their hospitality while preparing my Ph.D. in the History of Art, *Festive Funerals: the Art and Liturgy of Conspicuous Commemoration in Early Modern Rome*, at the University of Groningen.

1. L. Kolmer (ed.), *Der Tod des Mächtigen. Kult und Kultur des Todes Spätmittelalterlicher Herrscher* (Paderborn, 1997).

2. E.K. Kantorowicz, *The King's Two Bodies* (Princeton, 1957); R.E. Giesey, *Le roi ne meurt jamais* (Paris, 1987); S. Bertelli, *The King's Body: Sacred Rituals of Power in Medieval and Early Modern Europe* (University Park (PA), 2001).

3. P. Prodi, *The Papal Prince: One Body and Two Souls. The Papal Monarchy in Early Modern Europe* (Cambridge, 1987). In this respect, there are interesting parallels between the papal funeral ceremonies and those documented for the doge in Venice. E. Muir, 'The doge as *primus inter pares*: interregnum rites in early sixteenth century Venice', in S. Bertelli (ed.), *Essays Presented to Myron P. Gilmore* I (Florence, 1978), 145–60.

4. L. Lector, *Le conclave: origines, histoire, organisation ancienne et moderne* (Paris, 1894).

5. L. Nussdorfer, *Civic Politics in the Rome of Urban VIII* (Princeton, 1992), 235–45.

6. R. Ingersoll, 'The Possesso, the Via Papale and the stigma of Pope Joan', in H. de Mare and A. Vos (eds), *Urban Rituals in Italy and the Netherlands* (Assen, 1993), 39–50.

7. L. Nussdorfer, 'The vacant see: ritual and protest in early modern Rome', *Sixteenth Century Journal* 18 (1987), 173–89.

8. A. Paravicini Bagliani, *Il corpo del papa* (Turin, 1994), now also in English as A. Paravicini Bagliani, *The Pope's Body* (trans. D.S. Peterson) (Chicago, 2000).

9. 'Sancte Padre, sic transit gloria mundi.'

10. Paravicini Bagliani, *Il corpo del papa* (above, n. 8), 36–7.

11. Paravicini Bagliani, *Il corpo del papa* (above, n. 8), 155–6. Moreover, letters of newly-elected popes of this period contain standard references to the correct settlement of their predecessor's funeral.

12. M. Dykmans, *Le cérémonial papal de la fin du moyen âge à la renaissance: IV: le retour à Rome, ou le cérémonial de Pierre Ameil* (Brussels, 1985), 216–27.

13. M. Dykmans, *L'oeuvre de Patrizi Piccolomini, ou le cérémonial papal de la première renaissance* I (*Studi e testi* 293–4) (Vatican City, 1980–2), 26. A slightly revised edition of the *Pontifical Romanum* was published in 1596 as part of the post-Tridentine liturgical reform, but otherwise these two works were to remain standard until the Second Vatican Council in 1963. The new *Pontifical* was published in 1978.

14. J. Burckard, *Liber notarum* (ed. E. Celani) (Città di Castello, 1907); B. Schimmelpfennig, *Die Zeremoniebücher der Römischen Kurie im Mittelalter* (Tübingen, 1973). The initiative of appointing a Master of Ceremonies was subsequently taken up by other courts in early modern Europe —

see R. Ingersoll, *The Ritual Use of Public Space in Renaissance Rome* (Ann Arbor, 1985), 26–9; E. Muir, *Civic Ritual in Renaissance Venice* (Princeton, 1981), 187–9, 301–2.

15. I. Herklotz, 'Paris De Grassis 'Tractatus de Funeribus et Exequiis' und die Bestattungsfeiern von Päpsten und Kardinälen in Spätmittelalter und Renaissance', in *Skulptur und Grabmal des Spätmittelalters in Rom und Italien* (Vienna, 1990), 217–48, for the appearance of the *castrum doloris* in the late fifteenth and early sixteenth centuries.

16. M.J. Gill, 'Death and the cardinal: the two bodies of Guillaume d'Estouteville', *Renaissance Quarterly* 54 (2001), 347–88.

17. Burckard, *Liber Notarum* (above, n. 14), 15.

18. Burckard, *Liber Notarum* (above, n. 14), 354–5, 369.

19. Herklotz, 'Paris De Grassis' (above, n. 15), for the 1511 treatise written by De Grassis.

20. A. Paravicini Bagliani, 'Rileggendo i testi sulla nudità del papa', in G. Cantarella and F. Santi (eds), *I re nudi. Congiure, assassini, tracolli ed altri imprevisti nella storia del potere* (Spoleto, 1996), 103–25.

21. G. Gigli, *Diario di Roma 1608–70* II (ed. M. Barberito) (Rome, 1994), 731–2.

22. G. Eimer, *La Fabbrica di S. Agnese in Navona: Römische Architekten, Bauherren und Handwerker im Zeitalter des Nepotismus* II (Stockholm, 1971), 477–82.

23. M. Schraven, 'Veri disegni e gloriose memorie: ceremoniële prenten tijdens de Sede Vacante in barok Rome', *Leids Kunsthistorisch Jaarboek* 12 (Leiden, 2002), 109–26.

24. Biblioteca Apostolica Vaticana, MS Barb. Lat. 4436: *Diario nella sede vacante per la morte di PP. Alessandro Settimo fin all'elettione di PP. Clemente Nono con i scrutinii di ciaschedun giorno* (1667).

25. Apostolic constitution, *Universi dominici gregis*, dated February 22, 1996.

26. Ameil, in Dykmans (ed.), *L'oeuvre de Patrizi Piccolomini* (above, n. 13), 216: 'quomodo ipse est lumen totius universi, ideo debet dare exemplum omnibus regibus et principibus, laicis et clericis'.

27. 'Papa vere mortuus est.' This particular element is mentioned for the first time in a nineteenth-century source, although the practice must be much older, see G. Moroni, *Dizionario di erudizione storico-ecclesiastica da San Pietro sino ai giorni nostri* (Venice, 1840–79), 'Cadavere del papa'.

28. P. Argellata, *Chirurgia* (Venice, 1520), lib. V, tract. XII, cap. III, fol. 108v: 'et ego dico quod iste modus non debet fieri in summo pontefice quia manus et pedes debent videri et similiter facies', as cited by Paravicini Bagliani, *Il corpo del papa* (above, n. 8), 212, n. 59.

29. 'Ne scandalum fiat.' Burckard, *Liber notarum* (above, n. 14), 247.

30. Ameil, in Dykmans (ed.), *Le cérémonial papal* (above, n. 12), 219: 'ultimo etiam totum corpus multum fricetur et ungatur cum balsamo bono, et etiam manus'.

31. K. Park, 'The life of the corpse: division and dissection in late medieval Europe', *Journal of the History of Medicine and*

Allied Sciences 50 (1995), 111–32; K. Park, 'The criminal and saintly body: autopsy and dissection in Renaissance Italy', *Renaissance Quarterly* 47 (1994), 1–33.

32. 'Multos romanos Pontifices praeparavat', G. de Chauliac, *Cyrurgia magna* (Avignon, 1363), tract. I, doc. I, cap. VIII, 274. The apothecary has been identified as Jacobus Melioris apothecarius, present at the Avignon court for the period 1321–60, by Paravicini Bagliani, *Il corpo del papa* (above, n. 8), 211, n. 56.

33. Argellata, *Chirurgia* (above, n. 28), lib. V, tract. XII, cap. III, fol. 109r: '[Thus prepared, the corpse] stetit per dies octo sine aliquo fetore mundi', as cited by Paravicini Bagliani, *Il corpo del papa* (above, n. 8), 212, n. 59.

34. E. Brown, 'Death and the human body in the later Middle Ages: the legislation of Boniface VIII on the division of the corpse', *Viator* 12 (1981), 226–41. Boniface intended to attack the *mos teutonicos*, the practice among northern European aristocrats of having their bodies cut up and boiled after their deaths, in order to facilitate transport of their bones to the desired place of burial.

35. 'Chirurgus exenteret corpus, quod etiam repleatur balsamo', Biblioteca Apostolica Vaticana, Vat. Lat. 12268, fol. 442v: Ceremonial diary of P. De Grassis, 'Mors Iulii Papae II. di'.

36. See the accounts of G. Grimaldi, *Descrizione della basilica antica di San Pietro* (ed. R. Niggl) (Vatican City, 1972).

37. G.L. Marini, *Degli archiatri pontifici* (Rome, 1784), lists many medical autopsies on papal bodies. Ludovico Montocoli da Rimini, *chirurgo di palazzo*, disembowelled at least three popes: Pius IV (d. 1565), Pius V (d. 1572) and Gregory XIV (d. 1591). R. Palmer, 'Medicine at the papal court in the sixteenth century', in V. Nutton (ed.), *Medicine at the Courts of Europe 1500–1837* (London, 1990), 49–78; Biblioteca Apostolica Vaticana, R.G. Miscell. 2.13 (int. 2): Autopsia del cadavere della Felice Memoria di Leone XII (1829).

38. *Praecordia*, an anatomical term originally designating the area of the heart, here refers exclusively to the intestines of popes and cardinals. R. Cecchetelli Ippoliti, 'I precordi dei papi', *Rivista d'Italia* 20 (1917), 460–6; Moroni, *Dizionario* (above, n. 27), *s.v.* 'Precordi'.

39. Biblioteca Apostolica Vaticana, Urb. Lat. 1058, fols 441r–v (Avviso di Roma dated August 29, 1590): 'Il suo corpo fu aperto … et la notte sulle 3 hora, il suo cadavero fu portato da cavalli leggieri et Svizzeri in San Pietro, in vista di tutti'.

40. The most famous case being that of Queen Anne of Brittany (d. 1514) who, according to tradition, was buried in Saint Denis in Paris, the royal mausoleum. She left instructions that her heart was to be taken to Nantes, the capital of Brittany, where it was received with solemn ceremonies and became the centre of an intense cult. See A. Dietz, *Ewige Herzen: Kleine Kulturgeschichte der Herzbestattungen* (Munich, 1998).

41. R. Cecchetelli Ippoliti, 'L'imbalsazione delle salme papali', *Rivista d'Italia* 20 (1917), 249–54. *L'Osservatore Romano* (23 January 1922): 'i sanitari in oculazione endoverosa di formalina ed altri farmaci per la conservazione della salma,

avendo più volte il defunto pontefice esternato di rifuggire dall'imbalsamazione'.

42. *L'Osservatore Romano* (4–5 June 2001), 8.

43. Ameil, in Dykmans (ed.), *Le cérémonial papal* (above, n. 12), 219: 'dicti penitentiarii … induant ipsum totaliter sacris vestibus rubei coloris … ac si deberet celebrare, et ponant in capite eius biretam albam cum mitra alba sine perlis et sine auro'. The colour red is also prescribed in the ceremonial by Patrizi Piccolomini in Dykmans (ed.), *L'oeuvre de Patrizi Piccolomini* (above, n. 13), 234. On the colour symbolism of red and white, see Paravicini Bagliani, *Il corpo del papa* (above, n. 8), 117–25.

44. I. Herklotz, *Sepulchra et monumenta del medioevo* (Rome, 1985); J. Gardner, *The Tomb and the Tiara: Curial Tomb Sculpture in Rome and Avignon in the Later Middle Ages* (Oxford, 1992).

45. Ameil, in Dykmans (ed.), *Le cérémonial papal* (above, n. 12), 219: 'et semper ardeant ante ipsum ad minus duo magna torticia cum satis de candelis parvis … et circumquaque debent pendere arma sua et ecclesie, in panno serico nigro vel iacintino'. Burckard, *Liber notarum* (above, n. 14), 248.

46. Paravicini Bagliani, *Il corpo del papa* (above, n. 8), 192–4. In medieval Byzantium, the defunct emperor was laid in state on a porphyry disk in front of his palace, dressed in the clothes of his coronation: Constantin VII Porphyrogénète, *Le livre des cérémonies* (trans. A. Vogt) (Paris, 1939–40), I, 69.

47. G. Leti, *Itinerario della corte di Roma* (Valenza, 1675), 330.

48. Burckard, *Liber notarum* (above, n. 14), 248–9.

49. R. Cecchetelli Ippoliti, *Riti funebri per la morte del papa* (Perugia, 1919), 21.

50. Leti, *Itinerario* (above, n. 47), 331: 'si lascia detto corpo per lo spatio di tre giorni esposto alla vista del popolo, essendo a tutti permesso di andare a baciargli li piedi o le mani, o pure mani e piedi insieme'.

51. Gigli, *Diario* (above, n. 21), 427, reports on the public lying in state of Pope Urban VIII in July 1644: 'vi fu tumulto grandissimo et vi furno uccisi doi huomini, et si sentiva una puzza del cadavere molto grande nel primo giorno'.

52. Burckard, *Liber notarum* (above, n. 14), 249: 'et penes defunctum maneant aliqui clerici, quorum duo flabellos ex pennis pavonum continuo ducant ac si muscas abigeant'. Dykmans (ed.), *L'oeuvre de Patrizi Piccolomini* (above, n. 13), 226, prescribes their presence at cardinal's funerals.

53. Paravicini Bagliani, *Il corpo del papa* (above, n. 8), 231–2. The presence of so-called *flabelliferi* is mentioned for the first time at the funeral of Eugene IV (d. 1447). The custom persisted until the early seventeenth century at sumptuous and festive funerals of popes, cardinals and laity alike.

54. Ameil, in Dykmans (ed.), *Le cérémonial papal* (above, n. 12), 224, does not specify the moment of burial, leaving open the possibility that the corpse was not buried during the Novenas. Burckard, *Liber notarum* (above, n. 14), 249: 'et in sero, circa horam XXIIII, portetur […] a locum sepulture, ubi cum omnibus paramentis quibus indutus est, defunctus ponitur ad capsam ibidem paratam, in qua ex tunc sepelitur'.

55. Moroni, *Dizionario* (above, n. 27), 188, *s.v.* 'Cadavere del Papa'.

56. Leti, *Itinerario* (above, n. 47), 331: 'Però bisogna che il corpo resti un anno intiero per lo meno in deposito nella chiesa di San Pietro, essendo poi permesso di farsi la translatione del corpo predetto, con quella pompa che sarà stimata necessaria dai parenti'.

57. Moroni, *Dizionario* (above, n. 27), names the choir chapel, while Cecchetelli Ippoliti, *Riti funebri* (above, n. 49), 29, indicates a place above the doors of the *cantoria*, opposite the tomb of Pope Innocent VIII in the left nave of Saint Peter's.

58. P. Karlin-Hayter, 'L'adieu à l'empéreur', *Byzantion* 61 (1991), 112–55.

59. Herklotz, 'Paris De Grassis' (above, n. 15), 232.

60. The bull established a maximum sum of 1,500 *scudi* to be spent on cardinals' funerals, in order to prevent families from spending too conspicuously. Only a decade earlier, 3,000 to 4,000 *scudi* was thought a reasonable sum for a cardinal's funeral. Herklotz, 'Paris De Grassis' (above, n. 15), 243.

61. See my forthcoming dissertation on the festive funeral of Cardinal Farnese and other church officials in early modern Rome.

62. M. Schraven, 'Il lutto pretenzioso di cardinali-nipoti per la morte dei loro zii-papi: tre catafalchi papali 1591–1624', *Storia dell'Arte* 98 (2000), 5–24.

63. Biblioteca Apostolica Vaticana, Ferraiuoli IV, 7755, arm. 45: Riforme delle spese solite farsi in tempo di Sede Vacante e per il Conclave.

RELIGION AND SCIENCE: DISSECTION, TORTURE AND FRAGMENTATION

A THEATRE OF CRUELTY AND FORGIVENESS: DISSECTION, INSTITUTIONS AND THE MORAL DISCOURSE OF ANATOMY IN SIXTEENTH-CENTURY ROME

Andrea Carlino

Rodolfo di Bernabeo is a name that means little to anyone. He is simply one of the many who lived some four centuries or so ago, a man forgotten by history and now rescued from oblivion by a fortuitous archival discovery. In this chapter I shall use his history in an attempt to undo a simplistic but monolithic historiographical perception of a field of knowledge (I hesitate to define it as 'science'): that is, anatomy.

In recounting Bernabeo's story, I want to show how the theatrical formula underpinning the demonstration of dissection in sixteenth-century Rome allows us to reflect on notions that go beyond the proper field of 'science', such as 'cruelty' and 'forgiveness' and that they, therefore, articulate and determine its realization, they assign a sense to it that goes well beyond the value awarded by practices destined for intellectual evaluation. This last — at least in the case of anatomy — remains in great part unexplainable, an empty space, but one that can be assessed within the moral and emotional circumstances silently re-echoed in the rites and in the theatre in which the anatomy lesson takes place.

Rodolfo di Bernabeo is one of the many corpses dissected in Rome as part of a public anatomy lesson. The bodies used on these occasions were in various ways special, belonging to specific social and moral categories. These categories followed the same logic established by the complex academic and social ritual organizing the practice of dissection in Rome during the sixteenth century. The dissection of the body was not (and this may also apply today) an innocent operation: it implied contact with death and with blood — and, therefore, with the disintegration and loss of bodily integrity —, and the postponement of burial, all acts with ambiguous connotations from an anthropological, moral and religious point of view.

Alessandro Benedetti, in a text published in Venice in 1502, sets out some of the criteria that regulate the choice of cadavers to be dissected, as follows: the victims were not noble, were unknown, and were from far-away places.[1] Similar criteria are also found explicitly expressed in sixteenth-century regulations governing public anatomy theatres in Italian cities where these spectacles were performed. In Padua, for example, the university statutes in force in the sixteenth century allowed for the dissection of two cadavers per annum, chosen from those condemned to death, provided they were not from the region of Padua or Venice. In Pisa, in the decree with which Cosimo I established the teaching of anatomy, it was specified that the corpses of Florentine or Pisan citizens could not be used, nor the bodies of doctors and scholars of the university. In Bologna, in the statutes in force between 1442 and 1561, it was recorded that the dissected corpses of the condemned had to be from places at least 30 miles outside the city; and in the statutes of 1561, even though the dissection of the condemned originating from the Bolognese suburbs was permitted, the regulations specified that 'they should not be honest citizens', where 'honest', naturally, signifies 'of noble birth'.[2]

And in Rome? The statutes of the College of Physicians of 1531, as well as successive reforms introduced up until the second half of the seventeenth century, do not provide any evidence regarding restrictions in the choice of cadavers. The only clause or qualification was that the corpse had to be of someone sentenced to death, and it was specified that the corpse to be dissected was to be provided and chosen by the *senatore* or by the *governatore*.[3] The rest followed standard practice: the criteria

The body subjected to dissection, the opened body, torn to pieces, dismembered, fragmented, blasphemed, is therefore an infamous body and a body excluded from the community. This characterization was attained through complex bureaucratic procedures that, at different moments of the ritual, involved the representatives of various institutions: the Protomedico, the College of Doctors and the university, the Vicar of Rome (the political authority), the Archconfraternity of San Giovanni Decollato (embodying the religious authority by papal delegation) and the Governor or the Senator (the judicial authority). These last play a particularly important role because the entire history of anatomy, from Herophilus (c. 330–60 BCE) to Vesalius (1514–64) and even to the Visible Human Project, has been characterized by a constant association between dissection and the condemned, therefore dissection/sin, and dissection/transgression. The fact that the responsibility for choosing the condemned man to be sent to the Studium Urbis for dissection fell to the Governor or the Senator, in that they represented judicial power, indicates, on the one hand, a guarantee of legitimacy and that the choice of the subject to be used for the anatomy lesson is indeed that of one properly excluded from the community; and, on the other hand, it further indicates that the single competent authority has implicitly approved the ultimate use to which the sinner's body will be put.[8] In other words, it means considering the passage of the condemned to the table of the anatomists within the framework of a condemnation to death — that is, as part of the overall execution.

The legitimacy of this inscription is further evident at the moment one reflects on the shared fate of the dissected corpses and those condemned to death for whom the prescribed punishment extended *post mortem*. I am thinking in particular about those to be quartered. After the execution, the four pieces into which the body had been dismembered by the executioner were exposed for several days and then taken outside the city walls by the *maestri della giustizia*. This treatment was reserved for unrepentant criminals, for criminals guilty of particularly cruel crimes, and for some Jews, unbelievers and heretics whose corpses were not burned. Quartering was a much worse punishment than hanging and decapitation, and corresponded to a greater crime and thus punishment, such as, for example, that awarded the perpetrators of more than one crime in more than one place; such crimes were publicly affirmed in the procedure adopted for those quartered, such as the opening of the body, the display of the internal bodily

parts and a delayed (or even denied) burial. The similarity of treatment given to the quartered corpse was based on parallel characteristics: quartered bodies, like those dissected, were defiled by being subjected to a series of operations that destroyed their integrity and, in both cases, the bodies were exhibited extensively in public space and left unburied for much longer than was normal.

This parallel nature is shown clearly in the reporting of a case recorded in the books of the *provveditore* of San Giovanni Decollato dated 14 January 1587. The case deals with — in honour of *Roman Bodies* — the exception that confirms the rule: Rodolfo di Bernabeo, the only known case for which we have documentary evidence of a Roman citizen condemned to death and dissected in Rome in the sixteenth century. Bernabeo was hanged together with three companions; the three felons were also quartered. In contrast, wrote the *provveditore*, 'Rodolfo di Bernabeo was not quartered but, on the order of Monsignor the Governor of Rome, was given to the scholars at La Sapienza for them to perform an anatomy lesson'.[9] The dissection seems, in the words of the scribe composing the document, a supplementary punishment inflicted on the condemned that went beyond the limits of death; a punishment that, in this light, appears full of significance: dissection like quartering proclaims the vile character of the subject and the social exclusion of the tormented corpse, but even more so dissection is substituted here for quartering.[10]

Capital punishment, as is well known, is based on a double logic: that of individual punishment and that of prevention by way of example — such a one is condemned to hang because the crime must not go unpunished *and* because it serves as an example. In the sentence of capital punishment, therefore, there is a clear and recognizable individual dimension as well as a social and collective one. The execution of the death penalty is in fact a public event, a public ritual of cruelty, a way of regenerating social cohesion by way of the representation of a collective drama, as the anthropologist Victor Turner would say.[11]

Capital punishment is a drama focused on death, on blood and violence, and on collective participation. In a page of his *Journal de voyage en Italie*, Michel de Montaigne dedicates a section to the execution that he attended in Rome on 11 January 1581 and he recorded what he witnessed in great detail:

On sortoit de prison Catena, un fameux voleur et Capitaine des bandits ... Il [Montaigne] s'arresta pour

FIG. 13.2. Anonymous, *The Lamentation*, seventeenth-century, painting on wood, Archconfraternity of San Giovanni Decollato, Rome. *From D. Freedberg,* The Power of Images: Studies in the History and Theory of Response *(Chicago/London, 1989), 7, fig. 3.*

continuellement sur le visage et luy fait baiser sans cesse un tableau où est l'image de Nostre Seigneur; cela fait qu'on ne puisse pas voir le visage du criminel par la rue. A la potence, qui est une poutre entre deux appuis, on luy tenoit tousjours cette image contre le visage jusques à ce qu'il fust eslancé. Il fit une mort commune, sans mouvement et sans parole; estoit homme noir, de trente ans ou environ. Après qu'il fut estranglé on le detacha en quatre quartiers. Ils ne font guiere mourir les hommes que d'une mort simple, et exercent leur rudesse après la mort. M. de Montaigne y remerqua ce qu'il a dit ailleurs, combien le peuple s'effraye des rigeurs qui s'exercent sur les corps morts; car le peuple, qui n'avoit pas senti de le voir estrangler, à chaque coup qu'on lui donnoit pour le hacher, s'escrioit d'une voix piteuse. Soudain qu'ils sont morts, un ou plusieurs Jesuites ou autres se mettent sur quelque lieu haut et crient au peuple, qui deçà, qui delà, et le preschent pour luy faire gouster cet exemple.[12]

The spectacular representation of cruelty by way of public execution (in the public perception) has its parallel in as much as one is dealing with a representation that, at an individual level (the perception of the condemned), is also a rite of forgiveness. We need to return to our 'Roman Body', that of Rodolfo di Bernabeo, in order to try and understand this aspect of the problem. During the night preceding Rodolfo's execution, and that of his three companions, he receives, as was expected from the procedure, a visit by two 'comforters' (*confortatori*), two members of the Confraternity of San Giovanni Decollato who, as their name implies, have the task of comforting the condemned and bringing them to contrition and to a repentance of their sins. These same two confraternity members were those who accompanied the condemned to the gallows — as recorded by Montaigne. In the chapel adjacent to the *Conforteria*, Rodolfo is received by the chaplain for confession, mass and a final communion.

voir ce spectacle. Outre la forme de France, ils font marcher devant le criminel un grand crucifix couvert d'un rideau noir, et à pied un grand nombre d'hommes vestus et masqués de toile, qu'on dit estre des gentilshommes et autres apparens de Rome, qui se vouent à ce service d'accompaigner les criminels qu'on mene au supplice et les corps des trespassés, et en font une confrerie [l'Arciconfraternita di San Giovanni Decollato]. Il y en a deux de ceux là, ou moines, ainsi vestus et couverts, qui assistent le criminel sur la charrette et le preschent, et l'un d'eux luy presente

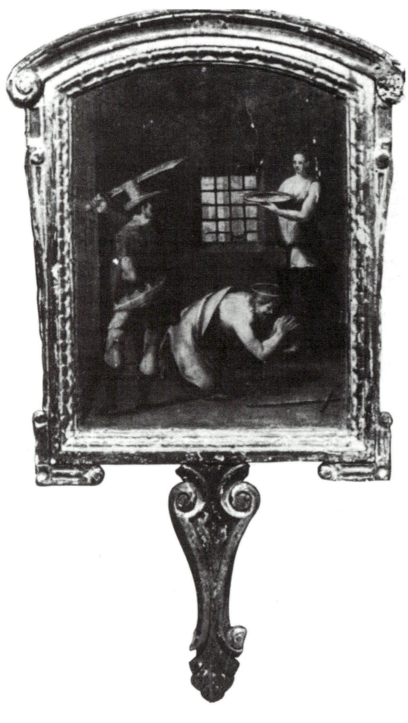

FIG. 13.3. Anonymous, *Beheading of Saint John the Baptist*, seventeenth-century, painting on wood, Archconfraternity of San Giovanni Decollato, Rome. *From D. Freedberg, The Power of Images: Studies in the History and Theory of Response (Chicago/London, 1989), 7, fig. 4.*

again hope for forgiveness in heaven and therefore admittance to God's presence either immediately or following a period spent in purgatory. In fact, even the most notorious sins, those which prompted justice in the form of capital punishment, could be forgiven the moment that the condemned was profoundly contrite, and this allowed them to enter heaven: 'and so fervently could such a punishment and torture be accepted by one sentenced to death, that the gallows and the axe would be a holy martyrdom permitting them to sail directly to heaven', wrote Zenobio Medici in his handbook of 1572 on comforting practices.[13] Bartolomeo d'Angelo wrote in similar vein in his *Ricordo del ben morire* of 1589 when, turning to someone condemned to death, he wrote,

> You demonstrate that merciful God loves you because having been sentenced you will die. What is justice, if not justified, what is it to be sentenced to death if not to pay with the price of your life the debt that your soul owes to the world and to the devil for the sins you have committed, so that it [the soul] remains free and returns to its heavenly Creator?[14]

From the writings of these authors it is clear that capital punishment is part of an elaborate theology of forgiveness: this includes, apart from a general pardon, also the remission of the punishment to be paid in the torments of purgatory for sins committed — or at least the remission of a conspicuous part of these. Zenobio Medici goes further and blatantly indicates that execution can be understood as 'a holy martyrdom' ('un santo martirio'). All this applies to such an extent that the repentant and contrite soul of a condemned man would go inevitably to heaven or, in the worst cases, to purgatory: hell was only for those who were executed unrepentant of their sins, or unbelievers or heretics.

The *confortatori* use every means available to them to induce the condemned to repent of the sins they had committed. Through confession and consequently through contrition, the condemned could once

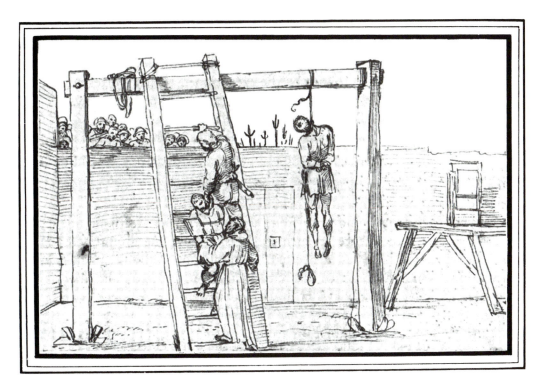

FIG. 13.4. Annibale Carracci (1560–1609), *An Execution, c.* 1599, drawing, Windsor Castle, Royal Library.
Neg. no. RL 1955. The Royal Collection © 2005, Her Majesty Queen Elizabeth II.

One is therefore dealing here with a viewpoint that reveals the relationship between earthly and divine justice, between the punished body and the purified soul. Earthly condemnation is inflicted above all on the punished body; such a sentence functions as a sort of process of expiation and purification of the sins committed, a process beneficial to the soul of the condemned that also brings about redemption and purification in the eyes of the heavenly court.

Rodolfo therefore expiates his sin by the defilement of his body through capital punishment, but at the same time is offered in exchange the promise of a saved and redeemed soul.

After the hearing of confession and the expression of contrition for their sins, Rodolfo and his companions are deemed ready for execution. In the early hours of the morning the executioner arrives and ties the rope around their necks as a preliminary to hanging. The confraternity members sing litanies and one of the two *confortatori* places a small panel with the image of Christ's Passion or of a saint's martyrdom directly before the face of the condemned men: yet again this is a promise of redemption by way of bodily sacrifice (Figs 13.2–3).[15]

The prisoners leave prison in this manner. Along the way they are joined by other confraternity members.

They form a procession, headed by the sacristan and by the confraternity members who carry the cross and the torches, with the condemned who follow. The two *confortatori* are now seated in a carriage drawn by two horses and then the 'officials' (*birri*) follow. Behind and around them a mass of curious onlookers assembles. The procession arrives now at the place of execution: the square in front of the bridge of Sant'Angelo. The confraternity members continually sing litanies and the *confortatori* continue to hold the sacred image directly in the sight of the condemned. Having reached the bridge, the condemned receive absolution and recite their final prayers in the chapel adjacent to the bridge, which belongs to the same Archconfraternity of San Giovanni Decollato. Finally, turning to face the place of his execution, the condemned man moves towards the gallows from the rear: only the executioner, a *confortatore* and the panel with the sacred image accompanies him onto the platform (Fig. 13.4).

Once Rodolfo has climbed the stairs and thrown himself into the emptiness before the gallows, the combined actions of the executioner, who holds on to his shoulders, and of the *tirapiedi* bring about death almost immediately. At this point, the mass of spectators and those same actors taking part in the

ceremony leave the place of execution; the hanged man remains on public display, as an advertisement and example until late in the evening.

The order to deliver Rodolfo's body to the students of La Sapienza in the name of the governor is issued during the night following the execution, while 30 brothers of the confraternity — the 'Trenta della sera' as they were called — are reunited in the church of Sant'Orsola in order to prepare themselves to recover the body. Having read the mandate, brought to them by a messenger or by the administrators of anatomy ('ministri della notomia'), the confraternity members go to the bridge as was the usual practice and take down the bodies of the condemned. The bodies to be dissected are then consigned to the scholars of La Sapienza ('scolari della Sapienza') and these same are responsible for carrying them to the anatomy theatre. There, already by the afternoon, the body of Rodolfo is publicly dissected, while 'the quarters of those quartered were taken outside the city of Rome, as an example'.[16]

The anatomy lessons normally would be conducted on the same corpse over three or four days; these lessons were attended by scholars of medicine and philosophy, students of both faculties, doctors, surgeons, barbers and the representatives of both academic and political authorities, distinguished guests and the simply curious. For all these people, as well as those who were implicated in direct and indirect ways in the organization of the lesson, the double aim of the event — desacralization of the human remains and correlated glorification of the soul of the condemned — was perpetuated in the rite of dissection. The anatomy lesson, in the same manner as capital punishment, was read and interpreted as a sacrifice, as a martyrdom.

On 15 February, about one month after the execution, the records indicate, in a formula as unusual as it is macabre, the restitution of Rodolfo's remains to the confraternity: 'The chaplain reassures the *provveditore* that the doctors have sent back the body, or rather the bones and flesh of the body of Rodolfo Bernabeo provided last 15 January for the anatomy lesson, and that they were buried in the usual place'.[17] The statutes of the College of Physicians on this issue explain: 'At the end of the anatomy, funeral rites should be held and at least twenty masses celebrated for the soul of the deceased'.[18] Yet again, one is dealing with a strategy that invokes the decorum of the procedure in order to emphasize the discourse of forgiveness underlying the ritual of the anatomy lesson and to reward the soul that once inhabited that body.

The double discourse of public cruelty exercized on the body and individual forgiveness guaranteed to the soul of the condemned was manifest in the rituals of public execution, just as it was in anatomical dissections performed in sixteenth-century Rome. Moreover, these last were ritually inscribed in the first. The ultimate meaning of this discourse I believe to be revealed and enunciated in the panel that the *confortatori* imposed before the eyes of those condemned to death. In this extraordinary moment, the images of the Passion of Christ and of saintly martyrdom are transformed into the particular meaning that these scenes have for all the faithful in general, and for those condemned to death in particular: they become *exempla* that give another sense to the rituals of death and public cruelty, *exempla* meant to transmute them into rituals of redemption and forgiveness. Thus, to the eyes of the condemned these images are appealing to self-identification: through them they can see themselves as 'sinners' returning to the court of the just. These images become a double, a mirror, a 'representation'.

A similar logic is created by the complex anatomical rituals, yet another flawless and powerful 'representation' that, in its culminating moment, unfolds in a setting endowed into a double meaning, a theatre of cruelty and redemption.

NOTES

1. 'Ad resectionem igitur ignobiles, ignoti, ex longinquis regionibus, sine vicinitatis iniuria propinquorumque nota, iure duntaxat peti possunt. suspendioque strangulati deliguntur, mediocris aetatis, non gracilis, non obesi corporis, staturae maioris, ut uberior materia evidentiorque sit spectantibus', cited in A. Benedetti, *Historia corporis humani sive anatomice* (ed. and trans. G. Ferrari) (Florence, 1998), 84.

2. 'Cives honesti non sint.' *Statuta Almae Universitatis DD. Philosophorum et Medicorum Cognomento Artistarum Patavini Gymnasii. Denuo correcta et emendata et nonnullis apostillis scitu digni aucta* (Padua, 1607), ch. XXVIII. 'Anatomia fieri non possit de corpore alicuius Civis Florentini, vel Pisani, aut alicuius Doctoris vel Scholaris'; A. Fabroni, *Historiae Academiae Pisanae* II (Pisa, 1791–5), 73–4; C. Malagola (ed.), *Statuti dell'Università e dei Collegi dello Studio Bolognese* (Bologna, 1888), 318, rubrica 19; 'Reformatio statutorum almi gymnasii Bononiensis philosophorum at medicorum (1561)', allegato (C) in A. Corradi, 'Dello studio e dell'insegnamento dell'anatomia in Italia nel medioevo e in parte nel Cinquecento', *Rendiconti del Regio Istituto Lombardo*, serie II, fasc. XV (1873), 632–49. Similar dispositions were foreseen for Genoa, Perugia, Modena and Mantua. On the criteria used in the choice of cadavers for dissection in Italy and in Rome in particular in the sixteenth century see A. Carlino, *Books of the Body: Anatomical Ritual and Renaissance Learning* (trans. J. Tedeschi and A. Tedeschi) (Chicago/London, 1999), 92–8.

3. *Bulla de protomedici et collegii medicorum urbis iurisdictione et facultatibus (1531)* (Rome, 1627), ch. 18.

4. The archival documents relating to the Archconfraternity of San Giovanni Decollato are in great part held at the Archivio di Stato di Roma. The series of *Libri del provveditore* is, however, incomplete, and the registers for the years 1522–57 are missing, for which see L. Firpo, 'Esecuzioni capitali in Roma (1567–1671)', in *Eresia e riforma nell'Italia del Cinquecento* (Florence/Chicago, 1974), 307–42. Also the *filze* and the registers of the Tribunale del Governatore and the Tribunale del Senatore are held at the Archivio di Stato.

5. See P. Farinacci, *Praxis et theoria criminalis* (Venice, 1595), question 18: 'certum est quod poena furcarum est maior poena quam poena capitis, quia magis ignominiosa'. The jurist Prospero Farinacci, apart from being the author of this sixteenth-century compendium volume of jurisprudence, which was to enjoy vast circulation, in the 1590s, in his role as Luogotenente del Monsignore della Camera, ceded for dissection the cadaver of a man condemned to death, for which see Archivio di Stato di Roma, Arciconfraternita di San Giovanni Decollato, b. 7, l. 15, fols 184r–v.

6. For archival references and for individual profiles of the corpses dissected in Rome see, Carlino, *Books of the Body* (above, n. 2), ch. 2 and the appendix.

7. W. Brockbank, 'Old anatomical theatres and what took place therein', *Medical History* 12 (1968), 371–84.

8. The Visible Human Project is a database of the National Library of Medicine at Bethesda in the USA that contains the images of two human corpses, a man and a woman, dissected in slices 1 mm and 0.33 mm respectively. Each slice has been photographed and then digitalized. The images are available on the internet and are used for research and teaching programmes in medicine and bioinformation. To consult the database, see: http://www.nlm.nih.gov/research/visible/visible_human.html. The body of the Visible Man is that of Paul Jennigan, condemned to death and executed in Texas, 5 August 1993. See L. Cartwright, 'A cultural anatomy of the Visible Human Project', in P.A. Treichler, L. Cartwright and C. Penley (eds), *The Visible Woman: Imaging Technologies, Gender, and Science* (New York/London, 1998), 21–43; C. Waldby, *The Visible Human Project: Informatic Bodies and Post-human Medicine* (London/New York, 2000).

9. 'Rodolfo di Bernabeo non fu squartato ma di hordine di Mons. Governatore di Roma fu dato per far notomia alli scolari della Sapienza', Archivio di Stato di Roma, Arciconfraternita di San Giovanni Decollato, b. 7, l. 14, fol. 54r. A similar case is recorded in the Modenese chronicle of Jacopino de' Lancellotti, of 7 March 1494: 'Fu apichato uno el quale aveva asasinato zente e morte e robate e era ordinato de squartarlo non li fu el m.o [maestro] che lo squartasse, poi fu dato a li medeci li quali lo portorno in contrada de san Zohano vecchio in caxxa de queli dal Banbaxo [medico] e li fu smembrato e fato notomia'.

10. It is necessary to specify that this does not mean that the body chosen for dissection is that of someone condemned for something considered a more heinous crime, as is the case for those who were quartered. Rather the regulations are those outlined above, for example by Alessandro Benedetti or the university statutes. Together with these, other criteria related to the 'anatomical quality' of the subject also were considered. If the offer of more than one condemned corpse responded to these criteria, then that of 'greater crime' could come into consideration.

11. See, above all, the second and third chapters of V. Turner, *From Ritual to Theatre: the Human Seriousness of Play* (New York, 1982). The theory of social drama was developed earlier in V. Turner, *Schism and Continuity in an African Society: a Study of Ndembu Village Life* (Manchester, 1957).

12. M. de Montaigne, *Journal de Voyage de Michel de Montaigne* (ed. F. Rigolot) (Paris, 1992), 97–8. As recorded in this passage, Montaigne had already commented on the exemplarity, on the collective dimension, of capital punishment in his *Essais*: 'Je conseillerois que ces exemples de rigeur, par le moyen desquels on veut tenir le peuple en office, s'exerçassent contre le corps des criminels ...', M. de Montaigne, *Essais* (Bordeaux, 1580), II, 11, 431a–432.

13. 'Et tanto ferventemente potrebb'essere accettata tal pena e supplizio d'uno sentenziato alla morte, che le forche et ceppo li sarebbono un santo martirio e subito senza purgatorio ne volarebbe al cielo', Z. Medici, *Trattato utilissimo di conforto de condannati a morte per via di giustizia ...* (Ancona, 1572), fol. 10r. On these themes also, see V. Paglia, *La morte*

confortata. Riti della paura e mentalità religiosa a Roma nell'età moderna (Rome, 1982).

14. 'Ti si dimostra che Dio benedetto ti ama poiché giustiziato ti fa morire. Che cosa è giustiziato, se non giustificato; che cosa è morire giustificato se non pagare con il prezzo della vita quel debito che deve l'anima al mondo e al demonio per i peccati commessi, acciocché ella rimanga libera e se ne torni al suo creatore Iddio?', B. d'Angelo, *Ricordo del ben morire* (Brescia, 1589), 369. Similar arguments were also advanced some years later by R. Bellarmino in *De arte bene moriendi* (1620) — see *L'arte di ben morire* (ed. and trans. C. Testore) (Turin, 1946), 418.

15. On the small panel of the Arciconfraternita di San Giovanni Decollato, see D. Freedberg, *The Power of Images: Studies in the History and Theory of Response* (Chicago/London, 1989), 5–9. See also S.Y. Edgerton, 'A little-known 'purpose of art' in the Italian Renaissance', *Art History* 2 (1979), 45–61, and J.S. Weisz, *Pittura e Misericordia: the Oratory of San Giovanni Decollato in Rome* (Ann Arbor, 1984).

16. 'Li quarti degli squartati furono portati fuori di Roma a esempio.'

17. 'Il cappellano referse al Provveditore essere stato rimandato da notomisti il corpo o fussero le ossa e carne del corpo ... che si dette al 15 gennaio passato di Rodolfo Bernabeo per farne notomia e che era stato sepolto nel luogo solito', Archivio di Stato di Roma, Arciconfraternita di San Giovanni Decollato, b. 7, l. 14, fol. 56v.

18. 'Post finitam anathomiam fiant ei exequiae, et pro anima illius celebrentur ad minus viginti Missae', *Bulla de protomedici* (above, n. 3), ch. 18.

Not torments, but delights: Antonio Gallonio's *Trattato de gli instrumenti di martirio* of 1591 and its illustrations

Opher Mansour

> Suspended, stretched, squashed, beaten, flogged, crucified, scraped, skinned, ulcerated, transfixed, mutilated, deformed, dismembered, butchered, disembowelled, flayed, parboiled in pots and cauldrons, fried in frying pans and skillets, toasted on charcoal and on griddles, spitted, and roasted on naked flames ...
>
> 'How does it look to you?' Dominici raised his eyes. Not so much though as to meet those of Monsignor Berlinghieri, right in front of him: 'Very nice', he muttered.
>
> P. Meldini, *L'avvocata delle vertigini* (Milan, 1994), 14[1]

The object responsible for Dominici's moment of consternation is a copy of the *Trattato de gli instrumenti di martirio, et delle varie maniere di martiriorare usate da' gentili contro cristiani*, which was written by the Oratorian priest and church historian Antonio Gallonio (1557–1605) and published, for the first time, in Rome in 1591.[2] The nature of the instruments and the manner of their use is illustrated extensively in engravings by Antonio Tempesta, incised after designs by Giovanni Guerra, depicting the execution of Christian martyrs at the hands of pagan executioners (below, **Figs 14.1, 4, 6, 8–9**).[3] These are not conventional depictions of the deaths of saints. The martyrs lack names, attributes, or identifiable physical characteristics beyond their generic haloes; they are predominantly young, male and naked save for loincloths, allowing the artist to display their perfect, classically idealized bodies to full effect. Some clasp their hands or look heavenwards, but otherwise seem as blissfully indifferent to their impending ascent into paradise as they are to the horrific actions being inflicted on their bodies, which the executioners carry out with a calm absence of aggression. Although each plate typically holds several figures, arranged in a coherent space, the lack of gestural interconnectedness and emotive interchange between the figures keeps them from ever coalescing into a single scene with a narrative to bind its constituent units. This blank absence of identity and narrative brings the mechanics of martyrdom — the instruments and their implementation — to the fore; though there is no gore, they are depicted with an exacting precision and specificity. As one page succeeds another, and the modes of torture and execution are multiplied far beyond the reader's knowledge, imagination or ingenuity, the images simply accumulate, with no apparent aim beyond that of describing and cataloguing the greatest possible range of tortures. There are 47 of these engravings, and an equal number of facing pages with explicatory captions (**Figs 14.1–2**). These captions detach the images from the remaining 65 pages of text, allowing the *Trattato* to be read much more as a picture-book than as a treatise. Read in this manner, it is not surprising that the book has given rise to self-consciously perverse fascination or, more straightforwardly, to simple revulsion.[4]

However idiosyncratic, even aberrant, it may have appeared to some commentators, the treatise's links with the fashion for martyr-cycles in church decoration have long been recognized by art historians. The most famous example of such a decorative scheme, a series of 31 scenes depicting the deaths of early Christian martyrs, was painted for the church of Santo Stefano Rotondo, the Jesuit-run German and Hungarian College, in 1581–2 by Antonio Circignani.[5] Two further lost contemporaneous cycles by the same artist are recorded, like the first, in a series of engravings by G.B. Cavalieri.[6] They were for the College's other church of Sant'Apollinare and the English

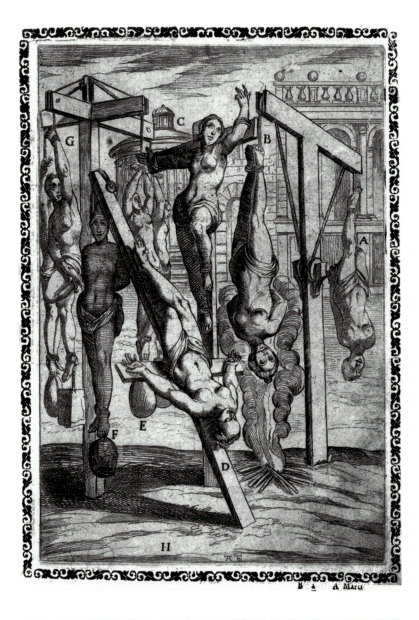

FIG. 14.1. **Antonio Tempesta (1555–1630),** *Trattato,* **martyrdom of women by crucifixion and suspension, p. 11.** *Reproduced courtesy of the Warburg Institute, University of London.*

A Martire appeſo per vn piè.

B Martire appeſo per due piedi.

C Martire crocifiſſo con la teſta all'in ſù.

D Martire crocifiſſo con la teſta all'in giù.

E Martiri ſoſpeſi per le braccia in varij modi, e con peſi a' piedi.

F Martire appeſa per li capelli.

G Martiri appeſi per vn braccio con ſaſsi a'piedi.

FIG. 14.2. **Antonio Tempesta,** *Trattato,* **captions facing the engraving of the martyrdom of women by crucifixion and suspension, p. 10.** *Reproduced courtesy of the Warburg Institute, University of London.*

College's church of San Tomasso di Cantorbery. All three colleges were dedicated to the training of seminarians who were to undertake the dangerous task of re-conversion in Protestant countries, running the very real risk of martyrdom themselves. Similar scenes in the noviciate complex of Sant'Andrea al Quirinale and its attached church of San Vitale were addressed by the Jesuits to their own.[7]

In the nineteenth century, the violence of these images contributed to their low aesthetic reputation.[8] Émile Mâle was the first modern art historian to make the connection between this peculiar iconography and the desire, on the Jesuits' part, to encourage the trainee missionaries to accept danger and inure them to the risk of martyrdom.[9] Their iconographic peculiarities reflect this very particular purpose, and narrowly circumscribed primary audience. As Richard Williams shows in his paper on the English College cycle, the connection between their imagery and the political and sectarian concerns of an institutionally defined viewing community could be very tight indeed.[10] Well-founded analysis of this sort also has a secondary function, however, of normalizing the depiction of violence. Representations that, according to Rudolf Wittkower, 'invariably have a nauseating effect on the modern beholder', are made more palatable and, if not attractive, at least rational and understandable, by an historicized analysis that explains their apparently excessive violence in terms of a particular propagandistic and hortatory function.[11] Similarly, though not, of course, identically, a set of discursive and representational conventions — centred on the idealized body — constituted the *Trattato* as a licit and virtuous combination of text and image, at once scholarly, devotional and deeply moving.

The most proximate and extensive treatment of violence and horror in late sixteenth-century religious art is provided by Cardinal Gabriele Paleotti, who visited Santo Stefano and viewed Circignani's frescoes soon after their completion.[12] Paleotti's approval is significant because, as archbishop of Bologna and as author of the *Discorso intorno alle imagini sacre e profane*, he made the most sustained and public effort of any post-Tridentine Italian prelate to expand the Council's brief pronouncement on the veneration of images into a programme for reform. The first version of the *Discorso* was published in 1582, as Circignani was executing his work.[13]

The chapter in which Paleotti addresses images of martyrs, 'Of fierce and horrible pictures',[14] is one of a sequence devoted to defining and proscribing categories of morally harmful images. It opens with an apparently outright proscription: since pictures exist principally to 'instruct with delight' ('per giovare con diletazzione'), those that represent abhorrent acts and that, moreover, lack any virtuous end, are doubly condemned; poet and painter alike are enjoined to shun them. In this category of *pitture orrende*, Paleotti placed what were, no doubt, the most horrifying subjects that he could imagine: a father torn to pieces by his son, a mother eating her own daughters, men drinking blood from the veins of living men, and 'others who roast human bodies and make a meal out of them, distributing whole limbs to each other for food'.[15]

From a strictly practical point of view, this invective seems forced. No such images existed in the Cinquecento; it is not till Goya that anything approximating them emerges in Western art. Paleotti's argument is not directed, as ostensibly appears, at proscribing a category of non-existent paintings, but at invoking images of almost unspeakable horror in order to justify and promote two 'signal exceptions': categories of images that depict similarly horrific subjects directed towards a virtuous end. He distinguishes those made 'in commendation and amplification of virtue', meaning, specifically, images of tortured saints; and 'images made in detestation of vice and sin', referring to salutary paintings of the torments of the damned and the rebel angels:

> For the first [of these reasons] we daily see the most terrible torments of the saints represented and the wheels, blades, iron-fitted pyres, flaming huts, griddles, racks and crucifixes and the infinite other sorts of most cruel torments expressed with precision. The Catholic Church has consented that these be shown to the eyes of Christian people as heroic emblems of the endurance and nobility of the holy martyrs and trophies of their unvanquished faith and glory; our zealous Holy Mother wishes that from these examples her children should take heart and learn to disdain life, should it befall [them], for divine service, and establish themselves in constancy in all the accidents of this world, and because also, considering how incomparably greater were the pains and afflictions of the martyrs than those that we feel in the infirmities and miseries of this life, [that we should] learn to manfully endure and disdain that which is apt to trouble us, increasing our faith in God and [our] desire for His glory ...[16]

In proposing two criteria, delectation and utility, by which the worth of a painting can be assessed, Paleotti argues for the permissibility of explicit and violent

FIG. 14.3. Antonio Tempesta, *Trattato*, ornamental arrangement of cutting instruments, spiked rakes and tongues, p. 67. *Reproduced courtesy of the Warburg Institute, University of London.*

images of martyrdom and of the torments of hell. In contrast to the perverse images he is anxious to condemn, these two long-established iconographic traditions uphold the Christian moral order and serve valid, didactic ends. For Paleotti, an image is only horrific if it lacks any legitimating moral qualities. Within this limit, sacred art turns a violent subject to a virtuous end, even accentuating that violence in order to heighten its impact. Paleotti specifically urges that painters be given their head (*campo franco*) in depicting the torments and anguish of hell 'even in a verisimilar manner'.[17] He takes advantage of this same licence to describe those horrendous crimes that he abhors, employing graphic, lingering descriptions of

violated bodies: the father is not simply killed, he is 'rent [to pieces] by his son'; the cannibals do not just consume their victims but 'roast the bodies … distributing whole members to each other for food'.

Paleotti's evocation of martyr imagery closely recalls Circignani's frescoes in its unremitting seriality and its insistence on the depiction of torture instruments, so his approval of them comes as no surprise. He does not, however, describe the torments of the blessed martyrs in the same specific and vivid prose he employs to convey the torments of the damned. Nor does he employ the same lurid imagery of bloodied and dismembered bodies that he uses in connection with scenes of parricide and cannibalism.

Both by implication and example, however, such explicitness is not to be employed to represent 'the most terrible sufferings of the saints'. Though forcefully descriptive, Paleotti's descriptions here employ a different set of tropes: the imagery of violated bodies is replaced by the enumeration of the instruments and techniques of martyrdom and by an appeal to affect. The martyred body is no longer represented directly, but only as the implied object of torture; in keeping with this displacement, the qualities of specificity and embodiment are also transferred to the instruments, which are insistently enumerated and distinguished and which, it is emphasized, must be 'minutely expressed'. While their physicality is stressed, that of the martyrs is not; instead, the instruments become 'heroic emblems' (*insegne eroiche*) that represent them metonymically. Paleotti's text reveals a comparatively decorous mode of representing extreme physical anguish. Violence is still forcefully expressed, but any suggestion of abjection is rigorously excluded.

Paleotti's banishment of the martyred body finds it closest visual parallel in the *Trattato*, four of whose illustrations are devoted to be-ribboned ornamental arrangements of torture instruments, *sans* martyrs, but surmounted by wreaths and the occasional palm, and composed in a hieratic and ornamental arrangement deliberately reminiscent of Roman military trophies. The plates are composed by category: one shows only

FIG. 14.4. Antonio Tempesta, *Trattato*, engraving illustrating the use of cutting instruments, spiked rakes and tongues, p. 69. *Reproduced courtesy of the Warburg Institute, University of London.*

scenes are a conjunction of force and restraint.[18] They depict the mechanics of martyrdom with a high level of clarity and detail, but find visual solutions that never compromise the martyrs' poise and elegance, going to some lengths to preserve their placid dignity and modesty. Such studied elegance is, of course, a perennial feature of Tempesta's style, but its deployment here, and his selection as engraver, is none the less significant. The assiduous avoidance of gore and blood is plainly the result of conscious decision, and contrasts markedly with Circignani's treatment of similar scenes. The torturer's rakes, tongs and hooks, for example, stop just short of piercing the skin and damaging the flesh (**Fig. 14.4**). Where Circignani, in depicting a martyr crushed between two stones, dwells on the deformation of the face and the bloody mess of the viscera (**Fig. 14.5**), Guerra, in depicting the same form of martyrdom, avoids such unpleasantness by depicting a slightly earlier moment, enabling Tempesta to depict the imminent martyr's body in all its pristine beauty (**Fig. 14.6**). The manner of his impending demise is, none the less, unflinchingly clear.

Paleotti's claim that such images would teach their beholders to disdain life itself for divine service certainly seems consistent with the missionary ideal of self-sacrifice. But he gives no sign of wanting to restrict them to such a small and particular audience, nor any sense that a contemporary Christian's emulation of the martyrs need be quite so literal-minded. Of course, he wrote to exhort rather than describe; there seems little doubt that the audience for the Jesuit-sponsored martyr-cycles consisted primarily of missionaries and priests. Kirstin Noreen, while making due allowance for the images' translation into print, suggests that this was largely true of Cavalieri's engraved editions, which 'accompanied new priests on their way to the Protestant north'.[19] The 1594 edition of the *Trattato*, translated into Latin for international circulation and re-entitled *De sancti martyrum cruciatibus*, also has clear affinities with Cavalieri's books and other atrocity literature that detailed the persecution of Catholics at Protestant hands.[20] Gallonio cites two such books, by the

fiery instruments, like torches; another depicts only instruments that cut (**Fig. 14.3**). The intention is not to banish the body: the engravings that follow each of these trophies (they are four in number) depict the torture instruments in use, being brought to bear on the martyrs (**Fig. 14.4**). Like Paleotti, Guerra and Tempesta isolate and emphasize the instruments themselves to epitomize the torments of the martyrs, and to frame them as a victory.

The greater part of the illustrations, however, represents the images in conjunction with the physical bodies of the martyrs. Like Circignani's scenes in Santo Stefano, where 'the most hideous torments are represented with a tranquil ferocity', Guerra and Tempesta's

CRVCIATVS SS. MART. 253

A *Martyribus ob Chrifti fidem vel pellis detrahebatur,*
B *Vel eifdem adhuc tepentibus cor & vifcera extrahebantur:*
C *Securi quandoque ipforum capita contundebantur:*
D *Aliqui gladio obtruncabantur,*
E *Alij vel telis configebantur,*
F *Vel præacuta fude aut confimilibus transuerberabantur:*
G *Alij ad duarum arborum ramos alligati defcerpebantur:*
H *Aliqui demum acutis calamis fub manuum pedumq. vnguibus infixis tor-*
 quebantur.

FIG. 14.7. Unknown artist, *De Sancti martyrii cruciatibus*, scenes of martyrdom, p. 253. *Reproduced courtesy of the Warburg Institute, University of London.*

by Gregory XIII in 1583 with the twofold purpose of bringing the liturgy into line with the newly-promulgated Gregorian calendar, and of creating a more complete and accurate list of saints, purged of questionable traditions. The *Martyrologium* was a work of collaborative scholarship in which Baronio was assisted by others, among them Gallonio, who contributed by soliciting, gathering and compiling the information that Baronio put into finished form. It was a protracted project, going through four editions

between 1584 and 1598, when it was finally deemed to be satisfactory.[30]

Baronio's stated aim, as he explains it in the treatise on martyrology that prefaces the full editions of the *Martyrologium* from 1586, was to subject the stories of the martyrs to scholarly scrutiny, weeding out the 'tares' of false traditions to make them as accurate and complete as possible. Specific knowledge of the 'instruments and machines' with which the opponents of the faith had tormented the martyrs was a necessary element of a complete account. However, in drawing attention to them, Baronio also emphasizes the difficulties of providing accurate explanations. Descriptions of the persecutors' instruments were apt to be obscure and hard to interpret, and Baronio apologizes to his readers for the likely mistakes in the text.[31] Gallonio's *Trattato* was, in part, an attempt to resolve this problem and to write a supplement to the *Martyrologium romanum* that would clarify the difficulties that had defeated Baronio. But, as Simon Ditchfield puts it, it was equally a response to Neri's 'practical view of learning as an instrument to inspire devotion to the example of the early Church rather than a mode of scholastic reasoning'.[32]

Gallonio is best remembered as an ardent campaigner for Filippo Neri's canonization and as his first biographer. Contemporaries also knew him, however, for his work as a spiritual counsellor to women and to the children of Rome's aristocracy, which earned him the epithet 'confessor of maidens' ('confessore delle zitelle') and facetious comparisons to Saint Hilarion, the companion of Saint Ursula and her 11,000 virgins.[33] While his best known book is the biography of Filippo Neri, a great part of Baronio's scholarly endeavours was devoted to researching the lives of ancient martyrs; this was the subject of most of his publications, beginning with the *Trattato*.[34] The Oratorian preoccupation with precision and exactitude in observing the bodies of saints is discussed, in relation to Filippo Neri himself, by Catrien Santing; it was a preoccupation that Gallonio, as the main chronicler of this information, clearly shared.[35] In writing the *Trattato*, Gallonio shows himself to have been concerned with the corporeal testimony of sainthood in the case of ancient martyrs, but while, in

FIG. 14.8. **Antonio Tempesta, *Trattato*, martyrdom by stretching and crushing, p. 31.**
Reproduced courtesy of the Warburg Institute, University of London.

cutting and sawing and, finally, a miscellaneous chapter for such torments that have eluded his classificatory scheme.

Within these chapters, Gallonio breaks these broader categories down into sub-varieties. Thus, in the chapter on 'Crucifixion, and modes of suspension', he painstakingly distinguishes three different modes of crucifixion, four kinds of suspension, and a range of permutations, which Guerra employed sixteen figures arranged over five plates to illustrate. The most extensive of these, one of only three in the entire book depicting the martyrdom of women (Fig 14.1), illustrates the most familiar forms of crucifixion — upright and upside-down — in the centre. Flanking these two crucifixes are two other devices, arranged so as to show two related kinds of martyrdom and their respective modes. The figures on the right demonstrate the practice of suspension upside-down by both feet, and by one. On the left are figures hanging upright with weights tied to their feet, suspended by, respectively, one arm, both, or from their hair. Letters surrounding the figures refer the reader to an explicatory key on the facing page (Fig 14.2).

Gallonio did not aim to multiply his examples *ad nauseam*. He sought to distinguish those he deemed materially different, to describe them as clearly as possible and to demonstrate that his analysis was founded on close reading of the ancient sources. His intention to clarify as well as catalogue is most apparent in his treatment of the *equuleo*, or wooden horse, to which he devoted an entire chapter.

Considerable uncertainty surrounded the nature of the *equuleo*, a form of rack. Gallonio begins by presenting a survey of contemporary views and an exhaustive listing of references to the instrument in ancient texts. Then, referring chiefly to the testimony of Eusebius, Prudentius and Ammianus Marcellinus, he proceeds to resolve the interpretative difficulties of the textual evidence so as to give the *equuleo* a definite form, which the engraving then reproduces visually. Gallonio insists that, contrary to the opinion of some, it was neither a crucifix nor an upright pole. The illustration accordingly shows a horizontal instrument

Neri's case, it was anatomy that provided the requisite level of proof and legitimation, in the case of the *Trattato*, this need was answered by a more exacting historical methodology.

The *Trattato* is a book poised between pastoral and scholarly concerns. In the first place, it is a response to Baronio's call for greater exactitude. It is not arranged calendrically or alphabetically, but analytically, as a typology of martyrdom. In eleven chapters Gallonio moves with unflinching logic from 'crucifixes, stakes and modes of suspension', through wheels, pulleys and presses, the wooden horse, flagellating instruments, tearing instruments and a terrifying variety of methods of torture and execution involving fire, deaths by

FIG. 14.9. Antonio Tempesta, *Trattato*, engraving of the *equuleo*, p. 41. *Reproduced courtesy of the Warburg Institute, University of London.*

Bozio, whose earlier work on the *equuleo* he refers to in his own text. According to Pietro Paolo Crescenzi, the author of a preface to the 1594 edition, the treatise (in either form) is a useful aid to understanding obscure or difficult passages of the acts of the martyrs.[37] Gallonio's later biographer, Paolo Aringhi, concurred.[38] They valued it chiefly as a useful glossary of martyrological terms, and the illustrations as an aid to grasping more vividly and accurately the nature of the torment in question. This didactic function of the book informs much of the design of its illustrations, which are always precise in distinguishing between variants of similar forms of execution (Figs 14.1, 4, 6, 7). The absence of narrative and the anonymity of the martyrs is largely explicable in terms of the need to direct the viewer's attention towards the instruments themselves, without any distracting dramatic elements, and to keep them generic, aiding their transposition into any one of a number of possible saints' lives. However, both these writers seem to envisage the illustrations being used as much, if not more, in relation to other texts as to the one they physically accompany. The engraving of the *equuleo*, for example, makes no attempt to illustrate the variations and uncertainties he admits in his text, but presents its conclusions in a vivid and direct manner. While the text of the *Trattato* sometimes engages in recondite disputation, its images are intended to instruct and inform, not to debate, and their relation to the main body of text is disrupted by the facing pages, which provide a quick, easily apprehensible, gloss of the image without exploring its sources.

Their pronounced didacticism arose from a confluence of Gallonio's scholarly and pastoral interests, revealed in his contemporary *Historia delle sante vergini romane*, a book whose genesis is tied closely to that of the *Trattato*.[39] In a letter to his editor, the Naples-based Oratorian Antonio Talpa, dated 19 January 1591, Gallonio described his intention to produce a book of female martyrs, composed of three sections: the first was to relate the lives of the Roman virgin martyrs, the second would deal similarly with a number of non-Roman saints; preceding both of these,

on trestles, situated on a distinct, and clearly labelled, wooden platform, because some writers had also confused the *equuleo* with the platform itself — wrongly, as Gallonio insists. To reconcile reports that martyrs were both stretched on and suspended from the instrument with his proposed horizontal configuration, Gallonio insisted that it could be used in two different ways. Accordingly, Guerra depicts its victims both above and below the horizontal bar (Fig. 14.9).[36]

The simplicity of the illustration is belied by the scholarly intricacy of the text, composed to meet the erudite standards of a comparatively expert audience, such as his fellow Oratorians Baronio and Tommaso

there was to be 'a treatise, divided into fifteen chapters, of the instruments and modes of martyrizing used by the ancients against the Christians, with their figures [engraved] in copper ... which will give, by the grace of God, the greatest devotion and satisfaction to whomever sees them'.[40] Thus Gallonio's intention at the beginning of 1591 was to publish his work on the instruments of martyrdom as an integral part of a larger collection of *vite*. Over the next few months, however, he must have decided to split these sections apart, since the *Trattato degli instrumenti di martirio* and the *Historia delle sante vergini romane* were eventually published as separate books. The former contains all the information on 'the instruments and modes of martyrising' mentioned in Gallonio's letter to Talpa, along with the illustrations. The latter relates the lives of Roman saints (the projected work on non-Roman saints never appeared). Both the *Trattato* and the *Historia* bear the date 1591 on the frontispiece. The *Trattato* was probably published by November of that year, when Gallonio's 'labours' are mentioned in another letter from the Neapolitan Oratory.[41] However, internal evidence dates the *Historia* to 1593; the erroneous date on the frontispiece is, most likely, intended to express the close relationship between the two books, which had originally been intended as a single volume.[42]

The *Historia* has its own smaller illustrations, one at the head of each of its 73 chapters, likewise engraved by Tempesta. The subjects of these *vite* are almost exclusively female, and they generally select the moment at which the protagonist was executed to epitomize her life in the illustration, so the modes of martyrdom depicted are almost as varied as those in the *Trattato*, and as clearly expressed. The illustration to the life of Saint Agrippina, for example, shows the unfortunate saint strung under an *equuleo* and whipped (Fig. 14.10), as could easily be glossed using the images and text in the companion volume. Like its engravings, those in the *Historia* insist that martyrdom is the defining quality of their subjects' lives, and that their unflinching faith is their main claim to the reader's attention.

However, as these engravings are tied to the individual biographies, whose protagonists are identified by captions, they have a different, and closer, attachment to one particular text. As the saints' faces are indistinguishable, the careful differentiation of modes of martyrdom becomes the sole visual means by which the figures are individuated. Thus, clear understanding of the manner of death ceases to be just an object of attention in its own right, but also serves to constitute its subjects' claims to historical identity.

As its title suggests, the *Historia* presents the lives and martyrdoms of a number of female saints, natives of ancient Rome, who professed Christianity and died for their faith at the hands of pagan executioners. Gallonio's selection emphasizes youthful martyrs who, refusing marriage, took vows of perpetual virginity. He also repeatedly selects nobly-born martyrs as his subjects and pays great attention to their kin, family ties and social status in his narratives. Therefore, it is easy to surmise that the book grew out of his concern to provide a spiritual guide to daughters of the contemporary Roman nobility, many of whom he would have helped to lead into the convent. One such, Elena de' Massimi, is mentioned in the book.[43] She died at a young age in 1593, shortly before she was about to take the veil, as she and her family intended. Soon afterwards, in October 1593, Gallonio wrote a short biography lauding her exceptional virtue. The booklet is addressed both to her younger sister, Giulia, exhorting her to emulate her sister's piety, and to her parents. Gallonio enjoins them to bring their surviving daughters up to follow Christ and, sure enough, in 1595 Giulia, like several of her sisters, entered a convent.[44]

Several of the longer lives in the *Historia* certainly could be read as exhortations to enter a nunnery. The *vita* of Saint Susanna emphasizes her heroic obduracy in rebuffing the repeated entreaties of the Emperor Diocletian, no less, to marry his adopted son, Maximinus.[45] In another, the pagan princess Flavia Domitilla accepts Christianity after the Christian eunuchs, Nereus and Achilleus, persuade her with a long, vivid description of the horrors of marriage. In her conversion, piety and celibacy are made to seem indistinguishable.[46] Such passages and, by extension, the entire book, were appropriate reading for nuns, or prospective nuns, whether youthful ones like Giulia de' Massimi, or mature women like Olimpia Orsini Cesi, who became a Franciscan tertiary later in life.[47] However, Simon Ditchfield has cautioned against taking too narrow a view of the *Historia*'s audience, whether actual or intended: heroic exemplars of female chastity had a wider appeal, most clearly within Gallonio's own order, but also beyond it.[48] A brief account of the life of the blessed Euphrosine in his biography of Elena de' Massimi seems carefully judged, like the book's twin dedications, to appeal to both father and daughter: by running away to join a convent, Euphrosine secures not only her own salvation, but also that of her father, Paphnutius.[49] The *vite*

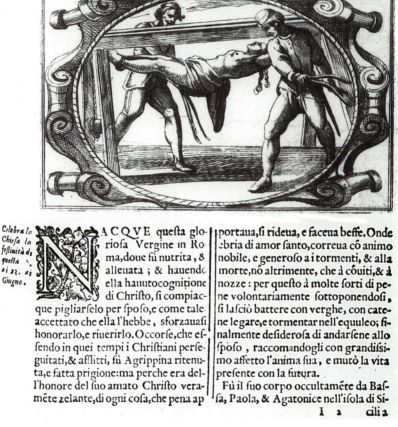

Fig. 14.10. Antonio Tempesta, *Historia delle sante vergini Romane*, martyrdom of Saint Agrippina, p. 131. *Reproduced courtesy of the Warburg Institute, University of London.*

in the *Historia* would have been expected to have a similarly multiple appeal, especially as their protagonists do not live in the desert, but, for the most part, inhabit a recognizably élite Roman world in which the virgin saints' family members are painstakingly enumerated, and in which their sanctity is shown to work for the good of all who come into contact with it.

The *Trattato*, in the form in which it was eventually published, clearly was not supposed to be read only with the *Historia*. The 1594 edition, published separately, finally severed any connection between the two books. While the stories in the *Historia* all concern women, the figures that appear in the

Trattato's engravings are overwhelmingly male. If this was because of sensitivity over showing female, rather than male, bodies, it was not so pronounced as to prevent their depiction when the nature of the torture, such as hanging by the hair, was specific to women (**Fig. 14.1**), or, in the *Historia*, when the engraving's purpose was to illustrate the death of a particular female saint (**Fig. 14.10**). But, in either case, women are only depicted when there is a reason to do so: they are always specifically marked as female. Male bodies could be considered normative, and hence unmarked; they could be made to stand for both male and female subjects. The predominance of men is indicative of the *Trattato*'s generality, its applicability to the widest

possible range of scenarios. By contrast, the female saints represented in the *Historia* work to lend greater specificity and concreteness to particular texts.

That said, the *Trattato*'s dedication, and its connection to the *Historia*, does imply a different audience for it: one that was not predominantly clerical, but also aristocratic and partly female. Guerra and Tempesta's images are geared to this audience's perceived need for a practical aid to devotional reading. The images are correspondingly more numerous and prominent in the 1591 edition than in the one of 1594. In fact, they are the most didactic element of the book, presenting its conclusions rather than its methodology, and are much clearer than their successors of three years later. They are also much more refined, produced in an elegant style by skilled artists. In contrast to most contemporaneous martyr imagery, these engravings were made to be acceptable to an élite audience for whom high artistic standards were the norm (Circignani's cycles have frequently been criticized for their ugliness and lack of artistry).[50] Their refinement may also have had a moral dimension: saints' lives were a staple of female devotional literature, considered ideal reading material even by those who advocated restricting girls' access to literature.[51] The mid-sixteenth-century writer Giovanni Battista Armenini accords images of the lives and deaths of saints a similar status, considering them one of the very few categories of images suitable for the private cells and devotions of nuns. However, he also warns that only very skilled painters should be allowed to produce them, since clumsy images would move such simple souls 'to laughter or lasciviousness'.[52]

According to Armenini, such clumsy pictures are a source of spiritual danger precisely because, by virtue of their subject, they so greatly move the *affetti*. Accounts of martyrdom imagery routinely emphasize its moving qualities: the Jesuit Louis Richeôme, describing a now vanished scene of the butchery of Jesuit missionaries in the Sant'Andrea complex, fully expects his readers to be moved to tears.[53] Gregory XIII, on viewing the Santo Stefano cycle, 'was continually much moved by this work, and was left very content by it'.[54] Sixtus V, after viewing the paintings minutely, was observed to weep tenderly and dry his eyes several times. On his return, he passed through the Campidoglio 'to see that beautiful source' from a distance.[55] A sense of uplift is as integral a part of these accounts as the initial, lachrymose response. Richeôme, in a section entitled 'La morte, cause de l'allegresse', emphasizes this point most strongly. He exhorts his imagined beholders to be

joyous, and to gaze no more 'with tearful eye' at the floating corpses of the missionaries (killed at sea), but to imagine their bodies' descent into the depths as a metaphor for their souls' ascent into heaven.[56]

Gallonio's work is no exception to this rule and it would be a mistake to see the didacticism of its illustrations as a cold one. He himself suggests that his images may be a source of 'great devotion and satisfaction' to whoever sees them. Crescenzi, in the preface to the edition of 1594, goes further: 'And surely whom does it not delight? Whom does it not excite to piety?' he writes, before commencing a page-long list of tortures.[57] His meditation on the martyrs' miraculous ability to overcome suffering leads him to an altogether more florid conclusion; the joy he enjoins in the reader is a mirroring of that with which he invests the martyrs, who absorb the blows against them and are filled with an inner sweetness, so that they 'rejoiced in torments, were joyful in suffering, exulted in torture and invited their punishments on themselves, as these were not torments to them, but pleasures, not tortures, but delights, not punishment, but sweetness they are seen to feel'.[58]

Crescenzi repeats, in emotive, empathic terms, that same warding-off of the abject that Paleotti had earlier articulated in more rationalistic fashion. But whereas Paleotti presupposes that his subject matter makes utility and delectation mutually exclusive, for Crescenzi the one is enfolded in the other. They employ different techniques to evoke the intensity of the martyrs' physical torment: while Paleotti largely ignores the martyrs themselves and diverts his attention to the instruments, Crescenzi focuses with considerable intensity on their mental state. He does not look away from their pain, but insists, rather, that it is transformed into joy: the martyrs' heroic willingness to undergo suffering is still the basis of their sanctity and their privileged status as objects of pious emulation. Holy status is manifested by outward signs of joy: the antithesis of the pain they voluntarily undergo. This, too, is a component of their sacred status, since it demonstrates the truth of the cause for which they (do not) suffer.

The meanings that representations of martyrdom held in Rome in the 1590s cannot be said to reside in these images of bodies alone. A range of practices, audiences and institutions modulated their meanings. At least three of these — missionary activity, church history and devotional reading (sometimes allied with catechizing) — could be, and were, applied to images of this sort. However, unlike, say, Circignani's

Santo Stefano Rotondo fresco cycle, which by its nature as an object was firmly attached to a particular audience and set of practices, Tempesta's illustrations for Gallonio were relatively mobile.

One reflection of this mobility is that, while being very informative in one respect — the mechanics of martyrdom —, other kinds of signification — identity, narrative action, historicity, and even gender — are suppressed or, like the historical setting, generalized to the point of vagueness. The violence, but also the sweetly melancholic tenor, of the responses they were regularly said to provoke also accord with this, since they are shown as the most universal element of their appeal, affecting popes and cardinals as much as missionaries or, indeed, as Crescenzi claims, any reader at all.

Images, and texts that refer to images, seem to have accommodated this leap from compassion to delight, dolefulness to triumphalism, more comfortably than purely verbal articulations. While Paleotti stresses, soberly, the salutary effects of seeing the instruments displayed, Crescenzi's highly charged rhetoric identifies the viewer's transported response with that of the martyrs themselves and with what 'they are seen to feel'. While Gallonio's text concentrates on the instruments to the exclusion of all else, Tempesta's engravings invariably have the body of the martyr as their focus. Similarly, invariably, it is the kind of idealized nude that was, in the Renaissance tradition, the primary vehicle of the *affetti* and the prompter of the viewer's emotive response to the image. Despite the absence of gesture, these conventionalized, idealized figures do convey unmistakable affective qualities: unscarred, blissfully embodied and untouchable in the midst of violence, they enact and communicate, through their unshakeable and indifferent faith, the transmutation of pain into joy.

Notes

1. 'Sospesi, tirati, torchiati, battuti, fustigati, crocifissi, grattati, scorticati, ulcerati, trapassati, mutilati, sconciati, smembrati, scannati, sventrati, scotennati, sboglientati in olle e lebeti, fritti in teglie e sartagini, abbrustiati sulla nuda brace e in gratella, schidionati, e arrostiti a fuoco vivo … 'Cosa gliene pare?' Dominici alzò gli occhi. Non tanto però da incontrare quelli di monsignor Berlinghieri, ritto davanti a lui: 'Molto bello', mormorò.'
2. A. Gallonio, *Trattato de gli instrumenti di martirio, e delle varie maniere di martiriorare usate da' gentili contro cristiani, descritte et intagliate in rame: opera di Antonio Gallonio romano sacerdote dell congregatione dell'oratorio* (Rome, 1591).
3. Guerra's career and his relations with the Roman Oratory are considered in S. Pierguidi, 'Riflessioni e novità su Giovanni Guerra', *Studi Romani* 48 (2000), 297–321. For Tempesta, see M. Bury, 'Antonio Tempesta as printmaker: invention, drawing and technique', in S. Currie (ed.), *Drawing 1400–1600: Invention and Innovation* (Aldershot, 1998), 189–205.
4. For an example of the latter, see D. Freedberg, 'The representation of martyrdoms during the early Counter-Reformation in Antwerp', *The Burlington Magazine* 118 (1976), 138.
5. G.A. Bailey, *Between Renaissance and Baroque: Jesuit Art in Rome, 1565–1610* (Toronto, 2003), 107–52. L.H. Monssen, 'The martyrdom cycle in Santo Stefano Rotondo', *Acta ad Archaeologium et Artium Historiam Pertinentia* (series altera) 2 (1982), 175–317; 3 (1983), 11–106, in this last esp. p. 19 for the evidence regarding the chronology and the collaboration of Matteo da Siena. Tempesta executed a related commission in the same church, see L.H. Monssen, 'Antonio Tempesta in Santo Stefano Rotondo', *Bollettino d'Arte* 57 (1982), 107–20; A. Vannugli, 'Gli affreschi di Antonio Tempesta a S. Stefano Rotondo e l'emblematica nella cultura del martirio presso la Compagnia di Gesù', *Storia dell'Arte* 48 (1983), 101–16.
6. The reproductions of the frescoes in Santo Stefano were the first to be issued: G.B. Cavalieri, *Ecclesiae militantis triumphi* (Rome, 1583). This was followed by G.B. Cavalieri, *Ecclesiae Anglicanae trophaea* (Rome, 1584) and G.B. Cavalieri, *Beati Apollinaris martyris primi Ravennatum episcopus res gestae* (Rome, 1586).
7. Bailey, *Between Renaissance and Baroque* (above, n. 5), 61–8, 153–86. F. Haskell, *Patrons and Painters: Art and Society in Baroque Italy* (New Haven/London, 1980), 66–8; L. Huetter and V. Golzio, *San Vitale* (Rome, 1938), 33, 45–63.
8. L. Korrick, 'On the meaning of style: Nicolò Circignani in Counter-Reformation Rome', *Word and Image* 15.2 (1999), 170–88, esp. pp. 170–1, nn. 10–11. Bailey, *Between Renaissance and Baroque* (above, n. 5).
9. É. Mâle, *L'art religieux après le Concile de Trente. Étude sur l'iconographie de la fin du XVIᵉ siècle, du XVIIᵉ siècle, du XVIIIᵉ siècle* (Paris, 1932), 109–16.
10. Williams in this volume, Chapter Fifteen.

11. R. Wittkower, *Art and Architecture in Italy 1600–1750* I (revised edition; eds J. Connors and J. Montagu) (New Haven/London, 1999), 4.

12. 'Il Cardinal Paleotti andò a dir messa à S Stefano, et doppo la Messa andò vedendo le pitture, et li piacquero molto', M. Lauretano, 'Diario', ms, Hist. 103, p. 57 in the Archivio del Collegio Germanico-Ungarico, Rome.

13. All references are to the modern edition, G. Paleotti, 'Discorso intorno alle imagini sacre e profane, diviso in cinque libri', in P. Barocchi (ed.), *Trattati d'arte del Cinquecento fra Manierismo a Controriforma* II (Bari, 1961), 117–509. Accounts of Paleotti's life and the complicated history of the *Discorso* are to be found in P. Prodi, *Il Cardinale Gabriele Paleotti (1522–1597)* (Rome, 1959); P. Prodi, *Ricerca sulla teorica delle arti figurative nella Riforma Cattolica* (Bologna, 1984).

14. 'Delle pitture fiere et orrende.'

15. Paleotti, 'Discorso' (above, n. 13), 416.

16. 'Imperò che, quanto al primo, noi veggiamo giornalmente figurarsi i cruciati atrocissimi de'santi e minutamente esprimirsi e le ruote e i rasoi e le cataste ferrate e le capanne di fuoco e le graticole e gli eculei e le croci et infinite altre sorti de crudelissimi tormenti; i quali ha approvato la Chiesa catolica che si rappresentano agli occhi del popolo cristiano come insegne eroiche della pazienza, della maganimità de'santi martiri e trofei della invitta fede e gloria loro, volendo la zelante madre nostra che di questi esempii piglino cuore i suoi figli et imparino a sprezzare la vita, se così accada, per servigio divino, et a stabilirsi nella costanza in tutti gli accidenti di questo mondo, e perché anco, considerandosi quanto incomparabilmente sono stati maggiori i dolori e l'afflizioni dei martiri, che quegli che noi sentiamo nelle infirmità e miserie di questa vita, impariamo di soportare e sprezzare virilmente ciò che ci suole perturbare, crescendoci la fiducia in Dio e desiderio della gloria sua', Paleotti, 'Discorso' (above, n. 13), 417.

17. Paleotti, 'Discorso' (above, n. 13), 418.

18. 'Les supplices les plus hideaux y sont représentés avec un férocité tranquille', Mâle, *L'art religieux* (above, n. 9), 112.

19. K. Noreen, '*Ecclesiae militantis triumphi*: Jesuit iconography and the Counter-Reformation', *The Sixteenth Century Journal* 29 (1998), 687–715, esp. pp. 692–3.

20. A. Gallonio, *De SS. Martyrum Cruciatibus / Antonii Gallonii rom: congregationis oratorii presbyteri / liber / quo potissimum instrumenta, & modi, quibus idem CHRISTI martyres olim torquebantur, accuratissime tabellis expressa describuntur* (Rome, 1594).

21. Gallonio, *De SS. Martyrum Cruciatibus* (above, n. 20), 76–94.

22. Gallonio, *De SS. Martyrum Cruciatibus* (above, n. 20), n.p.

23. For Olimpia Cesi, see n. 42 below.

24. The authorship of its illustrations is addressed by M. Pupillo, 'Trofeo con strumenti di martiro', in *La regola e la fama: San Filippo Neri e l'arte* (exhibition catalogue (Museo Nazionale del Palazzo Venezia, Rome), Milan, 1995), 513.

25. For Neri and the Oratory's influence on the arts see *La regola e la fama* (above, n. 24); A. Zuccari, 'La politica culturale

26. dell'Oratorio romano nella seconda metà del Cinquecento', *Storia dell'Arte* 41 (1981), 77–112.

26. As a patron on the arts, Baronio is examined in R. de Maio (ed.), *Baronio e l'arte* (Sora, 1985); A. Herz, 'Cardinal Cesare Baronio's restoration of SS. Nereo ed Achilleo and S. Cesareo de'Appia', *Art Bulletin* 70 (1988), 590–602; A. Zuccari, 'La politica culturale dell'Oratorio romano nelle imprese artistiche promose da C. Baronio', *Storia dell'Arte* 42 (1981), 171–93. See especially A. Zuccari, *Arte e committenza nella Roma di Caravaggio* (Turin, 1984).

27. S. Ditchfield, 'Leggere e vedere Roma come icone culturale (1500–1800 circa)', in L. Fiorani and A. Prosperi (eds), *Roma, la città del papa* (Turin, 2000), 30–72, esp. pp. 33–7, 56–63.

28. Herz, 'Cardinal Cesare' (above, n. 26); Zuccari, 'La politica culturale' (above, n. 26).

29. See Zuccari, 'La politica culturale' (above, n. 26), 174–5.

30. S. Ditchfield, *Liturgy, Sanctity and History in Tridentine Italy: Pietro Maria Campi and the Preservation of the Particular* (Cambridge, 1995), esp. pp. 51–2.

31. 'Tum etiam plurimarum dictionum sane obscuram notionem & vim declaravi: earum praesertim, quae ea instrumenta & machinas designant, quibus teterrimi fidei opugnatores fortissimos martyres miris modis cruciarunt, divexaruntque; in quorum instrumentorum, aliarumque nonnullarum rerum explicatione aliqui interdum a veritate fortasse aberrarunt; homines enim sumus omnes', from the foreword to the 1589 Plantin edition, *Martyrologium romanum, ad novam kalendarii rationem, et ecclesiasticae historiae veritatem restitutum. Accesserunt notationes atque Tractatio de martyrologio Romano auctore C. Baronio. Secunda editio ab ipso auctore. aucta.* (Antwerp, 1589), n.p.

32. S. Ditchfield, 'An early Christian school of sanctity in Tridentine Rome', in S. Ditchfield (ed.), *Christianity and Community in the West: Essays for John Bossy* (Aldershot, 2001), 183–205, esp. p. 199.

33. G. Ricci, *Breve notizia d'alcuni compagni di S. Filippo Neri* (Brescia, 1707), 99–100.

34. For Gallonio's life and a bibliography of both primary and secondary literature, see S. Ditchfield, 'Antonio Gallonio', in *Dizionario biografico degli Italiani* 51 (Rome, 1998), 729–31.

35. Gallonio wrote the first biography of Neri; it contained detailed information on the post-mortem condition of the body, intended to promote the cause of his canonization. See A. Gallonio, *La vita di San Filippo Neri pubblicata per la prima volta nel 1601* (ed. M.T. Bonadonna Russo) (Rome, 1995), 308, 310–12, and Santing, Chapter Sixteen of this volume, nn. 26, 30, 31, 37, 46.

36. Gallonio, *Trattato* (above, n. 2), 34–9.

37. Crescenzi, after complaining of the difficulty of understanding the Acts of the martyrs, singles out the illustrations for praise: 'itaque discussa tandem aliquando omni prorsus caligine, summa ANTONII GALLONII opera & industria sunt in pristinum candorem splendoremq. restituta, singulaq. tabellis accuratissime delineata, ut quam tormenti speciem lectio

peperisset, quasi præsentem oculis pictura proponat: solet enim non parum ad legentis delectationem confirmandam, augentdamq. conferre, si id ipsum, quod rude adhuc & informe ex sola verborum adumbratione conceperis, habeas ubi sine ulla mentis hæsitatione certum possis intueri', Gallonio, *De SS. Martyrum Cruciatibus* (above, n. 20), n.p.

38. According to Aringhi, the book is useful 'per ridursi in chiaro molte difficoltà che si rappresentano nel leggere gl'atti di martiri', P. Aringhi, *Le vite e detti de' padri, e fratelli della Congregazione dell' Oratorio* (Biblioteca Valicelliana, ms O 58, 361v). The description is transcribed almost word for word from that of an earlier *vita* by Antonio Zazzara, bound in the same codex (372v), which is now partly illegible.

39. The *Trattato*'s links with A. Gallonio, *Historia delle sante vergini romane con varie annotatione e con alcune vite brevi de' santi parenti loro* (Rome, 1593), have not been emphasized sufficiently. The date on the title-page is 1591, but see n. 42 below.

40. 'Mi sono sforzato metter insieme tutte le vergini romane, particolarmente raccolte da manoscritte antichi nostri e di altri; nel fine di ciascheduna historia ho assegnato il tempo della loro morte, gli autori gravi che ne scrivono o ne fanno mentione; di poi, levate via alcune difficoltà pertinenti alla verità dell'historia, inoltre nominati i parenti o altri di quella famiglia santi, e riferiti succintamente gli atti loro, finalmente poste nella seconda parte molte historie di vergini forastiere col medesimo ordine, et un trattato nel principio diviso in quindici capitoli de gli instrumenti e modi di martirizzare usati da gli antichi contra i christiani con le loro figure in rame, che saranno quaranta di numero per lo meno, et al presente ne ho in ordine ventitré, le quali danno, per la gratia del Signore, grandissima divozione e soddisfatione ad ognuno che la vede ...', A. Cistellini, *San Filippo Neri: l'Oratorio e la congregazione Oratoriana* I (Brescia, 1989), 731, n. 17.

41. The letter, from Francesco Maria Tarugi in Naples to the Congregation in Rome, expresses the hope that 'il Signore benedica a lui et al P. Gallonio e loro fatiche', Archivio di Santa Maria in Vallicella, Codex B. III 3 1591–2, 217v.

42. It is clear, from Gallonio's prefatory remarks to the *Historia*, how closely he saw them as being associated when he says that it was 'completed by me together with the treatise on the instruments of martyrdom'. 'La Historia delle Sante Vergini Romane ... essendo stata da me recata a fine insieme col trattato de gli instrumenti di martoriare usate specialmente da' Gentili ne' secoli passati contra i Christiani ...', Gallonio, *Historia delle sante vergini romane* (above, n. 39), n.p. The two books also share dedications to Olimpia Orsini Cesi, whose life and activities as a patron are discussed in C. Valone, 'Mothers and sons: two paintings for S. Bonaventura', *Renaissance Quarterly* 53.1 (2000), 108–32, and by E.S. van Kessel, 'Gender and spirit, *pietas at contemptus mundi*: matron-patrons in early modern Rome', in E.S. van Kessel (ed.), *Women and Men in Spiritual Culture: XIV–XVII Centuries. A Meeting of South and North* (The Hague, 1986), 47–68. This impression is reinforced by their common

appearance and format — they share the same typesetting, publisher and engraver — and by the fact that both bear the same date on the title page, even though it is more likely that they were published some time apart.

43. Gallonio, *Historia delle sante vergini romane* (above, n. 39), 342, 350.

44. A. Gallonio, *Historia della divotissima a spiritualissima vergine di Giesu Christo, Helena nobilissima romana di casa Massimi* (Rome, 1857). The subsequent history of her sisters is recounted in the introduction to the 1857 edition by D. Rebaudengo. The publication of the *Historia delle sante vergini romane* must post-date her death in 1593. This redating of the *Historia* is proposed by Ditchfield, 'An early Christian school of sanctity' (above, n. 32), 193, n. 35.

45. Gallonio, *Historia delle sante vergini romane* (above, n. 39), 145–54.

46. Gallonio, *Historia delle sante vergini romane* (above, n. 39), 51–3.

47. Van Kessel, 'Gender and spirit' (above, n. 42), 58.

48. Ditchfield, 'An early Christian school of sanctity' (above, n. 32), 201.

49. Gallonio, *Historia della divotissima* (above, n. 44), 5.

50. For a discussion of its critical history, see Korrick, 'On the meaning of style' (above n. 8).

51. S. Antoniano, *Dell'educazione cristiana e politica dei figlioli* (Rome, 1584), 397.

52. 'Vite di quelle sante verginelle, dalle quali esse tenessero esempi per i loro martirii' were one of the few subjects suitable for female religious, but that 'perché con più forza se gli movessero gli affetti, non le vorrei dipinte se non per mano di valentissimi pittori ... E certo che quelle pitture, le quali son fatte da' goffi, muovono alle volte la simplicità di quelle a riso et a lascivia, dove che le vivaci si torvano che le penetrano fino al vivo del cuore', G.B. Armenini, *De' veri precetti della pittura* (Ravenna, 1568), 196.

53. 'Et partant, mes bien-aimez, encor que vos yeuz ne puissent tenir le larmes iettans leur regard sur les figures de ce tableau, representeresses du piteux spectacle des vos tre-cheres freres occis, vous deves neantmoin estre joyeux, par la consideration de leur pelerinage, si heureusement terminé ...sacchans que leur tormens, & leur mort, one esté une voye, & une port glorieuse à la vie, & repos eternel. Resiouissez-vous donc, & au lieu de lamenter, chantez le TE DEUM ... Ne vous attristez plus de leur mort, par laquelle ils font entrez en la possession de la vraye vie; Et ne regardez plus la larme à l'oeil, leurs corps ensanglantez flottans sur le bransle des ondes: laissez les avaller d'une douce descente dans le profond des eaux, & y prendre leur dernier hebergement au sepulchre de paix, comme les ames ont ia prins possession sur les eaux immortelles du ciel', in L. Richeôme, *La peinture spirituelle ou l'art d'admirer aimer et louer Dieu en toutes Ses oeuvres* (Lyon, 1611), 209–11. See Bailey, *Between Renaissance and Baroque* (above, n. 5), 48–52, 61–8.

54. 'Si mostra di continuo molto affessionato à quest'opera, et ne resta molto contento', Lauretano, 'Diario' (above, n. 12), 49.

55. 'Domenica nostro Signore passò dalla sua vigna a messa nella chiesa di Santo Stefano Rotondo, notando poi e osservando minutamente le figure di diversi martiri depinte d'ogni intorno nella maniera con la quale sono stati martirizzati et fu vista Sua Beatitudine nel mirare quei spettacoli lacrimare un pezzo di tenerezza et più volte asciugarsi gli occhi et nel ritorno Sua Santità passò da Campidoglio per vedere quel vago fonte', Biblioteca Apostolica Vaticane, Urb. Lat. 1057, fol. 390, cited in J. Orbaan, 'La Roma di Sisto V negli avvisi', *Archivio della Reale Società Romana di Storia Patria* 33 (Rome, 1910), 309–10.

56. See n. 53, above.

57. 'Et sane quem non delectet? quem non excitet ad pietatem?', Gallonio, *De SS. Martyrum Cruciatibus* (above, n. 20), n.p.

58. 'Haec una tormentorum vim leniebat, acerbitatem absorbebat, sopiebat crudelitatem: hac denique sola repleti interiore dulcedine martyres gaudebant in tormentis, laetabantur in suppliciis, exultabant in cruciatibus, in ipsis gestibant poenis; ut non tormenta sibi, sed delicias, non cruciatus, sed voluptates, non poenam, sed suavitatem sentire viderentur', Gallonio, *De SS. Martyrum Cruciatibus* (above, n. 20), n.p.

Ancient bodies and contested identities in the English College martyrdom cycle, Rome

Richard L. Williams

The torture and cruel execution of the early Christians in ancient Rome had been an enduring source of fascination, and in the sixteenth century it was a subject of renewed relevance. Interest in the ancient martyrs was not only stimulated by the spirit of the Renaissance, as part of the humanist historical enquiry into the classical world, but also by the divisive spirit of the Reformation and the polemical designs of religious controversialists. The fate suffered by followers of Christ under the Romans symbolized the pure ideal of Christian martyrdom to which Catholics and Protestants both claimed to be the spiritual heir. Thus, representation of the tortured bodies of Roman martyrs became an important point of religious controversy across Europe during the second half of the sixteenth century, as these representations functioned within a range of symbolic systems in the construction of religious and national identity.

Many English Catholics likened their treatment at the hands of the Protestant government of Elizabeth I to the Roman persecution. A graphic expression of this was made in a series of frescoes commissioned in 1583 for the chapel of the English College in Rome. Images of the bodies of contemporary English priests being ripped apart by executioners were displayed alongside those of ancient martyrs. Such representations of the body formed a key site for the inscription of identity and, in a cycle beginning with the heroic Roman bodies of the early Church, the semi-naked bodies of recent English Catholic martyrs operated within a system of representation that helped Elizabethan Catholics establish an individual and collective identity. In attempting to redefine their Catholic identity, it will be argued that those living in exile in Rome also felt an urgent need to assert a sense of national identity.[1]

The English College in Rome had formerly acted as a hospice until it was refounded by the pope as a seminary college in 1579.[2] It sought to follow the success of another English seminary founded in Douai in 1568 by William (later Cardinal) Allen. The purpose of these colleges was to train the next generation of English priests and prepare them for the dangerous mission of stealing into Protestant England to conduct clandestine masses and other pastoral duties for those who remained faithful to the Catholic Church.[3]

The position of Catholics in England had deteriorated steadily since Elizabeth I came to the throne in 1558. After initial hopes of religious toleration, frustration turned to open revolt by many Catholics in the Northern Rebellion of 1569. In an attempt to show support for the uprising, Pius V issued a bull of excommunication against Elizabeth that absolved her subjects from their natural bonds of loyalty, leaving them free to wage violent revolt. The bull had been issued in 1570, but by the time news of it reached England the rebellion had already been crushed. The whole episode had only managed to cause greater, irreparable damage to the Catholic cause, since now it was widely perceived that loyalty to the Catholic Church was incompatible with loyalty to queen and country. Anti-Catholic prejudices seemed only confirmed by news of treasonous Catholic plots, the clandestine arrival of seminary and Jesuit priests, and fears of invasion by foreign Catholic forces. Political pressures and paranoia resulted in the English government enacting ever-harsher measures against Catholics.[4]

This was the context in which the Catholic Mission to England was launched, first by seminary priests in the 1570s and then by Jesuits from 1580. The beginnings of this Mission were nothing short of disastrous. Although their numbers were small, the priests were relentlessly hunted down by the Elizabethan state, and many were captured and executed as common traitors by hanging, drawing and quartering. Their fate began to be recorded almost immediately in English Catholic manuscripts,

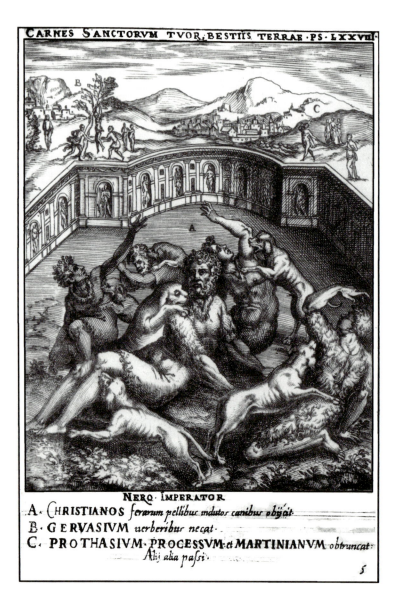

CARNES SANCTORVM TVOR. BESTIS TERRAE · PS · LXXVII·

NERO · IMPERATOR
A · CHRISTIANOS *ferarum pellibuc indutos canibur obijcit*
B · GERVASIVM *uerberibur necat* ·
C · PROTHASIVM · PROCESSVM *et* MARTINIANVM *obtruncat:*
Alij alia pafsi ·

5

FIG. 15.3. The persecution of the early Christians instigated by the Emperor Nero, engraving by G.B. Cavalieri (after a lost fresco by N. Circignani), in *Ecclesiae militantis triumphi* (Rome, 1583). *Photo: British Library, London, 551.e.36. Reproduced by permission of the British Library.*

as the Revolt of the Earls, and it is presumably one of those earls, the Earl of Northumberland, who is about to be beheaded at the left of the scene.

The inclusion of this scene in Circignani's cycle was clearly an attempt to incorporate those executed for their part in the Northern Rebellion into the tradition of Christian martyrs originating with the early Church. A similar attempt to suggest this continuity and legitimacy was reported by an English Protestant who managed to infiltrate the English College in Rome. The spy in question, Anthony Munday, wrote that during dinner

the assembled college community listened to one of their number read from the Bible:

> And then in their Martirilogium he readeth the martyrdom of some of the saints as St Francis, St Martin, St Langinus, that thrust the spear into Christ's side, St Agatha, St Barbara, St Cecilia, and divers other, among whom they have imprinted the martyrdom of Dr Story, the two Nortons, John Felton and others, calling them by the name of Saints who were executed at Tyburn.[19]

This charge was explicitly denied by the senior member of the English Catholic hierarchy, William Allen, who commented:

> As of the Martyrologue which Munday faineth to be put in print in the colledg of Rome, wherin the Martyrdoms of al late traitors very largely are written, as of Felton of Madder, of the Nortons and such other: it is knowen to be a flat lye, noe such being there at al.[20]

Yet, in spite of Allen's denials, a strong body of opinion that Felton, Dr Story and others were religious martyrs had indeed arisen among English Catholics in the aftermath of the failed rebellion. In his greatly influential polemical works, Nicholas Sander declared that those executed for their part in the Northern Revolt were martyrs, and even described the rebellion itself as a miracle.[21] The equally influential polemicist, Richard Bristow, expressed comparable views in his book known as the *Motives* (Antwerp, 1574). In that book Bristow listed the following as true martyrs: Sir Thomas More, Bishop John Fisher, the Carthusian monks and 'the good Earl of Northumberland, Dr Storey, Felton, the Nortons, Mr Woodhouse, Mr Plumbtree and so many hundreds of the Northern men'.[22] The painted scheme at the English College chapel reflected the propagandist message of these books.

The contemporary martyrs of the English Mission from 1580 to 1583 were similarly honoured by the inclusion of five scenes in the fresco cycle depicting their fate. English priests were shown tortured in prison, stretched on the rack, dragged on hurdles to the place of execution, and finally hanged, drawn and quartered (Fig. 15.1). The Jesuit priest, Edmund Campion, was one

of the best known of these newest martyrs. Those Elizabethan priests who had been executed up until the time the frescoes were painted were positioned as the culmination of a sequence of tortured bodies that connected them with the martyrs of the early Church.

In this respect the English College frescoes can be seen as part of a wider system of representation of recent events that attempted to find meaning, to make sense of the disastrous experience of Catholics in England. Not only had so many priests been rounded up and dispatched, but the ordinary Catholic laity suffered the stigma, the social and political exclusion of a mistrusted minority. It is a common thing for such a threatened and marginalized group to seek meaning in the present by looking to its past. The reclaiming of history to authenticate the political assertion of identity continues in the experience of both communities in contemporary Northern Ireland, for example.[23] Elizabethan Catholics looked to the heroic deeds of the traditional saints and martyrs of England to make sense of their plight. In so doing, their version of religious history set out in the cycle of frescoes was in direct conflict with that formulated by England's Protestants. In fact, Anne Dillon recently has made the important discovery that the traditional saints depicted in the frescoes constitute a direct response to the Protestant history of the faith in England printed by John Bale. Many of Bale's arguments and attacks are addressed and answered in the paintings. This controversy over the legitimacy of disputed martyrs, the 'pseudo-martyr' debate, forms the wider context in which the English College frescoes were created.[24]

Links between Catholics recently executed in England and the glorious tradition of martyrs reaching back to the ancient world were not only drawn out by the historical continuity in the cycle of paintings, for visual connections were also made. Parallels with traditional depictions of the Passion of Christ, including the dragging of the condemned to Tyburn recalling the way to Calvary, have been discussed elsewhere.[25] However, the very mode of representation of the body acted as a signifier that promoted further identification with ancient Roman martyrdom. For example, deliberate echoes of Circignani's scenes of early Christian martyrs in Santo Stefano Rotondo can be observed in the English College frescoes. In both, the figures are often naked or partially covered with drapery. The undraped body of one of Campion's fellow priests at Tyburn is laid out on a wooden bench in order to be hacked to pieces by one of executioners wielding a cleaver (Fig. 15.1). This makes a direct visual parallel

with the same detail as painted by Circignani to illustrate martyrdom during the persecution instigated by the Emperors Maximus and Lucian.[26] Even the cauldron in which the English executioner boils the limbs of the dead priests recalls those used by the Roman executioners at Santo Stefano Rotondo, including depiction of the martyrdom of Saint John the Apostle.[27] Both chapels were open to the public. Lay men and lay women could simply walk in off the street; indeed the pope issued an indulgence expressly to encourage the people of Rome to visit the English College chapel.[28] The painted schemes in both chapels would thus have been sufficiently well known for such comparisons to be made between them and, indeed, depictions of the Roman martyrs adorning other churches.

Representation of the body here served the important function of a site for the marking of difference, crucial to the construction of identity.[29] The English College frescoes fostered the identification felt by many Elizabethan Catholics with the ancient martyrs by depicting their oppressors in costumes evocative of ancient Roman soldiers. While the guards in the painting of Sir Thomas More's execution were shown in sixteenth-century dress, most of the Elizabethan executioners were dressed in quasi-Roman uniforms. The mixing of ancient with contemporary dress for polemical ends had been an important tradition in medieval art. For instance, images of Christ's crucifixion often had included soldiers at the foot of the cross wearing fifteenth- and sixteenth-century dress. The principal purpose of this rhetorical device was to bestow a contemporary relevance on the story, as an aid to affective meditation.[30] However, this tradition was effectively reversed in the English College frescoes, for here it was the depiction of contemporary events into which ancient costume had been introduced. The purpose of the medieval tradition was usually religious, sometimes satirical, whereas the significance at the English College was highly political.

The clear political implications of the frescoes were immediately recognized by the English government. An intelligence report survives in the Public Record Office, sent from Rome to Queen Elizabeth's chief minister, Lord Burghley, in 1593. Its author, John Arden, had successfully penetrated the English College. Arden describes how the English Catholics there

crye out of the persecution in Ingland. And most wickedly in every college of the Jesuyttes wher ys the

greattest resort of all the chief & others, they hang theyr tabiles in pictur worke of the wonderfull bloodye persecutions in Ingland daylie howe they be handled, & theise tabiles ar hanged with the persecution of Nero & those persecutors, to make our good Quens name mor odyous every waye, And them selves to be honoured.[31]

Similar attacks had been levelled at Lord Burghley personally by his English Catholic enemies, who accused him of persecuting innocent Catholics. For this he, too, had been called a Nero and a Diocletian.[32]

This, however, was not a new problem for the English government. Similar comparisons had been drawn earlier in the century between the Catholic martyrs of the reign of Henry VIII and the ancient Christian martyrs. Most notably the connection had been made by Maurice Chauncy, one of the few Carthusian monks to escape abroad from the Henrician persecution. His lengthy book, entitled *Historia aliquot saeculi martyrum Angolorum*, was published in 1550 at Louvain, and many subsequent editions were printed. Although the work was not illustrated, six engraved pictures were printed as a broadsheet in 1555 at Rome that dramatized the fate of the Carthusians, following the account in Chauncy's book. The unknown illustrator depicted London as a city of imposing classical architecture, and some of the soldiers and onlookers were dressed in a fashion reminiscent of the ancient world. This precedent possibly inspired the allusions to ancient Rome in the English College frescoes. It is clear that Circignani was intimately familiar with the engravings since he used them as a direct source for his own depiction of the fate of the Carthusians.[33]

In the broader context of sixteenth-century religious polemic, the depiction of enemies dressed in Roman costume became a weapon employed by both sides of the confessional divide. For example, in France during the 1560s prints and paintings of ancient Roman massacres were produced in large numbers. In particular, French Protestants commissioned images of the massacre at Rome in 41 BCE that had accompanied the foundation of the so-called Triumvirate of Octavius Caesar, Antony and Lepidus. The pictures served as a warning of the likely actions of the self-styled French Catholic Triumvirate, comprising the Duke of Guise, the Constable de Montmorency and Jacques d'Albon de Saint-André, established in 1561 as a bulwark against the Hugenots.[34] The English College fresco cycle, however, did more than suggest

historical precedent, — it mixed the ancient and the modern within the same picture.

Such a flagrant disregard for factual accuracy was at odds with the more usual approach taken in martyrology. Brad Gregory has argued convincingly that sixteenth-century written accounts of the executions of martyrs usually took great pains to be factually accurate. Any details that were mere invention would prove counter-productive, since these could be easily exposed by the opposition. Gregory found that, even in bitter exchanges over the legitimacy of a martyr, Catholic and Protestant writers were often in agreement to a remarkable extent as to the details of the event.[35] The controversy lay in the interpretation of these details. A similar care to be accurate can be observed in some of the frescoes at the English College in Rome. Circignani's use of the earlier engravings of the martyrdom of the Henrician Carthusians suggests an attempt to claim a higher degree of authenticity and authority for his painting. The same can be said for his depictions of the recent martyrdom of Elizabethan priests, which, as several scholars have noted, are indebted to an earlier series of six pictures of these events.[36] The six pictures had been printed together as a broadsheet at Rheims in 1582, and then adapted as separate illustrations in Robert Persons's book on the English persecution, printed at Rome in the same year. Persons, himself a survivor of the recent and fateful mission to England, was at pains to stress the historical accuracy of all that he reported in his martyrology. In following the illustrations printed in that work, Circignani might have been claiming a degree of authority for his images to strengthen their power as propaganda.

By representing Elizabethan oppressors in the uniforms of Roman soldiers, the English College frescoes seem to have followed a different strategy. Although this representation might have been an effective means of portraying the Protestant government as godless persecutors of the 'true religion', it undoubtedly furnished the Elizabethan regime with an easy opportunity to raise the counterclaim that English Catholic propaganda was nothing but tendentious lies. It is no coincidence that Lord Burghley wrote next to Arden's report concerning the frescoes, quoted above, the words 'falls pyctours'.[37]

Yet, there was one motif more than any other in Circignani's fresco cycle that the English Protestant authorities found most provocative. In the scene purporting to record the mistreatment and torture of contemporary Catholics in custody, an English official in quasi-Roman dress was shown forcing a Catholic victim into bear skins to be set upon by dogs (**Fig. 15.2**).

The sufferings of other Catholics in the same picture clearly followed the descriptions of such mistreatment that had been reported in harrowing detail in printed books and pamphlets. Victims endure the filthy squalor of prison, have needles driven under their fingernails, are beaten, have their ears burnt with hot irons, and have their bodies contorted into a circular posture by an iron frame known as the 'scavenger's daughter'.[38] However, the incident involving the bear skins and the dogs lacked this documentary authority. Rather it seems to have been inspired by the fresco Circignani had painted in Santo Stefano Rotondo in which an early Christian suffers the same fate in the Roman arena during the persecution instigated by the Emperor Nero (Fig. 15.3). Not only the soldier's uniform but also the architectural background lends a classical air that draws out further the analogy being made in Circignani's scene.[39]

It was this motif especially that caused outrage in Protestant England. It was invoked in 1586 at the trial of the Catholic conspirator, Anthony Babington, who had plotted to kill Queen Elizabeth and set the Catholic Mary Queen of Scots onto the throne. As a 'notable proof of the falsehood of these lying papists', Sir Christopher Hatton seems to have referred the court to the engravings made after the English College frescoes. Hatton cited 'a book printed in Rome and made by the papists, wherin they affirm that the English Catholics which suffer for religion be lapped in bear skins and bated to death with dogs; a monstrous lie and a manifest falsehood'.[40] The same image continued to cause anger in the reign of James I. In 1616, the king himself wrote that

the walles of divers Monasteries and Jesuites Colledges abroad, are filled with the painting of such lying Histories, … such are the innumerable sorts of torments and cruell deaths, that they record their Martyrs to have suffered here, some torne at foure Horses; some sowed in Beare skinnes, and then killed with Dogges …[41]

Another description of the college pictures was printed by Richard Carpenter in 1642, during the reign of Charles I. He noted that the painter had 'cunningly mingled old stories with these of late dayes; the more to deceive the beholder; and to passe them all under the same cause'. When he was shown elsewhere a print of Englishmen 'throwing Papists, being covered with beasts skins, to doggs' he judged that 'their invention hath some grounds in the Primitive Church'.[42] The English Catholics were evidently unrepentant, since the same motif continued to feature in illustrations of Protestant cruelty printed into their propaganda books.[43]

Images of the bodies of priests being racked or hanged, drawn and quartered, were not disputed. Protestants themselves produced pictures of Catholics executed, such as the famous print by Visscher of the fate of the Gunpowder Plotters.[44] This was the humiliating death of the common traitor, and so such images served the Elizabethan government's interests by emphasizing the fact that Catholic priests had been found guilty and were punished for treason, for political sedition and not for matters of faith. In his book, *The Execution of Justice in England*, Lord Burghley insisted that priests were tried under the due processes of the law and that punishments were those universally accepted as a necessary and long-established part of the criminal justice system. 'None', he insisted, 'do suffer death for matter of religion'.[45] The fresco of the Catholic set upon by dogs, further disseminated by the engraved copy, was thus a charge of tyranny against the English State: that it had abandoned the rule of law and descended into pagan barbarism.

Another reason for the degree of outrage provoked by Catholics comparing themselves to the early Christians was undoubtedly that Protestants instead saw themselves as the spiritual heirs to the primitive Church. The classic statement of this was John Foxe's *Actes and Monuments of These Latter and Perillous Dayes, Touching Matters of the Church*, popularly known as the *Book of Martyrs*.[46] First published in 1563 and reprinted in many later editions, this extremely influential book traced the history of the Church in England from ancient times to the present. Some editions included a large foldout woodcut print entitled 'A Table of the X. first Persecutions of the Primitive Church under the Heathen Tyrannes of Rome'.[47] It illustrates what are called 'the sundrye kindes of Torments devised against Christians', which include reeds being forced under fingernails, teeth being forcibly extracted and, at the centre, a Christian dressed in an animal skin being attacked by dogs. The English College fresco presented all of these torments as current practice in England (Figs 15.1–2). The later Protestant martyrs, most famously those condemned by Queen Elizabeth's predecessor, Mary Tudor, were set by Foxe within this historical continuum. The fresco cycle at the English College can be seen within the context of a Catholic reaction against Foxe's book. Yet whereas Foxe claimed to be scrupulously historical, each act of martyrdom being firmly documented or otherwise supported, the English College frescoes

deliberately blurred the distinctions between ancient history and recent executions.

Competing religious identities were thus bitterly contested between English Protestants and Catholics. Both had experienced the role of an oppressed minority. English Protestants were in a relatively exposed and vulnerable position in Europe, opposed as they were by hostile Catholic powers. Within England itself Protestants had only recently emerged from persecution during the reign of Mary Tudor. This was now the experience of Catholics in England. Not only did such marginalized groups typically seek to construct and assert their respective identities of origin, a nostalgic longing for reincorporation into what Benedict Anderson has called an 'imagined community' was a common response.[48] Whether yearning for a return to the values and purity of the primitive Church before the corruption of the popes, or a return to the unity of the Roman Catholic Church that saw itself as the only legitimate incarnation of that primitive Church, histories of former heroes, dramatic deeds and golden ages proved to be inspirational. History was such a powerful propaganda weapon for Catholics and Protestants alike because through their respective narratives each could demonstrate the operation of the will of God. Therefore, the recent execution of Jesuit priests in England could be understood not as symptomatic of the failure of the Mission but as yet another episode in the unfolding saga of God's purpose. God's intervention in history through his 'true' martyrs could be traced back directly to the early Church and even to the sacrifice of Christ himself.

The great importance the Elizabethan Catholic hierarchy attached to religious history in constructing religious identity, including the precedent of the early Church, is apparent from the instruction given to novices in the English seminary colleges established abroad. Writing in 1581, a key figure at the English College in Rheims, Gregory Martin, describes how it was customary for ecclesiastical history to be read out to the students at dinner-time, beginning with Eusebius, followed by several other authors including Bede's history of the conversion of England.[49] Eusebius's chronicle of the persecution and martyrdom of the early Christians contained accounts of victims stretched on the rack and also exposed to ravenous dogs — accounts that would have had clear resonance for Elizabethan Catholics.[50] Church history was also highly recommended to the students for private study, as Martin explains, 'namely of our own Countrie, and by our owne Countrie man Venerable Bede, there to

learne that the first faith planted in England, was the self same Catholike Romane faith, which we catholikes professe at this day'.[51] The legends of England's traditional saints could also be read in the *Golden Legend*, described as 'that little golden booke', which was another set text for the students. Most interestingly, Martin also relates that, 'there is now and then explicated to later comers, the Chronologie of all the old Testament, and other time the Chronologie of the Churche from Christ unto our dayes, in printed Tables made by some of the said Seminare'.[52] These 'printed tables' were a forerunner of the fresco cycle at the English College in Rome. Unfortunately, it is not reported whether these comprised anything other than text. However, only the following year, 1582, the Rheims College published the large broadsheet of printed pictures mentioned earlier, which recorded the martyrdom of Campion and his fellow missioners, and so similar imagery might have been included in these 'tables' of ecclesiastical history.

Catholic novices attending the English College in Rome would not only have been steeped in the history of Eusebius, but they had an even greater opportunity to identify with the illustrious martyrs of the early Church. The sites of ancient Roman martyrdom could be visited; so could the catacombs, including one only rediscovered by chance in 1578. The report of its discovery was thought so significant that it was printed illegally on a clandestine Catholic press back in England. Appended to the English translation of Gaspare Loarte's book, *The Exercise of a Christian Life* (1579), was a note entitled, *A most straunge and excellent monument, proving apparantly the Reverend antiquitie of our Catholike Religion, found at Rome, in July last past, in the yere of our Lorde, 1578 and is of al wise men beleeved to be the blessed virgin S Priscilla her Church-yarde.* The note described the wall-paintings and relics that had been found in the catacomb, from which it was concluded, 'By this most woorthie monument we may easily gather, howe great the persecutions and miseries, as also the pietie of those godly persons, were in the primitive Churche'.[53] The fact that the early Christians at Rome could only reverence their religious paintings in 'caves and secret corners' struck a cord with Catholics back in England, where churches had been stripped of their religious images and traditional forms of devotional art were illegal. Relics of these ancient martyrs' bodies were taken as a full vindication of the Catholic Church's current struggle. The bones and the wall-paintings in the catacomb were declared to be 'to the singuler confirmation of our undoubted and Catholike Religion'.[54]

Like the catacombs, the English College chapel in Rome served as a refuge for true believers against the barbarous and idolatrous persecutors in their native land. It even had its own relics. The evidence for this is a letter written in 1582 by William Allen, the head of the college in Rheims, addressed to George Gilbert at the college in Rome. In the letter Allen remarked, 'I send you here inclosed a little peece of Father Campion's holy ribbe. Take halfe for yourself and give thother halfe to Father Rector'.[55] This confirms that the recent Elizabethan Jesuit martyrs were considered worthy to be honoured alongside the traditional martyrs of England and the ancient world.

The college chapel might also have been evocative of the catacombs in having paintings of saints and martyrs on its walls. Some art historians have even suggested that the distinctive style of Niccolò Circignani's frescoes was intended to resemble the ancient paintings in the catacombs.[56] The awe in which the priests and novices held the catacombs is described vividly by Anthony Munday, who recounts how they visited a particular area where miracles had occurred recently.[57] These, together with the holy sites of martyrdom, clearly played a part in inspiring the commission for the English College frescoes. George Gilbert, a wealthy young English gentleman, is credited with raising the funds to paint the frescoes. According to the Annual Letters of the English Mission for the year 1583, Gilbert displayed a 'singular affection towards all who had died for the Catholike religion', so that he 'frequently made, in consequence, visits to the basilicas of the martyrs, and venerated the places where traces of their precious blood were still to be found'. The letter continued, 'for the same reason, he at his own expense beautifully decorated the College chapel with the pictures of those who, from the very first conversion of England to this present day, had given their lives for the faith'.[58]

The frescoes were, therefore, part of the wider enterprise to help the students to position themselves through identification with their illustrious predecessors. One of George Gilbert's hopes for the paintings, according to the rector of the college, was that 'the students of the College, beholding the example of their predecessors, might stimulate themselves to follow it'.[59] He personally encouraged the novices to this end. For example, the rector described how

He would have the students meditate first upon the life of Christ and the life of His Holy Mother; and secondly, upon the blessings of martyrdom, thirdly, in

their meditation he would have them exercise themselves in passing through the heavenly choirs and addressing now one saint and now another ... He remarked that this seemed to him an excellent method for animating ourselves to embrace their virtues, and to desire every kind of suffering for the love of God.[60]

That the visual stimulation of the chapel paintings of the saints was part of this method seems likely, given Gilbert's 'reverence which he showed towards their pictures'. One of the most common techniques of memorization, dating from the ancient world but still common in the early modern period, was to visualize items to be remembered within the corners of an imaginary room.[61] It thus seems likely that in 'addressing now one saint and now another' the novices, in their private meditation, were visualizing the sequence of martyr saints painted onto their college chapel walls.[62]

The great emphasis given to the broken and tortured bodies of the exalted figures in the fresco cycle seems calculated to help foster that desire for 'every kind of suffering for the love of God'. The visible marks of suffering on the body stood out as signifiers as to what constituted the true believer. The Elizabethan Catholic author Thomas Hide quoted from the Book of Timothy: 'all that will live godly in Christ, shall suffer persecutions'.[63] Christ's own martyrdom was the most authoritative example that the suffering body was not necessarily indicative of God's wrath but could be a sign of divine vindication. Through bodily torments the faithful could achieve an ultimate form of imitatio Christi.[64]

It comes as no surprise, therefore, that self-flagellation became eagerly adopted among the novices. During his stay in Rome from 1576 to 1578, Gregory Martin remarked that 'the mervelous sight of al, is to see the Flagellanti'. One day he observed a preacher bring 'a litle bagge ful of whipcord' and distribute them for every man 'to use afterward in his chamber'.[65] Only a few years afterwards, Anthony Munday witnessed members of the English College in Rome flagellating themselves with wire whips. He wrote, 'And this they will do in their chambers, wither before the crucifix or the image of Our Lady, turning their backs when they bleed towards the image, that it may see them'.[66]

Behaviour such as this, backed by the scenes of violence in the frescoes, could help to fortify the novices against the possible fate that awaited them on their return to England. One of the college rector's recollections of Gilbert was that, 'with the students,

whom he looked upon as sheep destined for the slaughter, he frequently conversed about martyrdom, putting before them the example of Christ their leader, of the blessed martyrs Campion, Sherwin, Briant, and of other brave companions'.[67] The paintings in the chapel served the same ends. The crucified Christ on the altarpiece and the fresco recording the executions of the Jesuits Campion, Sherwin and Briant would have continued to stir the novices long after Gilbert's death.

Furthermore, the inscriptions beneath the paintings on the walls charged the images with a chilling immediacy by stressing that the tortures depicted had been inflicted upon the novices' contemporaries in the previous three years. The names of students from the English College in Rome are listed among the victims. One of the inscriptions concluded by declaring that many more condemned Catholics across England were currently waiting, hour by hour, for the time of their own horrible execution. The persecution was ongoing; the painted scenes of martyrdom were a present reality and a future prospect. On learning of the martyrdom of a former student of the college the custom arose that the priests and novices would assemble in the chapel to sing a *Te Deum* before the altarpiece, where they would have been surrounded by Circignani's paintings.[68]

The frescoes and other images or texts of martyrdom seem to have played a role in conditioning the responses of novices to the potentially fatal consequences of their future ministry. In 1582, William Allen told the rector of the English College in Rome that the recent executions of Campion and others actually had increased the determination of those priests poised to cross over into England.[69] At its most extreme, this heightened religious enthusiasm could result in a thirst for martyrdom. The spirit of the Counter-Reformation lauded the glory of martyrdom, but often the accompanying virtue of humility was not a sufficient restraint.[70]

George Gilbert is a celebrated example of this. His preoccupation with England's newest martyrs was understandable, given his involvement with the English Mission. Back in England he had given financial help to the missioners, assisted in establishing a secret printing press, and even founded a Catholic Association there. His activities set the English authorities on his trail and so, had Persons not sent him over to France, Gilbert undoubtedly would have suffered the same fate as Campion, Briant and Sherwin.[71] Yet Gilbert evidently felt deprived by this departure, for the rector of the College in Rome made frequent references

to Gilbert's sore declarations of regret at being denied the martyr's crown. Apparently, Gilbert was more than willing to embrace death, but only 'after having been stretched many times on the rack, and then torne and ripped up by cruel executioners for the sake of Christ'. When Gilbert was struck with fever while at the English College in Rome, it became unbearably clear to him that his dreams of returning to England to die for Christ had been dashed, and that he was condemned to meet his end in a 'soft and easy bed'. This, he feared, was indicative of his own 'demerit'. In contrast to himself, he accorded a reverence to the recent martyrs that amounted to cult devotion. Even on his deathbed he 'called to his assistance those first most glorious martyrs, Campion, Sherwin and Briant'.[72] Gilbert wanted the marks of the blessed martyr etched violently onto his body. The reluctance he is reported to have shown when an attempt was made to have Circignani paint the face of Saint George in the fresco cycle with Gilbert's features might not necessarily have been owing to his reputed humility.[73] He might well have wanted to appear in the cycle, but as a glorious martyr in his own right.

However, many within the hierarchy of the Catholic Church were troubled by the new martyr cults. The Jesuit General Aquaviva believed that England would be better served by discrete but effective missionaries rather than potentially vainglorious additions to the litany of saints.[74] Yet such caution clearly did not hinder Gilbert's enthusiastic use of the paintings to promote the cult of martyrs and to arouse the love of martyrdom among impressionable young novices. In the frescoes themselves, a sense of triumph is discernible in some of the captions beneath the pictures that celebrated the successes of the martyrs' work. Patristic teaching had maintained that converts were won through the blood of martyrs, not violent insurrection, and English priests were claimed to have achieved this.[75] Thus, beneath the death scene of Campion, Briant and Sherwin (**Fig. 15.1**) was written: 'By the unflinching death of these men, some thousands have been converted to the Roman Church'.[76]

Their influence on the novices was, however, only one of the many purposes claimed for the frescoes. According to the rector of the English College in Rome, George Gilbert believed the objective of the paintings was

> not only to honour those glorious martyrs, and to manifest before the world the glory and splendour of the Church of England, but also that the students

of the College, beholding the example of their predecessors, might stimulate themselves to follow it; moreover that Rome and the world, when seeing the deplorable state of the country, might be moved to pray for it.[77]

The last aim, to publicize the plight of the English Catholics to 'Rome and the world', was achieved through the engraved copies after the frescoes, which were printed in several editions and sent out across Europe. They became part of a sophisticated strategy of visual propaganda, conducted by Elizabethan Catholics on a European scale, which sought to discredit Queen Elizabeth's government and generate political and financial help from sympathetic governments and their peoples. This strategy and the part played by the frescoes at the English College in Rome have been investigated elsewhere.[78]

However, the role of the frescoes in promoting the 'glory and splendour of the Church of England' deserves greater attention. Gilbert's enthusiasm was shared by Richard Barret, President of the English College in Rheims, who described his own reaction when a set of the printed copies made after the frescoes were sent to him as a gift. In a letter of thanks dated 8 November 1584 he remarked that 'in those very beautiful pictures I seem to see the greatest religious splendour and glory of your church and of all England'.[79] The 'glory' presumably lay in the celebrated figures from England's religious history honoured in the frescoes. Among the most important to be depicted was the Emperor Constantine who, according to the inscription painted beneath, 'in Anglia natus'. Saint Helena's part in the discovery of the True Cross of Christ had been dramatized frequently in Italian art. Yet here, in Circignani's version, the audience is reminded through the inscription that she was the daughter of King Coleus of England. Similarly, the popular martyr Saint Ursula was described as 'daughter of King Deonotus of Cornwall in England'.[80] Other famous English personalities such as Saint Thomas à Becket hardly needed an introduction.

Even Circignani's mode of representing the body can be interpreted as enhancing the impact of glory and splendour. In their distinctive poses some of the figures echo the great compositions made earlier in the century by Raphael. One of the assassins in the fresco illustrating the martyrdom of Saint Thomas à Becket was recognized by Wolfgang Stechow to derive, perhaps at one or more removes, from a detail in

Raphael's *The Expulsion of Heliodorus* (Stanza d'Eliodoro, Vatican).[81] To this, other parallels can be added. For example, the fallen posture of Saint Edwin as he is killed in battle is faintly reminiscent of the fallen Heliodorus himself in Raphael's great work. Perhaps the closest connection is between Circignani's version of *Saint George and the Dragon* and Raphael's famous painting of the same subject, now in the National Gallery of Art in Washington. Even the background setting of the final fresco in the English College cycle seems inspired by Raphael's view of Saint Peter's in his *School of Athens* (Stanza della Segnatura, Vatican). Circignani used this impressive backdrop in his scene of Gregory XIII, founder of the English College at Rome, kneeling at an altar with his nephew, Cardinal Boncompagni, who served as protector to the college, surrounded by the English priests and novices. Whether or not Circignani was making deliberate borrowings from Raphael in an attempt to attract some reflected prestige or simply painting in a tradition still heavily influenced by the great artist, the English College cycle was painted in fresco on a grand scale that in its own right would have brought a degree of prestige or 'splendour'. Unlike earlier attempts at propaganda images illustrating the martyrdom of Elizabethan priests produced in France, Circignani's figures do not have small matchstick-like bodies but monumental bodies that dominate the picture plane.

The monumental bodies in the English College frescoes are likely also to have sparked connections in the minds of a sophisticated Roman audience with antique sculpture. The naked bodies of the recently martyred English priests can be compared not only with the dead body of Christ held by God the Father in the chapel's painted altarpiece, but also with the examples of ancient Roman figurative sculpture that had become celebrated across Europe. Great excitement was still caused by newly-excavated examples of such works. Their fame was spread through prints copied by engravers, one of the most prominent being Giovanni Battista Cavalieri, the artist who copied the frescoes in the English College.[82] In the 1560s Cavalieri had printed an anthology of more than 50 prints after antique statues. This was reprinted in expanded editions, which by 1584 included 100 plates and by 1594, 200.[83] Although Circignani does not appear to have copied any of them directly, the reclining poses of his dead Elizabethan priests are strongly redolent of such reproductions of ancient statues (Fig. 15.1). The priests had not been well fed

whilst incarcerated in cramped cells before their execution, and so the highly developed, muscular bodies that Circignani gives them seem rather to operate as signifiers to associate them with heroic figures of a more glamorous age. Through making such references to sculpted Roman bodies a depressing scene of failure was transformed into a scene of glorious tragedy.

Thus, a variety of strategies, both visual and contextual, have been seen to operate in the English College frescoes in order to promote 'the glory and splendour of the Church of England'. By stressing the Englishness of Constantine and other heroic figures, the cycle, complemented by the stress on English ecclesiastical history in the college curriculum, aided the community of Elizabethan Catholics to define a sense of religious identity. If the paintings can be described as propaganda, then it is unlikely that their aim was to change the convictions of Protestants back in England. Rather their message seems more profitably addressed at a foreign audience, including the inhabitants of Rome itself.

In the 1580s it became particularly pressing for Elizabethan Catholics to forge a new identity as *English* Catholics. At this time, anti-Catholic legislation became more draconian in England and the executions of Jesuit priests caused scandal across Europe. In England those openly Catholic were denied public office and thus excluded from a significant participation in the life of the nation. In the event of a Spanish invasion it was widely assumed that English Catholics would side with the foreign enemy. To be Catholic was to be no true Englishman. In Catholic Europe, to be English was to be tainted with the hatred felt towards Elizabeth I and her heretical regime. Even English Catholics who resisted their own government and stayed loyal to the Roman Catholic Church could encounter prejudice on account of their nationality. This is hardly something that English Catholic exiles wished to acknowledge in their own writings: however, the Protestant polemicist, Lewis Owen, later makes an interesting aside in his book *The State of the English Colledges in Forraine Parts* (London, 1626): 'for our English Papists in forreine Countries, are farre more hypocriticall and superstitious then any other Nation whatsoeuer. And wherefore I pray you? Forsooth, to purchase them credit, and auoid all suspition of heresie'.[84] Owen claims that they made excessive displays of religious observance to counter the suspicion their nationality attracted. The cycle of paintings in the English College chapel could have

served similar ends in promoting to a foreign audience a positive view of England as a once highly orthodox Catholic country with an illustrious religious history.

The English exiles in Rome did admit that they had very little in common with their Italian hosts. Gregory Martin asked 'for concerning countrie what conjunction or affinitie is there betwene Italye and England, Lumbardie and kent, Bononie and London or any other towne in England?'. In seeking to explain the tremendous generosity shown by Cardinal Gabriel Paleotti to the English community in Rome, Martin concludes, 'it must nedes be that he respecteth the cause and not the men, or the men because of their cause, which is the cause of God and his Church'.[85]

Feelings of alienation were compounded by a deep sense of humiliation. English Catholics had failed to prevent their country from falling entirely into the hands of the Protestant heretics. Westminster Abbey, Canterbury Cathedral and all the other great churches and cathedrals of England had been desecrated. Gregory Martin vividly describes the mood of shame and inadequacy he encountered and shared with the English Catholics in Rome during his eighteen-month visit. Martin stayed at what was then the English Hospice in Rome. In 1576, the year he arrived, Bishop Cesare Spetiano conducted a formal visitation of the hospice that found it to be spartan, if not run down. The bishop even had to recommend that an altarpiece be installed on the high altar in the chapel. These inadequacies were most likely owing to a lack of funds.[86] By contrast, in the church of Santa Maria Maggiore, Martin was impressed to find a display cabinet devoted to such relics as 'the Dalmatica that S. Thomas of Canterburie ware, when he was martyred, of his arme, his bloud, his brayne, his hearecloth, and other Relikes'. The conclusion Martin draws from this is unsettling: 'that our countrie men may be ashamed to their condemnation, if Rome honour and esteme this English Sainte and glorious Martyr more than they'.[87] The situation improved somewhat after Gregory XIII refounded the hospice as a seminary college. It was possibly the pope's generous endowment that enabled the new altarpiece of the Trinity with Saints Edmund and Thomas à Becket by Durante Alberti finally to be installed in the chapel in 1580.[88]

However, even with its new altarpiece, the English College compared poorly with the splendour of the other churches and chapels of Rome. The contrast was particularly acute following the Jubilee year of 1575, when Rome witnessed a 'daily building of new

Churches and Garnishing the Old'. Gregory Martin and his fellow English exiles noted that 'we see every where some built from the ground, some costly repayred, some sumptuousely garnished'.[89] It was particularly mortifying each year on Trinity Sunday and the feast-day of Saint Thomas à Becket, when over 30 masses were held in the English College chapel 'partly by our owne Countrie men, partly by other Bishopes, Referendaries, Archdeacons, Cardinals, Chaplens, Jesuites, and other straungers that came of purpose (as the maner is) for the honour of our patrone that b. martyre, and of love to our Nation'. The splendour of the occasion was not matched by the paucity of the setting: 'But in Rome for al that, we must be content to be in the meanest degree for matters of solemnitie'.[90]

It seems to have been the example of the German and Hungarian seminary college chapels in Rome that finally inspired the English exiles to commission Circignani, who had painted frescoes of ancient martyrdom onto the walls of those chapels, to paint similar scenes at the English College. Although the detail of the scheme was said to have been devised by William Good, the original idea might have been prompted by one of the Englishmen's Italian hosts.[91] Writing once more about Cardinal Gabriel Paleotti, Gregory Martin remarks, 'he is wont to wish that he had a boke of al English Saincts and holy men from the beginning, asking if there be any such, and marveling that there is not, being a thing so greatly to God's glorie and the true honour of that blessed countrie'.[92] Furthermore, seeking to overcome another lack of initiative, the cardinal took pains to record the names and details of English priests who died, even commissioning pictures of them: 'Therefore doth he verie diligently take the names of al that passe, yea and the pictures of the same, to be an eternal monument of Godes glorie and praise of the English nation ...'.[93] Paleotti's prominent role in championing the importance of the visual arts in furthering the cause of the Counter-Reformation was to culminate in his writing a treatise on the subject, *De imaginibus sacris* (Ingolstadt, 1594). Whether or not at the direct instigation of the cardinal, five or more years later both his suggested strategies to bring 'honour' and 'praise to the English nation' were realized in the fresco cycle.

The 'glory and splendour' that Gilbert and others believed the frescoes bestowed upon the college chapel helped establish it as the principal centre of worship for English Catholics. Westminster Abbey and other great English churches might have been lost, but at least the college chapel enjoyed the privileged status of

a location in Rome, which Martin describes as 'the head and mother Citie where the cheefe Patriarche and high Vicar of Christ over al Patriarches is resident'.[94] The importance of the chapel and the enhanced status brought by its paintings is confirmed in an inscription printed beneath Cavalieri's engraved copy of the chapel's altarpiece, which was bound with the printed copies of the frescoes:

> Since the English have left in the whole world only one Catholic church, namely the Church of the Holy Trinity in Rome, on whose high altar this picture is displayed, rightly have they seen to it that the struggles of those martyrs of former times and of today are depicted therein, so that they may arouse in others praise and prayers, and in themselves a constancy of mind equal to that of their predecessors and colleagues.[95]

At their own admission, therefore, the English Catholics intended the fresco cycle in their college chapel to serve multiple and complex functions. It has been shown that representation of the body played a vital part in this. The tortured bodies of Elizabethan martyrs were the culmination of a historical continuum of heroic bodies beginning in the ancient Roman world. By depicting the contemporary persecutors in quasi-Roman costume, the paintings not only made a political attack that so troubled the English government, but also acted as a marker of difference in the construction of religious identity. The bodies of the victims were inscribed with the markings of martyrdom, suffering tortures associated with their early Christian predecessors. However, their muscular frames and dramatic poses were redolent of prestigious monumental fresco painting in Rome and of the sculpted bodies of antique statuary. Prestige and a sense of pride had been somewhat lacking before the commissioning of the frescoes enabled the English exiles to keep pace with the splendour of the churches and chapels around them. By promoting the glory and splendour of England's religious history, the paintings played a part in the reconstruction of a national identity for this group of exiles, as *English* Catholics.

However, it ought not to be forgotten that the commissioning of the English College frescoes was fundamentally an act of sincere and devout piety. England's traditional saints were deeply revered and its recent Catholic martyrs held in the highest respect. The identification of the Elizabethan martyrs with the glorious martyrs of ancient Rome sought to proclaim the imminent vindication of the English

Catholic cause. Despite the persecutions of the Roman emperors, the early Church had proved itself ultimately triumphant. Inspired by the frescoes, books and other sources, many Elizabethan Catholics saw themselves fulfilling a comparable role, which would likewise be vindicated by the ultimate triumph of the Catholic Church in England. Back in 1583, they were unaware that history would not repeat itself.

NOTES

1. A. Dillon, *The Construction of English Martyrdom in the English Catholic Community 1535–1603* (Aldershot, 2002), in particular ch. 4, 70–114; B.S. Gregory, *Salvation at Stake: Christian Martyrdom in Early Modern Europe* (Cambridge (MA)/London, 1999), 1–29, 250–314.

2. M.E. Williams, *The Venerable English College, Rome: a History 1579–1979* (London, 1979). For the earlier history of the English Hospice see M. Harvey, *The English in Rome 1362–1420: Portrait of an Expatriate Community* (Cambridge, 1999).

3. A. Morey, *The Catholic Subjects of Elizabeth I* (New Jersey, 1978), 105–8, 111–12; P. Guilday, *The English Catholic Refugees on the Continent 1558–1795* (London, 1914), 63–120; A.O. Meyer, *England and the Catholic Church Under Queen Elizabeth* (London, 1967), 99–144; L. Hicks, 'Father Persons and the seminaries in Spain', *The Month* (1931), 18–24; M. Murphy, 'St Gregory's College, Seville 1592–1767', *Catholic Record Society* 73 (1992), 1–37.

4. For an introduction to the deteriorating position of Catholics in Elizabethan England see Morey, *The Catholic Subjects* (above, n. 3); P. Holmes, *Resistance and Compromise: the Political Thought of the Elizabethan Catholics* (Cambridge, 1982).

5. H.C. White, *Tudor Books of Saints and Martyrs* (Madison, 1963), 255ff.

6. R.L. Williams, '"Libels and payntinges": Elizabethan Catholics and the international campaign of visual propaganda', in C. Highley and J. King (eds), *John Foxe and his World* (Aldershot, 2002), 198–215; Dillon, *The Construction* (above, n. 1), 114–276.

7. T. Buser, 'Jerome Nadal and early Jesuit art in Rome', *Art Bulletin* 58 (1976), 424–30; L.H. Monssen, 'Rex gloriose martyrum: a contribution to Jesuit iconography', *Art Bulletin* 63 (1981), 130–7; A. Herz, 'Imitators of Christ: the martyr-cycles of late sixteenth-century Rome seen in context', *Storia dell'Arte* 62 (1988), 52–70.

8. M.J. Lewine, *The Roman Church Interior 1527–1580* (Ph.D. thesis, Columbia University, 1960), 489–95.

9. J.A. Gere and P. Pouncey, *Italian Drawings in the Department of Prints and Drawings in the British Museum: Artists Working in Rome c. 1550 to c. 1640* (London, 1983), 55–6; R.L Williams, 'Collecting and religion in late sixteenth-century England', in E. Chaney (ed.), *The Evolution of English Collecting: Receptions of Italian Art in the Tudor and Stuart Periods* (*Studies in British Art* 12) (New Haven/London, 2003), 187–91.

10. *Ecclesiae Anglicanae trophae* (Rome, 1584). See A.F. Allison and D.M. Rogers (eds), *The Contemporary Printed Literature of the English Counter-Reformation between 1558 and 1640* I (Aldershot, 1994), entries 944–6.

11. H. Foley (ed.), *Records of the Province of the Society of Jesus* III (London, 1878), 697.

12. Buser, 'Jerome Nadal' (above, n. 7); Monssen, 'Rex gloriose martyrum' (above, n. 7); Herz, 'Imitators of Christ' (above,

n. 7), 52–70; L.H. Monssen, 'The martyrdom cycle in Santo Stefano Rotondo', *Acta ad Archaeologiam et Artium Historiam Pertinentia* (*series altera*) 2 (1982), 175–317; 3 (1983), 11–106. See also the discussion by Mansour, Chapter Fourteen.

13. The engravings after the frescoes in Santo Stefano Rotondo were printed first as a separate booklet, entitled *Ecclesiae militantis triumphi* (Rome, 1583).

14. *Ecclesiae Anglicanae trophae* (above, n. 10); É. Mâle, *L'art religieux de la fin du XVIᵉ siècle, du XVIIᵉ siècle et du XVIIIᵉ siècle* (Paris, 1951), 109–11; Dillon, *The Construction* (above, n. 1), 175–239.

15. E. Duffy, *The Stripping of the Altars* (New Haven/London, 1992), 412, 418.

16. Williams, *The Venerable English College* (above, n. 2), 229–30. The altarpiece was also copied as an engraved print by Cavalieri and issued with the copies after Circignani's frescoes in the English College. *Ecclesiae Anglicanae trophae* (above, n. 10), 2.

17. Morey, *The Catholic Subjects* (above, n. 3), 53.

18. A. Somerset, *Elizabeth I* (London, 1997), 245.

19. A. Munday, *The English Romayne Lyffe* (ed. P.J. Ayres) (Oxford, 1980), 42–3.

20. W. Allen, *A Briefe Historie of the Glorious Martyrdom of xii Reverend Priests* (Rheims, 1582), 14.

21. Holmes, *Resistance and Compromise* (above, n. 4), 27.

22. Holmes, *Resistance and Compromise* (above, n. 4), 31.

23. K. Woodward, 'Concepts of identity and difference', in K. Woodward (ed.), *Identity and Difference* (Milton Keynes, 1997), 8–47, esp. pp. 8–21.

24. Dillon, *The Construction* (above, n. 1), 18–71, 177–211.

25. Williams, "Libels and payntinges" (above, n. 6), 204; Dillon, *The Construction* (above, n. 1), 135–7.

26. *Ecclesiae militantis triumphi* (above, n. 13), 28.

27. *Ecclesiae militantis triumphi* (above, n. 13), 6.

28. A laywoman is described walking into the English chapel in G. Martin, *Roma sancta* (ed. G.B. Parks) (Rome, 1969), 64 (originally written 1581); Williams, "Libels and payntinges" (above, n. 6), 208.

29. C. Shilling, 'The body and difference', in Woodward (ed.), *Identity and Difference* (above, n. 23), 65–100.

30. A particularly vivid example is Hieronymus Bosch, *Christ Crowned With Thorns*, for which see the reproduction, commentary and bibliography in G. Finaldi (ed.), *The Image of Christ* (exhibition catalogue (National Gallery, London), London, 2000), 114–15.

31. Public Record Office, State Papers (Italian States), 85(1), fol. 151v.

32. Holmes, *Resistance and Compromise* (above, n. 4), 140.

33. D. Kunzle, *The Early Comic Strip: Narrative Strips and Picture Stories in the European Broadsheet from c. 1450 to 1825* (Berkeley, 1973), I, 38–9; J.B. Trapp and H.S. Herbruggen, *'The King's Good Servant': Sir Thomas More 1477/78–1535* (exhibition catalogue (National Portrait Gallery), London, 1977), 128, no. 252; Williams, "Libels and

payntinges" (above, n. 6), 202; Dillon, *The Construction* (above, n. 1), 52–62.

34. J. Ehrman, 'Massacre and persecution pictures in sixteenth-century Paris', *Journal of the Warburg and Courtauld Institutes* 8 (1945), 195–9; J. Adhemar, 'Antoine Caron's massacre paintings', *Journal of the Warburg and Courtauld Institutes* 12 (1949), 199–200.

35. Gregory, *Salvation at Stake* (above, n. 1), 1–29, 315–41.

36. A.G. Petti, 'Richard Verstegan and Catholic martyrologies of the later Elizabethan period', *Recusant History* 5 (1959), 64–90, esp. p. 65; Buser, 'Jerome Nadal' (above, n. 7), 428–9.

37. Public Record Office, State Papers (Italian States) 85(1), fol. 151v.

38. White, *Tudor Books* (above, n. 5), 155ff.

39. The architectural background can be compared with well-known prints by Serlio. See S. Serlio, *On Architecture* (eds V. Hart and P. Hicks) (New Haven/London, 1996–2001).

40. T.H. Clancy, *Papist Pamphleteers* (Chicago, 1964), 294.

41. C.H. McIlwain (ed.), *The Political Works of James I* (New York, 1965), 157.

42. R. Carpenter, *Experience, Historie and Divinitie* (London, 1642), 132.

43. See, for example, the engraving of the Elizabethan persecution printed in R. Verstegan, *Theatrum crudelitatum haereticorum nostri temporis* (Antwerp, 1587), 79.

44. Kunzle, *The Early Comic Strip* (above, n. 33), I, 123, 443.

45. R.M. King (ed.), *The Execution of Justice in England by William Cecil and a True, Sincere, and Modest Defense of English Catholics by William Allen* (New York, 1965), 61.

46. J. Foxe, *Actes and Monuments of Matters Most Speciall and Memorable, Happenyng in the Church, With an Universall History of the Same ...* (London, 1563). See D. Loades (ed.), *John Foxe and the English Reformation* (Cambridge, 1997) for further bibliography.

47. T. Watt, *Cheap Print and Popular Piety* (Cambridge, 1991), 158; M. Aston and E. Ingram, 'The iconography of the 'Acts and Monuments'', in Loades (ed.), *John Foxe* (above, n. 16), 99–142.

48. B. Anderson, *Imagined Communities: Reflections on the Origins and Spread of Nationalism* (London, 1983).

49. Martin, *Roma sancta* (above, n. 28), 116.

50. Eusebius, *The Ecclesiastical History and the Martyrs of Palestine* (trans. H.J. Lawlor and J.E.L. Oulton) (London, 1927).

51. Martin, *Roma sancta* (above, n. 28), 118.

52. Martin, *Roma sancta* (above, n. 28), 118.

53. G. Loarte, *The Exercise of a Christian Life* (London, 1579), fol. 233v.

54. Loarte, *The Exercise* (above, n. 53), fol. 233v.

55. William Allen's letter is dated 12 May 1582. It is transcribed in Foley (ed.), *Records of the Province* (above, n. 11), VII, 1342. See also Gregory, *Salvation at Stake* (above, n. 1), 298–303, 307–14.

56. Buser, 'Jerome Nadal' (above, n. 7), 424–30; Herz, 'Imitators of Christ' (above, n. 7).

The physical presence (*praesentia*) of holy bodies enabled Christianity to link heaven and earth and to conquer death, so the veneration of saintly bodies became more and more popular. These pieces of holy but dead material were already held to be imbued with the glory they would ultimately attain at the end of time, and as such were able to intercede in heaven on behalf of mortals. In her book on medieval religion, *Fragmentation and Redemption*, Carolyn Walker Bynum stresses the equivocal, or perhaps even paradoxical, positions taken with respect to the appropriateness of dividing dead bodies into parts, including those of future blessed and saints. On the one hand, religion, science and politics seem to have stimulated the practice of dissecting and dismembering bodies.[2] On the other hand, the mystery and taboo of the closed body still reigned, based on the cultural assumption that material continuity was crucial for salvation, supported by Aristotle's and Thomas of Aquinas's theory of the human being as a form–matter union of body and soul.

From the high Middle Ages onwards religion became more focused on the interior experience and was felt more literally than before. This transformation culminated in the intensely personal religious experiences so well documented in the seventeenth century, when the body functioned as 'an engine of faith', allotting a very special place to the heart.[3] As a 'contact organ' linked directly to the Holy Spirit, it constituted the embodiment of religious fervour, whether or not it was also considered the home of the soul.[4] The process is reflected in the gradually changing form of relics. From the later Middle Ages onwards, for instance, relics were more and more often retained in caskets designed in human shapes.[5]

Reflecting the apparently perfect physical reappearance of Christ on earth and the resistance to mutilation of martyrs' bodies, the early medieval notion of the *corpus incorruptum*, *corpus integrum* or *corpus inlaesum*, gained weight.[6] Incorruptibility was considered to indicate freedom from pollution by original sin as well as election by God. Whereas initially it referred to the essence of a corpse from which parts might have been removed, in the time of Filippo Neri (1515–95) and Carlo Borromeo (1538–84) the qualifications *incorruptum* and *integrum* were taken much more literally — despite the fact that there was still no generally accepted norm in this respect. For centuries many believers longed for material proof of the connection between heaven and earth, and this provided the impetus to anatomize holy bodies.[7]

With regard to the phenomenon of the relic we should not forget the influence of secular body relics. The habit of cutting up the corpses of medieval French and English kings and of burying the parts separately was well established, and the same holds true for the tradition of conserving the body parts of both the famous and infamous. For example, the finger of Galileo Galilei is still on display in the Science Museum of Florence and should be considered a relic of the history of science, which also has had its martyrs. The same goes for Jean Paul Marat, hero of the French Revolution, who was murdered in his bath, after which his heart was cut out and exhibited at his club. The heart of the martyr of English Romanticism, Percy Bysshe Shelley, allegedly withstood burning on a funeral pyre at the beach of Legnano and was brought to Rome. Later it was given to his widow, Mary, who took it with her to her grave.[8] Only towards the end of the nineteenth century did it become fashionable to display statesmen 'saint-style' in mausoleums open to the public. The remains of the Italian politician Giuseppe Mazzini were transformed into a mummy in 1872 and exhibited as the focal point of a left-wing republican cult.[9] For secular bodies, the idea of the *corpus incorruptum et integrum* ultimately dominated, but centuries later than in the case of holy bodies.

ANATOMY

Many medical historians consider the fifteenth- and sixteenth-century development of anatomy as the birth of modern medicine. Following the 'digestion' of redis-covered ancient sources, medics emulated their predecessors with empirical observation and experimentation, a process that resulted in a medical revolution that was, above all, a 'resurrection of the anatomical projects of the ancients', to quote the title of Andrew Cunningham's founding book on this theme.[10] However, religious and philosophical thought also had repercussions on the procedures of physicians, especially in Rome, a principal centre of Counter-Reformation zeal. After some time spent teaching at famous universities in northern Italy, many important physicians, such as Realdo Colombo, Archangelo Piccolomini, Bartolomeo Eustachio, Michele Mercati and Andrea Cesalpino, tried their luck in Rome. There, they could combine personal medical service to the papal court or a cardinal's household with teaching duties at La Sapienza, medical duties at a hospital, or a post in the Collegium Medicorum Almae Urbis.[11]

Generally speaking these doctors settled in Rome towards the end of their careers, after they had published their most important work. In the Eternal City, however, they could continue their scientific research and present new *summae* of their findings, utilizing the manuscripts and medical texts of the Vatican and cardinals' libraries, and, of course, taking every advantage of examining human corpses. As Andrea Carlino shows, in Chapter Thirteen of this volume, in Rome few material remains were made available to doctors by the authorities, so anatomists raided churchyards as well as catacombs. For physicians, clinical practice in hospitals such as Santo Spirito in Sassia and Santa Maria della Consolazione was a popular job, not so much for any financial reward, but because of the possibility of observing wounded bodies and of occasionally acquiring a cadaver. Sometimes famous patients considered it an honour to bequeath their material remains. This was the result of a long-standing custom in Italy for an autopsy to be requested in advance by a patient or his family, as they wanted to ascertain the origin of the illness.[12] In his *De re anatomica* (1559), in a special last chapter on 'things that were seldom to be seen in anatomy', Colombo boasts of having performed autopsies on the bodies of Cardinals Gambara, Cibo and Campeggi.[13]

In the religious fervour of the Counter-Reformation, the veneration of saints occupied centre stage and enhanced the taste for holy limbs. Interest in the dead bodies of saints, their limbs and organs, can be interpreted therefore as an ambiguous process in which cultic, political, medical, but also cultural and even legal, factors intermingled.[14] Four physicians, all part of Italy's medical élite, dissected the bodies of the three most important Counter-Reformation saints: Ignatius of Loyola's corpse was examined by Realdo Colombo, Carlo Borromeo's by Giambattista Carcano Leoni, and Filippo Neri's by Angelo Vittorio and Giuseppe Zerla.[15]

RELIGIOUS BODY LANGUAGE

At the same time, quite a few doctors fell under the spell of charismatic religious leaders such as Saint Filippo Neri and Saint Carlo Borromeo. As a consequence, in their private as well as their professional lives they tried to combine their religious fervour with medical interests. Apart from bringing spiritual satisfaction and relief, connections with aspiring saints were potentially useful for practical reasons. When

accused of possessing forbidden books, Bartolomeo Eustachio was saved from prosecution by Carlo Borromeo and thereupon became the saint's physician. In turn, Eustachio's *De renibus* was dedicated to his saviour.[16] The doctor Giovanni Modio was the author of a collection of facetious stories written on the occasion of the carnival of 1554 and of a book, *Il Tevere*, published in 1556, in which he underlines the connections between Roman fever epidemics and the Tiber's numerous floods. But following his acquaintance with Filippo Neri, he left his profession altogether and entered Neri's fraternity at the Oratory, dedicating the rest of his life to editing Jacopo da Todi's canticles. When, in 1556, the doctor fell gravely ill, both papal physicians, Ippolito Salviani and Pietro Antonio Contugi, believed that his chances of recovery were minimal, but Neri judged otherwise and Modio was thereupon restored to health.[17]

Filippo Neri is often hailed as the Roman apostle. Together with Ignatius of Loyola, he constituted a focal point of religious revival in Counter-Reformation Rome. The kind of devotion these men favoured showed many literal, almost physical, traces, of which enlightenment by the Holy Spirit was the most important. The brothers of Neri's Oratory always convened under its inspiration. Divine fervour regularly set Neri on fire, and therefore he never needed a coat, even during cold winters, and used to leave the windows and door of his cell open in order to cool off.[18] The saint felt the heat especially in his heart, which therefore functioned as the seismograph of his contact with heaven and earth. When communication was established, the holy man suffered strong and painful heartbeats, which subsided when he turned his mind to less elevated subjects. Likewise, he possessed the ability 'to know the hearts of men and see their hidden thoughts', which made him a very popular confessor.[19] He even performed this function for popes and important cardinals, conferring upon him significant influence on the city. The special religious status of Neri's heart is also interesting from a medical point of view, as the debate on the hegemony of either the heart or the brain in the human body was in full sway at that moment.

Serving God through service to the community was one of the characteristics of the Catholic Reformation. Neri also developed an extensive social programme that, among other things, brought about the renovation of old hospitals and the construction of new ones for pilgrims, syphilitics, orphans, reformed prostitutes, and for the poor and sick in general.[20] Visiting hospitals,

sweeping the floor, making the beds of patients and even emptying their chamber-pots was one of the regular exercises in humility Neri's followers had to endure.

Filippo Neri's poor health left its mark. His heart condition was just one of a whole series of ailments, among which fevers figured prominently. In curing his own body as well as those of others in Rome, Neri worked alongside other healers operating within the extensive and heterogeneous Roman medical market, where academically trained physicians competed with barbers, quacks and thaumaturgical healers. Neri claimed that the use of relics and giving alms to monasteries had more effect than medical therapy. To stimulate recovery he always took a Byzantine triptych with him when visiting the sick. Recovering from one of his own many illnesses, he showed his doctors the reliquary containing the bones of Peter and Paul, which had been donated to him by Cardinal Federico Borromeo. Neri told them that these bones were responsible for curing him. Every time Neri cured someone he also poured scorn on the procedures of physicians. In particular he blamed their expensive medicines, which he believed were useless. However, Neri's therapies often consisted purely of practical advice, such as performing hygienic measures or changing the air, and Neri also demonstrated his mastery of the basic assumptions of medical learning, which in those days was still part of general intellectual knowledge.[21] At other times, Neri invoked divine intervention, for which physical contact between healer and patient seems to have been crucial. Neri cured thaumaturgically, by praying or by placing his hand on the affected area and making the sign of the cross.[22] The healing process was usually precipitated by clasping the head of the ill to his chest, with its heavily pounding heart, in order to transfer its corporal and spiritual warmth. In particular it was this manoeuvre that was believed to give relief. In the canonization process, as well as in the *Vita* of Neri, again and again his combination of medical and religious analysis of illnesses is striking. Even the medical necessity of rebalancing the system of Galenic humours was achieved thaumaturgically. This method can be observed in Neri's healing of Archdeacon Sana Barsùm of Alexandria, who had become mortally ill and was bringing up blood in addition to his coughing, high fevers and respiration problems that caused insomnia. At the precise moment that Neri started to celebrate mass the archdeacon fell asleep, only to recover completely when repeatedly embraced and pressed firmly against the Neri's heart. Barsùm began to sweat out his bad humours and his strength returned. After an hour he no longer spat blood, except for the quantities that already had risen to his chest.[23]

An examination of Neri's healing reveals that every time he was moved to ecstasy his heart became inflamed with the love of God, as if the Holy Spirit itself had invaded his body. Through the power of the heat he generated, sometimes Neri was lifted into the air, especially when he elevated the Eucharist during the celebration of Mass and when he worked miraculous recoveries. One day, while saying his prayers in Saint Peter's, his burning body even managed to scorch the wooden *prie-dieu* he used. On such occasions, Neri's heart trembled ardently, as if asking permission to leave the confines of his narrow chest and ascend towards heaven.[24] These types of palpitations had begun in 1544 when Neri was praying in the Catacombs of San Sebastiano. There he experienced his personal Pentecost, as depicted in Bacci's engraving accompanying Neri's *Vita*, where he is shown praying among open coffins containing skeletons (Fig. 16.1). The Holy Ghost, disguised as a ball of fire, has entered his body via his mouth and installed itself in Neri's breast. This 'fire of love' (*fuoco d'amore*) was so hot that Neri had to lie on the floor in order to cool off. Rising again to his feet, Neri's feelings of joy continued and his body began to tremble. Thereafter, every time Neri became agitated, his divine ardour manifested itself in this heat and, on occasion, by temporary levitation. At the Oratory, Neri's rooms were later decorated by Niccolò Tornioli, who depicted one of Neri's levitations, when the Virgin Mary appeared in a vision to him and performed a miracle cure (Fig. 16.2).

The excessive beating of his heart presented severe medical problems for Neri that continued for the rest of his life. Despite 50 more years of painful suffering, Neri died serenely and without infirmity in his last hours. The *Vita* makes a particular point of the fact that although, in his last moments, Neri's mouth was full of sputum and blood, this did not detract from his serenity. Just like the martyrs of the early Church, Neri's body withstood the torment of physical affliction and conquered temptation. Ultimately, nothing had been able to damage either his body or his soul and, as a sign of his purity, the last moment of Neri's life consisted not of words spoken to his brothers, but his bodily levitation before them. The saint performed this final levitation and then lowered himself forever. Neri finally entered eternal life on the 26 May 1595 — not

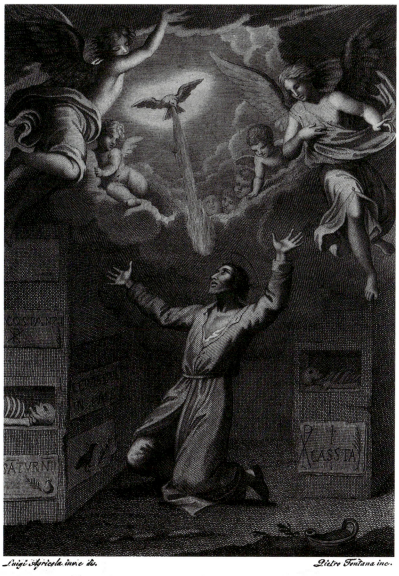

S. FILIPPO NERI.

Riceve lo Spirito Santo in forma d'un globo di fuoco nelle Catacombe di S. Sebastiano.

Luigi Agricola inve dis. Pietro Fontana inc.

FIG. 16.1. **Filippo Neri is struck by the fire of the Holy Spirit, while praying in the Catacombs of San Sebastiano.** *From Pietro Giacomo Bacci,* Vita di San Filippo Neri. *Reproduced courtesy of the Istituto Olandese, Rome.*

coincidentally, the night after the feast of Corpus Christi (**Fig. 16.3**).[25]

SAINTLY AUTOPSY

Even today physicians play a crucial role in the process of canonization. They testify as legal witnesses and are called in to undertake medical examinations on those who have had healing miracles performed on them by the saintly.[26] In the process of Neri's canonization many important Roman doctors functioned in this capacity. Their presence demonstrates the new emphasis sought for the miraculous on the basis of solid historical and, in this case, medico-empirical evidence.[27] This was paradoxical given that, in many cases, physicians admitted medical helplessness and failure, thereby undermining their own professional authority and promoting miraculous healing.

The second task of physicians with regard to canonization consisted of performing an autopsy on someone who had died in an odour of sanctity. In the case of a *corpus incorruptum*, they examined the corpse. This intact condition increasingly became one of the fundamental requirements for sanctification, and at every displacement of a holy body, or in case of saintly jubilees, the condition of the material remains is still inspected and reported meticulously. Three hundred years after his sanctification, between 6 and 9 March 1922, a team of Roman doctors performed another official 'ricognizione' of Filippo Neri's remains. Not surprisingly, the conclusion was that 'the body of the saint … has remained in a state of perfect conservation and during three centuries has not presented any notable changes'.[28] In 1950, even when Neri's head only had to be slightly turned, a team of doctors again made its appearance as official witnesses.[29]

When in 1595 Neri closed his eyes forever, his body was immediately washed and within an hour carried to the Chiesa Nuova to be exposed on a catafalque.[30] The next day his admirers bid Neri farewell and his autopsy was performed that evening. This was a major event. In the company of members of the Oratory and of Neri's family, several important physicians carried out the task, observed by 30 bystanders. The doctors were Angelo Vittorio da Bagnoregio, physician to Gregory XIII, and the Oratorians' doctor of the house (*medico di casa*), Bernardino Castellano, chief physician of the

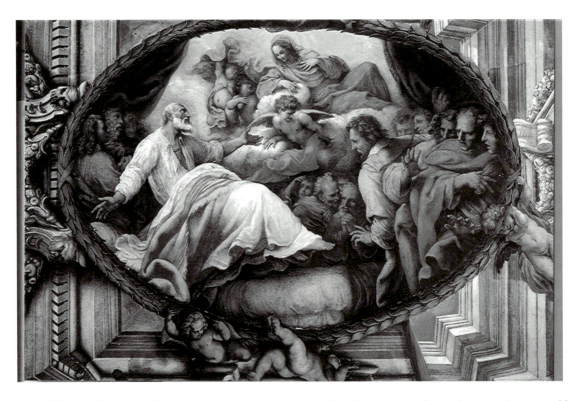

FIG. 16.2. **Niccolò Tornioli, Recovery of Neri thanks to the intervention of Mary. Chiesa Nuova, Rome.** *Reproduced courtesy of Santa Maria in Vallicella, Rome.*

Santo Spirito Hospital, together with the papal surgeon Giuseppe Zerla and Alessandro Alluminati, the pharmacist of the Oratorians. Following contemporary practice, each physician performed different tasks in the dissection. The actual incision and surgery was done by Giuseppe Zerla with the assistance of a barber named Marcantonio del Bello.[31] After opening the body, the doctors found every organ in perfect condition, supporting the medieval concept that material appearance reflects the beauty of the soul. The liver, the lungs, the heart and all the other organs were untainted — 'si trovò tutti li interiori netti, senza macagna alcuna' — and had the appearance of those belonging to a young boy. The saint's ailments had left no visible traces on his body: ergo, the autopsy results met the criteria of the accepted and recognized 'martyr model'. Despite the devastating pain Neri's heart condition had often caused, his body was not mutilated, and remained intact and well-preserved. This is further sustained by the statement in the *Vita* that the deceased, while being washed and even during dissection, was alleged to have repeatedly covered his body with a sheet as a sign of purity as nobody ought to see his naked body. In Neri's struggle to maintain a flawless completeness, he also tried to prevent his bodily degradation, and was said to have resisted the dissection of his body.

Although the examining doctors claimed never to have seen such a handsome human interior, physical beauty was not enough. Three cuts had been made in the heart to check the condition of its interior. These incisions revealed that the heart possessed an unheard-of inner beauty as the ventricles were without spots, blotches or any other traces of illness. It was impossible to see where all the blood the saint once coughed up had come from. The heart seemed only to be bigger in size than was usual, but for a future saint that was a positive sign. The pericardium lacked the water normally to be found there, a fact that was attributed to Neri's excessive internal ardour, 'la fiamma dell'amore divino'. A similar explanation was given for the size of the artery that led to the ventricles of the heart. It was twice as big as normal, supposedly because of all the spirits and vapours it had brought to the heart in order to sustain its divine fire.

According to medieval customs developed for popes, the internal organs were removed from the body in order to make possible a period of lying in state.[32] Remarkably, even with potential saints' bodies, no special attention was paid to the other organs, in contrast to the treatment of Saint Carlo Borromeo's heart, which had been carefully excised and cut into pieces to provide the whole country with relics.[33]

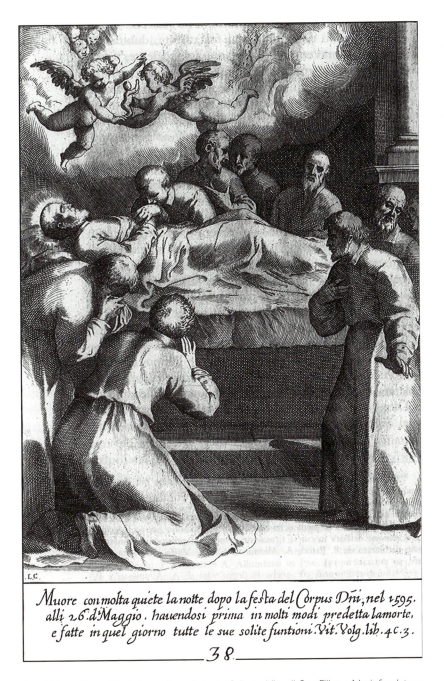

Muore con molta quiete la notte dopo la festa del Corpus Dñi, nel 1595. alli 26.d'Maggio. hauendosi prima in molti modi predetta lamorte, e fatte in quel giorno tutte le sue solite funtioni. Vit. Volg.lib.4.c.3.

— 38 —

FIG. 16.3. **Filippo Neri dying.** *From Antonio Gallonio,* Vita di San Filippo Neri, fondatore della Congregazione dell'Oratorio. *Reproduced courtesy of the Istituto Olandese, Rome.*

all the expert witnesses explicitly state that no preservatives or embalming ointments were applied. Holes in the corpse from the evisceration were filled with bundles of herbs such as rosemary, sage, laurel and myrrh, a procedure that may have helped conservation as these same ingredients are known to have been used for papal embalming.[35] After Zerla opened the corpse, the barber, del Bello, who must have been the most technically skilful surgeon, removed the organs, and it was he who, at the end of the dissection, stitched the body up with needle and thread. Unusually, there was no stench from the body during the entire autopsy. The corpse was dressed in the clothes of a priest and again exposed on a bier with a chalice in its hand, to be viewed during two further days busy with visitors. Then, on 27 May 1595, Neri's body was interred under the floor of his own church of Santa Maria in Vallicella.

Immediately after his death, the crowds had to be prevented from tearing Neri's body apart. Again and again devotees took away the roses that had been sprinkled over his habit, thus securing contact relics that immediately worked a series of curative wonders. His hair, beard and pieces of his clothing were secretly cut off and removed. Indeed, the Oratorians could scarcely prevent the complete exposure of his body and dismemberment of his corpse as people so cravenly desired genuine parts of his body as relics.[36] Because his canonization was expected, the requests for Neri's relics were constant, and important admirers could not be dis-

Neri's heart, lungs, liver and intestines were put in a container, and covered with sand and a lid before being buried in the collective cemetery of the Oratorians in the choir of the Chiesa Nuova.[34]

The *Vita* and records of Neri's canonization trials claim that his body did not undergo any special treatment and that its subsequent incorruptibility was therefore miraculous. At the same time, they detail the sponging dry and sprinkling with a mixture of powdered myrrh and roses of his insides. However,

appointed. Cardinal Agostino Cusano was a great venerator of Neri and eight months after the saint's demise he asked to see the *praecordia* of his hero, in particular his heart, as the cardinal probably wanted to secure a precious relic for himself. To satisfy this important prelate, the container holding Neri's intestines was dug up and brought to the sacristy. There, in the presence of Cusano, some doctors and Oratorians, the contents of the container were emptied onto a table. Not surprisingly, neither signs of decay nor stench

onus probandi. Years after the demise of Anthony of Padua, Porti remembers the mouth that had won so many devotees, which still contained his perfectly preserved tongue. The heart of Clara of Montefalco, for whom the crucifix had been central to her religious experience, displayed the image of a cross; the heart of Bernardino of Siena displayed an image of the tetragram of Jesus, a sign that his heart had always been full of the Lord. Porti starts to fantasize about Neri's missing heart and laments the fact that it had not been paid proper attention during autopsy. As he had already proven scientifically in his treatise, *De cordis palpitatione*, natural causes for the palpitations of Neri's heart could be deemed out of the question and therefore they were to be labelled supernatural. Consequently, the heart's beat and pulse followed heavenly powers. The doctor was convinced that, if the heart of Neri were to be found, it would certainly show some miraculous sign that the Holy Spirit had enflamed it so often.[45]

To conclude, one could say that the heart of Neri functioned as a symbol in two discourses. The religious debate hailed it as the essential engine of faith, the home of the soul and the place where the Holy Ghost manifested itself *par excellence*. Because of this, Neri's heart became a (lost) holy relic. The medical discussion elevated Neri's heart in the same way. According to Plato and Aristotle, the human soul was domiciled in the heart, an organ generating innate heat to be distributed through the body by way of arterial blood. Therefore, it is interesting that two of Neri's doctors wrote about his heart and its condition. Antonio Porti's treatise was written at the request of Cardinal Federico Borromeo, who wanted firm evidence that the heartbeats could not possibly have been of natural origin. The findings of Andrea Cesalpino are much more extensive. He studied under Realdo Colombo, who discovered the so-called small or pulmonary circulation of the blood and who came to Rome in 1592. During the following year, in his capacity as a heart specialist, Cesalpino was called to Neri's sickbed to take a closer look at the palpitations that for years had afflicted the saint. The medical diagnosis of the time was later officially recorded in the canonization process.[46] In consultation with Antonio Porti, Angelo Vittorio and Rodolfo Silvestri, Realdo provides a detailed analysis. Careful scrutiny of the saint's utterly emaciated chest revealed that he suffered from heavy, painful beatings of the heart that occurred every time he entered ecstasy. Subsequently, the heart would fill up with blood and the artery that led the liquid to the lungs expanded

to twice its normal size. In the end, the impact on his heart of frequent visions had caused the fracture of two of Neri's left ribs, the two closest to the heart. During periods of rest this was also visible, as the ribcage then showed a slight elevation. The cartilage of the ribs touched the pericardium, a defect that resulted in a tumour at the bottom left side of the ribcage. Although Cesalpino meticulously describes Neri's condition in medical terms, he too ultimately judges his heart condition to be miraculous and supernatural. After all, the palpitations only occurred when the saint concentrated on divine matters and diminished when he shifted his attention to earthly things. Divine intervention was the only possible explication. Extra proof was found in the circumstance that he could never have reached such an advanced age if it were a natural ailment. The fact that he also hardly needed food and all his life had been cheerful was yet another reason to consider Neri a saint.[47]

Analysis of the handling of Neri's living and dead body confirms Caroline Walker Bynum's thesis of the increasing corporeality of religious experience in the late Middle Ages. Counter-Reformation devotion stimulated this development even more, and the leaders of the medical renaissance could not escape religious reasoning in their medical work. From the outset, university-trained physicians were involved in the canonization process. The stricter rules of the Counter-Reformation, however, made medico-religious cooperation even closer. Vocabulary, ancient sources and discourses, as well as new anatomical criteria, were employed to demonstrate holiness according to professional medical standards. Research has demonstrated that by the early modern period incorruptibility, either of the whole cadaver or of part, had become a requirement for female sanctity, but this applies also to male saints such as Neri and Borromeo.[48] One difference is that the discourse around the latter's illness, autopsy and ultimate canonization is much more refined, both intellectually and medically. In line with the medical and artistic quest for physical beauty, the pressure to conserve holy bodies as complete and perfect as possible became stronger. As we have seen, Neri's corpse was successfully defended against partitioning. With regard to his friend Carlo Borromeo, only his eviscerated heart was divided, otherwise the procedures for his body resemble those for Neri. Material continuity was seen as a requirement for bodily resurrection, and thus the example of Christ became followed more strictly. In preparation for the reunion of body and soul at the Last Judgement, announced by Christ's Resurrection in total

corporeal perfection, the earthly frames of those who resembled him most, the holy, were meticulously preserved and exposed as precious treasures. Neri's body is preciously vested and adorned in his present glass casket. His preserved corpse is one of the best examples of this triumphant quest for holy wholeness.[49]

NOTES

1. The classic account is by P. Brown, *The Cult of the Saints: its Rise and Function in Latin Christianity* (London/Chicago, 1981); A. Angenendt, '*Corpus incorruptum*. Eine Leitidee der mittelalterlichen Reliquienverehrung', *Saeculum* 42 (1991), 320–48, esp. pp. 320–7; K. Cooper (ed.), *The Roman Martyrs and the Politics of Memory* (= *Early Medieval Europe* 9.3 (2000)). Also see Goodson, Chapter Eleven in this volume.

2. C. Walker Bynum, *The Resurrection of the Body in Western Christianity, 200–1336* (*Lectures on the History of Religions* 15) (New York, 1995); C. Walker Bynum, *Fragmentation and Redemption: Essays on Gender and the Human Body in Medieval Religion* (New York, 1992), chapters 3, 6 and 7. For the medical context see also K. Park, 'The life of the corpse: division and dissection in late medieval Europe', *Journal of the History of Medicine and Allied Sciences* 50 (1995), 111–32.

3. B. Treffers, 'Het lichaam als geloofsmachine: beeld, metafoor en werkelijkheid in de Italiaanse Barok', in A.-J. Gelderblom and H. Hendrix (eds), *De Grenzen van het Lichaam. Innerlijk en Uiterlijk in de Renaissance* (Amsterdam, 1999), 91–115.

4. A. Cunningham, *The Anatomical Renaissance: the Resurrection of the Anatomical Projects of the Ancients* (Aldershot, 1997), 15–21, 206–7.

5. Walker Bynum, *Fragmentation and Redemption* (above, n. 2), 271, 274.

6. Angenendt, '*Corpus incorruptum*' (above, n. 1).

7. Walker Bynum, *Fragmentation and Redemption* (above, n. 2), 284. The tradition of displaying intact bodies of saints in glass coffins is relatively modern. Cf. the eighteenth-century display of catacomb saints in the Stiftsbasilika Waldsasser, for which see T. Johnson, 'Holy fabrications: the catacomb saints and the Counter Reformation in Bavaria', *Journal of Ecclesiastical History* 47 (1996), 274–97. This observation agrees with the iconographic custom to interpret the resurrection as the triumph of the whole over the part, by showing men who collect their limbs and other members of depicting skeletons being re-clothed with flesh.

8. General surveys of these customs include C.A. Bradford, *Heart Burial* (London, 1933); C. Quigley, *The Corpse: a History* (Jefferson, 1996); A. Dietz, *Ewige Herzen. Kleine Kulturgeschichte der Herzbestattungen* (Munich, 1998).

9. S. Luzzatto, *La mummia della Repubblica. Storia di Mazzini imbalsamato, 1872–1946* (Milan, 2001).

10. Cunningham, *Anatomical Renaissance* (above, n. 4).

11. For a survey, see Cunningham, *Anatomical Renaissance* (above, n. 4); R. French, *Dissection and Vivisection in the European Renaissance* (Aldershot, 1999). For the Roman situation, see A. Carlino, *Books of the Body: Anatomical Ritual and Renaissance Learning* (trans. J. Tedeschi and A. Tedeschi) (Chicago/London, 1999); R. Palmer, 'Medicine at the papal court in the sixteenth century', in V. Nutton (ed.), *Medicine at the Courts of Europe 1500–1837* (London, 1990), 49–78.

12. Carlino, *Books of the Body* (above, n. 11), 93–119, discusses extensively the selection of cadavers and the rituals with which

a dissection was surrounded. K. Park, 'The criminal and the saintly body: autopsy and dissection in Renaissance Italy', *Renaissance Quarterly* 47 (1994), 1–33, at pp. 4–6; N.G. Siraisi, 'Signs and evidence: autopsy and sanctity in late sixteenth-century Italy', in N. Siraisi, *Medicine and the Italian Universities 1250–1600* (Leiden, 2001), 356–80.

13. Realdo Colombo, *De re anatomica libri* (Venice, 1559), book 15, 267–9.

14. For a general survey, see Park, 'The criminal and the saintly body' (above, n. 12).

15. Siraisi, 'Signs and evidence' (above, n. 12), 357, 363.

16. Part of his *Opuscula anatomica* (Venice, 1563).

17. A. Gallonio, *La vita di San Filippo Neri pubblicata per la prima volta nel 1601* (ed. M.T. Bonadonna Russo) (Rome, 1995), 28, 76–9; L. Ponnelle and L. Bordet, *Saint Philippe Néri et la société romaine de son temps (1515–1595)* (Paris, 1929), 152–7.

18. Ponelle and Bordet, *Saint Philippe Néri* (above, n. 17), 11–12, 85, 154–5.

19. Gallonio, *La vita* (above, n. 17), 52–4, 121–3, 126, 184–5.

20. J.F. d'Amico, *Renaissance Humanism in Papal Rome: Humanists and Churchmen on the Eve of the Reformation* (Baltimore, 1983), 107–10.

21. Ponelle and Bordet, *Saint Philippe Néri* (above, n. 17), 106–7.

22. For example, Gallonio, *La vita* (above, n. 17), 136, 279.

23. Ponelle and Bordet, *Saint Philippe Néri* (above, n. 17), 83, 114; Gallonio, *La vita* (above, n. 17), 289–91.

24. Gallonio, *La vita* (above, n. 17), 48–51.

25. Gallonio, *La vita* (above, n. 17), 300–6.

26. For a general discussion of this custom, see J. Ziegler, 'Practitioners and saints: medical men in canonization processes in the thirteenth to fifteenth centuries', *Social History of Medicine* 12 (1999), 191–225; Park, 'The criminal and the saintly body' (above, n. 12).

27. S. Ditchfield, *Liturgy, Sanctity and History in Tridentine Italy: Pietro Maria Campi and the Preservation of the Particular* (Cambridge, 1995), 117–34; Siraisi, 'Signs and evidence' (above, n. 12), 360–1.

28. 'Il corpo del Santo ... si è mantenuto in uno stato di perfetta conservazione, non presentando per tre circa tre secoli modificazioni sensibili', G. Antonelli, *La conservazione del corpo di S. Filippo Neri con appendice su Andrea Cesalpino scopritore della grande circolazione del sangue* (Rome, 1922); pp. 21–6 is a detailed report by a member.

29. G. Incisa della Rocchetta, *Il santuario Filippino della Vallicelliana* (*Quaderni dell'Oratorio* II, 5) (Rome, n.d.).

30. Gallonio, *La vita* (above, n. 17), 308.

31. Information on this is not clear. Gallonio, in his report of the autopsy, *La vita* (above, n. 17), 310–12, includes Andrea Cesalpino, and Cesalpino suggests his attendance in his first report, but is not mentioned in the other reports of the autopsy. The witnesses also give slightly different lists of who was present. In his own account, A. Vittorio, *Medica disputatio de palpitatione cordis, fractura costarum, aliisque affectionibus*

B. Philippi Neri Congregationis Oratorii Romani fundatoris. Qua ostenditur praedictas affectiones fuisse super naturam (Rome, 1613), 5–6, states that he was in charge of the autopsy and does not mention Cesalpino, whose attendance is, however, mentioned in the report by Zerla. There is no decisive report of Cesalpino's attendance at the autopsy, for which see G. Incisa della Rocchetta and N. Vian (eds), *Il primo processo per San Filippo Neri nel Codice Vaticano Latino 3798 e in altri esemplari dell'Archivio dell'Oratorio di Roma* (*Studi e testi* 191 (I), 196 (II), 205 (III), 224 (IV)) (Vatican City, 1957–63), I, no. 63, pp. 235–6 (Cesalpino); II, no. 223, pp. 218–20 (del Bello), no. 224, pp. 220–2 (Zerla); and in IV, 207 no. 1234 (Castellano), who also wrote a separate statement on the section. The autopsy is also discussed by Siraisi, 'Signs and evidence' (above, n. 12), 364–5.

32. A. Paravicini Bagliani, *Il corpo del papa* (Turin, 1994), 194–6, now also in English as *The Pope's Body* (trans. D.S. Peterson) (Chicago, 2000).

33. G.B. Carcano, *Exenteratio cadaveris illustrissimi cardinalis Caroli Borromei* (Milan, 1584).

34. Gallonio, *La vita* (above, n. 17), 310–12; Incisa della Rocchetta and Vian, *Il primo processo* (above, n. 31), II, no. 162, pp. 48–52 (Giulio Savera).

35. Paravicini Bagliani, *Il corpo del papa* (above, n. 32), 312–16.

36. Gallonio, *La vita* (above, n. 17), 309.

37. Incisa della Rocchetta and Vian, *Il primo processo* (above, n. 31), II, no. 162, pp. 48–9 (Savera), no. 163, pp. 49–52 (Battista Guerra), no. 189, pp. 137–9 (Antonio Gallonio), and no. 229, pp. 235–6 (Angelo Vittorio). Also see Antonelli, *La conservazione* (above, n. 28), 10.

38. Antonelli, *La conservazione* (above, n. 28), 18–21; Incisa della Rocchetta and Vian, *Il primo processo* (above, n. 31), IV, no. 460, pp. 194–5; G. Ricciotti, 'Un episodio occorso alla salma di S. Filippo Neri', *Roma* 16 (1938), 166–8. Cf. G. Gigli, *Diario di Roma 1608–70* (ed. M. Barberito) (Rome, 1994).

39. Incisa della Rocchetta and Vian, *Il primo processo* (above, n. 31), II, no. 225, pp. 222–5 (Cesalpino), no. 226, pp. 225–7 (Porti), no. 227, pp. 227–32 (Silvestri). See also Antonelli, *La conservazione* (above, n. 28), 12–13.

40. All four cases are discussed by Incisa della Rocchetta, *Il santuario* (above, n. 29), 4–5 and 9–11.

41. On this see B. Treffers, 'Il cuore malato', in S. Rossi (ed.), *Scienza e miracoli nell'arte del '600. All'origini della medicina moderna* (Milan, 1998), 146–56.

42. J. Sawday, *The Body Emblazoned: Dissection and the Human Body in Renaissance Literature* (London, 1995).

43. On the changing iconography of anatomical illustration see the discussion by Carlino, *Books of the Body* (above, n. 10), esp. pp. 42–5.

44. French, *Dissection* (above, n. 11), frontispiece.

45. Printed in Incisa della Rocchetta and Vian, *Il primo processo* (above, n. 31), III, *Extra Urbem* no. XLII, pp. 439–45; L. Belloni, 'L'aneurisma di S. Filippo Neri nella relazione di Antonio Porto', *Istituto Lombardo di Scienze e Lettere* (*Rendiconto: Classe di Scienze* 83) (1950), 1–16. For the

report see, Incisa della Rocchetta and Vian, *Il primo processo* (above, n. 31), II, no. 225, pp. 225–7.

46. Gallonio, *La vita* (above, n. 17), 27, 119. Incisa della Rocchetta and Vian, *Il primo processo* (above, n. 31), I, no. 63, pp. 235–6; III, *Extra Urbem* no. XLI, pp. 437–9. On the interest in Neri's heart also see Siraisi, 'Signs and evidence' (above, n. 12), 368–75.

47. Siraisi, 'Autopsy and sanctity' (above, n. 12), 372–5 extensively discusses the analyses by Vittorio and Porti.

48. Walker Bynum, *Fragmentation and Redemption* (above, n. 2), 187, 266–7; H. Thurston, *The Physical Phenomena of Mysticism* (Chicago, 1952).

49. Walker Bynum, *Fragmentation and Redemption* (above, n. 2), 228. A hesitant sign of this tendency is, of course, the Church laws against dividing the corpse, for which see E.A.R. Brown, 'Death and the human body in the later Middle Ages: the legislation of Boniface VIII on the division of the corpse', *Viator* 12 (1981), 221–70.

Contesting the Sacred Heart of Jesus in late eighteenth-century Rome

Jon L. Seydl

When Pompeo Batoni painted *The Sacred Heart of Jesus* in 1767 for Rome's church of the Gesù, he established the canonical image of the cult of the Sacred Heart, reining in well over a century of cacophonous and competing representations with surprising efficiency (**Fig. 17.1**). Yet today, despite the omnipresence of Batoni's work and its continued vitality in contemporary Catholic practice, the image stands outside any meaningful historical context for many viewers, who find its sweet style and elusive iconography alienating. Twentieth-century critics have vigorously attacked this image as kitsch — extending beyond the limits of good taste in religious art and exemplifying an enervated and sentimental brand of Catholicism that lacks sincerity, intelligence and conviction.[1] Such aggressive criticism springs from a long tradition of concern over Sacred Heart imagery. Indeed, not long after this painting was installed, and countless variations and reproductions began to spread across the world, one Catholic theologian condemned a depiction of the Sacred Heart as 'one of the most horrible paintings I ever saw, which I could not look at without going pale and scaring myself half to death'.[2] Such withering criticism dogged images of the Sacred Heart of Jesus, despite the exploding popularity of the cult in the eighteenth century. This vitriol focused on an innovative iconography of the Heart of Jesus that emerged in the 1760s, which gave an embodied, tangible form to a devotion previously represented exclusively as an abstract symbol.

As Christopher Johns and Mario Rosa have observed recently, Sacred Heart devotion stood at the intersection of debates in the eighteenth century between proponents of a papal-bound, traditional church, rooted in Counter-Reformation spirituality, and advocates of a reformed Catholicism responding to the new intellectual demands of the Enlightenment.[3] Images of the Sacred Heart took centre stage in this controversy. With *The Sacred Heart of Jesus*, Pompeo Batoni (1708–87) and his patron, the Jesuit priest Domenico Maria Saverio Calvi (1714–88), forged a work that responded rigorously to fierce attacks by opponents of the cult.[4] The deceptively simple image first appears to be an unlikely target for the virulent criticism it drew from the moment of its inception. Within the small oval format, Christ stands half-length before the beholder, pulled to the front of the picture plane.[5] Christ's head and torso twist in easy, unforced *contrapposto*, an elegance enhanced by Batoni's fresh, bright palette, polished draughtsmanship and sleek handling of paint. Gently proffering a heart, to which he meaningfully gestures with his right hand, Christ is also notably marked by stigmata. Torn by a spurting gash and surmounted by a cross, a tongue of flame and a crown of thorns, the organ radiates hot, saturated yellow–white rays that surpass the halo in brightness and dominate the composition. With its glistening black background and classicizing robes, the image lacks historical specificity. It resists narrative, and instead of didactically conveying a story, the work engages the beholder in a deeply personal exchange that stands outside space and time. Christ's outward gaze, locking eyes with the beholder, cements this relationship. His elevated position and the downward sweep of his hands suggest paternal benevolence, but the mild, undemanding glance, doe-eyes, epicene body and sentimental gesture transform this connection into a more equalized, two-directional and activated relationship.

The modest scale, sweet style and precise iconography of Batoni's painting emerge as deliberate strategies by the artist and patron to address the specific events of 1765, the year that witnessed both the first official liturgy for the Sacred Heart and the subsequent assault on the cult initiated by the Augustinian theologian, Camillo Blasi (1718–85). In light of this conflict, Batoni and Calvi drew both on popular devotional imagery and high ecclesiastical art, forging an innovative image that consciously hovered between these categories and led to significant disputes among the Jesuits about the placement

and use of the painting at the Gesù. This liminal position gave Batoni's image a foothold in the church on both the popular and ecclesiastical fronts while confounding its critics, approaches that defined how the cult would spread through the end of the eighteenth century. Moreover, by shifting the iconography of the heart away from a purely emblematic symbol to a tangible, carnal organ, the image squarely addressed changing understandings of the human heart and current debates about the embodiment of Christ.

The cult of the Heart of Jesus developed out of the medieval devotion to Christ's wounds and intensified with the familiar narratives of sixteenth-century figures such as Saint Filippo Neri (1515–95) and Saint Teresa of Avila (1515–82), who emphasized the heart as a site of mystic activity.[6] The growth of the Sacred Heart as a specific devotion dovetailed with new notions of interiority developing in seventeenth-century Europe, which shifted considerations of the heart from the ethical and theological to the psychological and affective realms. These ideas in turn influenced the emotive and profoundly personal religious modes that characterized eighteenth-century religiosity.[7] Other advocates also contributed to the expansion of the cult, especially Saint Francis de Sales (1567–1622) and Saint Jeanne-Françoise de Chantal (1572–1641), who stressed the heart as the location of spiritual communication with God, and Saint Jean Eudes (1601–80), who isolated the Hearts of Mary and Jesus as specific objects of devotion.[8]

It was, however, the three visions of Saint Marguerite Marie Alacoque (1647–90), a nun in the Visitation Order at Paray-le-Monial from 1673 to 1675, that launched the specific cult of the Sacred Heart into wide circulation. In these dramatic, self-annihilating events, Christ offered Alacoque his heart — suffering pitifully from human sin — to demonstrate his selfless, charitable love and to underscore the redemption of humanity.[9] The Society of Jesus had long promoted the heart as a nexus of affective spirituality, and Alacoque's Jesuit confessor, Saint Claude de la Colombière (1641–82), grasped the significance of this devotion, fuelling the quick absorption of the cult by the order, which fiercely advocated the cause worldwide. Its early supporters, including Jean Croiset (1656–1738) and Joseph-François de Gallifet (1633–1749), transformed the devotion, consciously moving away from the most extreme aspects of Alacoque's visions, rooted in traditional Counter-Reformation mysticism, in order to emphasize the sweetness, tenderness and accessibility of the devotion.[10] Thus reformulated, the Sacred

Heart gained worldwide acceptance on a popular level by the first decades of the Settecento as a newly emotional, sentimental cult of the heart.

Official approval of the Sacred Heart none the less came slowly, as the devotion emerged as a touchstone for many key issues confronting eighteenth-century Catholicism. Proposals for an official Mass and Office for the devotion had been rebuffed by Benedict XIII Orsini (reg. 1724–30) and Benedict XIV Lambertini (reg. 1740–58), who responded to concerns that the cult represented devotional excess, novelty and a suspect brand of mysticism to those advocating a moderate, rational Catholicism.[11] Moreover, the cult's links to the Jesuits grew to dominate the debate and subsumed other concerns. Throughout the eighteenth century, absolutist monarchies in France, Spain and Portugal viewed the order's papal fealty as a dangerous threat to their hegemony, which led ultimately to the 1773 suppression of the Society of Jesus. The Sacred Heart came under suspicion as an uncontrollable, populist, Jesuit-tainted devotion, removed from the central tenets of Catholicism. Combined with the relentless assault on the Jesuits by many Catholic reformers, especially the advocates of Jansenism (the Augustinian-influenced movement that sought an austere, decentralized and deeply individual spirituality), the Sacred Heart fell into the crossfire between those advocating a church reformed along moderated, Enlightenment principles and those reaffirming a more traditional spirituality.

The events of 1765 brought the debates circling around the Sacred Heart to a fevered pitch that would not abate until the Napoleonic invasions of Italy. On 26 January, Clement XIII Rezzonico (reg. 1758–69) announced the first major official endorsement of the Sacred Heart, approving a Feast and Mass for the bishops of Poland and the Archconfraternity of the Sacred Heart of Jesus in Rome.[12] By the mid-1760s the cult had spread across the Catholic world and a ground-swell of support united the personal devotional interests of the Rezzonico family and an aggressively vocal, worldwide network of advocates that included 1,088 confraternities, 150 bishops and monarchs (including Augustus III, king of Poland, Marie Leczinska, queen of France, and Clement Francis, duke of Bavaria).[13] The significance of the papal imprimatur moreover addressed the political aims of Clement XIII. Only fifteen days prior to the approval, the pope had issued the constitution, *Apostolicum pascendi munus*, a bold reaffirmation of papal support for the Jesuits, which flew in the face of pressure from

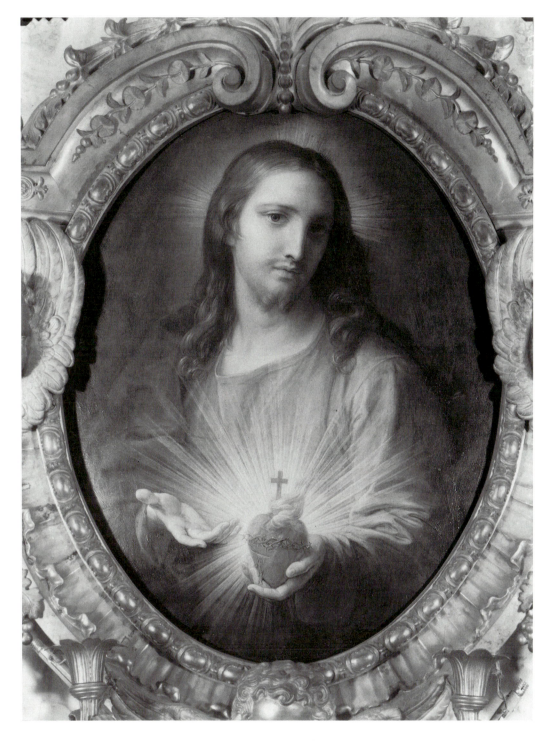

FIG. 17.1. **Pompeo Batoni (1708–87),** *The Sacred Heart of Jesus,* **1767, oil on copper, Il Gesù, Rome.** *Photo: Istituto Centrale per il Catalogo e la Documentazione, Rome, neg. no. D.6225. Reproduced courtesy of the Istituto Centrale per il Catalogo e la Documentazione, Ministero per i Beni e le Attività Culturali.*

France and Spain to abolish the order altogether.[14] Given the Jesuit stamp on Sacred Heart devotion from the late seventeenth century onward, and the increasing criticism of the cult precisely for its connection to the Society of Jesus, these twin decrees announced a

determined, conjoined stand on behalf of the central principles of the Catholic Reformation: reaffirming the international authority of the papacy and bolstering mystic, emotive spirituality, thereby rejecting outright the inroads of decentralized Enlightenment religious

ideas pursued by the supporters of Jansenism and other Catholic reformers.

In late 1765, Camillo Blasi, an Augustinian cleric who had witnessed the proceedings of the Sacred Congregation of Rites (*Sacra Congregazione dei Riti*) approving the cult earlier that year, registered his outrage against the Sacred Heart in a widely distributed tract. This text, together with the more thorough and legalistic dissertation that followed in 1771, *De festo Cordis Jesu*, unified opposition to the cult among Catholic reformers.[15] Blasi criticized the novelty of the Sacred Heart, noting its lack of biblical and patristic precedents and questioning the historical justifications constructed by the cult's adherents.

Blasi's most resonant claim was that the Sacred Heart implied a heretical rupture of Christ's body, a potent critique that would dominate subsequent discussion of the cult. According to Blasi, the approval of the Feast by the Sacred Congregation of Rites endorsed a limited devotion to the Heart of Jesus as a symbol, with the Sacred Heart representing the love of Christ and the Feast symbolically renewing divine charity.[16] He rejected any direct connection of the Sacred Heart to the Eucharist, considered by many advocates parallel sacrificial acts of the divine for the love of humanity. Above all, he repudiated the notion, enthusiastically embraced in devotional literature, that Christ offered humanity his carnal heart, which simultaneously symbolized *and* tangibly expressed his love.

Such a fundamental misreading, erroneously projected onto the newly-approved Feast, derived from an axiomatic misunderstanding about the Heart of Christ. Blasi argued that overwhelming emphasis on the heart split the holy body in parts, privileging one organ over all others. Instead, Blasi believed that the heart should be worshipped only as far as it signified metaphorically beyond the corporeal organ. Approaching the bodily heart as an object of devotion endorsed the worship of parts of Christ's body over the whole and promoted idolatry, fundamental apostasies that reopened debates of early Christianity, especially Nestorianism (which maintained the existence of two separate persons in the Incarnated Christ: one divine, the other human) and Arianism (which denied the divinity of Christ).[17] The carnal, heretical organ of Christ in his human manifestation prevailed over the figural heart of the God–Man, and the hypostatic union, which depends on the simultaneity as opposed to the separation of the human and divine, thus appeared to crumble.

The insistence on corporeality by advocates of the Sacred Heart horrified Blasi. His concern struck at the very conception of the physical organ of the heart, which itself intersected with burgeoning scientific conceptions of the body, ancient notions of human anatomy and patristic ideas about the soul. The seventeenth and eighteenth centuries witnessed tremendous scientific advances in understanding the structure of the heart, spearheaded by surgeons in Italy and based on the pioneering early seventeenth-century work of the English physiologist William Harvey, who mapped the human circulatory system and discovered the cyclical, pumping function of the heart. Harvey's ideas definitively overturned ideas about the human body, based on Aristotle and Galen, that had dominated European medicine for centuries. The ancient view, rooted in the notion of the four humours, considered heat the fundamental element of life and the heart its generative furnace. The heart transformed spirit (*pneuma*) from the lungs into the life force activating the body.[18] The new discoveries dislodged this connection of the heart to the intellect and soul. None the less, earlier notions of the heart remained powerful, and the debate remained in constant flux throughout this period. Not only did the heart as a literary trope of interiority intensify, but advocates of the Sacred Heart also played a crucial role in maintaining the Aristotelian conception of the physical heart as the seat of the soul and the well-spring of human emotion and intelligence.[19] For example, in the most widely distributed Sacred Heart devotional treatise of the eighteenth century, the Jesuit priest Joseph-François de Gallifet wholly rejected the new empirical view of the heart, arguing that the Sacred Heart was 'the principal and most noble organ of the sensible affections of our Lord ... centre of all the interior sufferings'. He tied his interpretation to ancient tradition, considering the heart the core of human life, meant 'to import to the whole body a gentle life-giving influence, which together with the vital heat conveys life and movement to all the members'.[20]

Blasi, by contrast, rejected outright any materialist reading of the organ and refused to cast the Sacred Heart of Jesus as the seat of the Lord's 'affezioni' or the location of Christ's humanity.[21] Drawing heavily on Saint Thomas Aquinas and wholly avoiding scientific discourse, Blasi separated the corporeal from the figurative: his conception of the heart bypasses flesh entirely.[22] He objected to granting the heart special status within the human body, which ranked the heart above all other organs. To distance Sacred Heart devotion from the Eucharist, Blasi further distinguished between the Blood of Christ and other internal organs,

that life springs from this organ to all the other parts.[24] While Gallifet considered love the primary emotion of the heart, Blasi posited a more intellectualized conception of love derived from Aquinas and Augustine. For Blasi, true love was not felt physically but understood in the soul, the real source of human life. The heart therefore assumed a secondary position to the soul and remained united with the rest of the physical body.[25]

The frontispiece to Blasi's volume, dedicated to the Feast of the Sacred Heart of Jesus, gives visual form to his ideas about the appropriate conception and use of the heart in Christian practice (Fig. 17.2). Writing in his study, Saint Augustine carries aloft a flaming, schematic heart inscribed with the words 'unde ardet' ('from where it burns'). Turning backwards, he witnesses a hovering triangle whose rays beam 'inde lucet' ('to where it shines') down to the saint. Heretical books by Faustus of Milevis, Donatus and Pelagius, representing mistaken ideas about the nature of Christ crushed by Augustine's writings, lie strewn on the floor.[26] This discursive image argues for the purely symbolic use of the heart and the unity of Christ's body. Much as Blasi's conception of the soul surpasses the bodily heart, the vision depicted in the print rejects the tangible for abstract, mental vision. According to Augustine, vision exists in three forms. *Corporeal* vision apprehends solely with the eyes, while *spiritual* vision incorporates the internal perception of events and objects through higher mental processes that surpass optics, such as memory or imagination. Finally, *intellectual* vision, the goal of Christian thought, eliminates any connection to sensory perception.[27] Abstract thoughts, particularly religious conceptions, come through intellectual vision. The frontispiece, with Augustine perceiving the Trinity (in the symbolic form of a triangle), depicts intellectual vision superseding optical vision and, accordingly, parallels the rejection of the tangibility of the Sacred Heart in the text. By extension, the burning heart held aloft, which refers to Augustine's writings on charity and has a long

noting that the separation of the blood from the body during the Crucifixion made it a legitimate focus of independent devotion. Other organs were never divided from the body in the narrative of Christ's life, making the devotional dismemberment inconceivable, senseless and heretical.[23] Blasi instead argued for the primacy of the soul over the concrete organ. He rejected the connection of heart and soul posited by the devotion's advocates, such as Gallifet, who maintained

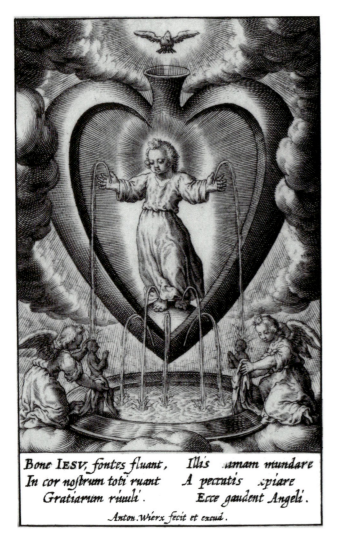

misunderstand the complex figurative language of the heart. In this way, popular spirituality, which had aggressively embraced the devotion, emerged as the contested ground.[29]

The painting devised by Batoni and Calvi stood at the hinge of this historical moment: it addressed not only the controversies swirling around the cult, but also its contested connections to the Jesuits, manifested in debates over its location and ritual use within the Gesù. These issues both determined the visual form and iconography of the painting and had a direct impact on its diffusion and popularity. Responding directly to Blasi's concerns about tangibility and carnality, the painting in the Gesù marks a crucial departure in representing the heart as a corporeal organ in religious art. Heart imagery appeared regularly from the fifteenth century onward in both northern and southern Europe, not only in the well-known and widely circulated Jesuit emblem books, but also in the more common forms of votive images and popular prints.[30] In all of these works, no matter the level of refinement or place of origin, the heart remains symbolic. The hearts resist human scale and organic accuracy, and they become anthropomorphized in the most improbable forms. Consistently they take on metaphoric meaning: the heart as a house for the soul, as a humanized embodiment of abstract ideas (Fig. 17.3), or as a symbol of the pierced side of Christ. Batoni's language of the heart stands distinct from this emblematic tradition and the new form advanced by the painting both celebrates the newly-approved cult and directly confronts Blasi's concerns.

The heart now teeters with calculated precariousness on the border between the carnal and symbolic. Despite being surmounted by its symbolic apparatus (taken from the visions of Marguerite Marie Alacoque), the heart offered to the viewer is now a pulsating, naturalistic organ, with the valves, ventricles, musculature and dripping blood rendered with unnerving accuracy. Moreover, the heart rests in Christ's hand and obscures his chest, offering no doubt that the heart has tangibly, if mysteriously, emerged from Christ's own body. The image therefore gives visual form to the thorniest problem identified by Blasi: the insistence on interpreting the heart as both corporeal and metaphorical.

While theological texts prior to Blasi discuss the simultaneous symbolic and carnal nature of the heart, the visual rhetoric of Calvi and Batoni marked a fundamental shift in the debate toward fully embracing this dual aspect of the devotion.[31] Calvi, an important Jesuit mission preacher and the primary advocate of

FIG. 17.3. Antoon Wierix (1555/59–1604), *The Christ Child as a Fountain*, from a series: *Cor Iesu amanti sacrum*, engraving. The Metropolitan Museum of Art, Harris Brisbane Dick Fund, 1951 [51.501.6296(11)] negative MM87824B. *Reproduced courtesy of the Metropolitan Museum of Art.*

history in Augustinian imagery, also must be interpreted on the level of intellectual vision, an approach that squarely rejects the carnality of the organ.[28]

The frontispiece indicates that Blasi could accept the purely symbolic use of the heart, but any materialist interpretation suggested the body of Christ and the hypostatic union torn asunder. According to Blasi, the Sacred Heart's advocates brought on a crisis of misreading in which synecdoche usurped metaphor: the carnal, heretical organ of Christ in his human manifestation overrode the figural heart of the God–Man. Over and over, Blasi feared especially for the uneducated worshipper, who would confuse the distinction between symbolic and tangible and would

the cult in eighteenth-century Italy, addressed the issue in his devotional texts, emphasizing the Sacred Heart as a symbol of Christ's love and spirit, while constantly stressing the tangibility of the organ.[32] Yet only after the advent of Batoni's painting did advocates of the devotion aggressively espouse the twin carnal-symbolic approach to the heart, fully aware of how this dual reading of the organ opened into a critique of Catholic reform and rational, Enlightened thought. Closely tied to this transformation, the discourse of opponents and supporters surrounding the Sacred Heart began at precisely this moment to use and to refer explicitly to images. These changes indicate the increasing conception of the cult in visual terms, prefigured in Calvi's devotional writings and fuelled directly by the explosion of images.[33]

The rapid diffusion, especially on the popular level, of this innovative Sacred Heart imagery required new responses from critics of the cult. Six years after the advent of Batoni's painting, Blasi amplified and recast his thesis in *De festo cultus Jesu*, a far more expansive and juridical text. The new salvo expands on theological misinterpretations and heavily bolsters its arguments with both scripture and patristics, but it also raises a new set of issues that directly attack Marguerite Marie Alacoque, other Sacred Heart visionaries and mysticism in general. Blasi now emphasized the cult as a superstitious, populist invention, almost unsalvageable for Christian practice. To prove this point, he adopted tactics honed by earlier opponents, and discredited Alacoque's visions as puerile fantasy and dismantled the early Christian genealogy of the heart claimed by its advocates. His argument thus metamorphosed from the earlier theological treatise into a broader assault on devotional practice and the affective, mystic spirituality it represents. Blasi attacked 'religione del cuore' more generally and, by implication, acknowledged ritual and devotional practice across a wider range of social levels as crucial to the spread of the devotion.

Batoni's painting played a pivotal role in spurring the shift in tone for Blasi's second treatise, *De festo cordis Jesu*, in its move from theological concerns to a broader-based attack on mysticism, embodiment and popular response. This shift also attests to the spread of the cult beyond the rarefied circles of educated theologians, and suggests that the very popularity of the Sacred Heart with a wide public required new arguments to control the devotion. However, while Blasi's tracts opened the floodgate for a torrent of polemic thrusts and counter-thrusts, including later

influential writings by the Jansenist advocates Giovanni Battista Faure (1702–79) and Scipione de Ricci (1741–1810), the battle should not be considered an exclusively textual phenomenon.[34] Batoni's image and its variants emerged in fact much earlier than any written response to Blasi and received quick and wide distribution through prints. The painting, baldly asserting the mystic, tangible heart, therefore provided the most pervasive and aggressive counter-attacks to Blasi's thesis, presented in a reproducible format designed to reach the widest possible audience.[35]

While *The Sacred Heart of Jesus* argues polemically for the embodiment of the heart, its sentimental style, small scale and oval shape all initially appear to counteract the power of the work to announce the new devotion. However, in the context of 1767, the painting needed to negotiate its contested and controversial role within the Gesù and the larger Catholic world while speaking to the Jesuit interest in popular piety. Batoni and Calvi thus designed their image of the Sacred Heart with full awareness of its subaltern status and embattled position. To commemorate a newly-endorsed cult with such a modest work departed significantly from precedent. Commanding altarpieces, conspicuous ephemera and prominent civic events generally announced recently-approved devotions in Rome, even those that attracted a significant amount of controversy.[36] Moreover, eighteenth-century Rome had inherited a long tradition of forging new iconography for canonizations and beatifications, as seen in the massive spectacle and significant paintings, sculpture and ephemeral decorations that greeted the six saints canonized in 1767, the same year as Batoni's painting in the Gesù. Even the most contested of these figures, the levitating Franciscan saint, Joseph of Copertino, had conspicuous public events held in his honour and highly visible altars dedicated to his worship, culminating in the 1779 altarpiece in Santi Apostoli by Giuseppe Cades (1750–99).[37] By contrast, visual fanfare of this sort did not greet the approval of the Sacred Heart. The cult remained visible only in ephemeral forms, mostly processional banners such as those recorded inside the Colosseum, but also in the decorative arts and small, widely distributed prints.[38] Indeed, before the 1780s, a conspicuous absence of altarpieces or large-scale works of art marked the cult in Rome, and the small, quiet work by Batoni emerged as the best-known and most visible manifestation of the devotion in that city.[39] Such a lack of authoritative, discursive public images emphasized not only the

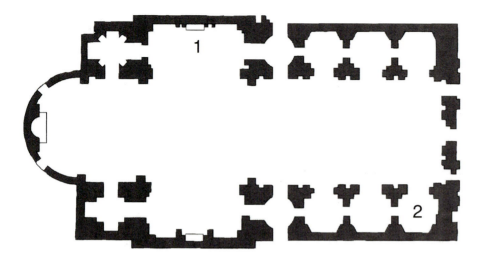

FIG. 17.4. **Plan of the Gesù, Rome.**

controversial position of the cult, but also its unsettled iconography.

The struggles among the priests of the Gesù to isolate an appropriate location for the painting reveals the anxiety and debate surrounding *The Sacred Heart of Jesus.* In 1920, the church reinstalled Batoni's oil on copper as a small, ornate altarpiece in a prominent aedicule to the right of the high altar (formerly dedicated to Saint Francis), where the work stands today.[40] This dramatically focused, shrine-like setting completely erases the picture's original, more modest placements. Prior to its present installation, the *Sacred Heart* stood in three other locations around the church before 1840. On 23 June 1767, the painting was mounted atop the altar of San Francesco Saverio, designed to fit a pre-existing oval in the altarpiece frame (**Fig. 17.4**, no. 1).[41] However, in November of that year, the image was moved to the first chapel inside the door on the left (**Fig. 17.4**, no. 2). Batoni's painting was therefore transferred from a massive chapel in the crossing (designed by Pietro da Cortona, with a major altarpiece, *The Death of Saint Francis Xavier* by Carlo Maratti) to a smaller side chapel. Daily Mass records have, furthermore, revealed the Francesco Saverio Chapel as the most active liturgical space in the Gesù during the 1760s.[42] By contrast, the new chapel had an uncertain identity and featured no important daily activities. Initially dedicated to the Apostles, the chapel also bore a dedication to Rome's patron saints, Peter and Paul. By the early eighteenth century, it was also consecrated to Saint Francesco Borgia, and the Jesuits once again rededicated the chapel in 1763, this time to the Crucifixion. Further-

more, documents referring to this space constantly switch nomenclature, pointing to a lack of consensus on the purpose of the space, which lacked a powerful patron and only received full decoration funded by the order itself in the seventeenth century.[43]

The painting's shift from the most liturgically central location of the church to the undisputed margin fostered debate in 1767 that extended over several months. Documents refer to the work being moved to its new location only after extensive discussion about an appropriate place to mount the painting and when the priests paid for the construction of an elaborate gilded frame to stand below the altarpiece in September.[44] Yet even after this installation, the chapel never received a formal (or even informal) rededication to the Sacred Heart and priests said no regular Masses at that altar. The only public ceremony occurred once a year on the actual Feast (celebrated without official sanction) and a small group of priests, including Calvi, supported the expenses themselves, rather than drawing on the general fund for liturgical materials.[45] The chapel also became increasingly used for private rituals, which were well suited to the smaller space and the small-scale image. Such evidence not only reveals new public interest in the cult, but also a desire to move the Sacred Heart out of the zone of official, public worship, a place perceived as overly provocative and potentially dangerous for the Jesuits at this precarious moment in their history. The uncertainty faced by the priests of the Gesù in finding an appropriate site to mount Batoni's painting reflects their anxious desire to site the work in a more marginal setting that downplayed full Jesuit identification with the cult. Yet, despite the evasiveness, flexibility and timelessness of the painting, the iconography provides a sophisticated theological response to the cult's sharpest critics and forges new strategies for drawing on both popular and high ecclesiastical traditions.

The Sacred Heart of Jesus, rather than drawing on the tradition of the altarpiece, derives from popular prints and devotional pictures: small-scale, simple images that connect to a personal, subaltern spirituality and stand apart from official visual language. Batoni's painting follows a mode well-established by the

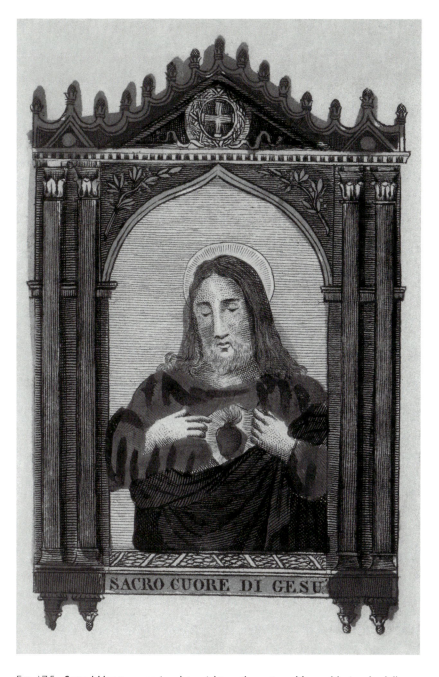

FIG. 17.5. *Sacred Heart*, engraving, late eighteenth-century, Museo Nazionale delle Arti e Tradizioni Popolari, Rome. *Photo: Museo Nazionale delle Arti e Tradizioni Popolari. © Civica Raccolta delle Stampe Achille Bertarelli, Milan. Reproduced courtesy of the Civica Raccolta delle Stampe Achille Bertarelli.*

century, linked to trends in late medieval religion, especially the rise of an individualistic, private piety that promoted the intimacy and immediacy of images with a concomitant interest in proximity to the physical body of Christ and the Virgin. These images thus present an intense empathetic psychology focused on the beholder — 'a deep emotional experience' — rather than a didactic event or theological discourse.[46] More precisely, Batoni's painting directly invokes Seicento tradition by eschewing the domestic, genre elements of the Arcadian sensibility that dominated eighteenth-century devotional painting. Instead, adopting the tender, elegant and polished style of Guido Reni, Carlo Dolci and Sassoferrato, Batoni tied *The Sacred Heart* to long-standing visual and theological traditions: its throwback mode thereby acted as a foil to concerns about the cult's novelty.

The new iconography of the Sacred Heart thus emerged in a seasoned, cherished and accomplished form, particularly important for audiences in the 1760s accustomed to seeing the cult largely in unrefined, mass-produced popular prints.[47] Batoni's painting therefore represented a distinct move toward refinement and official status, albeit one still pitched on the level of personal spirituality rather than assertive, authorized dogma. The installation of *The Sacred Heart of Jesus* at the Gesù similarly emphasizes these notions of alterity and liminality. Rather than a devotional picture or an icon installed as an altarpiece, Batoni's picture is a *sottoquadro*, a small painting designed to rest below the altarpiece or on the altar. As its installation at the Gesù reveals, such works can be positioned inside the church without the enormous cost or the public attention that greeted large-scale ecclesiastical commissions.[48] Unlike predella paintings mounted below the altarpiece to inflect the larger picture's subject, *sottoquadri*, designed for independent worship, can unofficially wrest dedications from altars and become

eighteenth century, the 'dramatic close-up', a half-length portrait adapted for devotional imagery. The format emerged from the Eastern tradition of the icon and shares its isolation in space and time. Like icons, these pictures do not simply portray the divine, but lead directly and actively to the object of worship. This genre greatly increased in popularity in the fifteenth

the site of unsanctioned rituals or alternative spiritual traditions.

Batoni was one of the few artists who could fix original iconography in the guise of authoritative religious imagery while bridging the gap between popular prints and formal ecclesiastical art. Well-known for his intense piety, Batoni, the dominant artist of his generation, often executed *gratis* small devotional pictures for religious causes he supported. Calvi's documented rapport with the painter led to at least three commissions for Sacred Heart paintings and provided the model for the priest's subsequent diffusion of the image. Above all, employing Batoni spoke of an aggressive commitment to ally the image not only with high-style ecclesiastical painting, but especially the 'intense, almost tottering spiritualization' of the artist's late religious pictures.[49]

The *sottoquadro* format, which lends itself to easy movement around the church, stood consciously between popular devotional imagery and high ecclesiastical painting. The painting allied itself instantly with popular expressions of faith far more than *recherché* theological debate. Operating without significant precedent in official visual culture, Batoni drew equally on the forms of devotional painting and the popular religious print, engaging the beholder with a simple, clear gesture and the empathetic psychology of the close-up. At the same time, Batoni resisted the blunt, often crude style associated with popular prints, and the painting stands distinct from his source material through its extraordinary elegance, characteristic of the deeply-refined mode of late Settecento ecclesiastical art, which reconstituted Seicento precedent for contemporary spiritual concerns.

Batoni adopted the cultivated style of official church art to invest his work with the authority necessary to stabilize and thus to control the devotion on the popular level, a process that led to the rapid diffusion of his typology in popular print format (**Fig. 17.5**). While *The Sacred Heart of Jesus* resembles standard devotional imagery, its subject-matter fundamentally departs from this genre, which customarily avoids narrative and pointed historical context. Batoni's image, by contrast, closely follows the account of Alacoque's first vision and embodies the devotional ideas promoted by such populist figures as Calvi, although its simple, iconic format masks these qualities.[50] The image therefore presents an unsettled, discursive theological argument in the guise of a devotional picture. By borrowing the subaltern language and mutability of popular prints and the small,

inexpensive scale of the devotional picture, the image skirted ecclesiastical control while maintaining the authority of official church painting.

The caustic debates over the Sacred Heart in the eighteenth century, as well as the specific drama of how to present the devotion at the Gesù, played out through competing conceptions of the body of Christ. Emblems provided the original visual language of the heart in the eighteenth century, and this metaphoric tradition remained prominent across the period. However, the events of 1765 demanded new visual rhetoric, capable of thwarting attacks spawned by Blasi on the carnality of Christ's heart while conveying the complex idea of the simultaneous physicality and symbology of the Sacred Heart, all the while retaining a clarity and simplicity for its broad-based audience. Calvi's religious writings united the harsh, annihilating visions of Alacoque with the overwhelming tenderness and sweetness of Christ's adorable heart, fostered by theologians such as Gallifet. In much the same way, Batoni and Calvi melded diverse visual conceptions of the heart — embodied and symbolic, metaphor and synecdoche — in the enduring image of Christ holding his tangible and figurative heart before his chest. Rational, scientific imagery of the anatomical heart, though now subverted, mystic vision and an empathetic, tender religiosity merge on the frame of Christ's body.

NOTES

I would like to thank Malcolm Campbell, Victoria C. Gardner Coates, Judith Dolkart, Christopher M.S. Johns and Daniel R. McLean for assistance and encouragement.

1. R. Egenter, *The Desecration of Christ* (Chicago, 1967), 48, 55, 100; C. McDannell, *Material Christianity: Religion and Popular Culture in America* (New Haven, 1995), 180–1, nn. 55–8.

2. '... una delle più orride pitture che giammai siano vedute, nella quale non potrebbe fissari lo sguardo senza raccapricciarsi ed impallidire lo spavento', [P.M. del Mare,] *Lettera istruttiva di un teologo romano ad una religiosa sua congiunta intorno alla divozione al Cuore di Gesù* (Rome, 1773), 58.

3. C.M.S. Johns, "That amiable object of adoration': Pompeo Batoni and the Sacred Heart', *Gazette des Beaux-Arts* 132 (July–August 1998), 19–28; M. Rosa, *Settecento religioso: politica della ragione e religione del cuore* (Venice, 1999).

4. For Calvi, see T. Termanini, *Vita e virtù del Sacerdoto Domenico Maria Saverio Calvi ...* (Parma, 1796).

5. The copper support measures 73.7 × 61 cm.

6. The key histories of the devotion remain J.-V. Bainvel, *Devotion to the Sacred Heart: the Doctrine and its History* (New York, 1924); A. Hamon, *Histoire de la dévotion au Sacré-Coeur* (Paris, 1924–39).

7. Rosa, *Settecento religioso* (above, n. 3); B. Papàsogli, *Il 'fondo del cuore': figure dello spazio interiore nel Seicento francese* (Pisa, 1991); T.A. Campbell, *The Religion of the Heart: a Study of European Religious Life in the Seventeenth and Eighteenth Century* (Columbia (SC), 1991).

8. W.M. Wright, "That which is what it is made for': the image of the heart in the spirituality of Francis de Sales and Jane de Chantal', in A. Callahan (ed.), *Spiritualities of the Heart: Approaches to Personal Wholeness in Christian Tradition* (Mawah (NJ), 1990), 143–58.

9. M.M. Alacoque, *The Autobiography of St. Marguerite Marie Alacoque* (eds Sisters of the Visitation) (Rockford (IL), 1986), 67–70, 106–7.

10. Rosa, *Settecento religioso* (above, n. 3), 34–40.

11. Rosa, *Settecento religioso* (above, n. 3), 28–33.

12. Archiconfraternità del Sacro Cuore di Gesù al San Teodoro.

13. At his *possesso*, Clement XIII devoted a benediction to the Sacred Heart. See Archivio del Vicariato, Rome, pachetto 149, tomo 101, Breve notizie istoriche della Venerabile Archiconfra. del Santissimo Cuore di Gesù, fondata in Roma ... che cominciano dall'anno 1729 a tutto l'anno corrente 1783, section 205. The Rezzonico family participated actively in the Archiconfraternità del Sacro Cuore di Gesù at San Teodoro al Palatino. For Rezzonico family devotion, see J.L. Seydl, *The Sacred Heart: Religious Imagery in Eighteenth-century Italy* (Ph.D. thesis, University of Pennsylvania, 2003); G. Pavanello, 'I Rezzonico: committenza e collezionismo fra Venezia e Roma', *Arte Veneta* 52 (1998), 86–111. Documents in support of the 1765 appeal appear in N. Nilles, *De rationibus festorum*

Ssi. Cordis Iesu et purissimi Cordis Mariae I (Innsbruck, 1875), 87–100.

14. C.M.S. Johns, 'The entrepôt of Europe: Rome in the eighteenth century', in E.P. Bowron and J.J. Rishel (eds), *Art in Rome in the Eighteenth Century* (exhibition catalogue (Philadelphia Museum of Art), London, 2000), 29.

15. C. Blasi, *Osservazioni sopra l'oggetto del culto della festa recente e particolare del SS.ᵐᵒ Cuore di Gesù* (Rome, 1765); C. Blasi, *De festo Cordis Jesu dissertatio commonitera* (Rome, 1771). For a biography of Blasi, see G. Pignatelli, 'Blasi, Camillo', in *Dizionario biografico degli italiani* 10 (Rome, 1968), 782–4.

16. Blasi, *Osservazioni* (above, n. 15), 4, 49–50.

17. Blasi, *Osservazioni* (above, n. 15), 20–1, 51 and 17, where Blasi carefully distinguished the appropriate objective for worship: 'Corpi, e le Reliquie de' Santi, e Lui stesso nel Sacramento dell'Altare: ma a modo di simbolo, che veneriamo le sacre Immagini, conforme spiega S. Tommaso ...'.

18. W. Harvey, *Exercitatio anatomica de motu cordis et sanguinis in animalibus* (Frankfurt, 1628). For the history of the heart, see R.A. Erickson, *The Language of the Heart, 1600–1750* (*New Cultural Studies*) (Philadelphia, 1997), 1–22; L. Guerrieri, *Cuore e polmone nella chirurgia attraverso i tempi* (Florence, 1966); N. Latronico (ed.), *Il cuore nella storia della medicina* (*Monografie cardiologiche* 4) (Milan, 1955). Also see Santing, Chapter Sixteen in this volume, for other early modern ideas about the heart.

19. For the heart as a location for interiority, see Papàsogli, *Il 'fondo del cuore'* (above, n. 7); E. Dubois, 'Some interpretations of the notion of 'coeur' in seventeenth-century France', *Seventeenth-Century French Studies* 9 (1987), 235–52; M. Bergamo, *L'anatomia dell'anima da François de Sales a Fénelon* (Bologna, 1991). For an alternative view, focused on early modern England, see Erickson, *The Language of the Heart* (above, n. 18).

20. J. de Gallifet, *De cultu Sacrosancti Cordis Dei ac Domini Nostri J. Christi* (Rome, 1726). English translation as *The Adorable Heart of Jesus* (Philadelphia, 1890), 58, 68–9.

21. Blasi, *Osservazioni* (above, n. 15), 7–8.

22. Blasi, *Osservazioni* (above, n. 15), 38–9.

23. Blasi, *Osservazioni* (above, n. 15), 51–2.

24. Gallifet, *De cultu Sacrosancti Cordis* (above, n. 20), 48–9, 80, 158.

25. Blasi, *Osservazioni* (above, n. 15), 14, 'questo Cuore consideriamo come una cosa inanimata ... senza aver riguardo alla spirituali cose, che gli sono ...', and earlier at p. 10, 'Eppure perchè l'anima di Gesù Cristo, a motivo dell'unione ipostatica col Verbo, non fà, come in noi, la prima, e principal figura nell'Uomo Dio, non è ella, che in ispezial modo s'onori ...'.

26. Faustus of Milevis fostered a primitive, dualistic conception of the world, rooted in Manichean thought; Donatism argued the invalidity of sacraments conferred by an unworthy minister, while Augustine argued that Christ as the true minister overrode the machinations of the human representatives of

the Church; Pelagius argued that man took key steps toward salvation without the intervention of the divine. The undated print by Pancratio Cappello reproduces a painting by Philippe de Champaigne of *c.* 1645–50 (Los Angeles County Museum of Art), although the printmaker has enhanced the discursiveness of the image by adding text. The inscription 'Charitas Dei diffusa est in cordibus nostris per Spiritum Sanctum. qui datus est nobis Ad. Rom. 3. v. 5.', links the frontispiece to Augustinian and Jansenist ideas about justification by faith. The printmaker changed the names of the authors written on the spines from Celestius, Pelagius and Julian of Eclanum in order to focus the issues more clearly on the Body of Christ via the Trinity and Communion. Seventeenth- and eighteenth-century Parisian printmakers had already adapted the painting into engravings with the band of text at the bottom stating 'unde ardet, inde lucet', surely the direct source for Cappello's work; see B. Dorival, 'Recherches sur les sujets sacrés et allégoriques gravés au XVII^e et au XVII^e siècle d'après Phillipe de Champaigne', *Gazette des Beaux-Arts* 80 (July–August 1972), 43–4.

27. Augustine, *De trinitate* VII–XV, and Augustine, *De genesi ad litteram,* especially V.

28. For Augustine on the heart, see *Confessions* 9.2. For Augustinian heart imagery see E. Kirschbaum (ed.), *Lexicon der Christlichen Ikonographie* V (Rome, 1970), col. 284. The connection of Augustine and the heart intensified across Europe in the seventeenth century. In addition to the painting by Phillipe de Champaigne cited above, see the altarpieces *Saint Augustine with the Virgin and Child,* by Bartolomeo Estaban Murillo (Museo de Bellas Artes, Seville), *Saint Augustine and Saint Monica,* by Luca Giordano (Monastery of the Incarnation, Madrid), and *The Virgin and Child with Saints Cecilia, Dorothy, Catherine of Alexandria, and Mary Magdalen,* by Gaspar de Crayer (Kunsthistorisches Museum, Vienna). For the heart as the emblem of Charity, see C. Ripa, *Iconologia overo descrittione di diverse imagini cavate dal'antichità, e di proprio inventione* (first edition Rome, 1603; reprint Hildesheim/Zürich/New York, 1984), 63–6.

29. Blasi, *Osservazioni* (above, n. 15), 46, 61, 77. G. Pozzi, 'Schola Cordis': di metafora in metonomia', in *Lombardia elvetica: studi offerti a Virgilio Gilardoni* (*Studi, testi, strumenti*) (Bellinzona, 1987), 189–226.

30. The most useful general source on the emblematic tradition of heart imagery remains M. Praz, *Studies in Seventeenth-century Imagery* (*Sussidi eruditi* 16) (Rome, 1964), 134–54. Also see J. Hamburger, *Nuns As Artists: the Visual Culture of a Medieval Convent* (Berkeley, 1997), esp. ch. 4; P. Striederi, 'Folk art sources of Cranach's woodcut of the sacred heart', *Print Review* 5 (Spring 1976), 160–6.

31. Gallifet, *De cultu Sacrosancti Cordis* (above, n. 20), 41.

32. Termanini, *Vita e virtù del Sacerdoto* (above, n. 4); D.M.S. Calvi, *Della divozione al Sacro Cuore di Gesù secondo lo spirito della Chiesa. Ragionamenti due con l'aggiunta di nove considerazioni* (Naples, 1805), 6, where, on the carnal heart, 'Questo non è un cuor metaforico, siccome è metaforica quella destra, che spuntando dalle nuvole figurava nella primitiva Chiesa la potenza di Padre Eterno. È il cuore adorabile di un Uomo, che insieme è dio ...'.

33. For the new visual rhetoric of the devotion, see the sermon by U. Tosetti in L. Preti, *Raccolta di ragionamenti in lode del Santissimo Cuore di Gesù. Parte prima dedicata alla Santità di Nostro Signore Papa Clemente XIII* (Rome, 1768), 190–208. For a critique of the visual manifestations of Sacred Heart devotion see [*alias* T. Acoristo,] 'Lettera terza ad un'amico che contiene l'estratto della Diss. *De Festo Cordis Jesu* del Signor Avvoc. Blasi', in *Lettere italiane aggiunte all'antirretico in difesa della dissertatione commonitoria dell'Avvocato Camillo Blasi sopra l'adorazione, e la festa del Cuore di Gesù* (Rome, 1772), 193, 198–200.

34. [G. Faure,] *Biglietti confidenziali critici contra il libro del Sig. Camillo Blasi ...* (Venice, 1772); S. de Ricci, *Istruzione pastorale di Monsignor Vescovo di Pistoja e Prato sulla nuova devozione al Cuor di Gesù* (Brescia, 1781).

35. The textual battles raging across the last quarter of the century only began in earnest after the publication of Blasi's second book, a gap explained only in part by the ardent support of the Sacred Heart by Clement XIII, which restrained the printing of accounts hostile to the devotion. Only during the papacy of Clement XIV Ganganelli (reg. 1769–74) — a figure less personally invested in the Sacred Heart and certainly less protective of the Jesuits — could the devotion be attacked more freely. The first real textual responses to Blasi emerged only in 1771–2. Critiques of Blasi include the author of *Lettera di un villeggiante ad un amico di città per avergli mandato il libro contro la Festa del Sacro Cuore* (Florence, 1771); B. Tetamo, *De vero cultu et festo sanctissimi cordis Jesu adversus Camilli Blasii commonitoriam dissertationem apologeticus Benedicti Tetami* (Venice, 1772). Early texts supporting Blasi include A.A. Giorgi, *Christotimi Ameristae* [pseud.] *adversus epistolas duas ab anonymo censore in dissertationem Camilli Blasi De Festo Cordi Jesu antirrheticus* (Rome, 1772); *Lettere italiane aggiunte all'antirretico in difesa della dissertatione commonitoria dell'Avvocato Camillo Blasi sopra l'adorazione, e la Festa del Cuore di Gesù* (Rome, 1772). By the following year, the bibliography on the issue had swelled enormously and continued unabated for years.

36. Consider the Immaculate Conception. Several Roman altarpieces, including that of Carlo Maratti for the 1687 Cybo Chapel in Santa Maria del Popolo, marked the stages in the papal endorsement of the cult, whose status remained challenged and unsettled throughout this period. See É. Mâle, *L'art réligieux après le Concile de Trente. Étude sur l'iconographie de la fin du XVI^e siècle, du XVII^e, du XVIII^e siècle* (Paris, 1932), 38–48; M. Levi d'Ancona, *The Iconography of the Immaculate Conception in the Middle Ages and the Early Renaissance* (*Monographs on Archaeology and Fine Arts* 7) (New York, 1957); Kirschbaum (ed.), *Lexicon* (above, n. 28), II, cols 338–44.

37. Clement XIII canonized Joseph Calasanz, Jeanne-Françoise de Chantal, Joseph of Copertino, Jan Kanty, Girolamo Maini and

Serafino da Montegranaro on 16 July 1767. For Settecento canonization and beatification ceremonies, see V. Casale, 'Gloria ai beati e ai santi: le feste di canonizzazione' and 'Addobbi per beatificazioni e canonizzazione', in M. Fagiolo (ed.), *La festa a Roma: dal Rinascimento al 1870* (Turin/ Rome, 1997), I, 124–41; II, 56–65. Taken together, these figures indicate a Rezzonico endorsement of figures representing a range of devotions opposed by enlightened Catholicism: Jeanne-Françoise de Chantal founded the Visitation Order and wrote extensively on a spirituality of the heart. The populist figures Girolamo Maini and Serafino da Montegranaro endorsed monasticism. Most importantly, Joseph of Copertino represented a populist, anti-Enlightenment spirituality under attack in these years.

38. For the Colosseum *palliotti*, see Johns, 'The entrepôt of Europe' (above, n. 14), 29.

39. The sole exception, the altarpiece commissioned from Giuseppe Adrizzoia by the Archconfraternity of the Sacred Heart of Jesus for San Teodoro al Palatino, remained out of the public eye and virtually ignored. See Seydl, *The Sacred Heart* (above, n. 13), for more on this organization and their representations of the Sacred Heart.

40. For this chapel, see C. Galassi Paluzzi, 'Nota di storia e d'arte su le cappelle e gli altri del Gesù', *Roma* (1929), 303–8, 385–94; C. Galassi Paluzzi, 'La Capella del S. Cuore al Gesù', *Roma* 9 (1931), 65–8; A. Dionisi, *Il Gesù di Roma: breve storia e illustrazione della prima chiesa eretta dalla Compagnia di Gesù* (Rome, 1982), 75–7.

41. MS, Archivium Romanum Societatis Iesu, Rome [hereafter *ARSI*], Catalogo dei volumi riguaranti la Ven. Chiesa del Gesù, doc. 2041; Diario della Chiesa e Sagrestia del Gesù (1763–1773), entries for June 23, 1767, and September 26, 1767.

42. MS, *ARSI* (above, n. 41), busta VII, see docs 801, 802.

43. For this chapel, see Istituto di Studi Romani (ed.), *Il Gesù (Le chiese di Roma* 16) (Rome, 1947); P. Pecchai, *Il Gesù di Roma: descritto e illustrato* (Rome, 1952), 94; Galassi Paluzzi, 'Nota di storia' (above, n. 40), 385.

44. See n. 40. September 26, 1767: 'A dì 26 d:o Sabato coll'assenso del N. Padre Senezali fù collocato il Ritratto del S:mo Salvatore in onore del Cuore di Gesù nell'Altare de SS:i Apostoli Pietro, e Paolo, dopo essersi molto consultato qual luogo fusse più proprio per questa S:ta immagine', and *ARSI* (above, n. 41), Catalogo dei volumi riguaranti la Ven. Chiesa del Gesù, doc. 2022; Libro entrate e uscite anni 1756–1767. November 1767: 'All'Intagliatore, Indoratore, Ferzar, e Falganame per collocare all'Alt.e del S.S. Pietro, e Paolo il Ritratto del S:mo/Cuore di Gesù–2:80'.

45. MS, *ARSI* (above, n. 41), Catalogo dei volumi riguaranti la Ven. Chiesa del Gesù, doc. 2022, Libro entrate e uscite anni 1756–1767, July 1768; Catalogo dei volumi riguaranti la Ven. Chiesa del Gesù, doc. 2023, Libro entrate e uscite anni 1767–1773, July 1768, July 1769.

46. S. Ringbom, *Icon to Narrative: the Rise of the Dramatic Close-up in Fifteenth-century Devotional Painting* (Doornspijk, 1984), 15–19, 23–30, 39–40, 47–50.

47. E. Gulli Grigioni, *Schola Cordis: amore sacro e profano, devozioni, pellegrinaggi, pregheria, attraverso il simbolismo del cuore in immagini e oggetti europei. Secoli XVII–XX prima metà* (Ravenna, 2000).

48. New altarpieces customarily received considerable public attention, including that of the press. The Roman weekly *Diario ordinario* constantly announced the debut of major religious pictures, but rarely mentioned small devotional works. See Associazione Culturale Alma Roma (ed.), *Chracas, diario ordinario (di Roma). Sunto di notizie e indici* (Rome, 1997–9).

49. A.M. Clark, *Pompeo Batoni: a Complete Catalogue of his Works with an Introductory Text* (Oxford, 1985), 20, 22, 60, n. 29, 305–6; A.M. Clark, *Studies in Eighteenth-century Roman Painting* (Washington, 1981), 111; Termanini, *Vita e virtù del Sacerdoto* (above, n. 4), 130, 234.

50. Alacoque, *The Autobiography of St. Marguerite Marie Alacoque* (above, n. 9), 67–8.

Y.-M. Duval (ed.), *Ambroise de Milan. XVI^e centenaire de son élection épiscopale* (Paris, 1974), 9–66.

Dwelly, E., *The Illustrated Gaelic–English Dictionary* (Glasgow, 1971).

Dyer, J., 'Prolegomena to a history of music and liturgy at Rome in the Middle Ages', in G. Boone (ed.), *Essays on Medieval Music in Honor of David G. Hughes* (*Isham Library Papers* 4) (Cambridge (MA), 1995), 87–115.

Dyer, J., 'Double offices at the Lateran in the mid-twelfth century', in J. Daverio and J. Ogasapian (eds), *The Varieties of Musicology: Essays in Honor of Murray Lefkowitz* (Warren (MI), 2000), 27–46.

Dykmans, M., *L' oeuvre de Patrizi Piccolomini, ou le cérémonial papal de la première renaissance*, 2 vols (*Studi e testi* 293–4) (Vatican City, 1980–2).

Dykmans, M., *Le cérémonial papal de la fin du moyen âge à la renaissance: IV: le retour à Rome, ou le cérémonial de Pierre Ameil* (Brussels, 1985).

Eck, W., 'The Bar Kokhba revolt: the Roman point of view', *Journal of Roman Studies* 89 (1999), 76–89.

Edgerton, S.Y., 'A little-known 'purpose of art' in the Italian Renaissance', *Art History* 2 (1979), 45–61.

Edwards, C., *Writing Rome: Textual Approaches to the City* (Cambridge, 1996).

Edwards, C., 'The suffering body: philosophy and pain in Seneca's *Letters*', in J.I. Porter (ed.), *Constructions of the Classical Body* (Ann Arbor, 1999), 252–68.

Edwards, C., 'Performing the self: some death scenes', in E. Hall and P. Easterling (eds), *Greek and Roman Actors* (Cambridge, 2002), 379–96.

Edwards, C. 'Incorporating the alien: the art of conquest', in C. Edwards and G. Woolf (eds), *Rome the Cosmopolis* (Cambridge, 2003), 44–70.

Edwards, M.J., 'The Clementina: a response to the pagan novel?', *Classical Quarterly* 42 (1992), 459–74.

Egenter, R., *The Desecration of Christ* (Chicago, 1967).

Ehrman, J., 'Massacre and persecution pictures in sixteenth-century Paris', *Journal of the Warburg and Courtauld Institutes* 8 (1945), 195–9.

Eimer, G., *La Fabbrica di Sant'Agnese in Navona: Römische Architekten, Bauherren und Handwerker im Zeitalter des Nepotismus*, 2 vols (Stockholm, 1971).

Englen, A., 'La difesa delle immagini intrapresa dalla Chiesa di Roma nel IX secolo: note sulla lettera di Papa Pasquale I all'imperatore Leone V l'Armeno', in A. Englen (ed.), *Caelius I Santa Maria in Domnica, San Tommaso in Formis e l'area circostante* (*Palinsesti Romani* 1) (Rome, 2003), 257–84.

Erickson, R.A., *The Language of the Heart, 1600–1750* (*New Cultural Studies*) (Philadelphia, 1997).

Ernout, A. and Meillet, A., *Dictionnaire étymologique de la langue latine* (Paris, 1959).

Eusebius, *The Ecclesiastical History and the Martyrs of Palestine* (trans. H.J. Lawlor and J.E.L. Oulton) (London, 1927).

Eustachio, Bartolomeo, *Opuscula anatomica* (Venice, 1563).

Fabroni, A., *Historiae Academiae Pisanae*, 3 vols (Pisa, 1791–5).

Farinacci, P., *Praxis et theoria criminalis* (Venice, 1595).

Farmer, S., 'The beggar's body: intersections of gender and social status in high medieval Paris', in S. Farmer and B.H. Rosenwein (eds), *Monks and Nuns, Saints and Outcasts: Religion in Medieval Society: Essays in Honour of Lester K. Little* (Ithaca/London, 2000), 153–71.

Farmer, S. and Rosenwein, B.H. (eds), *Monks and Nuns, Saints and Outcasts: Religion in Medieval Society: Essays in Honour of Lester K. Little* (Ithaca/London, 2000).

[Faure, G.,] *Biglietti confidenziali critici contra il libro del Sig. Camillo Blasi ...* (Venice, 1772).

Federici, V., 'La notitia martyrum di Santa Prassede', *Bullettino dell'Archivio Paleografico Italiano* 8 (1949), 25–38.

Feldman, L.H., *Jew and Gentile in the Ancient World: Attitudes and Interactions from Alexander to Justinian* (Princeton, 1993).

Feldman, L.H. and Reinhold, M., *Jewish Life and Thought Among Greeks and Romans: Primary Readings* (Edinburgh, 1996).

Ferris, I.M., *Enemies of Rome: Barbarians through Roman Eyes* (Phoenix Mill, 2000).

Ferrua, A., 'Il catalogo dei martiri di Santa Prassede', *Atti della Pontificia Accademia Romana di Archeologia. Rendiconti* 30–1 (1957–8), 129–40.

Ferrua, A., 'Un nuovo cubiculo dipinto della via Latina', *Rendiconti della Pontificia Accademia Romana di Archeologia* 45 (1972–3), 171–87.

Finaldi, G. (ed.), *The Image of Christ* (exhibition catalogue (National Gallery, London), London, 2000).

Finkelpearl, E., *Metamorphosis of Language in Apuleius* (Ann Arbor, 1998).

Firpo, G., 'L'imperatore circonciso (Dio Cassius 79; *Jer. Meg.* 1.11) e la pace religiosa delle età antonina e severiana', *Miscellanea Greca et Romana* 11 (1987), 145–87.

Firpo, G., 'Considerazioni sull'evoluzione della normativa relativa alla circoncisione tra Adriano e l'età severiana', *Miscellanea Greca et Romana* 12 (1987), 163–82.

Firpo, L., 'Esecuzioni capitali in Roma (1567–1671)', in *Eresia e riforma nell'Italia del Cinquecento* (Florence/Chicago, 1974), 307–42.

Fittschen, K. and Zanker, P., *Katalog der Römischen Porträts in den Capitolinischen Museen und den Anderen Kommunalen Sammlungen der Stadt Rom 1. Kaiser- und Prinzenbildnisse* (Mainz, 1985).

Florescu, F.B., *Die Trajanssäule: das Siegendenkmal von Adamklissi* (Bucharest/Bonn, 1965).

Flory, M.B., 'Livia and the history of public honorific statues for women in Rome', *Transactions of the American Philological Association* 123 (1993), 287–308.

Flower, H., *Ancestor Masks and Aristocratic Power in Roman Culture* (Oxford, 1996).

Flower, H., 'Rethinking *damnatio memoriae*: the case of Cn. Piso Pater in A.D. 20', *Classical Antiquity* 17 (1998), 155–86.

Foley, H. (ed.), *Records of the Province of the Society of Jesus*, 7 vols (London, 1878).

Foley, H.P., 'Marriage and sacrifice in Euripides' Iphigenia in Aulis', *Arethusa* 15 (1982), 159–80.

Forberg, F.K., *Manuel d' érotologie classique* (trans. A. Bonneau) (Paris, 1906).

Foucault, M., *Madness and Civilization: a History of Insanity in the Age of Reason* (London, 1971).

Foucault, M., *The Birth of the Clinic: an Archaeology of Medical Perception* (New York, 1973).

Foucault, M., *Discipline and Punish: the Birth of the Prison* (London, 1977).

Fowden, G., *The Egyptian Hermes* (Cambridge, 1986).

Foxe, J., *Actes and Monuments of Matters Most Speciall and Memorable, Happenyng in the Church, with an Universall History of the Same ...* (London, 1563).

Franchi de' Cavalieri, P., *La leggenda di S. Clemente papa e martiri* (*Studi e testi* 27) (Rome, 1915).

Franchi de' Cavalieri, P., 'Sant'Agnese nella tradizione e nella leggenda', in P. Franchi de' Cavalieri, *Scritti agiografici* (*Studi e testi* 221) (Vatican City, 1962), 293–379.

Fredriksen, P., 'Judaism, the circumcision of Gentiles, and apocalyptic hope: another look at *Galatians* 1 and 2', *Journal of Theological Studies* 42 (1991), 532–64.

Fredriksen, P., '*Secundum Carnem*: history and Israel in the theology of Saint Augustine', in W. Klingshirn and M. Vessey (eds), *The Limits of Ancient Christianity: Essays on Late Antique Thought and Culture in Honor of R.A. Markus* (Michigan, 1999), 37–9.

Freedberg, D., 'The representation of martyrdoms during the early Counter-Reformation in Antwerp', *The Burlington Magazine* 118 (1976), 128–38.

Freedberg, D., *The Power of Images: Studies in the History and Theory of Response* (Chicago/London, 1989).

French, R., *Dissection and Vivisection in the European Renaissance* (Aldershot, 1999).

Frugoni, C., *Francesco e l'invenzione delle stimmate* (Turin, 1993).

Frutaz, A.P., *Il complesso monumentale di Sant'Agnese* (Rome, 1969).

Fuchs, M., Liverani, P. and Santoro, P., *Il teatro e il ciclo statuario giulio-claudio* (*Caere* II) (Rome, 1989).

Fuchs, M., 'Besser als sein Ruf', *Boreas* 20 (1997), 83–96.

Gager, J.A., *The Origins of Anti-Semitism: Attitudes toward Judaism in Pagan and Christian Antiquity* (Oxford, 1983).

Galassi Paluzzi, C., 'Nota di storia e d'arte su le cappelle e gli altri del Gesù', *Roma* (1929), 303–8, 385–94.

Galassi Paluzzi, C., 'La Capella del S. Cuore al Gesù', *Roma* 9 (1931), 65–8.

Galinsky, G.K., *Augustan Culture* (Princeton, 1998).

Gallifet, J. de, *De cultu Sacrosancti Cordis Dei ac Domini Nostri J. Christi* (Rome, 1726).

Gallifet, J. de, *The Adorable Heart of Jesus* (Philadelphia, 1890).

Gallonio, A., *Trattato de gli instrumenti di martirio, e delle varie maniere di martiriorare usate da' gentili contro cristiani, descritte et intagliate in rame: opera di Antonio Gallonio romano sacerdote dell congregatione dell'oratorio* (Rome, 1591).

Gallonio, A., *Historia delle sante vergini romane con varie annotatione e con alcune vite brevi de' santi parenti loro* (Rome, 1593).

Gallonio, A., *De SS. Martyrum Cruciatibus/Antonii Gallonii rom: congregationis oratoriii presbyteri/liber/quo posissimum instrumenta, & modi, quibus idem CHRISTI martyres olim torquebantur, accuratissime tabellis expressa describuntur* (Rome, 1594).

Gallonio, A., *Historia della divotissima a spiritualissima vergine di Giesu Christo, Helena nobilissima romana di casa Massimi* (Rome, 1857).

Gallonio, A., *La vita di San Filippo Neri pubblicata per la prima volta nel 1601* (ed. M.T. Bonadonna Russo) (Rome, 1995).

Gandolfo, F., 'Gli affreschi di San Saba', in *Fragmenta picta: affreschi e mosaici staccati del medioevo romano* (exhibition catalogue (Castel Sant'Angelo, Rome), Rome, 1989).

Gardner, J., *The Tomb and the Tiara: Curial Tomb Sculpture in Rome and Avignon in the Later Middle Ages* (Oxford, 1992).

Garland, R., *The Greek Way of Death* (London, 1985).

Garland, R., *The Eye of the Beholder: Deformity and Disability in the Graeco-Roman World* (Ithaca/New York, 1995).

Garrucci, R., *Vetri ornati di figure in oro* (Rome, 1864).

Geary, P., *Furta Sacra: Thefts of Relics in the Central Middle Ages* (second edition; Princeton, 1990).

Geiger, J., *Cornelius Nepos and Ancient Political Biography* (*Einzelschriften* 47) (Stuttgart, 1985).

Gere, J.A. and Pouncey, P., *Italian Drawings in the Department of Prints and Drawings in the British Museum: Artists Working in Rome c. 1550 to c. 1640* (London, 1983).

Geremek, B., *Inutiles au monde. Truands et misérables dans l'Europe moderne (1350–1600)* (Paris, 1980).

Geremek, B., *The Margins of Society in Late Medieval Paris* (Cambridge, 1987).

Geremek, B., *Poverty: a History* (Oxford, 1994).

Gergel, R., 'Costume as geographic indicator: barbarians and prisoners on cuirassed statue breastplates', in J.L. Sebesta and L. Bonfante (eds), *The World of Roman Costume* (Madison (WI), 1994), 199–203.

Ghedini, F., *Giulia Domna tra Oriente e Occidente: le fonti archeologiche* (Rome, 1984).

Giesey, R.E., *Le roi ne meurt jamais* (Paris, 1987).

Gigli, G., *Diario di Roma 1608–70* (ed. M. Barberito), 2 vols (Rome, 1994).

Gill, M.J., 'Death and the cardinal: the two bodies of Guillaume d'Estouteville', *Renaissance Quarterly* 54 (2001), 347–88.

Giorgi, A.A., *Christotimi Ameristae* [pseud.] *adversus epistolas duas ab anonymo censore in dissertationem Camilli Blasi De Festo Cordi Jesu antirrheticus* (Rome, 1772).

Glare, P.G.W., *Oxford Latin Dictionary* (Oxford, 1976).

Gleason, M., *Making Men: Sophists and Self-presentation in Ancient Rome* (Princeton, 1995).

Gleason, M., 'Truth contests and talking corpses', in J.I. Porter (ed.), *Constructions of the Classical Body* (Ann Arbor, 1999), 295–7.

Goffen, R., *Spirituality in Conflict: Saint Francis and Giotto's Bardi Chapel* (University Park (PA), 1988).

Joplin, P.K., 'Ritual work on human flesh: Livy's Lucretia and the rape of the body politic', *Helios* 17 (1990), 51–70.

Jounel, P., 'Le culte collectif des saints à Rome du VII^e au IX^e siècle', in *Le Jugement, le ciel et l'enfer dans l'histoire du christianisme* (*Publications du Centre de Recherches d'Histoire Religieuse et d'Histoire des Idées* 12) (Angers, 1989), 19–31.

Jucker, H., 'Caligula', *Arts in Virginia* 13.2 (1973), 17–25.

Jucker, H., 'Iulisch-claudische Kaiser- und Prinzenporträts als 'Palimpseste'', *Jahrbuch des Deutschen Archäologischen Instituts* 96 (1981), 236–316.

Juster, J., *Les Juifs dans l'empire romain: leur condition juridique, économique et sociale* (Paris, 1914).

Kaftal, G., 'The fabulous life of a saint', *Mitteilungen des Kunsthistorischen Institutes in Florenz* 17 (1973), 123–8.

Kajanto, I., *The Latin Cognomina* (*Commentationes humanorum litterarum* 36.2.1–4) (Helsinki, 1965).

Kamesar, A., *Jerome, Greek Scholarship and the Hebrew Bible* (Oxford, 1993).

Kampen, N.B., 'Between public and private: women as historical subjects in Roman art', in S.B. Pomeroy (ed.), *Women's History and Ancient History* (Chapel Hill, 1991), 218–48.

Kantorowicz, E.K., *The King's Two Bodies* (Princeton, 1957).

Kaplan, E.A., 'Is the gaze male?', in A. Snitow, C. Stansell and S. Thompson (eds), *Desire: the Politics of Sexuality* (London, 1983), 321–38.

Karlin-Hayter, P., 'L'adieu à l'empéreur', *Byzantion* 61 (1991), 112–55.

Kee, H.C., *Miracle in the Early Christian World* (New Haven, 1983).

Keith, A.M., *Engendering Rome: Women in Latin Epic* (Cambridge, 2000).

Kellum, B., 'Sculptural programs and propaganda in Augustan Rome: the Temple of Apollo on the Palatine', in R. Winkes (ed.), *The Age of Augustus* (Providence, 1985), 169–76.

King, H., *Hippocrates' Woman: Reading the Female Body in Ancient Greece* (London/New York, 1998).

King, R.M. (ed.), *The Execution of Justice in England by William Cecil and a True, Sincere, and Modest Defense of English Catholics by William Allen* (New York, 1965).

Kinney, D., 'Spolia: *damnatio* and *renovatio memoriae*', *Memoirs of the American Academy in Rome* 42 (1997), 117–48.

Kirby, V., *Telling Flesh: the Substance of the Corporeal* (New York, 1997).

Kirschbaum, E. (ed.), *Lexicon der Christlichen Ikonographie*, 8 vols (Rome, 1970).

Kitzinger, E., *The Mosaics of Monreale* (Palermo, 1960).

Kleiner, D.E.E., *Roman Sculpture* (New Haven/London, 1992).

Kolmer, L. (ed.), *Der Tod des Mächtigen. Kult und Kultur des Todes Spätmittelalterlicher Herrscher* (Paderborn, 1997).

Kondic, V., 'Two recent acquisitions in Belgrade museums', *Journal of Roman Studies* 63 (1973), 47–9.

Korrick, L., 'On the meaning of style: Nicolò Circignani in Counter–Reformation Rome', *Word and Image* 15.2 (1999), 170–88.

Koshi, K., *Die Frühmittelalterlichen Wandmalereien der St. Georgskirche zu Oberzell auf der Bodenseeinsel Reichenau*, 2 vols (Berlin, 1999).

Krautheimer, R., 'The Carolingian revival of early Christian architecture', *Art Bulletin* 24.1 (1942), 1–38.

Krautheimer, R., 'Postscript', in *Early Christian, Medieval, and Renaissance Art* (New York, 1969), 254–6.

Krautheimer, R., 'Postkript 1987', in *Ausgewählte Aufsätze zur Europäischen Kunstgeschichte* (Cologne, 1988), 272–6.

Krautheimer, R., Corbett, S. and Frankl, W., *Corpus Basilicarum Christianarum Romae*, 5 vols (New York/Vatican City, 1937–77).

Krug, A., *Heilkunst und Heilkult: Medizin in der Antike* (Munich, 1985).

Kruger, K., *Der Frühe Bildkult des Franziskus in Italien: Gestalt- und Funktionswandel des Tafelbildes im 13. und 14. Jahrhundert* (Berlin, 1992).

Kuefler, M., *The Manly Eunuch: Masculinity, Gender Ambiguity and Christian Ideology in Late Antiquity* (Chicago, 2001).

Kunzle, D., *The Early Comic Strip: Narrative Strips and Picture Stories in the European Broadsheet from c. 1450 to 1825*, 2 vols (Berkeley, 1973).

Kuttner, A., *Dynasty and Empire in the Age of Augustus: the Case of the Boscoreale Cups* (Berkeley, 1995).

Kyle, D.G., *Spectacles of Death in Ancient Rome* (London, 1998).

Kyle, D.G., *Spectacles of Death in Ancient Rome* (London, 2001).

Lane Fox, R., *Pagans and Christians* (London, 1998).

Langdon, H., *Caravaggio: a Life* (London, 1998).

Langslow, D.R., *Medical Latin in the Roman Empire* (Oxford, 2000).

Laqueur, T., *Making Sex: Body and Gender from the Greeks to Freud* (Harvard, 1990).

Latronico, N. (ed.), *Il cuore nella storia della medicina* (*Monografie cardiologiche* 4) (Milan, 1955).

Leander Touati, A.-M., *The Great Trajanic Frieze: the Study of a Monument and the Mechanism of Message Transmission in Roman Art* (*Acta Instituti Romani Regni Sueciae* 4.45) (Stockholm, 1987).

Leclercq, H., 'Laurent', in F. Chabrol and H. Leclercq (eds), *Dictionnaire d'archéologie Chrétienne et de liturgie*, 15 vols (Paris, 1907–53), VIII (1929), 2.

Lector, L., *Le conclave: origines, histoire, organisation ancienne et moderne* (Paris, 1894).

Lendon, J.F., 'Homeric vengeance and the outbreak of Greek wars', in H. van Wees (ed.), *War and Violence in Ancient Greece* (London, 2000), 3–11.

Lepper, F. and Frere, S.S., *Trajan's Column* (Gloucester, 1988).

Leti, G., *Itinerario della corte di Roma*, 3 vols (Valenza, 1675).

Lettera di un villeggiante ad un amico di città per avergli mandato il libro contro la Festa del Sacro Cuore (Florence, 1771).

Lettere italiane aggiunte all'antirretico in difesa della dissertatione commonitoria dell'Avvocato Camillo Blasi sopra l'adorazione, e la Festa del Cuore di Gesù (Rome, 1772).

Levi, P., *Virgil: his Life and Times* (London, 1998).

Levi d'Ancona, M., *The Iconography of the Immaculate Conception in the Middle Ages and the Early Renaissance* (*Monographs on Archaeology and Fine Arts* 7) (New York, 1957).

Lewine, M.J., *The Roman Church Interior 1527–1580* (Ph.D. thesis, Columbia University, 1960).

Lewis, N., *Life in Egypt Under Roman Rule* (Oxford, 1983).

Lexicon Iconographicum Mythologiae Classicae, 7 vols (Zurich, 1981–94).

Leyerle, B., 'John Chrysostom on the gaze', *Journal of Early Christian Studies* 1 (1993), 159–73.

Lieu, J., 'History and theology in Christian views of Judaism', in J. Lieu, J. North and T. Rajak (eds), *The Jews Among Pagans and Christians in the Roman Empire* (London/New York, 1992), 79–96.

Linder, A., *The Jews in Roman Imperial Legislation* (Detroit, 1987).

Lindman, J.M. and Tarter, M.L. (eds), *A Centre of Wonders: the Body in Early America* (Ithaca, 2001).

Little, L.K., 'Evangelical poverty, the new money economy and violence', in D. Flood (ed.), *Poverty in the Middle Ages* (Werl/Westphalia, 1975), 11–26.

Little, L.K., *Religious Poverty and the Profit Economy in Medieval Europe* (London, 1978).

Llewellyn, P., 'The Roman church during the Laurentian schism: priests and senators', *Church History* 45 (1976), 417–27.

Loades, D. (ed.), *John Foxe and the English Reformation* (Cambridge, 1997).

Loarte, G., *The Exercise of a Christian Life* (London, 1579).

Loewe, G. and Goetz, G. (eds), *Corpus glossariorum latinorum*, 7 vols (Leipzig, 1888–1923).

Longhurst, R., *Bodies: Exploring Fluid Boundaries* (London, 2001).

L'Orange, H.P. and von Gerkan, A., *Der Spätantike Bildschmuck des Konstantinsbogen* (Berlin, 1939).

Loraux, N., *Tragic Ways of Killing a Woman* (trans. A. Forster) (London, 1987).

Loraux, N., *The Experiences of Tiresias: the Feminine and the Greek Man* (Princeton, 1995).

Lucrezi, F., '*CTH* 16.9.2: diritto romano-cristiano e antisemitismo', *Labeo* 40 (1994), 220–34.

Luzzatto, S., *La mummia della Repubblica. Storia di Mazzini imbalsamato, 1872–1946* (Milan, 2001).

Mackie, G., 'The Zeno chapel: a prayer for salvation', *Papers of the British School at Rome* 62 (1989), 172–99.

Maderna, C., *Iuppiter Diomedes und Merkur als Vorbilder für Römische Bildnisstatuen* (*Archäologie und Geschichte* 1) (Heidelberg, 1988).

Malagola, C. (ed.), *Statuti dell'Università e dei Collegi dello Studio Bolognese* (Bologna, 1888).

Malamud, M.A., *Poetics of Transformation: Prudentius and Classical Mythology* (London, 1989).

Malamud, M.A., 'Making a virtue of perversity: the poetry of Prudentius', *Ramus* 19 (1990), 64–88.

Mâle, É., *L'art réligieux après le Concile de Trente. Étude sur l'iconographie de la fin du XVI^e siècle, du XVII^e, du XVIII^e siècle* (Paris, 1932).

Mâle, É., *L'art religieux de la fin du XVI^e siècle, du XVII^e siècle et du XVIII^e siècle* (Paris, 1951).

Mâle, É., *The Gothic Image: Religious Art in France of the Thirteenth Century* (New York, 1972).

Mango, C., 'Antique statuary and the Byzantine beholder', *Dumbarton Oaks Papers* 17 (1963), 55–75.

Marcus, J., 'The circumcision and the uncircumcision in Rome', *New Testament Studies* 35 (1989), 67–81.

Marini, G.L., *Degli archiatri pontifici* (Rome, 1784).

Marotta, V., *Politica imperiale e culture periferiche nel mondo romano: il problema della circoncisione* (Naples, 1985).

Marrou, H., *Saint Augustin et la fin de la culture antique* (Paris, 1958).

Martin, G., *Roma sancta* (ed. G.B. Parks) (Rome, 1969) (originally published 1581).

'The martyrs' picture', *The Venerabile* 4 (1930), 383–7 and 6 (1934), 433–9.

Marucchi, O., *Epigrafia cristiana* (Milan, 1910).

Mattern, S.P., *Rome and the Enemy: Imperial Strategy in the Principate* (Berkeley, 1999).

Mattingly, H., *Coins of the Roman Empire in the British Museum*, 5 vols (London, 1923–50).

Mauck, M., 'The mosaic of the triumphal arch of Santa Prassede: a liturgical interpretation', *Speculum* 62 (1987), 813–28.

Mayer, C., 'Circumcisio', in *Augustinus-Lexikon*, 2 vols (Basel, 1986–96), I (1986), 936–9.

Mayer, G., 'Circumcision', in G.J. Botterweck, H. Ringgren and H.J. Fabry (eds), *Theological Dictionary of the Old Testament*, 11 vols (trans. D.W. Stott) (Grand Rapids (MI)/Cambridge, 1997–2001), VIII (1997), 158–9.

Mayne, J., *Cinema and Spectatorship* (London, 1993).

McCann, A.M., 'Beyond the classical in third century portraiture', in H. Temporani (ed.), *Aufstieg und Niedergang der Römischen Welt* 2.12.2 (Berlin, 1981), 636 + plates.

McClendon, C., 'Louis the Pious, Rome, and Constantinople', in C. Striker (ed.), *Architectural Studies in Memory of Richard Krautheimer* (Mainz, 1996), 103–6.

McCulloh, J., 'The cult of relics in the letters and 'Dialogues' of Pope Gregory the Great: a lexicographical study', *Traditio* 32 (1976), 145–84.

McCulloh, J., 'From antiquity to the Middle Ages: continuity and change in papal relic policy from the sixth to the eighth century', in E. Dassmann and K. Suso Frank (eds), *Pietas: Festschrift für Bernhard Kötting* (*Jahrbuch für Antike und Christentum Ergänzungband* 8) (Münster, 1980), 313–24.

McDannell, C., *Material Christianity: Religion and Popular Culture in America* (New Haven, 1995).

McGrath, E., *Rubens: Subjects from History*, 2 vols (*Corpus Rubenianum Ludwig Burchard* 13) (London, 1997).

McIlwain, C.H. (ed.), *The Political Works of James I* (New York, 1965).

Medici, Z., *Trattato utilissimo di conforto de condannati a morte per via di giustizia …* (Ancona, 1572).

Megow, W.-R., 'Priapos', *Lexicon Iconographicum Mythologiae Classicae, Supplement* (1997), 1028–44.

Meldini, P., *L'avvocata delle vertigini* (Milan, 1994).

Mellinkoff, R., *Outcasts: Signs of Otherness in Northern European Art of the Late Middle Ages* (Berkeley, 1993).

Menestò, E. (ed.), *La conversione alla povertà nell'Italia dei secoli XII–XIV* (Spoleto, 1991).

Merback, M., *The Thief, the Cross and the Wheel: Pain and the Spectacle of Punishment in Medieval and Renaissance Europe* (London, 1999).

Meskell, L.M., 'Writing the body in archaeology', in A.E. Rautman (ed.), *Reading the Body: Representations and Remains in the Archaeological Record* (Philadelphia, 2000), 13–21.

Meyer, A.O., *England and the Catholic Church Under Queen Elizabeth* (London, 1967).

Michaelides, D., 'A Roman surgeon's tomb from Nea Paphos', *Report of the Department of Antiquities, Cyprus* (1984), 315–32.

Miles, M., 'Vision: the eye of the body and the eye of the mind in Saint Augustine's *De trinitate* and *Confessions*', *Journal of Religion* 63 (1983), 125–42.

Miles, M., *Carnal Knowing: Female Nakedness and Religious Meaning in the Christian West* (Boston, 1989).

Miller, P.C., 'The blazing body: ascetic desire in Jerome's letter to Eustochium', *Journal of Early Christian Studies* 1 (1993), 21–45.

Mitchell, S., 'The cult of Theos Hypsistos between pagans, Jews and Christians', in P. Athanassiadi and M. Frede (eds), *Pagan Monotheism in Late Antiquity* (Oxford, 1999), 81–148.

Modio, G., *Il Tevere* (Rome, 1556).

Molho, A., 'The Brancacci Chapel: studies in its iconography and history', *Journal of the Warburg and Courtauld Institutes* 40 (1977), 50–98.

Mollat, M., *Les pauvres au Moyen Age* (Paris, 1978).

Mombritius, B., *Sanctuarium seu Vitae sanctorum*, 2 vols (second edition; Paris, 1910).

Monssen, L.H., 'Rex Gloriose Martyrum: a contribution to Jesuit iconography', *Art Bulletin* 63 (1981), 130–7.

Monssen, L.H., 'Antonio Tempesta in Santo Stefano Rotondo', *Bollettino d'Arte* 57 (1982), 107–20.

Monssen, L.H., 'The martyrdom cycle in Santo Stefano Rotondo', *Acta ad Archaeologium et Artium Historiam Pertinentia* (*series altera*) 2 (1982), 175–317.

Monssen, L.H., 'The martyrdom cycle in Santo Stefano Rotondo', *Acta ad Archaeologium et Artium Historiam Pertinentia* (*series altera*) 3 (1983), 11–106.

Montserrat, D., *Sex and Society in Graeco-Roman Egypt* (London, 1996).

Montserrat, D. (ed.), *Changing Bodies, Changing Meanings: Studies on the Human Body in Antiquity* (London, 1998).

Monumenta Germaniae Historica (Hanover/Berlin/Munich, 1826–present).

Morey, A., *The Catholic Subjects of Elizabeth I* (New Jersey, 1978).

Moroni, G., *Dizionario di erudizione storico-eclesiastica da San Pietro sino ai giorni nostri* (Venice, 1840–79).

Moscati, S. (ed. and coordinator), *The Celts* (New York, 1991).

Mudry, P., 'Le *De medicina* de Celse: rapport bibliographique', in W. Haase (ed.), *Aufstieg und Niedergang der Römischen Welt (Geschichte und Kultur Roms im Spiegel der Neueren Forschung* II, 37:1) (Berlin/New York, 1993), 787–818.

Muir, E., 'The doge as *primus inter pares*: interregnum rites in early sixteenth century Venice', in S. Bertelli (ed.), *Essays Presented to Myron P. Gilmore*, 2 vols (Florence, 1978), I, 145–60.

Muir, E., *Civic Ritual in Renaissance Venice* (Princeton, 1981).

Mulvey, L., 'Visual pleasure and narrative cinema', in L. Mulvey, *Visual and Other Pleasures* (Bloomington, 1989), 14–26.

Munday, A., *The English Romayne Lyffe* (ed. P.J. Ayres) (Oxford, 1980).

Murphy, M., 'St Gregory's College, Seville 1592–1767', *Catholic Record Society* 73 (1992), 1–37.

Murray, C., *Rebirth and Afterlife: a Study of the Transmutation of some Pagan Imagery in Early Christian Funerary Art* (Oxford, 1981).

Mustakallio, K., *Death and Disgrace: Capital Penalties with Post Mortem Sanctions in Early Roman Historiography* (Helsinki, 1994).

Nash, D., 'Reconstructing Posidonios' Celtic ethnography: some considerations', *Britannia* 7 (1976), 111–26.

Nicoll, W.S.M., 'The death of Turnus', *Classical Quarterly* 51.1 (2001), 190–200.

Nilgen, U., 'Die große Reliquieninschrift von Santa Prassede', *Römische Quartalschrift* 69 (1974), 7–29.

Nilgen, U., 'Die Bilder über dem Altar. Triumph- und Apsisbogenprogramme in Rom und Mittelitalien und ihr Bezug zur Liturgie', in N. Bock, S. de Blaauw, C.L. Frommel and H. Kessler (eds), *Kunst und Liturgie im Mittelalter, Akten des Internationalen Kongresses der Bibliotheca Hertziana und des Nederlands Instituut te Rome, Rom, 28–30. September 1997* (Munich, 2000), 75–90.

Nilles, N., *De rationibus festorum Ssi. Cordis Iesu et purissimi Cordis Mariae*, 2 vols (Innsbruck, 1875).

Noble, T., 'The monastic ideal as a model for empire: the case of Louis the Pious', *Revue Bénédictine* 96 (1976), 235–50.

Noble, T., *The Republic of St Peter: the Birth of the Papal State 680–825* (Philadelphia, 1984).

Noreen, K., '*Ecclesiae militantis triumphi*: Jesuit iconography and the Counter-Reformation', *The Sixteenth Century Journal* 29 (1998), 687–715.

Norris, K., 'Maria Goretti — cipher or saint?', in S. Bergman (ed.), *A Cloud of Witnesses* (London, 1996), 300–11.

Nunn, J., *Ancient Egyptian Medicine* (London, 1996).

Nussdorfer, L., 'The vacant see: ritual and protest in early modern Rome', *Sixteenth Century Journal* 18 (1987), 173–89.

Nussdorfer, L., *Civic Politics in the Rome of Urban VIII* (Princeton, 1992).

O'Connor, E.M., '*Sumbolum salacitatis*': a Study of the God Priapus as a Literary Character (Studien zur Klassischen Philologie* 40) (Frankfurt, 1989).

O'Donnell, J.J., *Augustine: Confessions*, 3 vols (Oxford, 1992).

Olender, M., 'Priape, le dernier des dieux', in Y. Bonnefoy (ed.), *Dictionnaires des mythologies* (Paris, 1981), 311–14.

Olender, M., 'Priape à tort et de travers', *Nouvelle Revue de Psychanalyse* 63 (1991), 59–82.

Oliver, A., 'Honors to Romans: bronze portraits', in C. Mattusch (ed.), *The Fire of Hephaistos: Large Classical Bronzes from North American Collections* (Cambridge (MA), 1996), 138–60.

Omont, H.A. (ed.), *Évangiles avec peintures byzantine du XI^e siècle*, 2 vols (Paris, 1908).

Orbaan, J., 'La Roma di Sisto V negli avvisi', *Archivio della Reale Società Romana di Storia Patria* 33 (Rome, 1910), 309–10.

Osborne, J., 'The Roman catacombs in the Middle Ages', *Papers of the British School at Rome* 53 (1985), 278–328.

The Oxford English Dictionary, 12 vols (Oxford, 1989).

Owen, L., *The State of the English Colledges in Forraine Parts* (London, 1626).

Packer, J.E., *The Forum of Trajan in Rome: a Study of the Monuments (California Studies in the History of Art* 31), 2 vols (Berkeley, 1997).

Paglia, V., *La morte confortata. Riti della paura e mentalità religiosa a Roma nell'età moderna* (Rome, 1982).

Palazzini, P. (ed.), *Dizionario dei Concili*, 6 vols (Rome, 1963–8).

Paleotti, G., *De imaginibus sacris* (Ingolstadt, 1594).

Paleotti, G., 'Discorso intorno alle imagini sacre e profane, diviso in cinque libri', in P. Barocchi (ed.), *Trattati d'arte del Cinquecento fra Manierismo a Controriforma*, 3 vols (Bari, 1961), II, 117–509.

Palmer, A.-M., *Prudentius on the Martyrs* (Oxford, 1989).

Palmer, R., 'Medicine at the papal court in the sixteenth century', in V. Nutton (ed.), *Medicine at the Courts of Europe 1500–1837* (London, 1990), 49–78.

Paoletti O., 'Gorgones romanae', in *Lexicon Iconographicum Mythologiae Classicae* 4 (Zurich, 1988), 345–62.

Papadopoulos, I. and Kelami, A., 'Priapus and priapism: from mythology to medicine', *Urology* 32 (1988), 385–6.

Papàsogli, B., *Il 'fondo del cuore': figure dello spazio interiore nel Seicento francese* (Pisa, 1991).

Paravicini Bagliani, A., *Il corpo del papa* (Turin, 1994).

Paravicini Bagliani, A., 'Rileggendo i testi sulla nudità del papa', in G. Cantarella and F. Santi (eds), *I re nudi. Congiure, assassini, tracolli ed altri imprevisti nella storia del potere* (Spoleto, 1996), 103–25.

Paravicini Bagliani, A., *The Pope's Body* (trans. D.S. Peterson) (Chicago, 2000).

Park, K., 'The criminal and the saintly body: autopsy and dissection in Renaissance Italy', *Renaissance Quarterly* 47 (1994), 1–33.

Park, K., 'The life of the corpse: division and dissection in late medieval Europe', *Journal of the History of Medicine and Allied Sciences* 50 (1995), 111–32.

Pavanello, G., 'I Rezzonico: committenza e collezionismo fra Venezia e Roma', *Arte Veneta* 52 (1998), 86–111.

Pavone, M.A., *Iconologia francescana: il Quattrocento* (Todi, 1988).

Pecchai, P., *Il Gesù di Roma: descritto e illustrato* (Rome, 1952).

Pekáry, T., *Das Römische Kaiserbildnis in Staat, Kult und Gesellschaft (Das Römische Herrscherbild* 3.5) (Berlin, 1985).

Pelliccia, G. and Rocca, G. (eds), *Dizionario degli istituti di perfezione*, 9 vols (Rome, 1974–2003).

Penn, J., 'Penile reform', *British Journal of Plastic Surgery* 16 (1963), 287–8.

Perkins, J., *The Suffering Self: Pain and Narrative Representation in the Early Christian Era* (London, 1995).

Petruccione, J., 'The portrait of Saint Eulalia of Merida in Prudentius's *Peristephanon* 3', *Annalecta Bollandiana* 108 (1990), 81–104.

Petti, A.G., 'Richard Verstegan and Catholic martyrologies of the later Elizabethan period', *Recusant History* 5 (1959), 64–90.

Pierguidi, S., 'Riflessioni e novità su Giovanni Guerra', *Studi Romani* 48 (2000), 297–321.

Pietri, C., *Roma Christiana: recherches sur l'Église de Rome, son organisation, sa politique, son idéologie de Miltiade à Sixte III (311–440)* (Rome, 1976).

Pignatelli, G., 'Blasi, Camillo', in *Dizionario biografico degli italiani* 10 (Rome, 1968), 782–4.

Plumer, E., *Augustine's Commentary on Galatians (Oxford Early Christian Studies)* (Oxford, 2002).

Pöschl, V., *The Art of Virgil: Image and Symbol in the* Aeneid (Ann Arbor, 1962).

Pollini, J., 'Damnatio memoriae in stone: two portraits of Nero recut to Vespasian in American museums', *American Journal of Archaeology* 88 (1984), 547–55.

Ponnelle, L. and Bordet, L., *Saint Philippe Néri et la société romaine de son temps (1515–1595)* (Paris, 1929).

Poque, S., *Le langage symbolique dans la prédication d'Augustin d'Hippone*, 2 vols (Paris, 1984).

Porter, J.I. (ed.), *Constructions of the Classical Body* (Ann Arbor, 1999).

Pozzi, G., '*Schola Cordis*: di metafora in metonomia', in *Lombardia elvetica: studi offerti a Virgilio Gilardoni (Collana studi, testi, strumenti)* (Bellinzona, 1987), 189–226.

Praz, M., *Studies in Seventeenth-century Imagery (Sussidi eruditi* 16) (Rome, 1964).

Preisigke, F., *Griechische Papyrus der Kaiser Universitäts- und Landesbibliothek zu Stassburg*, 1 vol. in 3 (Leipzig, 1906–12).

Preuss, J., *Biblisch-Talmudische Medizin: Beiträge zur Geschichte der Heilkunde und der Kultur* (Berlin, 1911).

Preuss, J., *Biblical and Talmudic Medicine* (trans. F. Rosner) (Northvale (NJ)/London, 1993).

Previté-Orton, C.W. (ed.), *The Defensor Pacis of Marsilius of Padua* (Cambridge, 1928).

Price, J. and Shildrick, M. (eds), *Feminist Theory and the Body: a Reader* (Edinburgh, 1999).

Price S.R.F., 'From noble funerals to divine cult: the consecration of the Roman emperor', in D. Cannadine and S.R.F. Price (eds), *Rituals of Royalty: Power and Ceremonial in Traditional Societies* (Cambridge, 1987), 56–108.

Prodi, P., *Il Cardinale Gabriele Paleotti (1522–1597)* (Rome, 1959).

Prodi, P., *Ricerca sulla teorica delle arti figurative nella Riforma Cattolica* (Bologna, 1984).

Prodi, P., *The Papal Prince: One Body and Two Souls. The Papal Monarchy in Early Modern Europe* (Cambridge, 1987).

Prosperi Valenti Rodinò, S. and Strinati, C. (eds), *L' immagine di San Francesco nella Controriforma* (exhibition catalogue (Calcografia, Rome), Rome, 1983).

Pupillo, M., 'Trofeo con strumenti di martirio', in *La regola e la fama: San Filippo Neri e l'arte* (exhibition catalogue (Museo Nazionale del Palazzo Venezia, Rome), Milan, 1995).

Purcell N., 'Livia and the womanhood of Rome', *Proceedings of the Cambridge Philological Society* 32 (1986), 78–105.

Py, M., 'Les fanums de Castels à Nâges et de Roque-de-Viou', *Documents d'Archéologie Méridonale* 15 (1992), 44–9.

Quigley, C., *The Corpse: a History* (Jefferson, 1996).

Rabello, A.M., 'Il problema della circumcisione in diritto romano fino ad Antonino Pio', *Studi Biscardi* 2 (1982), 201–4.

Raffaelli, R., Danese, R.M. and Lanciotti, S. (eds), *Pietas e allattamento filiale: la vicenda, l'exemplum, l'iconografia* (Urbino, 1997).

Rahner, K., 'Le debut d'une doctrine des cinque sens spirituels chez Origène', *Revue d'Ascétique et de Mystique* 14 (1932), 113–45.

Rawlings, L., 'Celts, Spaniards, and Samnites: warriors in a soldiers' war', in T.J. Cornell, B. Rankov and P. Sabin (eds), *The Second Punic War: a Reappraisal* (London, 1996), 84–6.

Rebillard, E., 'Le figure du catéchumene et le problème du délai du baptême dans la pastorale d'Augustin', in G. Madec (ed.), *Augustin Prédicateur (395–411) (Actes du colloque international de Chantilly 5–7 septembre 1996)* (Paris, 1998), 285–92.

Rebillard, E., *In Hora Mortis: evolution de la pastorale chrétienne de la mort aux IVe et Ve siècles* (Paris, 1994).

La Regola e la fama: San Filippo Neri e l'arte (exhibition catalogue (Museo Nazionale del Palazzo Venezia, Rome), Milan, 1995).

Reynold, P. (ed.), 'Letters of William Allen and Richard Barret 1572–1598', *Catholic Record Society* 58 (1967), 113–14.

Ricci, G., *Breve notizia d'alcuni compagni di S. Filippo Neri* (Brescia, 1707).

Ricciotti, G., 'Un episodio occorso alla salma di S. Filippo Neri', *Roma* 16 (1938), 166–8.

Richard, J.-C., 'Les funérailles de Trajan et le triomphe sur les Parthes', *Revue des Études Latines* 44 (1966), 351–62.

Richeôme, L., *La peinture spirituelle ou l'art d'admirer aimer et louer Dieu en toutes Ses oeuvres* (Lyon, 1611).

Richlin, A., 'Cicero's head', in J.I. Porter (ed.), *Constructions of the Classical Body* (Ann Arbor, 1999), 190–211.

Richmond, I.A., *Trajan's Army on Trajan's Column* (London, 1982).

Riis, T., 'I poveri nell'arte italiana (secoli XV–XVIII)', in G. Politi, M. Rosa and F. della Peruta (eds), *Timore e carità: i poveri nell'Italia moderna* (Cremona, 1982), 45–58.

Ringbom, S., *Icon to Narrative: the Rise of the Dramatic Close-up in Fifteenth-century Devotional Painting* (Doornspijk, 1984).

Ringrose, K., 'Passing the test of sanctity: denial of sexuality and involuntary castration', in L. James (ed.), *Desire and Denial in Byzantium* (London, 2000), 123–37.

Ripa, C., *Iconologia overo descrittione di diverse imagini cavate dal'antichità, e di proprio inventione* (first edition Rome, 1603; reprint Hildesheim/Zürich/New York, 1984).

Roberts, C. and Manchester, K., *The Archaeology of Disease* (Stroud/New York, 1995).

Roberts, M., *Poetry and the Cult of the Martyrs* (London, 1993).

Robins, W., 'Romance and renunciation at the turn of the fifth century', *Journal of Early Christian Studies* 8.4 (2000), 531–57.

Robinson, O.F., *The Criminal Law of Ancient Rome* (London, 1995).

Rordorf, W., 'Tradition and composition in the acts of Saint Thecla: the state of the question', *Semeia* 38 (1986), 43–66.

Rosa, M., *Settecento religioso: politica della ragione e religione del cuore* (Venice, 1999).

Rose, C.B., *Dynastic Commemoration and Imperial Portraiture in the Julio-Claudian Period* (Cambridge, 1997).

Rossi, L., *Trajan's Column and the Dacian Wars* (London, 1971).

Rossi, L., 'A historical reassessment of the metopes of the Tropaeum Traiani at Adamklissi', *Archaeological Journal* 129 (1972), 56–68.

Roth, A.M., *Egyptian Phyles in the Old Kingdom* (Chicago, 1991).

Rubin, J., 'Celsus's de-circumcision operation', *Urology* 16.1 (1980), 121–4.

Rubin, N., 'The stretching of the foreskin and the enactment of *peri'ah*', *Zion* 54 (1989), 105–17.

Salomon, N., 'Making a world of difference: gender, asymmetry, and the classical Greek nude', in A.O. Koloski-Ostrow and C.L. Lyons (eds), *Naked Truths: Women, Sexuality and Gender in Classical Art and Archaeology* (London, 1997), 197–219.

Salzman, M.R., *On Roman Time: the Chronograph Calendar of 354 and the Rhythms of Urban Life in Late Antiquity* (Oxford, 1990).

Salzmann, D., 'Die Bildnisse des Macrinus', *Jahrbuch des Deutschen Archäologischen Instituts* 98 (1983), 362–5, 371–9.

Sansterre, J.-M., 'Les justifications du culte des reliques dans le haut Moyen Âge', in E. Bozóky and A.-M. Helvétius (eds), *Les reliques: objets, cultes, symbols (Actes du colloque international de l'Université du Littoral-Côte d'Opale (Boulogne-sur-Mer) 4–6 septembre 1997)* (Turnhout, 1999), 81–93.

Sawday, J., *The Body Emblazoned: Dissection and the Human Body in Renaissance Literature* (London, 1995).

Schäfer, P., 'Hadrian's policy in Judaea', in P. Davies and R. White (eds), *A Tribute to Geza Vermes* (Sheffield, 1990), 293–5.

Schäfer, P., *Judeophobia: Attitudes towards the Jews in the Ancient World* (trans. D.R. Shackleton Bailey) (Cambridge (MA)/London, 1997).

Schefold, K., with Bayard, A.-C., Cahn, H.A., Guggisberg, M., Jenny, M.T. and Schneider, C., *Die Bildnisse der Antiken Dichter, Redner und Denker* (Basel, 1997).

Scheid, J., 'La mort du tyran: chronique de quelques morts programmées', in *Du châtiment dans la cité: supplices corporels et peine de mort dans le monde antique* (Collection de L'École Française de Rome 79) (Rome, 1984), 181–90.

Schimmelpfennig, B., *Die Zeremoniebücher der Römischen Kurie im Mittelalter* (Tübingen, 1973).

Schmit-Neuerburg, T., *Vergils 'Aeneis' und die Antike Homerexegese: Untersuchungen zum Einfluß Ethischer und Kritischer Homerrezeption auf 'imitatio' und 'aemulatio' Vergils* (Berlin, 1999).

Schönegg, B., *Senecas epistulae morales als Philosophisches Kunstwerk* (Bern, 1999).

Schraven, M., 'Il lutto pretenzioso di cardinali-nipoti per la morte dei loro zii-papi: tre catafalchi papali 1591–1624', *Storia dell'Arte* 98 (2000), 5–24.

Schraven, M., 'Veri disegni e gloriose memorie: ceremoniële prenten tijdens de Sede Vacante in barok Rome', *Leids Kunsthistorisch Jaarboek* 12 (Leiden, 2002), 109–26.

Schuerer, E., *The History of the Jewish People in the Age of Jesus Christ* I *(175 BC – AD 135)* (rev. G. Vermes and F. Millar) (Edinburgh, 1973–87).

Sealey, P.R., *The Boudican Revolt Against Rome* (Princes Risborough, 2000).

Segal, C., *The Theme of the Mutilation of the Corpse in the* Iliad (Leiden, 1971).

Sennett, R., *Flesh and Stone: the Body and the City in Western Civilization* (London, 1994).

Serlio, S., *On Architecture* (eds V. Hart and P. Hicks), 2 vols (New Haven/London, 1996–2001).

Settis, S. *et al.* (ed.), *La Colonna Traiana* (Turin, 1988).

Seydl, J.L., *The Sacred Heart: Religious Imagery in Eighteenth-century Italy* (Ph.D. thesis, University of Pennsylvania, 2003).

Shaw, B.D., 'Eaters of flesh, drinkers of milk: the ancient Mediterranean ideology of the pastoral nomad', *Ancient Society* 13 (1982), 5–31.

Shaw, B., 'Body/power/identity: passions of the martyrs', *Journal of Early Christian Studies* 4.3 (1996), 269–312.

Shaw, T., *The Burden of the Flesh* (Minneapolis, 1998).

Shilling, C., 'The body and difference', in K. Woodward (ed.), *Identity and Difference* (Milton Keynes, 1997), 65–100.

Shumate, N., *Crisis and Conversion in Apuleius's* Metamorphoses (Ann Arbor, 1995).

Silvagni, A. (ed.), *Monumenta epigraphica christiana saeculo XIII antiquiora quae in Italiae finibus adhuc exstant*, 3 vols (Rome, 1943).

Siraisi, N.G., 'Signs and evidence: autopsy and sanctity in late sixteenth-century Italy', in N. Siraisi, *Medicine and the Italian Universities 1250–1600* (Leiden, 2001), 356–80.

Slater, N., 'Passion and petrification: the gaze in Apuleius', *Classical Philology* 93 (1998), 18–48.

Smallwood, E.M., 'The legislation of Hadrian and Antoninus Pius against circumcision', *Latomus* 18 (1959), 334–57.

Smallwood, E.M., 'Addendum', *Latomus* 20 (1961), 93–6.

Smith, G.E. and Dawson, W.R., *Egyptian Mummies* (London, 1924).

Smith, J.M.H., 'Old saints, new cults: Roman relics in Carolingian Francia', in J.M.H. Smith (ed.), *Early Medieval Rome and the Christian West: Essays in Honour of Donald A. Bullough* (The Medieval Mediterranean 28) (Leiden, 2000), 317–39.

Smith, K.A., 'Inventing marital chastity: the iconography of Susanna and the elders in early Christian art', *Oxford Art Journal* 16 (1993), 3–24.

Smith, R.R.R., 'Greeks, foreigners, Roman Republican portraits', *Journal of Roman Studies* 71 (1981), 24–38.

Solazzi, S., *Note di diritto romano* (Atti della Societa Reale di Napoli 58) (Naples, 1937).

Solin, H., 'Juden und Syrer im Westlichen Teil der römischen Welt: eine ethnischdemographische Studie mit besonderer Berücksichtigung der sprachlichen Zustände', *Aufstieg und Niedergang der Römischen Welt* 2.29.2 (1983), 587–1249.

Solin, H. and Salomies, O., *Repertorium nominum gentilium et cognominum latinorum* (Alpha–Omega A 80) (Hildesheim, 1988).

Somerset, A., *Elizabeth I* (London, 1997).

Speidel, M.A., 'The captor of Decebalus: a new inscription from Philippi', *Journal of Roman Studies* 60 (1970), 142–53.

Speidel, M.P., *Riding for Caesar: the Roman Emperors' Horse Guards* (London, 1994).

Spinola, G., *Il Museo Pio-Clementino* (Guide e cataloghi dei Musei Vaticani 3) (Rome, 1996).

Stahl, H.P., 'The death of Turnus: Augustan Virgil and the political revival', in K.A. Raaflaub and M. Toher (eds), *Between Republic and Empire: Interpretations of Augustus and his Principate* (Berkeley, 1993), 174–9.

Statuta Almae Universitatis DD. Philosophorum et Medicorum Cognomento Artistarum Patavini Gymnasii. Denuo correcta et emendata et nonnullis apostillis scitu digni aucta (Padua, 1607).

Stechow, W., *Old Master Drawings* 10 (1935), text to pl. 18.

Stemmer, K., *Untersuchungen zur Typologie, Chronologie und Ikonographie der Panzerstatuen* (Archäologische Forschungen 4) (Berlin, 1978).

Stern, M., *Greek and Latin Authors on Jews and Judaism*, 3 vols (Jerusalem, 1974–84).

Stewart, A., *Art, Desire and the Body in Classical Greece* (Cambridge, 1997).

Stewart, P., 'The destruction of statues in late antiquity', in R. Miles (ed.), *Constructing Identity in Late Antiquity* (London, 1999), 89–130.

Stiker, H.J., *A History of Disability* (Ann Arbor, 1999).

Stone, S., 'The toga: from national to ceremonial costume', in J.L. Sebesta and L. Bonfante (eds), *The World of the Roman Costume* (Madison (WI), 1994), 13–45.

Strieder, P., 'Folk art sources of Cranach's woodcut of the sacred heart', *Print Review* 5 (Spring 1976), 160–6.

Synott, A., *The Body Social: Symbolism, Self and Society* (London, 1993).

Tanner, J., 'Portraits, power and patronage in the late Roman Republic', *Journal of Roman Studies* 90 (2000), 18–50.

Wortley, J., 'Iconoclasm and leipsanoclasm: Leo III, Constantine and the relics', *Byzantinische Forschungen* 8 (1982), 253–79.

Wright, W.M., "That which is what it is made for': the image of the heart in the spirituality of Francis de Sales and Jane de Chantal', in A. Callahan (ed.), *Spiritualities of the Heart: Approaches to Personal Wholeness in Christian Tradition* (Mawah (NJ), 1990), 143–58.

Wyke, M. (ed.), *Gender and the Body in the Ancient Mediterranean* (Oxford, 1998).

Wyke, M., *Parchments of Gender: Deciphering the Bodies of Antiquity* (Oxford, 1998).

Wyss, A., 'Müstair, Kloster St. Johann. Zur Pflege der Wandbilder in der Klosterkirche', in *Wandmalerei des Frühen Mittelalters* (*Icomos* 23) (Munich, 1998), 49–55.

Yates, F., *The Art of Memory* (London, 1966).

Yegül, F., *Baths and Bathing in Classical Antiquity* (New York/ Cambridge (MA)/London, 1992).

Zanker, P., *The Power of Images in the Age of Augustus* (Ann Arbor, 1990).

Zanker, P., 'I ritratti di Seneca', in P. Parroni (ed.), *Seneca e il suo tempo: atti del convegno internazionale di Roma–Cassino 11– 14 novembre 1998* (Rome, 2000), 47–58.

Ziegler, J., 'Practitioners and saints: medical men in canonization processes in the thirteenth to fifteenth centuries', *Social History of Medicine* 12 (1999), 191–225.

Zilliacus, H., *Vierzehn Berliner Griechische: Urkunden und Briefe* (Helsingfors, 1941).

Zuccari, A., 'La politica culturale dell'Oratorio romano nella seconda metà del Cinquecento', *Storia dell'Arte* 41 (1981), 77–112.

Zuccari, A., 'La politica culturale dell'Oratorio romano nelle imprese artistiche promose da C. Baronio', *Storia dell'Arte* 42 (1981), 171–93.

Zuccari, A., *Arte e committenza nella Roma di Caravaggio* (Turin, 1984).

BIOGRAPHICAL NOTES ON THE CONTRIBUTORS

and

CONTRIBUTORS' ADDRESSES

ANDREA CARLINO teaches the history of medicine at the University of Geneva. After having completed a series of works that centred upon the cultural history of anatomy and dissection in the Renaissance, for the last few years his research interests have focused upon three topics: the relationships between medicine, natural philosophy and humanistic culture in Europe; medicine and literary practices in the Ancien Regime; the history of scepticism and of literature against doctors and medicine. He has published *Books of the Body* (Chicago/London, 1999), *Paper Bodies* (London, 1999) and, in collaboration with Deanna Petherbridge and Claude Ritschard, the catalogue for the exhibition *Corps à vif. Art et anatomie* (Geneva, 1998). He is preparing a book on the relationships between the arts and sciences in Renaissance Italy that will be published in 2005 by Carocci Editore.

GILLIAN CLARK is Professor of Ancient History at the University of Bristol. She works on the interaction of Christianity and Graeco-Roman culture in the early centuries CE, with a particular interest in gender history. Publications include *Women in Late Antiquity* (Oxford, 1993), *Augustine: Confessions 1–4* (Cambridge, 1995), *Christianity and Roman Society* (Cambridge, 2004), and many papers in journals and edited volumes. She is currently directing a collaborative international commentary on Augustine, *City of God*. She also co-edits the monograph series *Oxford Early Christian Studies* and the series of scholarly annotated translations *Translated Texts for Historians, AD 300–900*.

PIERRE CORDIER, *ancien élève* of the École Normale Supérieure (Paris), has taught Roman History at the University of Toulouse II – Le Mirail (France) for the last two years. He is a member of a research group in Toulouse (ERASME: Equipe de Recherche sur la Réception de l'Antiquité. Sources, Mémoire, Enjeux) and an associate member of the Centre Louis Gernet (École des Hautes Études en Sciences Sociales, Paris). In his most recent writings, he has looked at Roman facts and representations from a dual perspective: history and cultural anthropology. He edited and introduced (with P. Ballet and N. Dieudonné-Glad), *La ville et ses déchets dans le monde romain. Rebuts et recyclages (Actes du Colloque de Poitiers, 19–21 septembre 2002)* (Montagnac, 2003). With regard to the subject matter of *Roman Bodies*, key publications include: 'Tertium genus hominum. L'étrange sexualité des castrats', in P. Moreau (ed.), *Corps romain. Actes de la table ronde de la SFARA, Collège International de Philosophie/École Normale Supérieure, 28–30 janvier 1999* (Paris, 2001), 61–75; 'Remarques sur les inscriptions corporelles dans le monde romain: du signe d'identification (*notitia*) à la marque d'identité (*identitas*)', *Pallas* 65 (2004), 189–98; *Nudités romaines. Un problème d'histoire et d'anthropologie (Collection des Études Anciennes 63)* (Paris, forthcoming).

CATHARINE EDWARDS teaches Classics and Ancient History at Birkbeck College. Her publications include *The Politics of Immorality in Ancient Rome* (Cambridge, 1993) and *Reading Rome: Textual Approaches to the City* (Cambridge, 1996), as well as a number of articles on Seneca's *Letters*. Among her current projects are a book on attitudes to death in ancient Rome and a commentary on selected letters of Seneca for the Cambridge Greek and Latin Classics series. She offers a rather diffferent perspective on bodies in Rome in 'Incorporating the alien: the art of conquest', in C. Edwards and G. Woolf (eds), *Rome the Cosmopolis* (Cambridge, 2003), 44–70.

NIC FIELDS received his BA and PhD in Ancient History from the University of Newcastle upon Tyne. He was the Lillian Jeffery Student at the British School at Athens in 1991–2 and 1992–3. With special expertise in the history of Greek and Roman warfare, he has published several articles and monographs on ancient warfare. (He served as an officer in the Royal Marines before turning to Ancient History.) Dr Fields was Assistant Director at the British School at Athens. Additionally, in 1993 he organized and led the British School at Athens Summer School, where he taught summer courses for four years. From 1994 to 1998 he was a free-lance lecturer and guide — in this capacity he has worked in Greece, Turkey and Italy for the

Smithsonian Institute, and has taught American undergraduates on study abroad programmes at institutions such as Beaver College in Athens and The Athens Centre. After leaving Athens, Nic lectured in Ancient History at the University of Edinburgh. He is now a free-lance writer.

CAROLINE GOODSON is interested in the ways in which early medieval architecture reflects the negotiations between the material remnants of antiquity and the development of new cult practices. She completed a PhD at Columbia University (2004), with a dissertation on the basilicas of Paschal I (817–24), and is presently researching and writing up various projects related to the architecture and archaeology of the early medieval Mediterranean. In 2004–5, she has been the Skaggs Postdoctoral Fellow in Medieval Architecture at the Medieval Institute, University of Notre Dame.

LUCY GRIG is a Lecturer in Classics (Roman History) at the University of Edinburgh and former Rome Scholar at the British School at Rome. Her research is focused on the religious and cultural history of late antiquity. She has published on martyr literature and iconography, including a monograph, *Making Martyrs in Late Antiquity* (London, 2004). Her current research concerns the transformation of the city of Rome in the fourth century, and she has recently published an article on late Roman gold glass in *Papers of the British School at Rome* (72 (2004), 203–30). Forthcoming work includes articles on poverty and splendour in early Christianity and on late Roman epitaphs.

ANDREW HOPKINS is a Research Professor at the University of l'Aquila. His previous edited volumes are *Lutyens Abroad* (London, 2002) with Gavin Stamp, and *Architettura e tecnologia* (Rome, 2002) with Claudia Conforti, the acts of conferences organized while he was Assistant Director of the British School at Rome from 1998 to 2002. He is currently writing a book on the Italian Baroque, *L'ingegno e l'archittetura barocca*, and with Arnold Witte is preparing a translation and commentary, *Alois Riegl's Roman Baroque*.

RALPH JACKSON, an archaeology graduate of University College, Cardiff in 1972, is Curator of the Romano-British Collections at the British Museum, where, in 2000, he mounted the popular and highly-acclaimed exhibition 'Gladiators and Caesars: the Power of Spectacle in Ancient Rome'. With the late Tim Potter he led excavations at the Roman site of Stonea, Cambridgeshire (R.P.J. Jackson and T.W. Potter, *Excavations at Stonea, Cambridgeshire 1980–85* (London, 1996)), and he is currently researching a new Romano-British temple treasure and shrine. He specializes in Roman metalwork and the archaeology of ancient medicine. His publications on ancient medicine include *Doctors and Diseases in the Roman Empire* (London, 1988), and he is just completing a book on objects of body care in Roman Britain. His main medical research interests are in ancient surgery, surgical practitioners and their instrumentation, and major projects in progress include a book on Greek and Roman surgery, a catalogue of the British Museum's medical collections and, with Dr Jacopo Ortalli, the publication of the remarkable medical assemblage from the 'House of the Surgeon' at Rimini.

OPHER MANSOUR completed his doctorate at the Courtauld Institute of Art. He has been a Rome Scholar at the British School at Rome (2000–1), and teaches at the University of Cambridge. His research interests include the theory and practice of art censorship in early modern Italy, and the aesthetics of 'reform' in the Catholic Reformation. He is currently working on publications on the censorship of works of art in the Visitation of Clement VIII, on the decorum of the Camerino Farnese, and on the role of asceticism in the visual culture of the papal court.

LIVIO PESTILLI is the Director of Trinity College/Rome Campus, where he teaches Renaissance and Baroque Art. He has published articles on a wide range of subjects, such as Cavallini's mosaics in Santa Maria in Trastevere, Michelangelo's Rome *Pietà*, Michael Sweerts's *Artist in his Studio*, and Lord Shaftesbury's artistic theory and patronage. He is currently working on a book on representations of the disabled in Italian art from antiquity through to the eighteenth century, as well as on a monograph on the Neapolitan painter Paolo de Matteis (1662–1728).

CATRIEN SANTING studied history and art history. She is presently a Reader in the History of Culture at the University of Groningen (Netherlands). From 1998 until 2002 she was the staff member responsible for history at the Istituto Olandese di Roma. She has published widely on the intellectual history, medical history and historiography of the late Middle Ages and early modern period. Currently she is writing a book, *The Secrets of the Heart in Papal Rome, 1450/1600*, on the relation between knowledge and belief at the papal court.

MINOU SCHRAVEN, after graduating in History of Art and Italian Language and Literature, entered the doctoral programme at the University of Groningen, in the Netherlands. Her dissertation, entitled *Festive Funerals. The Art and Liturgy of Conspicuous Commemoration in Early Modern Rome*, is an interdisciplinary study of the origins and function of funeral *apparati* at the papal court and their position within post-Tridentine festival culture.

KRISTINA SESSA received her PhD from the University of California at Berkeley and is currently an Assistant Professor in Ancient Mediterranean History at Claremont McKenna College in Claremont (CA). She is presently writing a book on social trust and the establishment of episcopal authority in late antique Rome.

JON L. SEYDL is Assistant Curator of Paintings at the J. Paul Getty Museum, and his research centres on the art and cultural history of eighteenth-century Europe. His 2003 dissertation at the University of Pennsylvania is entitled *The Sacred Heart of Jesus: Art and Religion in Eighteenth-Century Italy*, and he is the author of *Giambattista Tiepolo: Fifteen Oil Sketches* (Los Angeles, 2005). He is currently at work on exhibitions and publications on eighteenth-century pastels, Fragonard's late allegories of love, and Vincenzo Camuccini's history paintings. A volume of essays that he has co-edited with Victoria Coates, *Antiquity Recovered: the Legacy of Pompeii and Herculaneum*, will appear in 2006.

ERIC R. VARNER (PhD Yale University 1993) is Associate Professor of Art History and Classics at Emory University. His areas of specialization include Roman sculpture and the monuments and topography of ancient Rome. He has published on Neronian art and literature and on Roman portraits, most recently *Mutilation and Transformation:* Damnatio Memoriae *and Roman Imperial Portraiture* (Leiden, 2004).

RICHARD L. WILLIAMS is an Associate Lecturer in the Department of Art History, Film and Visual Media at Birkbeck College, University of London. After reading theology and law, he completed a doctorate in History of Art at the Courtauld Institute. His research focuses on issues relating to the impact of the Reformation on the visual culture of sixteenth-century England, together with the production of visual imagery by English Catholics across Europe. He has published several articles and contributions to books, and is soon to co-edit a volume of conference papers concerning the Reformation and the visual arts.

MARIA WYKE is Professor of Classics at the University of Reading. On the body and gender in antiquity, she has edited *Gender and the Body in the Ancient Mediterranean* (Oxford, 1998) and *Parchments of Gender: Deciphering the Bodies of Antiquity* (Oxford, 1998). On the reception of Rome, she has published the book *Projecting the Past: Ancient Rome, Cinema and History* (London, 1997) and edited, along with Michael Biddiss, *The Uses and Abuses of Antiquity* (Basle, 1999). Her current research concerns the reception of Julius Caesar in western culture, to pursue which she received a Major Leverhulme Fellowship. This work is being published as a monograph, *Caesar: a Life in Western Culture* (with Granta), and in a collection she is editing entitled *Julius Caesar in Western Culture* (with Blackwell). The latter stems from a conference held at the British School at Rome in March 2003.

Contributors' Addresses

Prof. Andrea Carlino
Institut d'Histoire de la Médecine,
Université de Genève, CMU p.o. box,
CH–1211 Genève 4, Switzerland
andrea.carlino@medecine.unige.ch

Prof. Gillian Clark
Department of Classics and Ancient History,
University of Bristol, 11 Woodland Road,
Bristol, BS8 1TB, Great Britain
gillian.clark@bris.ac.uk

Prof. Pierre Cordier
Université de Toulouse II – Le Mirail, U.F.R.
d'Histoire, Arts et Archéologie, 5, allées
Antonio Machado, 31100 Toulouse, France
pierre.cordier@univ-tlse2.fr

Dr Catharine Edwards
School of History, Classics & Archaeology,
Birkbeck College, University of London,
Malet Street, London, WC1E 7HX,
Great Britain
C.Edwards@bbk.ac.uk

Dr Nic Fields
nic.fields@ed.ac.uk

Dr Caroline Goodson
Medieval Institute, 715 Hesburgh Library,
University of Notre Dame, Notre Dame,
IN 46556, USA
cg202@columbia.edu

Dr Lucy Grig
Classics, School of History and Classics,
David Hume Tower, George Square,
Edinburgh, EH8 9JX, Great Britain
lucy.grig@ed.ac.uk

Prof. Andrew Hopkins
Villa I Tatti, Via di Vincigliata 26,
50135 Florence, Italy
hopkins@cc.univaq.it

Dr Ralph Jackson
Department of Prehistory and Europe,
The British Museum, London, WC1B 3DG,
Great Britain
rjackson@thebritishmuseum.ac.uk

Dr Opher Mansour
om227@cam.ac.uk

Prof. Livio Pestilli
Trinity College/Rome Campus,
Clivo dei Publicii 2,
00153 Rome, Italy
lpestilli@trincoll.it

Dr Catrien Santing
Instituut voor Geschiedenis, RUG,
Postbus 716, 9700 AS Groningen,
The Netherlands
C.G.Santing@let.rug.nl

Dr Minou Schraven
University of Groningen,
Centre for Postgraduate
and Postdoctoral Research (PPC),
Groote Rozenstraat 38, 9712 TJ Groningen,
The Netherlands

Prof. Kristina Sessa
Department of History, Claremont McKenna
College, 850 Columbia Ave, Claremont,
CA 91711, USA
kristina.sessa@claremontmckenna.edu

Dr Jon L. Seydl
J. Paul Getty Museum, 1100 Getty
Center Drive, Suite 1000, Los Angeles,
CA 90049, USA
jseydl@getty.edu

Prof. Eric R. Varner
Departments of Art History and Classics,
Emory University, Atlanta, GA 30322, USA
evarner@emory.edu

Dr Richard L. Williams
12 Ilchester Place, London, W14 8AA,
Great Britain
rlwilliams_arthistory@yahoo.com

Prof. Maria Wyke
Department of Classics, HUMSS,
University of Reading, Whiteknights Campus,
Reading, RG6 6AA, Great Britain
lkswyke@reading.ac.uk

INDEX